Formal Design in
Renaissance Architecture
from Brunelleschi
to Palladio

Michele Furnari

Formal Design in Renaissance Architecture
from Brunelleschi to Palladio

RIZZOLI
NEW YORK

First published in the United States
of America in 1995 by
Rizzoli International Publications, Inc.
300 Park Avenue South, New York,
NY 10010

First published in Italy in 1993 by
Electa Napoli

Library of Congress
Cataloging-in-Publication Data

Furnari, Michele.
Formal design in renaissance
architecture from Brunelleschi to
Palladio / by Michele Furnari.
p. 208 cm. 25 x 28
Includes bibliographical references
and index.
ISBN 0-8478-1860-8
1. Architecture, Renaissance-Italy.
2. Architecture, Italian.
I. Title.
NA1115.F87 1995
94-39306
720' .945' 09024–dc20 CIP

Front cover
The Ideal City (detail).
Urbino, Galleria Nazionale delle
Marche.

Designer
Enrica D'Aguanno
Nadia Bronzuto

Printed and bound in Italy, 1995

Contents

Foreword

This book is intended to be a useful and easily accessible guide, not only for architects and students of architecture, but also for anyone who has an interest in the fascinating and complex field of Renaissance architecture. It contains a wide selection of documentation on some of the most important buildings of the Italian Renaissance, presented by means of the architect's "tools of the trade" – plans, sections and elevations, axonometric views – and studies of the proportional relationships between the various parts of the buildings.

More exhaustive discussions of these buildings can, of course, be found in the myriad texts that have been written on Renaissance architecture ever since the fifteenth century (whole shelves of volumes have been published on Palladio's Villa la Rotonda alone). This book is a practical anthology of Renaissance buildings, bringing a large number of particularly significant buildings together for study and comparative analysis.

The book is organized into sections, according to the principal building types – churches, palaces, and villas – with an introductory essay covering the most important issues and problems of interpretation in the formal design of Renaissance architecture. The first three sections, on churches and other religious structures, are organized according to type of plan: central-plan churches with a square plan, central-plan churches with a polygonal or circular plan, and longitudinal churches. The religious buildings are presented in order of increasing complexity, from the simplest, the Old Sacristy in the church of San Lorenzo in Florence, to the most elaborate, Saint Peter's in Rome. The palazzi, on the other hand, are grouped according to location and different types of facade treatment, creating a classification according to "families" of buildings that share the same architectural themes. This will facilitate consultation for the reader, it is not meant to be a critical approach. The table at the beginning of each section provides an overview of all of the buildings of each different type, making it possible to see the various structures in their proper chronological context.

Highly detailed plans and elevations would not serve the purpose of this book. Thus I have drawn each of the figures with the intention of providing series of clear, simplified illustrations that bring out the essential elements to be examined in each case, and also make it possible to give an accurate idea of the original state of buildings that have been altered or even destroyed. The two-part reference scale provided with each figure defines one meter and ten meters.

I sincerely hope that this collection of documentation will serve as a stimulus for further study of the compositional methods and techniques that went into their conception, a study that is made even more interesting if one considers that it was in this, the Renaissance period, that many of the foundations were laid for the role of the architect in the modern sense of the term. The schematic drawings of the relationships between the various parts of the buildings and the spatial matrices have this objective.

Finally, while it must be understood that any errors or omissions are my responsibility alone, I would like to express my thanks to Eduardo Catalano for his comments and advice and his expertise concerning the drawings and the most appropriate graphic technique to use for the illustrations; to Silvio D'Ascia, who served as a model student and provided me with many interesting opinions; to Piero Ostilio Rossi, who with great patience gave me many valuable insights as the work progressed; and Kim Wessling, for the care and attention with which he assisted in the rewriting of the original Italian text for this edition. I also thank Silvia Cassani of Electa Napoli and David Morton, Megan McFarland, and Sharon Herson of Rizzoli for their care, expertise and friendly guidance in bringing this book to press. A special note of thanks goes to Gianni D'Angelo and, finally, to Maria Paola.

This book is dedicated to my parents.

Michele Furnari
Rome, December 1994

Centers of Renaissance Architecture in Italy

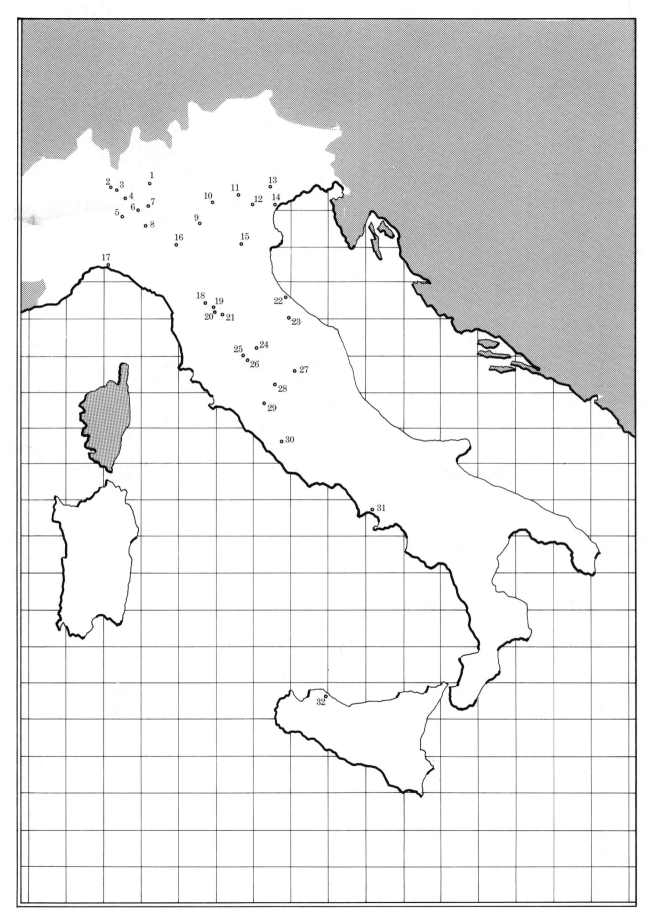

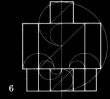

1

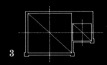

2

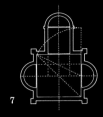

3

6

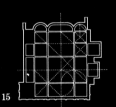

7

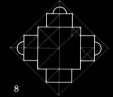

8

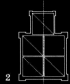

9

10

12

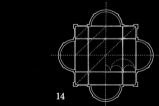

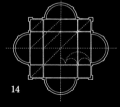

14

15

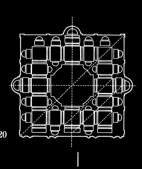

20

4

5

Central system churches on square based geometry Chronological table

1. Old Sacristy, Basilica of San Lorenzo, 1422-1428, Florence, p. 13.
2. Portinari Chapel or Chapel of St. Peter Martyr, 1462-1468, Milan Sant'Eustorgio, p. 16.
3. Colleoni Chapel, 1470-1473, Bergamo, p. 17.
4. Sant'Andrea on the Via Flaminia, 1550-1553, Rome, p. 18.
5. New Sacristy, Basilica of San Lorenzo, 1519-1534, Florence, p. 19.
6. Pazzi Chapel, ca. 1429-ca. 1461, Florence, Santa Croce, p. 21.
7. Tribune, Santa Maria delle Grazie, 1492, Milan, p. 24.
8. San Sebastiano, 1460, Mantua, p. 25.
9. Santa Maria delle Carceri, 1484-1491, Prato (Florence), p. 27.
10. Chapel of the Cardinal of Portugal, from 1460, Florence, San Miniato, p. 29.
11. Madonna di San Biagio, 1518-1537, Montepulciano (Siena), p. 30.
12. Santa Maria della Consolazione, ca. 1509, Todi (Perugia), p. 32.
13. Sant'Eligio degli Orefici, c. 1514-1536, then rebuilt starting in 1601, Rome, p. 35.
14. Central-plan temple based on a square c. 1489, Paris, Institut de France (Codex Ashburnham, Ms. B.N. 2037), f. 3v, p. 36.
15. San Giovanni Crisostomo, 1497-1504, Venice, p. 39.
16. Santa Maria Nuova, from 1550, Cortona (Arezzo), p. 40.
17. Santa Maria della Steccata, 1521-1539, Parma, p. 41.
18. Project for Santi Celso e Giuliano, from 1509, London, Soane Museum (Codice Coner), p. 42.
19. Santa Maria di Campagna, 1522-1528, Piacenza, p. 42.
20. Projects for the Basilica of St. Peter, c. 1505-1546, Rome, p. 43.
21. Santa Maria Assunta del Carignano, c. 1552-1570, Genoa, p. 52.

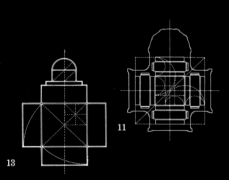

13

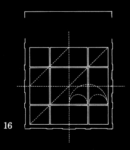

11

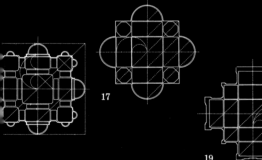

17

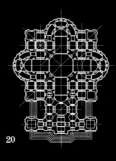

19

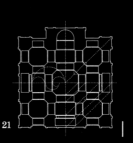

16

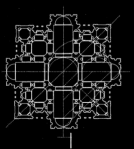

20

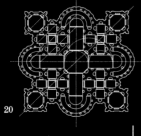

20

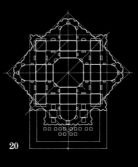

20

20

21

Filippo Brunelleschi
Old Sacristy
Basilica of San Lorenzo
1422–28
Florence

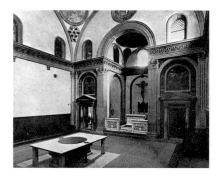

1. Plan of the San Lorenzo complex.
The church, designed by Brunelleschi, has two sacristies: the Old Sacristy on the left, by Brunelleschi, and the New Sacristy on the right, by Michelangelo. The church complex also includes the Laurentian Library, designed by Michelangelo and Bartolomeo Ammanati between 1523 and 1559, and the Princes' Chapel – the large funerary chapel of the Medici family – designed by Don Giovanni de' Medici, Buontalenti, Nigetti, and others and built behind the sanctuary between 1605 and 1737.
The church was built on the site of an existing early Christian basilica. At the beginning, the prior himself was the master mason, and only from around 1425 can it be assumed that Brunelleschi became involved in the project. Giorgio Vasari, in his *Lives of the Artists*, tells a colorful story about Brunelleschi's involvement in the construction of the church. Giovanni di Bicci de' Medici, a wealthy and prominent citizen of Florence, had promised to build at his own expense a sacristy and a chapel for the new church of San Lorenzo.
One day, during lunch with Brunelleschi, Giovanni insisted on knowing the architect's opinion about the ongoing construction; Brunelleschi criticized the structure on many points. Giovanni asked whether it would be possible to build something better and even more magnificent, and Brunelleschi replied that it would indeed be possible, noting his surprise that such an important man was not willing to invest "thousands of scudi" in a church worthy of the city of Florence.
Thus the San Lorenzo project was finally handed over to Brunelleschi. According to Vasari, many changes were made to adapt the structure to Brunelleschi's design. Specifically, a large presbytery was added, while at

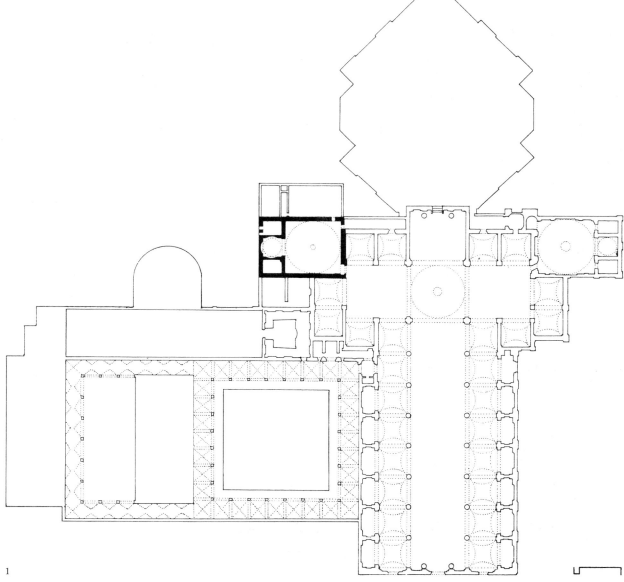

1

the ends of the already built transept, space was provided for a pair of sacristies.
The Old Sacristy, to the left of the sanctuary, was built even before the nave of the church was started. Unfortunately, Giovanni di Bicci de' Medici died before the Old Sacristy could be completed. His son Cosimo carried on the construction with even greater effort and, in order to honor his father, arranged for his burial in the middle of the Sacristy, under a large marble slab supported by four balustradelike legs.

2. Plan of the Old Sacristy.
The geometry of the plan is based on two squares of different sizes, aligned along the longitudinal axis of symmetry. The main square is covered with a ribs-and-sails dome on pendentives, while the smaller one – the *scarsella*, where the altar is located – is covered with a small hemispherical dome.

3. Plan of the Old Sacristy, with the altar in the *scarsella*, the marble table in the center of the main room, and, on the left, the sarcophagus of the two nephews of Giovanni di Bicci de' Medici, Pietro il Gottoso and Giovanni.
Although the organization of the Sacristy evokes a symmetrical and centralized sense of space there are three elements that suggest a different perception of it: the entrance to the Sacristy is to the left rather than along the central axis; the marble table is in the center of the main room; and the altar is located in a self-contained, smaller room that is centered on the main space. Such elements would force the visitor out of the center of the

space. According to Ragghianti, the sight lines were deliberately removed from the central axis in an attempt to avoid a too static perception of the space. Instead, the lateral views bring into focus the relationship between the larger space and the scarsella, and accentuate the dynamic connection of pendentives and dome and the rhythm of sails and ribs.

4–5. Transverse section and longitudinal section.
While Brunelleschi was responsible for the architecture, it was Donatello who provided stucco decoration for part of the wall surfaces. The transverse section shows the wall at the altar end, where most of Donatello's decorative work is concentrated. The longitudinal section demonstrates the relationship in scale between the two interior spaces.

13

The walls of the main space are organized into three superimposed registers: the lowest, with the Corinthian pilasters, is related to the scale of a person; the middle one, in which a full arch is inscribed, sets the height of the base line of the dome and bears its weight; and the upper corresponds to the actual dome.

The sparse use of decorative elements indicates the early origin of this Renaissance work, as does the existence of some weaknesses in the design that were pointed out by von Fabriczy, on the basis of an analysis made by Stegmann and Geymüller at the end of the nineteenth century: one, for example, is in the lack of any transitional element between the visually polygonal base of the ribs-and-sails dome and the circular support underneath–a problem that all successive churches with a similar design, like the Portinari Chapel or Santa Maria delle Carceri, will try to solve; another may be in the lack of visual hierarchy between structural and nonstructural elements. For example, there is no differentiation between the expression of the decorative cornices of the medallions and the load-bearing archivolts supporting the dome.

6. Axonometric projection of the dome. The view shows the ribs (primary elements), the sails (secondary surfaces), and the iron ties, which together constitute the structure. Such a system was widely used during the medieval period to pierce windows through the outer wall of a dome without affecting its stability.

7. Spatial diagram of the plan.

8. Geometric scheme with main proportional relations.
Two independent volumes are aligned along a common longitudinal axis of symmetry. Their relationship is controlled by a set of harmonic dimensions: the square of the main area is divided into nine parts; the *scarsella* is equal to one of these parts and thus constitutes the basic spatial module of the whole plan.
The same module also applies in elevation. In order to set dimensions and proportional relations between the registers and to define the rhythm of the decorative elements, a measure of ten florentine arms (a typical unit of measurement of that time) – equal to half the side of the square base – is used to define the height of the lower and middle registers. The dome, therefore, rests upon a volume which has the same proportions as the plan.

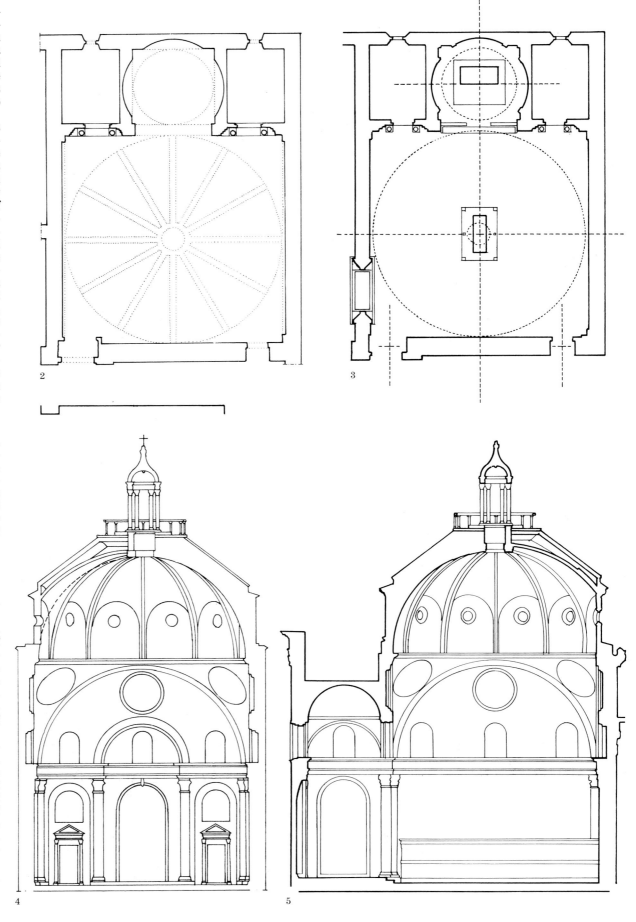

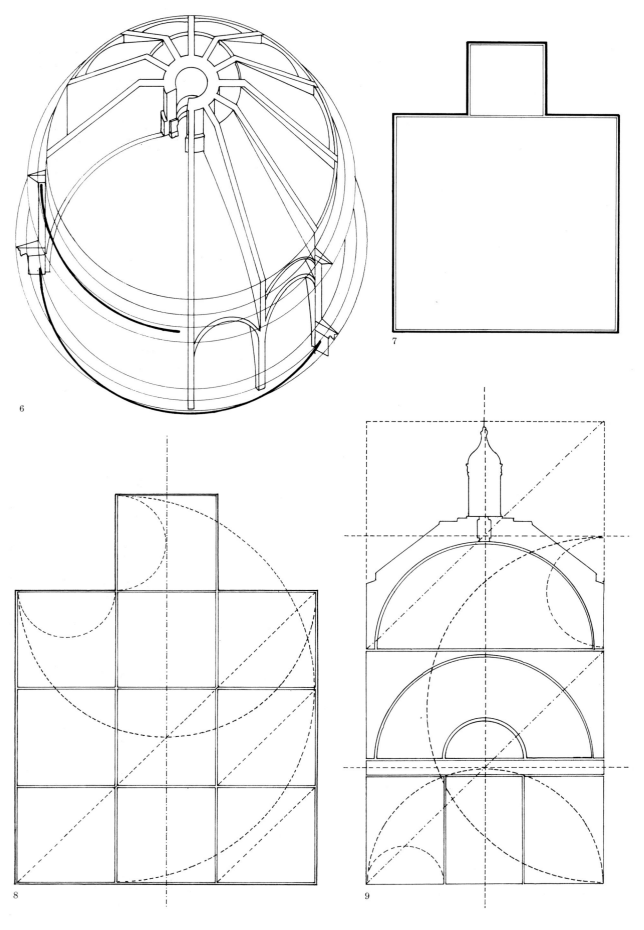

6

7

8

9

9. Geometric scheme of the section with main proportional relations.

According to Battisti, a ternary theme is present throughout the Sacristy. The interior is organized in three registers and the walls are organized in three bays. Each register is characterized by a different design quality of the wall surface.

The first has a predominantly linear, horizontal motif, while the second is characterized by semi-circular lines and the third by full arches.

In the wall toward the altar the tripartite bay rhythm is given a vertical emphasis. However, Donatello's grand reliefs and monumental doors, with their tympanums and Ionic columns, are completely alien to Brunelleschi's architectonic system.

10. X-ray axonometric projection of the main volumes of the enclosed space.

In this drawing the four pendentives are clearly represented. In a square-plan building covered with a circular vault, their function is to make the transition between the square space below and the circular base above.

Pendentives were used extensively over square and polygonal rooms by the Romans and Byzantines. The so-called Temple of Minerva Medica in Rome and the Basilica of Santa Sophia in Istanbul are two well-known examples of earlier buildings in which these elements were employed.

As Battisti reminds us, the Sacristy provides a key to understanding the details and the meaning of Brunelleschi's architecture.

The interest in the relation between the two purely geometric forms of the square and circle; the search for an overall proportion of elements; the keen attention to scale and to coordination between the parts and the whole; a sensibility for the archeological quotation; the intention to articulate the architecture in a limited chromatic range, using only whites and grays; the differentiation of interior space through the modulation of light from high windows – all of this shows, in Battisti's words, "the application of a complete system, a rational and measured devotion, without any mystic or passionate outbursts, but not devoid of symbolic motifs."

15

11. Plan of a baptistry
In his monograph on Brunelleschi, Battisti illustrates this building, which was built in Padua during the 13th century, as an example of the long-standing Italian tradition of chapels with the same typology as that used by Brunelleschi.

Thus, the innovation in the Old Sacristy is not the plan itself, but the way in which all the architectural elements are subjected to the same proportional and geometric rule, and integrated with a classical language in the articulation of interior space.

Michelozzo di Bartolomeo
Portinari Chapel or Chapel of St. Peter Martyr
1462–68
Milan, Sant'Eustorgio

12–13. Plan and section.
This chapel, built only few years after Brunelleschi's Old Sacristy, is commonly attributed to Michelozzo. The plan and the architectural organization of the interior space show that the Portinari Chapel belongs to the same tradition of central-plan chapels based on a square. The differences between the Florentine model and the Michelozzo building lie in the proportion that governs the relation of the altar recess to the main space and in the style of the decoration. In proportioning the two spaces Michelozzo employs a ratio close to 1:2 so that the altar area is larger relative to the main space than is the case in the Old Sacristy, and his interior decoration combines classical elements with many regional north Italian themes.

The chapel may also be compared with the little church of the Madonna of Loreto in Finale Ligure and Bramante's apse in Santa Maria delle Grazie in Milan (see figs. 37–41 below).

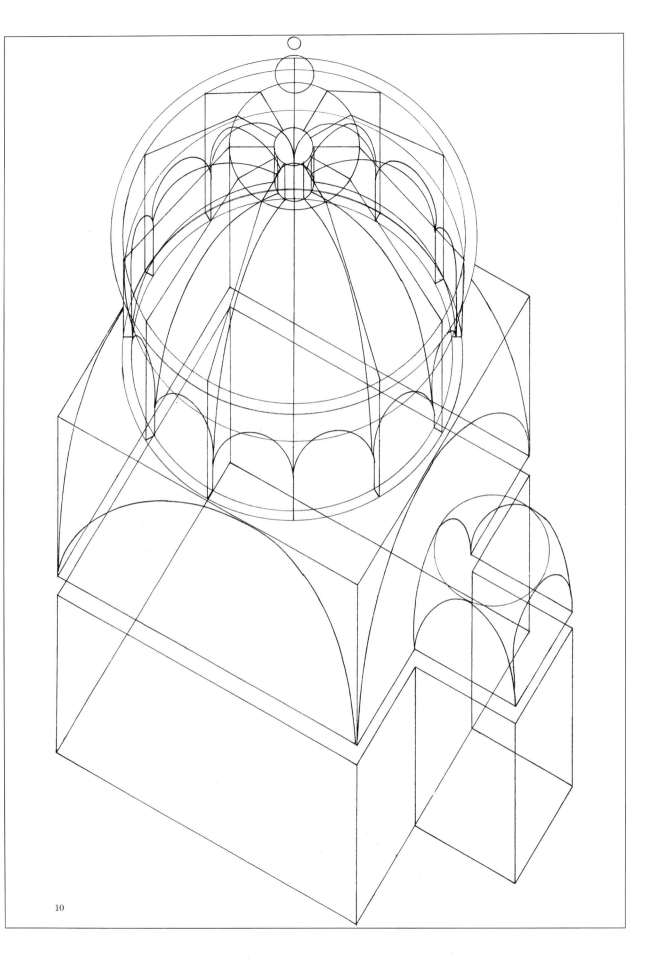

10

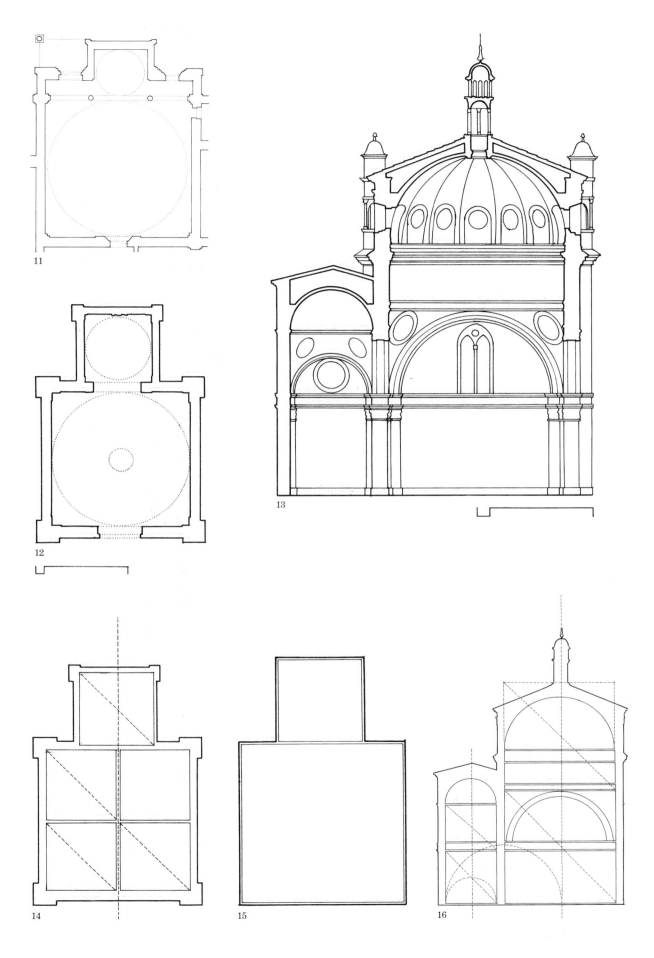

11

12

13

14

15

16

14. Geometric scheme with main proportional relations.

15. Spatial diagram of the plan.

16. Geometric scheme of the section with main proportional relations.

Giovanni Antonio Amadeo
Colleoni Chapel
1470–73
Bergamo

17. Plan.
This building – richly decorated by Giovanni Antonio Amadeo himself – seems at first glance to belong to the Old Sacristy tradition. However, in the Colleoni Chapel the sequence of the two spaces is completely different, as is the roofing solution. The entrance to the chapel is at right angles to the longitudinal axis of symmetry; therefore, the altar recess does not face the entering visitor, as is the case in both the Old Sacristy and the Portinari Chapel, but is located to the right. This radically alters one's perception of the space. The roofing here is not a dome with ribs and sails, but a segmented vault on an octagonal base–a return to a model of Romanesque origin typical of the Milan region.

18. Geometric scheme with main proportional relations.

Jacopo Barozzi da Vignola
Church of Sant'Andrea
on the Via Flaminia
1550–53
Rome

19. Plan.
Throughout the sixteenth century, the idea of a space based on the alignment of two volumes of different size along a common axis of symmetry recurs in many buildings; differences lie mainly in the proportion that links the two rooms. This late example by Vignola is one of these. Here, the plan is based on a rectangular geometry, which, together with a more mature classical decoration, defines an architecture of completely different meaning and taste.

20. Geometric scheme with main proportional relations.

21. Spatial diagram of the plan.

22–23. Facade elevation and section.

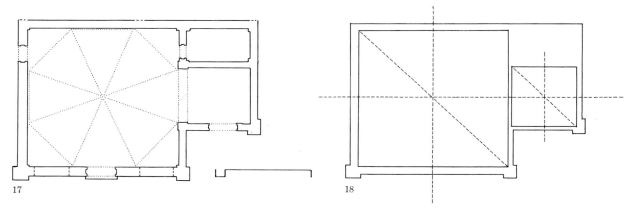

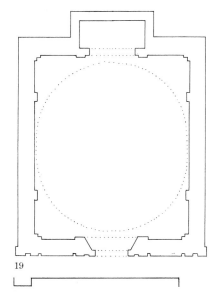

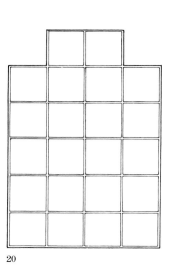

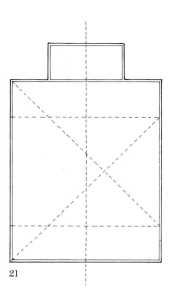

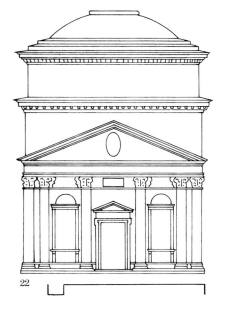

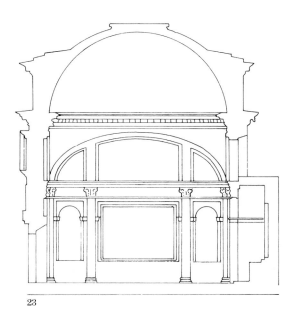

Michelangelo Buonarroti
New Sacristy
Basilica of San Lorenzo
1519–34
Florence

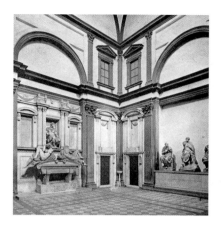

24. Plan.

In the plan of San Lorenzo, the New Sacristy occupies a position perfectly symmetrical to the Old Sacristy, and Michelangelo follows Brunelleschi's basic plan – a plan, Vasari relates, quoting Michelangelo himself, that can be varied but not improved!

The geometry of the plan is laid out on two squares of different size, aligned with respect to a common longitudinal axis of symmetry. As in the Old Sacristy, the main square corresponds to the front space, and the smaller one in the back – the *scarsella* – contains the altar. The first is covered with a coffered dome on pendentives, the second with a smaller, hemispherical dome.

The chapel houses the tombs of Lorenzo de' Medici, Duke of Urbino, and Giuliano de' Medici, Duke of Nemours (respectively, to the left and to the right, facing the altar).

During his stay in Florence, Michelangelo also worked on the project for the facade of San Lorenzo and later, in the same complex, on the construction of its new library. The events of those years were not always favorable to the success of his projects – for example, the facade of San Lorenzo was never completed. Nevertheless, a man of a very complex bearing emerges, an artist, as Wittkower notes, gifted with a "diabolical creative impulse," one who had a tremendous ability to express himself with equal power in painting, sculpture, architecture, and even poetry; but at the same time, a man difficult to get along with, one who was incapable of even being polite to people not considered among his closest friends. The "awfulness" of Michelangelo became proverbial: who-

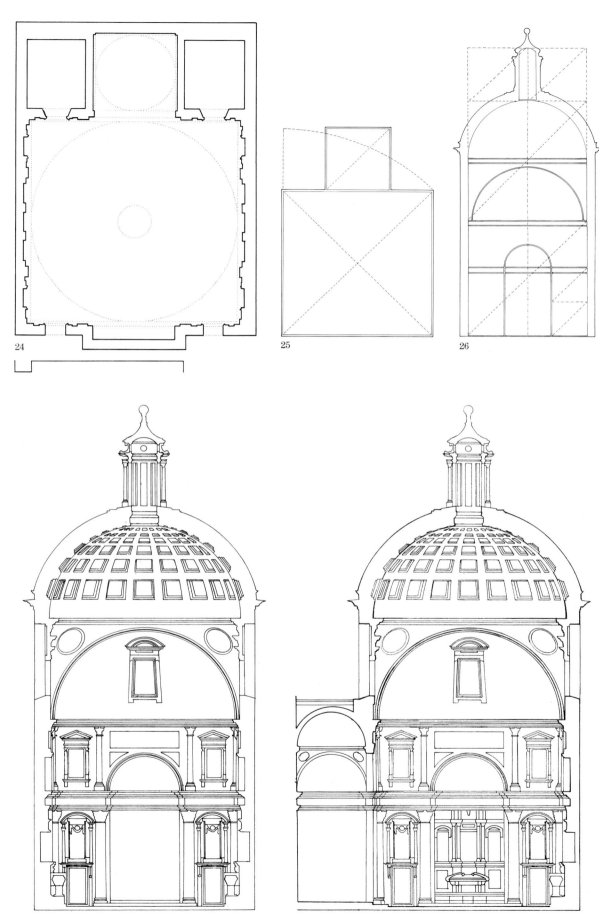

24

25

26

27

28

ever had to deal with him was exposed to "the tormented impetuosity of his character" and, at the same time, the "sublimity of his Art."

25. Geometric scheme with main proportional relations.
As in the Old Sacristy of Brunelleschi, two independent volumes are aligned along a common axis of symmetry. Their relation is again governed by a set of harmonic dimensions. In order to define the depth of the smaller space, however, a different process is followed.
Whereas Brunelleschi defines the dimension of the smaller unit in a simple 1:3 ratio to the side of the main square, Michelangelo takes the difference between the diagonal and the side of the larger square as the length of the side of the smaller square.

26–27–28. Geometric scheme of the section with main proportional relations, transverse and longitudinal sections.
The geometric scheme shows the repetition of a uniform, proportional pattern based on a square equal to that used in the plan of the sacristy: the space is therefore twice as high as the side of the square plan.
The sections show the insertion of an extra register compared to the Old Sacristy: thus, not only is the vertical thrust of the internal space extended, but each register is characterized by a far richer design quality of the wall surfaces as well. The lowest register is defined by the heavy horizontal of the entablature, which marks the transition to the next level. The wall surface with its three bays forms a somewhat vertical thrust of extraordinary sculptural value, the middle bay housing the tombs of Lorenzo and Giuliano.
The second register is the "extra" one. As an attic storey, resembling the rhythm and organization of a Roman triumphal arch, this level has multiple purposes: it continues the three-bay theme of the bottom register and articulates the windows that correspond to the aediculae in the two side bays; its full arch above the middle bay echoes the aediculae arches, as well as the arch above.
The third register, in which a full arch is inscribed, sets the height of the base line of the dome, while the fourth corresponds to the coffered dome itself.
According to Tafuri, this design of the inner elevation shows a dramatic tension in Michelangelo between his respect for the existing architecture of Brunelleschi and his wish to transcend it.

Although Michelangelo is constrained to use the same basic plan as the Florentine master, he manages to entirely alter the spatial perception: he changes the proportional relation between the larger and smaller spaces by using an irrational number as the ratio (the ratio between the side of a square and its diagonal is 1:1.4142 . . .); he emphasizes the verticality of the building by adding an extra level; and he handles the architectonic space as a background for an ideal engagement between decorative elements and sculptural motifs. With the strength of his innovative details, Michelangelo reforms the whole repertoire of classic ornament.
Cornices, capitals and bases, doors, tabernacles, windows and aediculae all have dimensions, proportions, and details that differ greatly from those commonly used by his contemporaries.

29. X-ray axonometric projection of the main volumes of the enclosed space.
In the New Sacristy, Michelangelo articulates the interior wall surfaces through rich sculptural play, while the volume of the architectonic space is completely void.
Brunelleschi had outlined a cubic space and defined it through a network of lines, so that gray moldings on white planes marked the projection of the architectural perspective structure. Brunelleschi did not conceive these gray moldings as belonging to the surfaces of the cube, but rather as an independent cage that bounded the space.
In the New Sacristy, as Argan suggests, the tombs and statues form a part of the walls themselves, and the gray moldings – bases, columns, entablatures, cornices – are not simply elements of a geometrical projection; they shape a sculptural framework strictly interwoven with the white surfaces of the walls; windows, aediculae, and doors are the components of this framework and they reinforce it.
Michelangelo combines every detail – decorative and nondecorative – in an overall pattern so that the architecture is truly perceived as the expression of a volumetric whole.

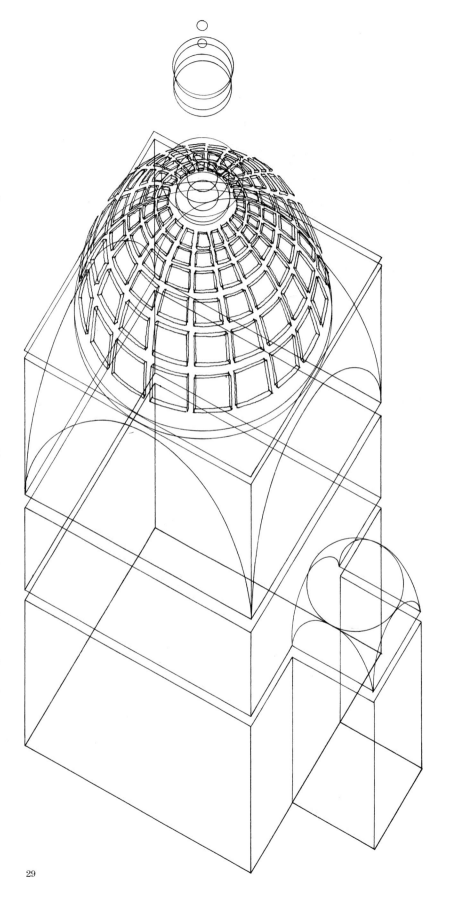

29

Filippo Brunelleschi
Pazzi Chapel
c. 1429–c. 1461
Florence, Santa Croce

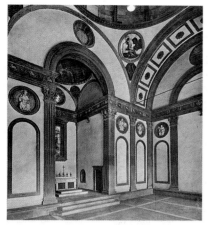

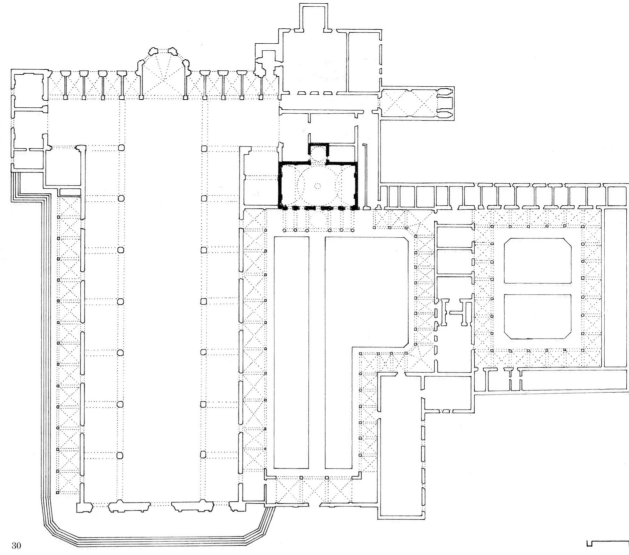

30

30. Plan of the Santa Croce complex.
The Chapel–intended to serve as chapter hall and ancestral chapel for the Pazzi family–faces one of the cloisters of the Santa Croce complex. The chapel site is defined, on the left, by the body of the existing church and, on the right, by convent rooms probably already built before Brunelleschi's construction.

As Benevolo notes, there are two possible procedures Brunelleschi could have followed in the design process. In the first case, i.e., if the chapel design had to comply only with the pre-existing church, the dimension of the shorter side of the hall and the depth of the smaller room would have been set; therefore, as a study by Laschi, Roselli, and Rossi shows, the remaining planimetric dimensions of the chapel could have been derived completely from these two measurements.

In the second instance, i.e., if the constraints of both the church and the convent rooms existed, then the long side of the rectangle would have been set, and the existing dimensions of the chapel would have been the only really possible solution. In either instance, the result is a building with a precise geometric construction governed by a set of harmonic dimensions.

Brunelleschi most likely developed the design of the Pazzi Chapel through a continuous comparison between the physical constraints of the site and a design he thought suitable for the occasion, eventually arriving at the balanced, harmonic outline of the final design. In this regard, von Fabriczy points out the simplicity of the various dimensions; for example, the total height inside (20.85 meters) is virtually twice that of the central square (10.49 meters).

31. Plan of the Pazzi Chapel.
The plan of the Chapel derives directly from the Old Sacristy. The geometry of the plan again presents two volumes of different size, aligned with respect to a common longitudinal axis of symmetry. The main volume corresponds to the front space; the *scarsella* contains the altar.

Departing from the San Lorenzo prototype, Brunelleschi has added a barrel-vaulted space on each side of the central square, thereby widening the main space and creating a second axis perpendicular to the main axis. The inner space thus grows in complexity: the main hall is covered in the center with a ribs-and-sails dome on pendentives and is connected through full arches to the two lateral barrel vaults. The secondary space is covered with the usual small hemispherical cupola. In addition, an exterior portico – independent of the chapel and added later – defines a transition of space, reinforcing the longitudinal axis of symmetry and emphasizing the central position of the entrance.

In the past the Pazzi Chapel was considered the highest achievement of Brunelleschi's art. However, according to recent studies by Battisti, the Chapel should really be considered an anomalous building. All that can be attributed with certainty to Brunelleschi is the plan of the chapel and the lower wall structure. In fact, the completion of the building, with the dome and the portico, might have been carried out by others who were too strictly following principles and models that had originated with Brunelleschi. During its completion the structure was significantly changed. Thus, its completed appearance, in the opinion of Battisti, is derivative and too much in concert with the evolution of the Florentine taste during the fifteenth century. The dome is a good demonstration of this: it is a direct adaptation of the rib-vaulted structure of the Old Sacristy dome with only minor changes to comply with the different conditions of the Pazzi Chapel.

32. Spatial diagram of the plan.

33. Geometric scheme with main proportional relations.

34–35. Transverse section and longitudinal section along the axis of symmetry.
The first section illustrates the side that connects to the altar recess which is symmetrically articulated with respect to the entrance side; the second

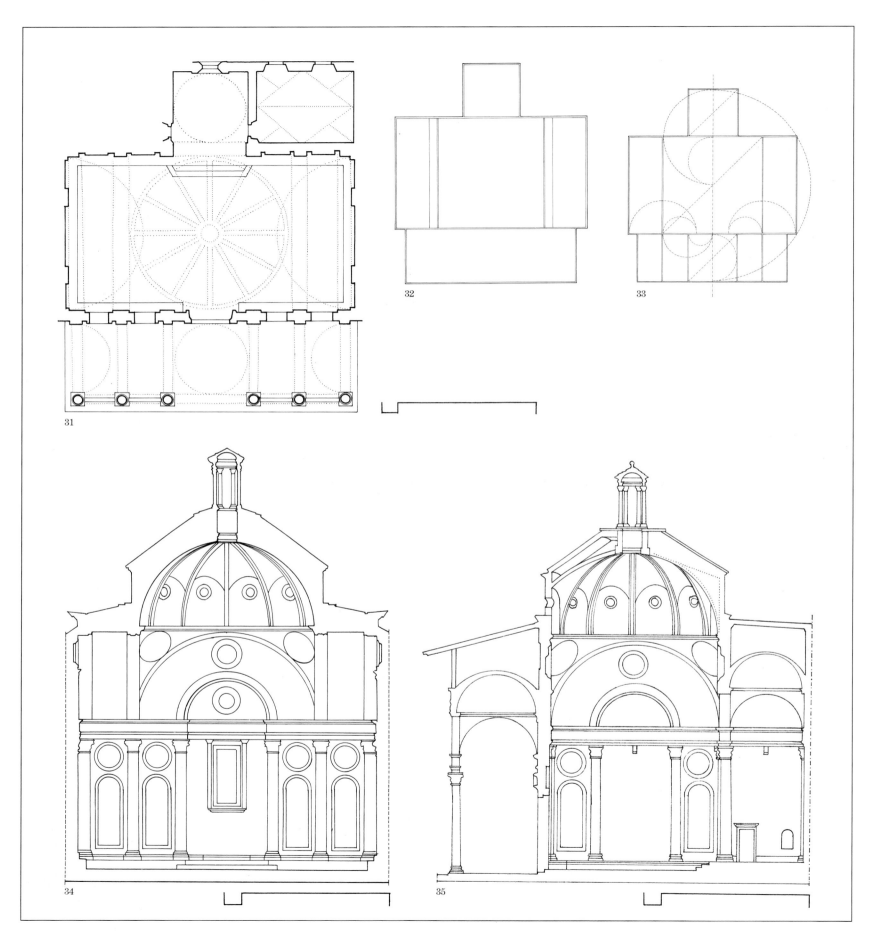

31

32

33

34

35

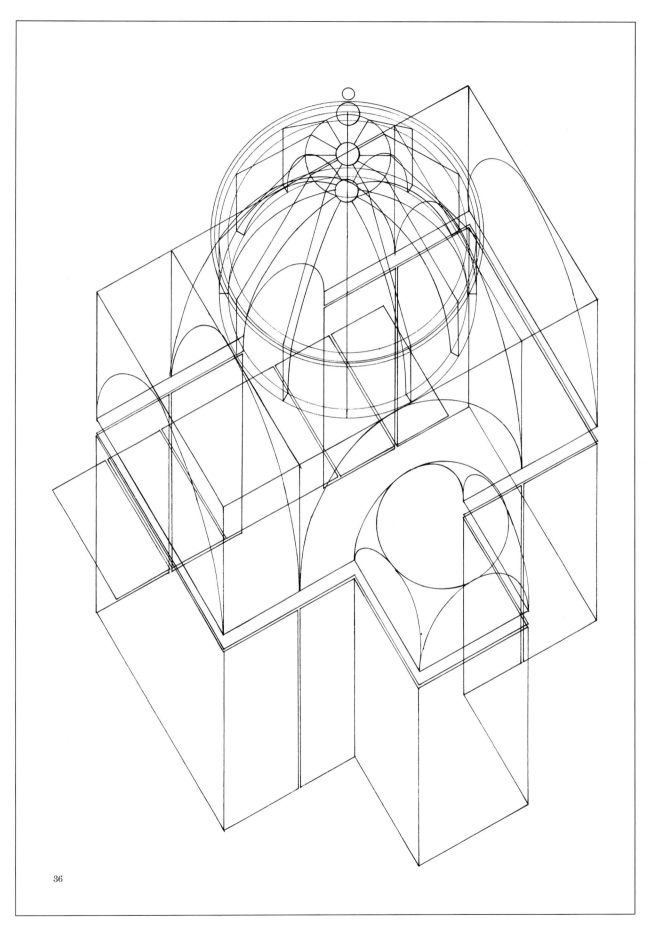

section shows the relationship in scale between the two spaces.

As in the Old Sacristy, the space is organized on three levels. In the lowest, however, the Corinthian pilasters have been rather elongated. Contrary to the proportions in the Old Sacristy, the height of the columns here is greater than the dimension set by half of the square base. Therefore the relationship with the other two registers – the middle one, which sets the height of the dome base line, and the top one, which corresponds to the dome itself – changes, and the central space is perceived as being more vertically articulated toward the lantern.

36. X-ray axonometric projection of the main volumes of the enclosed space.

The original nucleus of the Old Sacristy is recognizable not only in the cupola, which is rendered according to the same technique and decorative detailing, but also throughout the organization of space, which is based on the same elementary relationship between two simple geometric volumes. The addition of the buttresses reinforce the symmetry of the transversal arch. The composition is enriched and thus a more balanced relationship between the principal structural axes is achieved.

36

Donato Bramante
Tribune
Santa Maria delle Grazie
1492
Milan

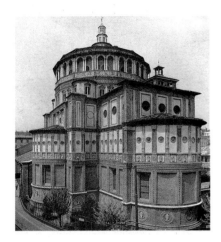

37–38. Plan and section of Santa Maria delle Grazie.

Around the middle of the fifteenth century, the original church of Santa Maria delle Grazie was built according to a project outlined by a member of a famous family of Milanese architects: Guiniforte Solari. Several decades later, however, the sanctuary was demolished because Ludovico il Moro decided to build a large funerary chapel for his family, the Sforza, on the model of the ancestral chapels of families like the Medici in Florence or the Visconti in Pavia.

Once more, Brunelleschi's Old Sacristy was used as a reference. This was not a novelty for Milan, where thirty years earlier, Michelozzo di Bartolomeo had used a similar scheme for his Portinari Chapel. This time, though, the experience of the Florentine architect is merged with a local tradition of late Roman votive chapels. The basic two-room scheme is transformed into a trilobed plan by the addition of three semicircular spaces. This arrangement expands the space along the transverse axis and creates a strong contrast between the darker longitudinal space of the Solari church and the bright central space of the tribune. This trilobed plan, Bruschi suggests, might be related to the contemporary cross-shaped plans of the churches of San Sebastiano in Mantua and San Bernardino in Urbino.

In addition, according to Borsi, certain affinities with Brunelleschi may shed light on the meaning of Bramante's architecture as well. There are three main parallels between the two architects. First, each of their buildings

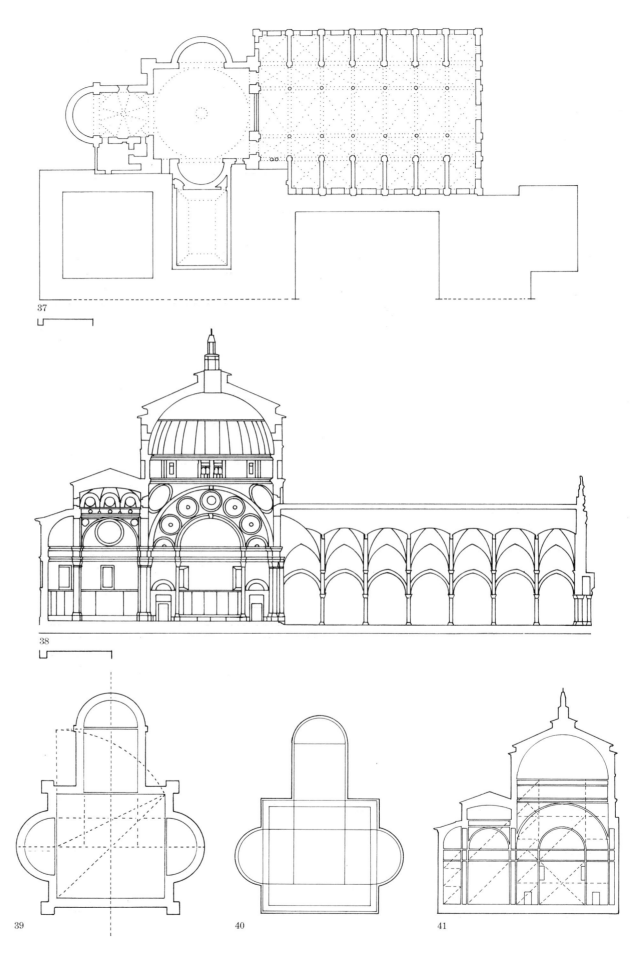

37

38

39 40 41

represents an opportunity to apply a creative approach to new architectural principles and includes a process of revision in which traditional elements and innovative themes merge together. Second, their buildings imply a transformation of the surrounding urban fabric, in Florence as an outcome of a democratic political order, in Milan as an expression of the power of the autocrat. Third, both Brunelleschi and Bramante are able to set the standard for a new architectural language, based on different ways of combining regional and classical motifs.

In Santa Maria delle Grazie Bramante underscores the centrality of the space through the use of a single architectonic order: whereas in the first register of the Brunelleschi Sacristy, the tripartite rhythm – two small bays flanking a larger one, topped by a full arch – appears only on the wall at the altar end, in the Sforza church this theme is used on all four sides of the central space. This design principle not only solves the transition between the tribune and the existing church but also provides an effective connection to the second square of the altar space and, on the sides, creates the possibility of inserting two semicircular, apselike spaces.

39. Spatial diagram of the plan.

40. Geometric scheme with main proportional relations.
Two independent rooms with square plans are aligned along a common longitudinal axis of symmetry, providing continuity with respect to the nave of the existing church. Three semicircular volumes are then added: two flank the larger room, the third one closes the far end of the smaller room. Each element has its own roof structure: the higher, central space is covered by the dome, which stands on a rather low drum; the smaller room has a segmented, octagonal roof that is clearly of regional origin. The three semicircular spaces have semidomes.

41. Geometric scheme of the section with main proportional relations.
The geometry of the square and inscribed circle is not confined to the ground plan; a similar principle is employed to differentiate the superimposed registers of the wall surfaces by means of contrasting decoration: the first and third levels have a predominantly rectilinear motif, while the second and fourth are characterized by circular elements on the exterior as well as in the interior.

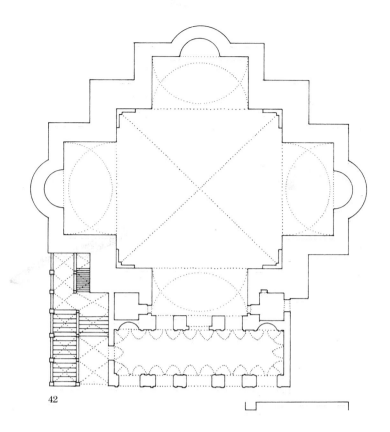
42

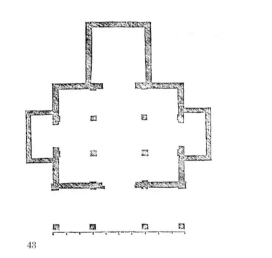
43

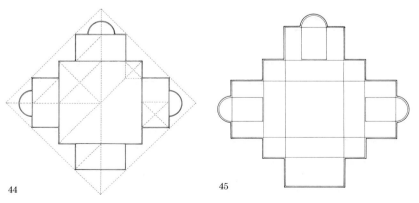
44 45

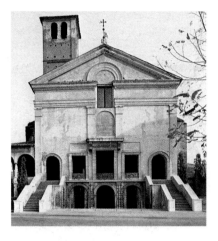

Leon Battista Alberti
San Sebastiano
1460
Mantua

42–43. Plan of San Sebastiano and plan of a typical Tuscan temple as reconstructed by Cosimo Bartoli.

Certain characteristic features of San Sebastiano can be seen in this interpretation of a traditional Italian temple, as well as in the "ideal church" outlined by Alberti in his *De Re Aedificatoria* (Florence, 1485). For Alberti the "ideal temple" is a building with two main parts: a portico in front and a cella within. Although these two elements are always present, the overall shape varies from temple to temple: some have a circular plan, others a quadrilateral one, and still others conform to a polygonal outline.

The circular temples are characterized by an outline based on a circle, which can vary only in scale, whereas the quadrilateral ones include a wide range of proportions governing the relationships between their sides. In addition, Alberti reports that the ancients generally preferred an elongated plan. For example, in quadrilateral plans, the length was usually greater than the width by a third or by half; it could even be twice the width. The polygonal plans were mostly hexagonal, octagonal, or sometimes dodecagonal. All of them had to be inscribable in a circle and were, in fact, drawn from a circle through a variety of graphic geometric construction procedures. (Usually the starting dimension was the radius of the circle, equal to the side of the inscribed hexagon; once the hexagon was constructed, a dodecagon could be drawn by simply dividing the sides in two. Similarly, an octagon could be constructed by dividing each side of an inscribed square.)

Such geometric constructions were used to shape the main central room of the temple: the tribune. Once this process was completed, a series of apses could be added to the sides of the space. In temples based on a square, Alberti relates that traditionally there is a single apse, facing the main entrance along a longitudinal axis (this is the concept that Brunelleschi employs in the Old Sacristy). If more apses are needed on the sides, a more elongated plan must be selected. Instead of a square, Alberti suggests a rectangle with a two to one proportion of length to width. Ideally, there should be only one apse per side; thus, if a larger number of apses is needed, a circular or a polygonal plan will be more suitable, with an apse on each side, or on every other side.

As a final comment, Alberti also suggests two basic shapes for the apse: rectangular or semicircular. He mentions, as a model for an ideal church, a traditional Tuscan temple, in which small chapels, rather than apses, are built along the sides of the central room. The plan of this temple is based on a slightly elongated rectangle, the ratio of the sides being 5:6. In front of the main facade it was traditional to build a portico to be used as a vestibule for the temple. Inside, two sides have apselike elements attached, and there is also a rectangular apse on the side opposite the entrance. This space, where the altar is located, is larger than the other two rectangular recesses.

The transition from a central room to semicircular apses, through the intermediate rectangular spaces of the Tuscan temple scheme, is considered by some critics to be a reference for the San Sebastiano plan. Moreover, in one point of his *De Re Aedificatoria*, Alberti clearly emphasizes the tradition of enriching this kind of temple by adding an apse at the end of every side space.

44. Geometric scheme with main proportional relations.

45. Spatial diagram of the plan.
The composition of the plan begins with a square central space. A rectangular chapel is then added, centered on each side. Three of these chapels are completed with semicircular apses; the fourth gives access to an exterior, rectangular room functioning as an atrium.
This sequence creates a hierarchy of interlocked spaces from the great central cross vault, to the four intermediate barrel vaults, to the semidomes in the apses.

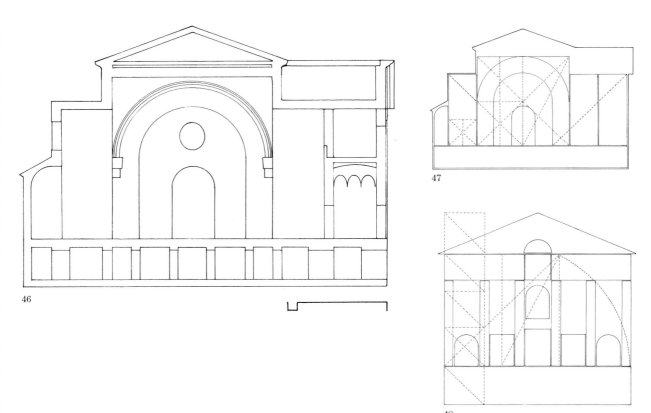

46

47

48

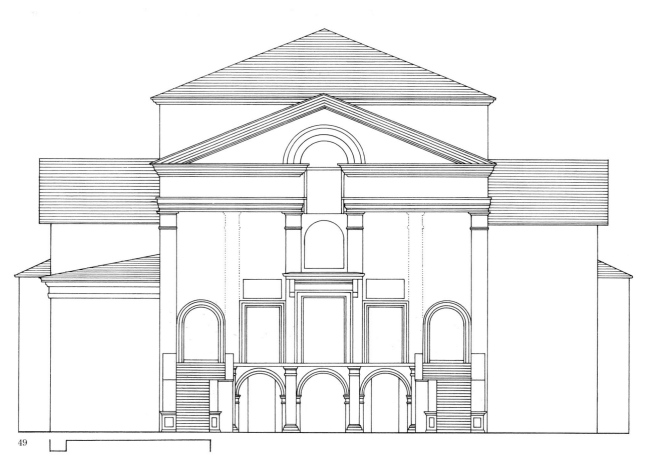

49

26

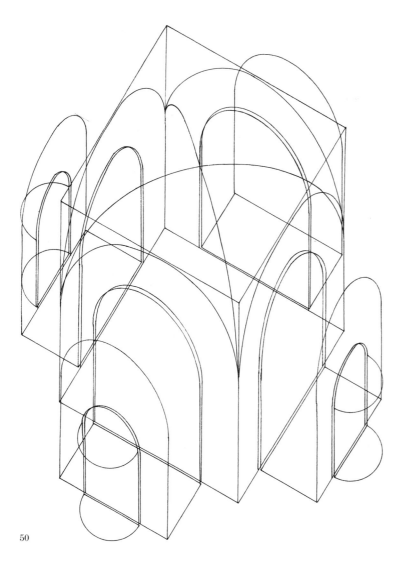

50

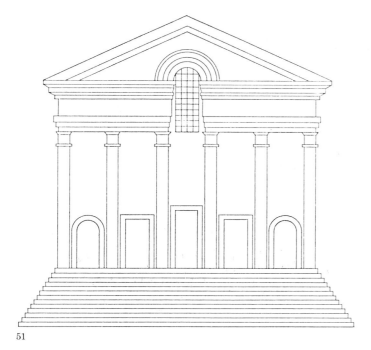

51

46–47. Section and geometric scheme of section with main proportional relations.

The same spatial hierarchy seen in the plan is carried out in section. The central space is highest; to it are connected the intermediate chapels and the minor apses.

48. Geometric scheme of the facade with main proportional relations.

49. Facade.

The solution for the facade presents a whole new set of references and raises some problems for understanding the sources of classical decorative details. According to Wittkower, this church – which can be considered an early Renaissance example of a Greek-cross plan – has a facade that only partially reflects Alberti's original design; in Wittkower's opinion, Alberti's solution of 1460 presented a facade based on a classical temple elevation.

Another controversial aspect of the facade is the split entablature, the two parts of which are linked by an arch aligned on the elevation's axis of symmetry. Wittkower points out that although this detail is very common in Hellenistic temples in Asia Minor, it is unlikely that Alberti had any knowledge of those buildings; Wittkower therefore suggests that the source might have been the Arch of Orange, which was very well known to artists of the fifteenth century.

50. X-ray axonometric projection of main volumes of the enclosed space.

This representation shows the links between three volumetric elements: the cross vault of the central room, the barrel vaults of the rectangular chapels, and the semidomes of the apses. Despite the aggressive twentieth-century restoration, when the two front flights of stairs were added, the church and its inner-face brick vaults, as Borsi has noted, have not lost their resemblance to a typical monumental hall of a Roman bath.

51. Reconstruction by Rudolf Wittkower of the 1460 Alberti design.

Here the facade is reconstructed as a temple front, with the connecting arch restoring continuity to the "broken pediment." This decorative motif is characteristic of Hellenistic architecture and shows an interest by Alberti in investigating the use of innovative elements as part of the classic language of architecture.

Giuliano da Sangallo
Santa Maria delle Carceri
1484–91
Prato (Florence)

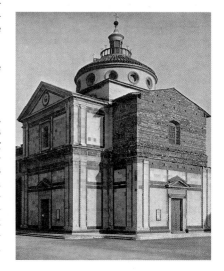

52. Plan.

This is one of the first Renaissance churches designed on a Greek-cross plan, a concept which merges – according to Wittkower – an aspiration for spatial centrality with a symbolic religious reference to the cross. Four equal, rectangular arms are joined to the square central space of the tribune, whose importance is emphasized by the dome above. The pure geometry of Santa Maria delle Carceri is based on the square and the circle, and the whole architectural body is ruled by a simple 1:2 proportional relationship.

53–54. Geometric scheme with main proportional relations and space spatial diagram of the plan.

The tribune, at the center of the plan, is laid out on a square-based geometry. Within this central square is inscribed a circular ribs-and-sails dome on pendentives, which derives directly from Brunelleschi. Four rectangular, barrel-vaulted volumes are joined to the square of the tribune, aligned along two main, orthogonal axes of symmetry. The whole composition thus resembles a cross with four equal arms. The width of each arm is twice the depth, and equal to the side, of the central tribune. The whole plan is therefore contained in a perfect square.

The space framework outline shows the relationship and alignment of the central space to the four side arms. Four piers in local sandstone (a gray variety known as *pietra serena*) mark the junction points between the spaces. These reliefs, at the four corners of the tribune, emphasize the centrality of the plan.

27

55–56. Section and geometric scheme of section with main proportional relations.

The interior walls are in white plaster, with moldings in *pietra serena*. The two materials contrast sharply: the dark lines of the structural skeleton stand out against the light wall surfaces. As Wittkower notes, this articulation emphasizes the precise geometric scheme.

The exterior, on the other hand, has a richer decoration. White marble slabs are set off by green marble strips, with double, white marble pilasters marking the corners.

The articulation of the inner space is extremely clear. The first, lowest register is outlined by the height of the corner piers in the tribune, with their massive entablature.

This entablature, which runs continuously around the perimeter of the Greek cross, also marks the bottom of the second register. Four pairs of semicircular arches–two per arm–rise from this line to set the height of the drum impost line.

The third register consists of the whole dome system–drum, dome, and lantern. An interesting detail, pointed out by Wittkower, is that the dark bottom ring of the drum does not touch the moldings of the arches below, giving the sensation that the dome is "magically" suspended, floating weightlessly in the atmosphere.

57. X-ray axonometric projection of the main volumes.

A precise correspondence between the interior and exterior articulation is a typical feature of the ideal Renaissance central-plan church. Santa Maria delle Carceri is one of the best examples of this new architectonic conception.

The simple hierarchy of the plan is reflected in the articulation of the volumes: the sequence of spaces decreases in size as the eye moves outward from the central tribune toward the side arms and downward from the highest point of the lantern to the base of the building.

This spatial organization is most evident in the elevation, where the alignment of the architectonic masses follows a diagonal attitude that can be visualized as an ideal pyramidal pattern.

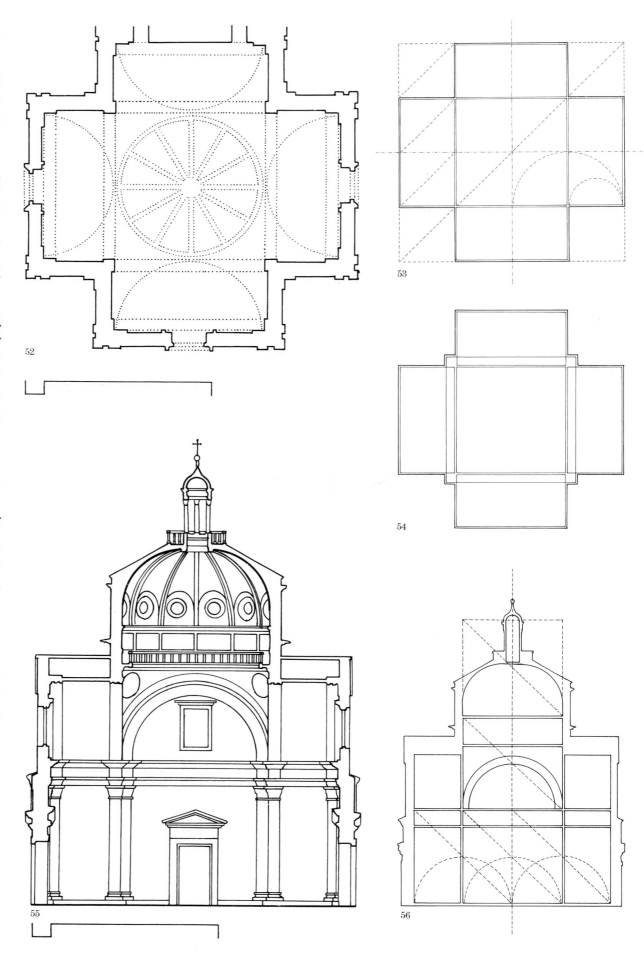

52

53

54

55

56

58 59 60 61

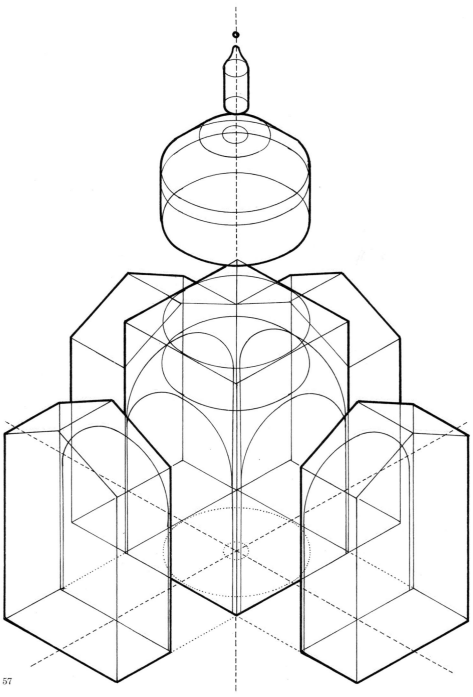

57

Bernardo Rossellino
Chapel of the Cardinal of Portugal
from 1460
Florence, San Miniato

58. Plan.
This funerary chapel, built as a private side chapel in the main nave of the church of San Miniato al Monte, represents one of the earliest revivals of the Greek-cross scheme. The chapel is experienced only as an interior room, closely connected to the nave of the church. Rossellino employs the Greek-cross scheme as a principle of organization for the Cardinal's tomb: the lateral arms each accommodate a finely decorated sarcophagus, while the altar is situated in the recess facing the entrance. The rich sculptural details of the altar and the sarcophaguses sometimes even overflow onto the architectural elements of the chapel. The chapel is roofed with a very elegant sail vault resting on the four arches that articulate the side arms.

It is interesting to note that this type of plan recurs in other funerary chapels outside the region of Florence. Two such examples are in Naples, both in the church of Sant'Anna dei Lombardi: the Piccolomini chapel, attributed to Rossellino himself, and the Mastrogiudice chapel, attributed to another Florentine architect, Benedetto da Maiano; the former is especially close to the San Miniato model.

59. Geometric scheme with main proportional relations.

60. Section.

61. Geometric scheme of section with main proportional relations.

Antonio da Sangallo the Elder
Madonna di San Biagio
1518–37
Montepulciano (Siena)

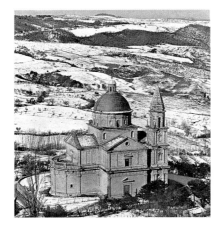

62. Geometric scheme with main proportional relations.

Although the Madonna di San Biagio church adopts an outline similar to that of Santa Maria delle Carceri, i.e., a Greek-cross plan, the resulting design is quite different on several points: First, the relationship between the central square and the four arms is ruled by a ratio of almost 2:3 –larger than the 1:2 ratio of Santa Maria delle Carceri; second, there is a more elaborate series of connecting elements at the corners between the central space and the side arms; third, pilasters and semicolumns, aediculae and niches are interlocked in an uninterrupted decorative play, which shifts continuously forward and backward with respect to the wall plane.

63. Spatial diagram of the plan.

64–65. Geometric schemes of section and of elevation with main proportional relations.

66. Plan.

This church, located in the middle of the hilly Tuscan countryside just outside the walls of Montepulciano, follows the same design tradition as Santa Maria delle Carceri in Prato. As Renato de Fusco points out, the uniqueness of the Madonna di San Biagio lies not only in its being an ideal, model church, but also in the fact that it puts into practice a Renaissance design concept previously existing only as an ideal, theoretical reference. Like Bramante's project for St. Peter's in Rome (in relation to the polycentric plan) or the church of Santa Maria della Consolazione in Todi (in relation to Leonardo da Vinci's idea of a central-plan church),

this late building by Antonio da Sangallo further develops a basic principle of earlier Renaissance architecture.

The plan is based on a central, square space corresponding to the tribune. A circular dome on pendentives is inscribed within this central square. Four rectangular, barrel-vaulted volumes are joined to the square of the tribune, aligned along two main, orthogonal axes of symmetry. The whole composition thus resembles a cross with four equal arms.

67–68. Longitudinal and transverse sections.

The volume of the tribune – a parallelepiped whose height is defined by the keys of the four arches that connect the arms to the tribune – is topped by a hemispherical dome with lantern, set on a high drum. The cylindrical drum rests on four pendentives and serves several functions: it constitutes the element of transition between the lower space and the dome; it allows light to enter through a series of high windows; and it dramatically emphasizes the verticality of the tribune space.

69. Facade.

On the exterior, the centrality of the inner space is contradicted by the introduction of two elements–an apse and a pair of bell towers. Seen from outside, only three arms are articulated in the same way: two superimposed registers with a tympanum above. The fourth, at the altar end, has an addition for the sacristy; only one story high, it functions as an apse and gives greater prominence to this arm with respect to the other three. The bell towers (the right-hand one is complete only to the first story) symmetrically flank the arm on the opposite side, the side facing the altar.

The introduction of these elements, which emphasize an alignment along a longitudinal axis, breaks up the characteristic balance among the sides of a central-plan composition. This is evident only from the exterior, however. Once inside, it is no longer possible to perceive the longitudinal sequence of the external masses, because the inner space is organized on a pure Greek-cross scheme, firmly focused on the centrality of the tribune.

70. X-ray axonometric projection of the most important volumes.

In the Madonna di San Biagio, the precise correspondence between interior and exterior articulation – to be expected as a feature in a typical Renaissance central-plan church – is disrupted. Here a longitudinal axis of symme-

try is emphasized on the exterior through the sequence of bell tower, tribune area, and apse; while the centrality is preserved in the inner space.

According to Heydenreich and Passavant, this building represents the highest expression of Antonio da Sangallo's art. He unites many details both from the ongoing construction of St. Peter's and from the classic Tuscan tradition. His building experience in Rome can be perceived in the pier construction system, while his extensive studies of ancient monuments are evident in the way he articulates the Tuscan Doric order. Here he creates a truly original and imaginative whole. Aside from the gigantic and incomplete project for St. Peter's and the small, unfinished Roman churches of Bramante – San Biagio in Via Giulia and Santi Celso e Giuliano in Via Banchi –

the Madonna di San Biagio is the only building with a Greek-cross plan that fully represents, at the beginning of the sixteenth century, the mature style of the early Renaissance.

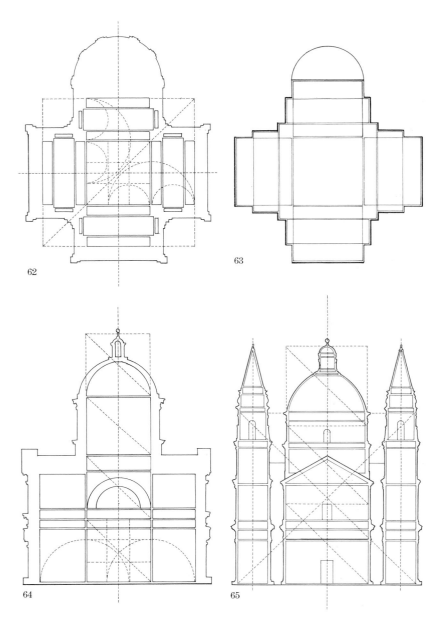

62

63

64

65

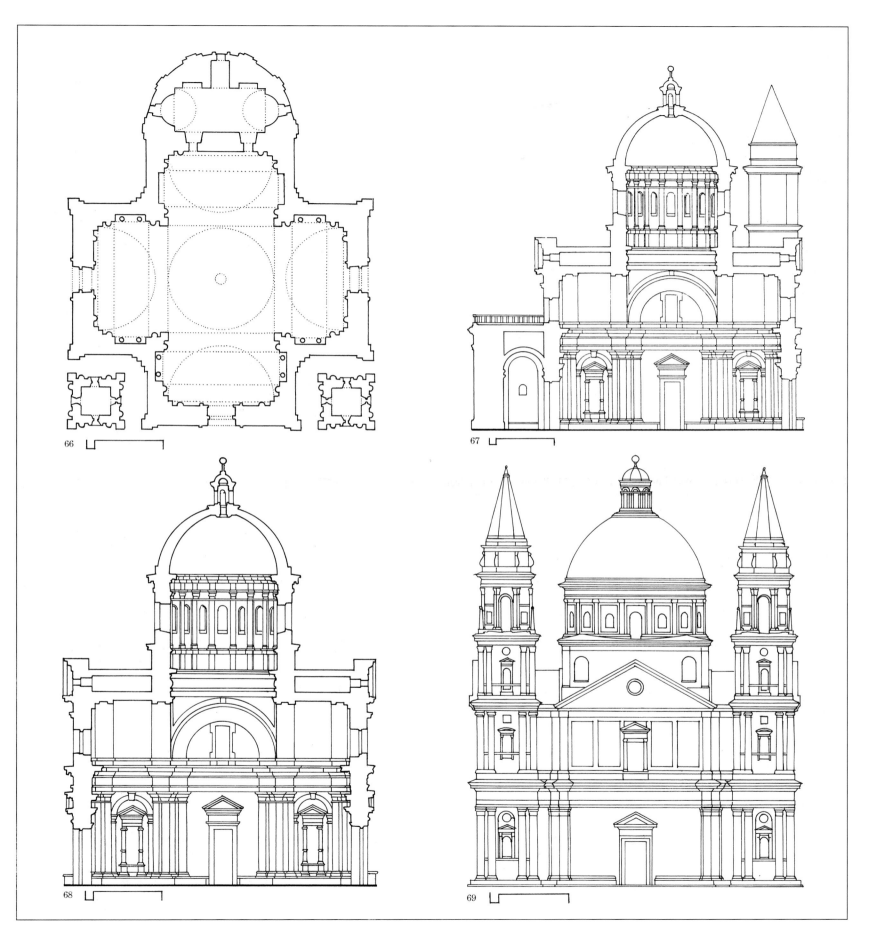

66

67

68

69

31

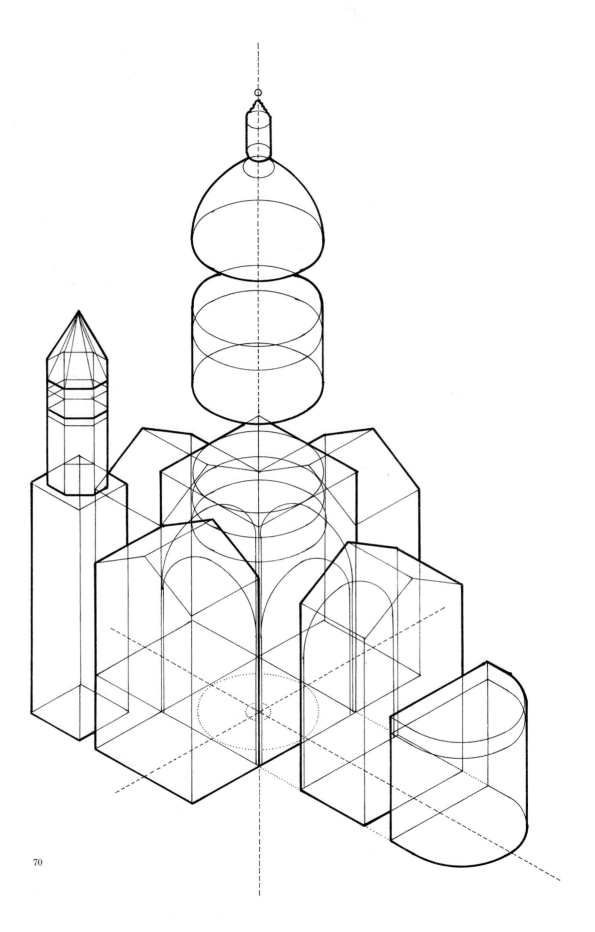

70

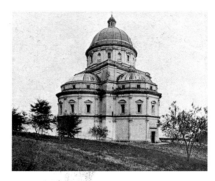

71. Plan.

This church also belongs to the Renaissance tradition of churches with Greek-cross plans, which includes Santa Maria delle Carceri and the Madonna di San Biagio, although here, a central volume with four apselike appendages replaces the square tribune with rectangular, barrel-vaulted arms. Three of the apsidal wings are semidodecagonal, while the sanctuary is semicircular; all are roofed with semidomes. The ribs of these semidomes are marked by continuous stone molding tapering slightly toward the key of an arch that functions as a connector to the central volume. In the apsidal wings there are no chapels or secondary spaces other than a series of niches along the inner perimeter of the semidodecagonal arms.

Although the main body of the church was not completed until the late sixteenth century – and the dome nearly a hundred years later – the church, according to Cesare Brandi, nevertheless has the freshness and character of a pure example of early-sixteenth-century Renaissance taste. Its architect is not known with certainty; Cola da Caprarola was probably a local master builder who merely supervised the early stages of construction.

What is most striking about the building is its unique site, on top of a hill just outside the small town of Todi, with a beautiful, deep valley below. This location invites some interesting reflections on the Renaissance conception of the relationship between natural and artificial space. Christian Norberg-Schulz points out that the self-contained, ideal form of the church could have been built on any site. The development of Renaissance space, he continues, breaks away from the late medieval concept of the building as a living urban organism tightly interwo-

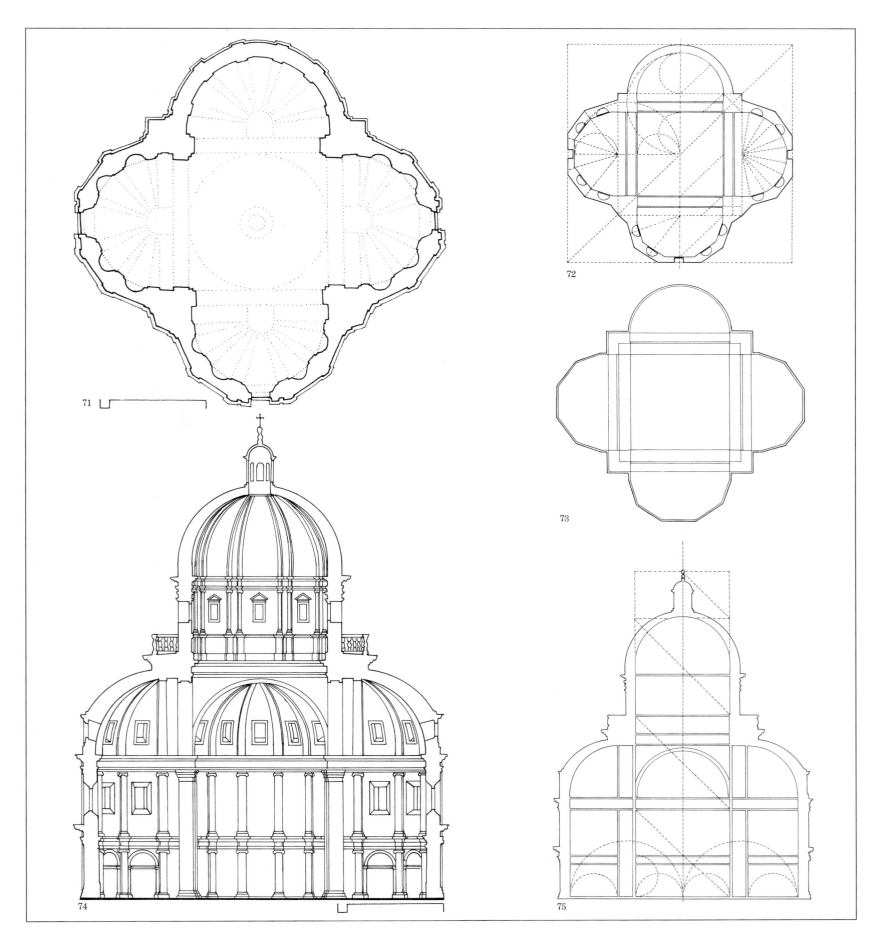

71

72

73

74

75

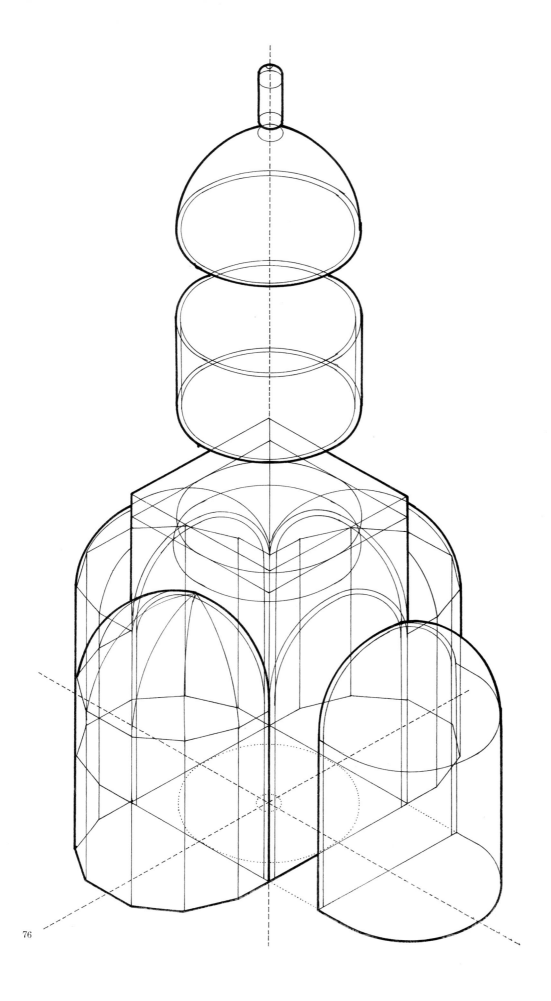

ven with its surroundings, and moves toward an ideal of pure formal perfection.

72. Geometric scheme with main proportional relations.

73. Spatial diagram of the plan.
As Nofrini remarks, there is a great difference in the perception of centrality between Santa Maria della Consolazione and a church like Santa Maria delle Carceri. In the latter, there is a continuity between the rectilinear outline of the tribune and the rectangular shape of the arms, but in Santa Maria della Consolazione the development of the typical Greek-cross scheme is suggested only by the corners of the tribune–the apselike spaces follow a nonrectilinear outline. In Santa Maria delle Carceri, the central-plan system is emphasized by four corner piers; in Santa Maria della Consolazione the same points are marked by pairs of piers, joined on the two faces of the corner.
With respect to the contemporary example of central-system churches, the use of rounded arms completely changes the perception of space. The semidodecagonal sides and the semicircular one emphasize the centrality of the church outline. Due to their one point geometric construction and dissimilar rectangular arms, they do not constitute spaces which may be interpreted and used as independent ones; in contrast, they are strictly related to the central tribune space and form a unified whole with it.
The use of rounded rather than rectangular shapes completely changes the perception of space, and even overemphasizes the church's central system plan. There is a transition from a rectilinear articulation, based on a right-angle geometry, to a configuration characterized by volumes constructed on a single, central point.

74. Section.
Two different systems characterize the wall surfaces. The first has a vertical emphasis, from the floor up to the keystones of the arches, and then from the base of the drum to the lantern. Like the bars of an iron cage, groups of parallel elements (pilasters on the walls, ribs on the dome and semidomes) emphasize the vertical dynamism of the architecture of Santa Maria della Consolazione. The second system is horizontal, articulating the wall surfaces in a complex sequence of registers and subregisters. The section shows two principal registers: the dome and drum belong to the upper, whose impost plane is set by the keystones of the

four arches in the tribune; this height, from keystones to floor, defines the lower. This lower principal register has two main subdivisions, one marked by the giant Doric corner piers, the other by the arches of the tribune. Finally, the subdivision corresponding to the giant corner piers is in turn articulated in two subregisters: the first of these accommodates the semicircular niches, while the second is marked by a series of monumental rectangular windows.

75. Geometric scheme of section with the most important proportional relations.

76. X-ray axonometric projection of the main volumes of the enclosed space.
The parallelepipedal volume of the tribune is perfectly legible from the outside, as are the other volumetric components – arms, semidomes, drum, dome, lantern. Except for the minor detail of the low drums associated with the semidomes, there is a very close relationship between the construction of the inner space and the articulation of the external forms. This typical central system outline, based on a composition of tapering volumes, symbolically resembles a pyramidlike distribution of masses.

Original project of *Raphael Sanzio*
Sant'Eligio degli Orefici
c. 1514–36, then rebuilt starting
in 1601
Rome

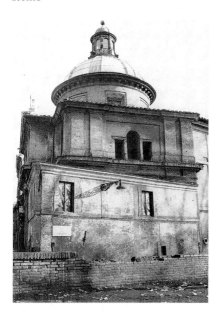

77. Plan.
This building–the church of the confra-

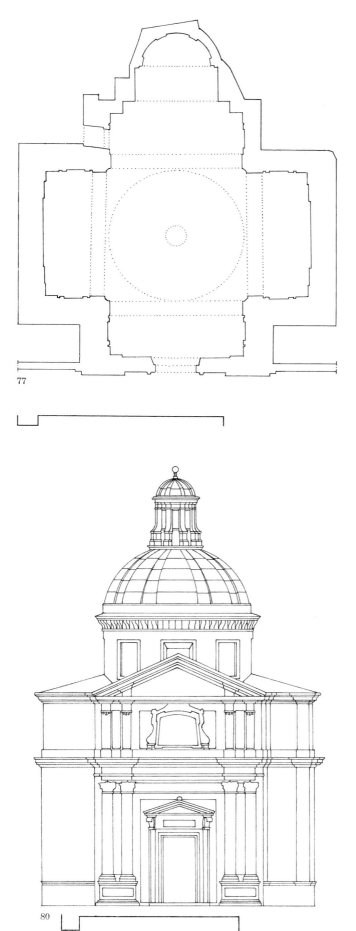

77

80

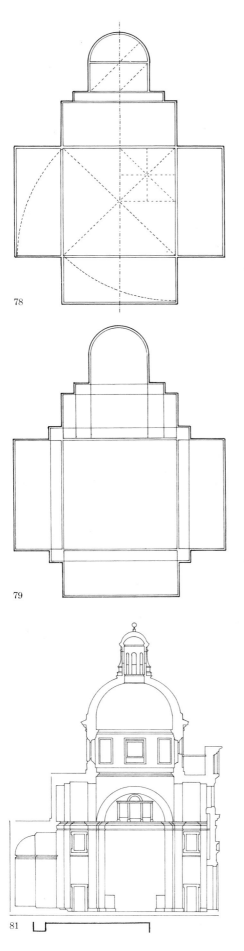

78

79

81

ternity of goldsmiths—is outlined on a typical Greek-cross plan, with one significant difference: a rectangular space connected to a semicircular apse is added at the end of the altar arm.

This solution, according to Frommel, relates to Raphael's contemporary experience in the construction work of St. Peter's; the plan of Sant'Eligio is actually akin to the apsidal spaces of the nave side aisles as designed for the 1514 project of the Rome cathedral.

The central square space was originally covered by a slender dome on a drum (the existing one was built later, during a massive seventeenth-century reconstruction). The arms are covered by barrel vaults and are connected to the tribune volume through four full arches.

78. Geometric scheme with main proportional relations.

79. Space framework outline.
In contrast to churches like Santa Maria delle Carceri or Santa Maria della Consolazione, the addition of an apse to the Greek-cross shape emphasizes the longitudinal axis of symmetry.

This breaks the overall balance of the composition and creates a spatial tension between the self-centrality of the basic plan and the effective tridimensional configuration – a tension that, for example, does not exist in San Biagio, where the longitudinal emphasis is visible only from the outside.

80–81. Elevation and section.
The original part of Raphael's project is limited to the overall plan and a small part of the elevation of the first register. The remaining parts of the church were completely remodelled in 1601.

Leonardo da Vinci
Central-plan temple based on a square
c. 1489
Paris, Institut de France (Codex Ashburnham, Ms. B.N. 2037), f. 3v

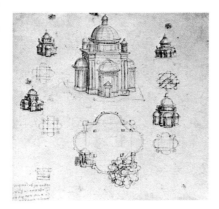

82–83. Reconstruction of the plan and hypothetical elevation from the original sketch.

The surviving manuscripts by Leonardo – more than five thousand three hundred pages on the most diverse subjects – reveal the figure of a great and complex artist. According to Vasari, Leonardo was handsome, amiable, generous and beloved by all; yet he seemed to maintain an aloof behavior in his social relationships, which he carried over into a detached approach to all his studies. As Wittkower notes, his impassiveness and self-control, both in affections and passions, must have impressed his contemporaries no less than the passionate and impetuous behavior of Michelangelo.

The temple, known only through the many sketches of the Ashburnham Codex, belongs to a series of studies Leonardo made on the central-plan typology. As Heydenreich points out, this example is but one of many variations on the theme, ranging from simple plans based on a square or circle to richer, more complex ones based on polygonal shapes. These sketches bear precious witness to continuous experimentation with the concept of the central-plan system.

As Pedretti reports, Leonardo was involved in the construction of the Milan Cathedral in 1487–90. As a result of his work on the *tiburio* of the cathedral, Leonardo turned his attention to analyze the structure of a sacred building with a central plan, a typology in which the geometric center coincides with the central balance point of mass. Even though most of Leonardo's work on the Milan Cathedral involved a solution to the static problem of reinforcing the stone structure, Firpo sug-

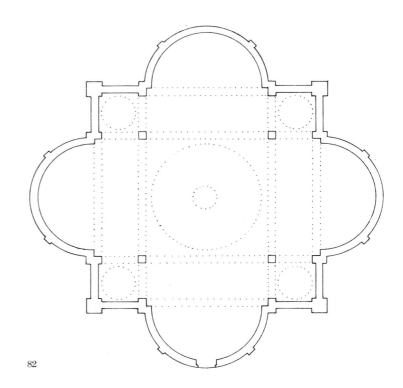

82

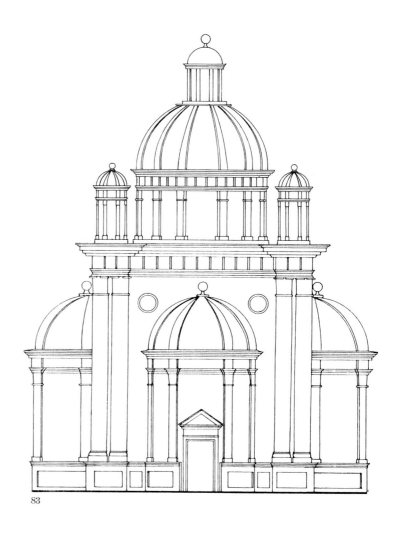

83

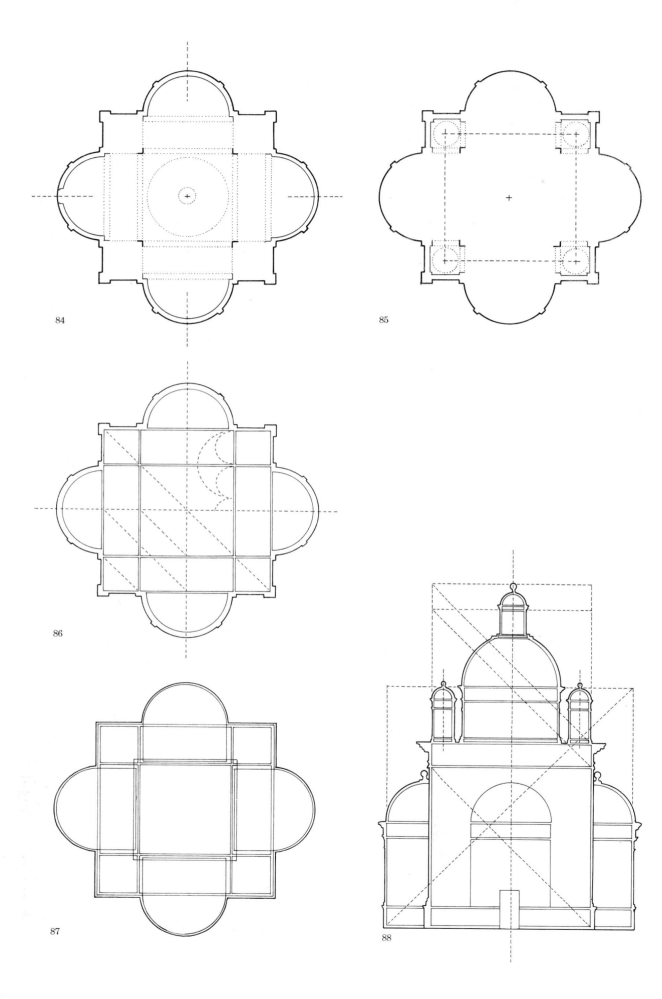

84

85

86

87

88

gests that, nevertheless, it was a key undertaking for the evolution of his architectural conception. Subsequently, Leonardo continued to study the theme of centrality. He soon left the technical and practical problems of the Cathedral to develop a more complex architectural ideal of a free-standing volume isolated in space and fully expressed in a formal sense.

Leonardo began to combine different geometries and multiple models, starting from the core concept of a building composed of a pivotal inner space to which side spaces are added radially and symmetrically. He emphasized this idea through the use of a high central volume, covered by a dome, while the other architectonic masses around it are directly expressed. He composed variations of ever-increasing complexity: from square to circular plans, from polygonal to lobed ones. The central-plan concept was thus progressively enriched by the addition of new volumes to the central space.

This process of articulation generates an architecture of connections. The intersection between the basic circular shape of the dome and the other figures (squares, octagons, and so on) gives rise to a variety of surfaces of cylindrical and spherical derivation. Further connections are set by the relationship of the volume of the tribune to the subsidiary spaces. As a result, there is a continuous hierarchy of sequenced elements, an uninterrupted flow from the top downwards. Quoting a comment by Leonardo that a building should be "set free" in order to express its true shape, Maltese notes a prevailing monocentric principle in his conception of architecture: an underlying idea that does not result from a fusion among the different elements but rather results from a process of juxtaposition of independent and self-contained volumes. This appears to recall the late Byzantine tradition of building smaller domed chapels around the larger or higher central portion of a church.

84–85. Analysis of the two systems that define the central plan based on a square.

Leonardo's plan is one of the first examples of a Greek-cross scheme in which the cross, rather than being fully expressed, is contained in a larger, square space. In this design, the cross is augmented by four smaller, square spaces placed in the corners and aligned along the diagonals of the square-based tribune.

Starting at the turn of the sixteenth century, a sequence of similar solutions will explore the possible relationships

between a main central space and a series of minor ones. On the basis of this conception, the four corner spaces can be interpreted either as completely self-contained volumes, each with a small cupola, or as belonging to the tribune space. In the first instance, the design would gradually lead toward increasingly complex polycentric-plan churches, a development typical of the design projects for St. Peter's. In the other case, the four subsidiary spaces, together with the rectangular arms of the cross, would create, as it were, a continuous square ambulatory around the tribune – a square path, superimposed on the cross, which unifies the inner space of the church. In this example, such ambiguity is not particularly evident. The articulation of the plan is still balanced, and the smaller spaces do not compete with the central volume.

However, three dimensionally, the clear attachment of the wings to the tribune, seen in churches like Santa Maria delle Carceri and Santa Maria della Consolazione, has been modified; the insertion of another element between the apselike spaces and the central tribune disconnects the former from the latter, completely altering the spatial articulation. This intermediate space between the square volume under the central dome and the semidome-covered, apselike spaces increases the distance from the center to the periphery of the building. It introduces a further articulation of the plan which, three dimensionally, means that the pyramidlike mass of the building is now widened toward the sides. The tribune becomes larger and more important, partially absorbing the arms and reducing their size and volumetric expression on the exterior. The increasing complexity makes it more difficult to achieve the close correspondence between the articulation of the interior space and exterior forms typical of early developments in Renaissance architecture.

86. Geometric scheme with main proportional relations.

87. Spatial diagram of the plan.

88. Geometric scheme of the facade with main harmonic relationships.
The sequence of interlocking elements is reflected in a pattern of superimposed squares, which govern the principal relationships between the volumes.

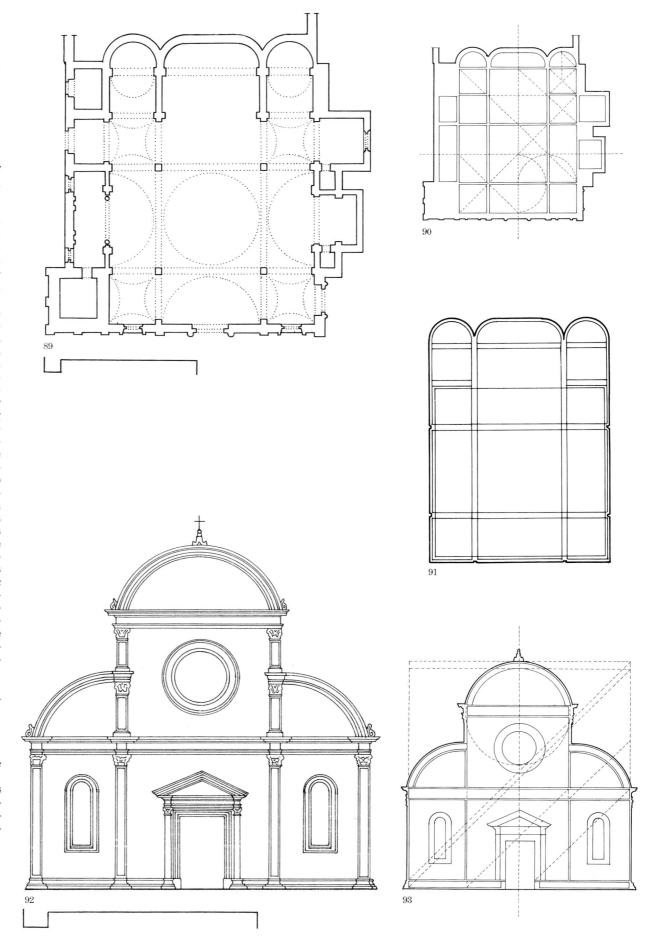

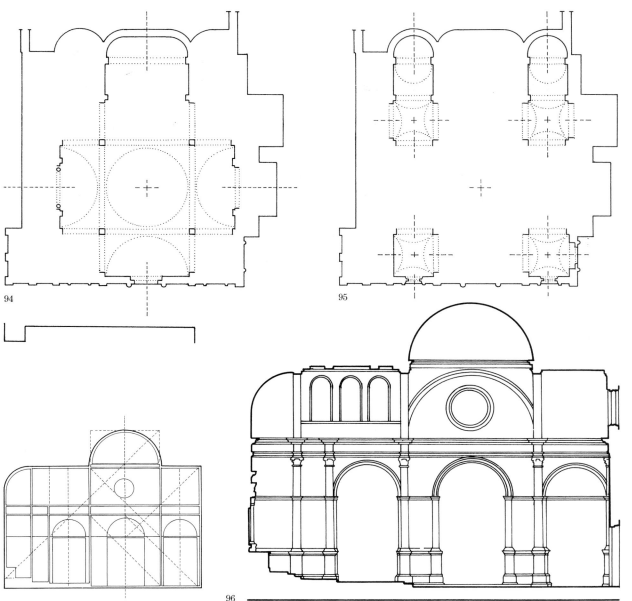

94

95

96

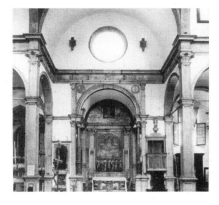

Mauro Codussi,
completed by his son *Domenico*
after 1504
San Giovanni Crisostomo
1497–1504
Venice

89. Plan.
The church is built on a restricted site, with its facade on a narrow street, the Salizzada di San Giovanni Crisostomo, and one side overlooking a small square, or campo, of the same name.
The interior is organized on the plan of a Greek cross inscribed in a square, with lesser squares carved out of the four corners – a theme which also interested Leonardo. The arms are therefore present, but are not volumetrically expressed on the exterior because they are fully contained by the overall volume of the church. Mauro Codussi had already employed a similar plan in his church of Santa Maria Formosa.
On one side, however, three recesses – a larger one at the center flanked by two smaller ones – extend the basic outline along the longitudinal axis.

Each of these recesses is articulated in an intermediate space, equal in depth to the corner squares plus a semicircular apse.
Every volume of the church is characterized by a different roofing which spatially defines its role and relation to the whole: the central square is surmounted by a hemispherical dome on pendentives, while the minor, corner squares have sail vaults; three of the arms are defined by barrel vaults; the fourth, at the altar end, has a flat coffered ceiling ending in a shallow, curved semivault. The two lateral spaces flanking the fourth arm have barrel vaults terminating in small semidomes.
The variety of spatial definition creates a very interesting relationship between the parts. Each element carries a vault scaled to its own dimension in

plan; thus, the larger the area, the higher the volume. As l'Angelini remarks, the chain of connections between the various volumes is dramatically emphasized by the large amount of light coming through the circular windows placed at the ends of the cross. Although this space articulation allows a clear perception of spatial relationships, there is an underlying ambiguity between the church's central plan and the longitudinal emphasis introduced by the extended altar end.
As Olivato and Puppi point out, the church maintains its integrity in spite of the setbacks encountered and alterations made during the long period taken to complete it. The strength of the basic design principle overcomes certain inconsistencies, especially regarding the Bernabò chapel on the right, and a number of poorly executed details in the upper part of the church.

90. Geometric scheme with main proportional relations.

91. Spatial diagram of the plan.

92. Facade elevation.
The elevation, defined by moldings in Istrian stone and walls in white plaster, is articulated in three bays. The central bay, corresponding to the longitudinal nave of the cross, is almost twice the width of the other two.
The whole facade is based on the relation between a full arch high above the central bay and two lower half-arches over the flanking bays. The play of the arches, the large circular window, and the monumental entrance focus the whole composition on the central part.

93. Geometric scheme of the facade with main harmonic relationships between the parts.

94–95. Analysis of the two systems that define the central plan based on a square.

96. Longitudinal section and its geometric scheme with main relations between the different elements.
Through an analysis of the lines defined horizontally and vertically by columns, entablatures, cornices and arches, and of the proportional relations between them, it is possible to establish a sort of network, a design grid that rules the whole architectural composition.

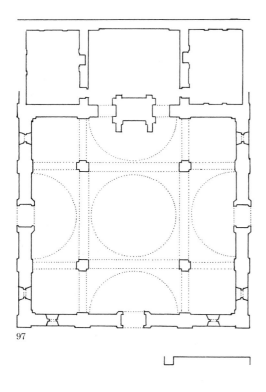

97

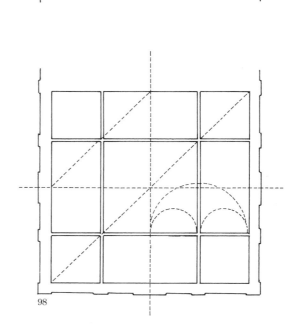

98

Cristoforo Infregnati,
followed by *Giorgio Vasari*
Santa Maria Nuova
From 1550
Cortona

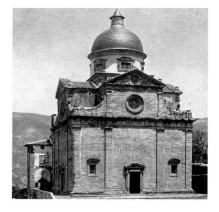

97. Plan.
Although this building is a rather late example of Renaissance architecture, it is important to show a mature development of the fifteenth-century central-plan church based on a square. As Patetta points out, Santa Maria Nuova evokes–on a minor scale–the design experiences of St. Peter's. The church is another example of the shift from a monocentric to a polycentric principle of space organization, a development which, at the turn of the sixteenth century, was actually common to many design proposals for the Rome church.

98. Geometric scheme with main proportional relations.

99. Spatial diagram of the plan.
The plan is a Greek cross completely inscribed in a square. This scheme may be related to examples like Mauro Codussi's San Giovanni Crisostomo and Leonardo's central-plan church sketches. The central cross is within a square and smaller square spaces are in each of the four corners. The arms are not expressed because they are fully contained by the volume of the church. The four corner spaces are not conceived as completely self-contained volumes; rather they are part of a square ambulatory surrounding the tribune space. This conception weakens the perception of the cross in favor of creating a single, homogeneous environment.

100. Longitudinal section.
The apse area is not shown because it is part of a later addition.

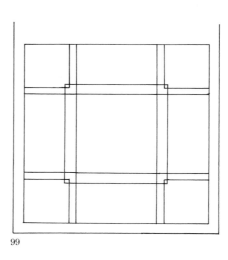

99

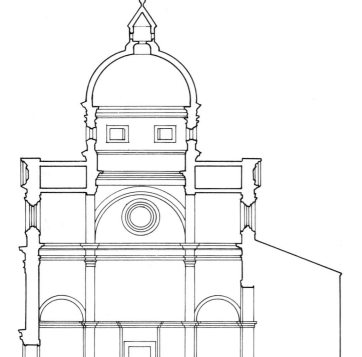

100

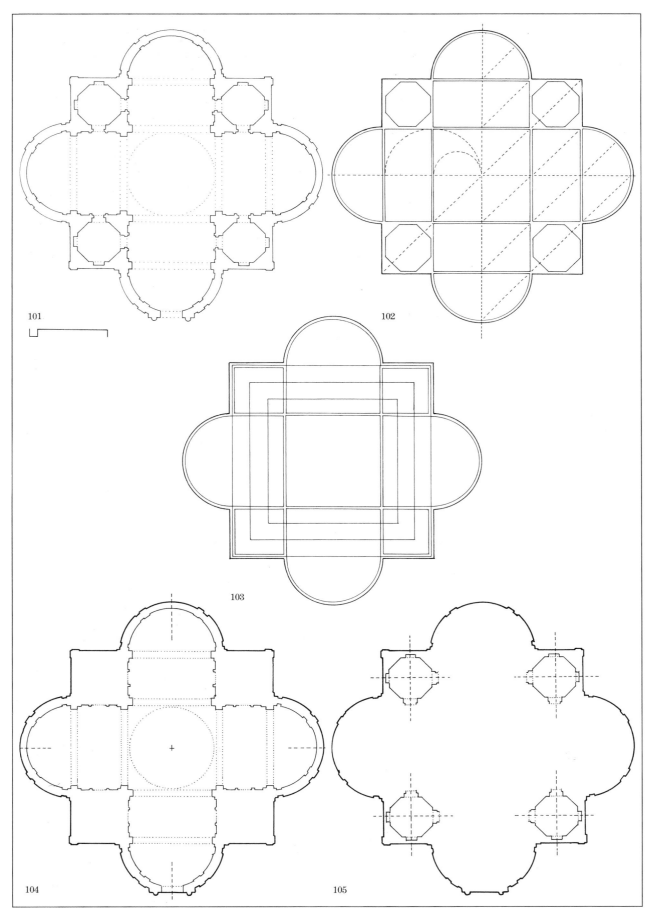

101

103

104 105

Bernardino Zaccagni
with his son *Giovanfrancesco*
Santa Maria della Steccata
1521–39
Parma

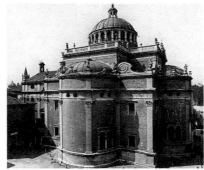

101. Plan.
The plan of this church goes back to
Leonardo's central-plan churches and
to examples of the Greek-cross plan in
which the cross, rather than being fully
expressed, is partially contained in a
larger, square space. In this design, the
cross is augmented by four smaller
spaces placed in the corners and
aligned along the diagonals of the
square-based tribune. The four corner
spaces may not be considered as be-
longing to a continuous ambulatory
surrounding the tribune space. They
can be interpreted only as completely
self-contained volumes, because their
octagonal shape is independent with
respect to the geometry of the church
as a whole. This articulation is so
strong, emphasized as it is by the re-
duced passage toward the central cross
space, that it creates a double architec-
tonic order: one set by the actual
church space, the other defined by each
of the four side chapels.

102. Geometric scheme with main pro-
portional relations.

103. Spatial diagram of plan.

104–105. Analysis of the two systems that
define the central plan based on a square.
The Greek cross, instead of being fully
expressed, is partially contained by a
larger square space. The arms of the
cross end in four equal semicircular
apselike spaces. The major central
space contains four smaller octagonal
spaces, placed in the corners and
aligned along the two diagonals of the
square-based tribune. Although the
four octagonal corner spaces can be in-
terpreted only as completely self-con-
tained volumes, they are not marked
on the outside by small domes. In fact,
it would be impossible to shape a con-
tinuous ambulatory around the space
where the dome is, as occurs in the

41

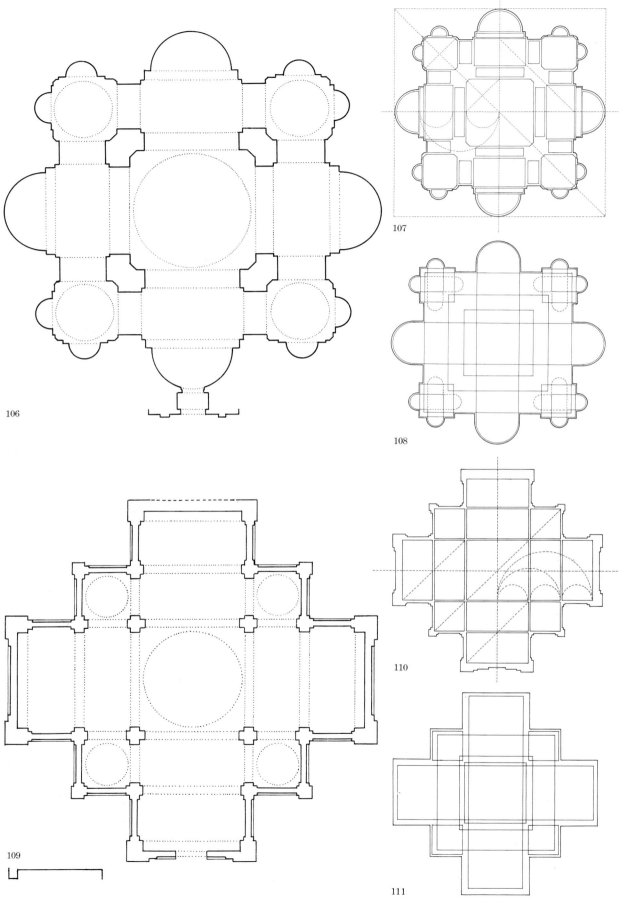

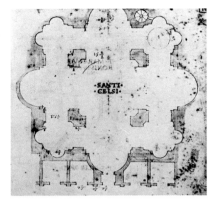

106. Plan.
The plan is based on a fusion of two different systems: the first, a Greek cross with semicircular apselike ends; the second, four independent, central plan spaces connected by a continuous, square space, which creates an ambulatory around the tribune.

107-108. Geometric scheme with main proportional relations and spatial diagram of the plan.

Alessio Tramello
Santa Maria di Campagna
1522–28
Piacenza

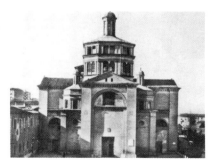

109. Plan.
The plan of this church is based on a Greek cross with the insertion of a square ambulatory around the tribune. As the Arisis remark, the plan recalls a classic scheme by Cesare Cesariano and originates, both in plan and in volume, an interesting articulation of right-angle-shaped spaces.

110. Geometric scheme with main proportional relations.

111. Spatial diagram of the plan.

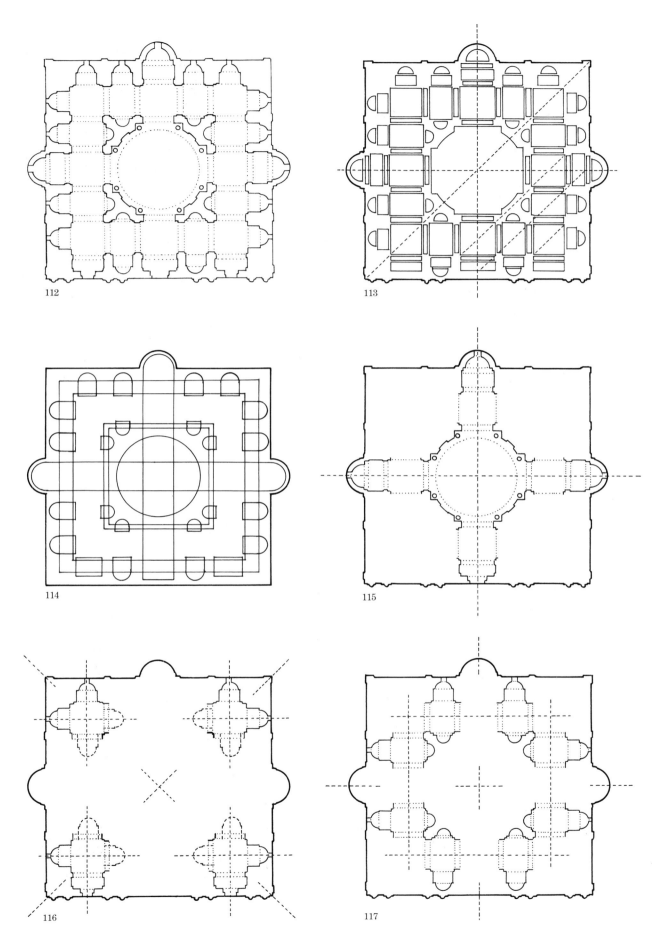

112

113

114

115

116

117

Giuliano da Sangallo, Donato Bramante, Raphael Sanzio, Baldassarre Peruzzi, Antonio da Sangallo the Younger, Michelangelo Buonarroti
Projects for the Basilica of St. Peter
c. 1505–46
Rome

112. Plan by Giuliano da Sangallo, c. 1505.

After Pope Nicholas V's minor remodelling of the early Christian basilica dating from the Constantinian period, Pope Julius II developed the idea of completely rebuilding St. Peter's. As Portoghesi suggests, the program for the new church, which was to be a symbol for all Christianity, was essentially based on a concentric, nondirectional, free-standing volume isolated within a great square and fully expressed in a formal sense; the church was most likely intended to be a central-plan building based on a square that contained an inscribed Greek cross, a hemispherical dome, and an undetermined number of minor chapels.

As a result of this program, Giuliano da Sangallo, one of the first architects to be involved in the project, designed a plan whose two major components were an imposing octagonal tribune and a continuous square ambulatory surrounding it. The first space is placed in the center and is emphasized by a large hemispherical dome, while the second constitutes a self-contained space around the periphery of the building. A series of side chapels are located along the outer wall. However, Giuliano da Sangallo does not succeed in creating a balanced hierarchy between the two spaces. The Greek-cross scheme is completely absorbed by the peripheral environment. The tribune is too large, and the ambulatory too independent, to set a proper harmonic relationship; and the cross fails to unify the inner space. In spite

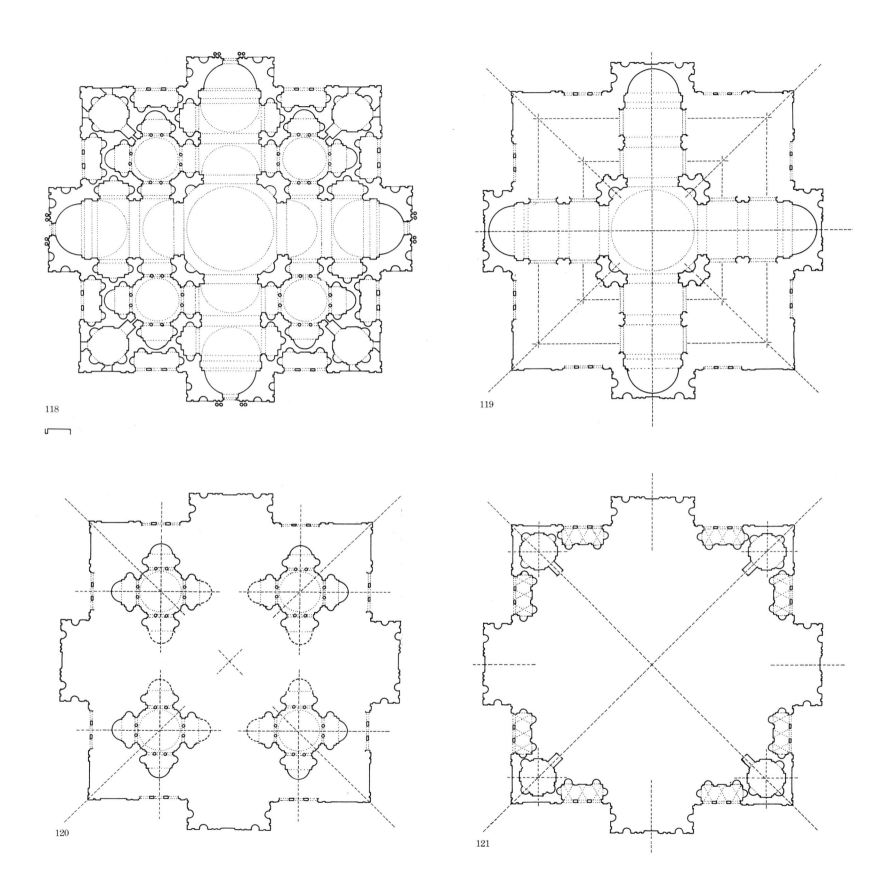

118

119

120

121

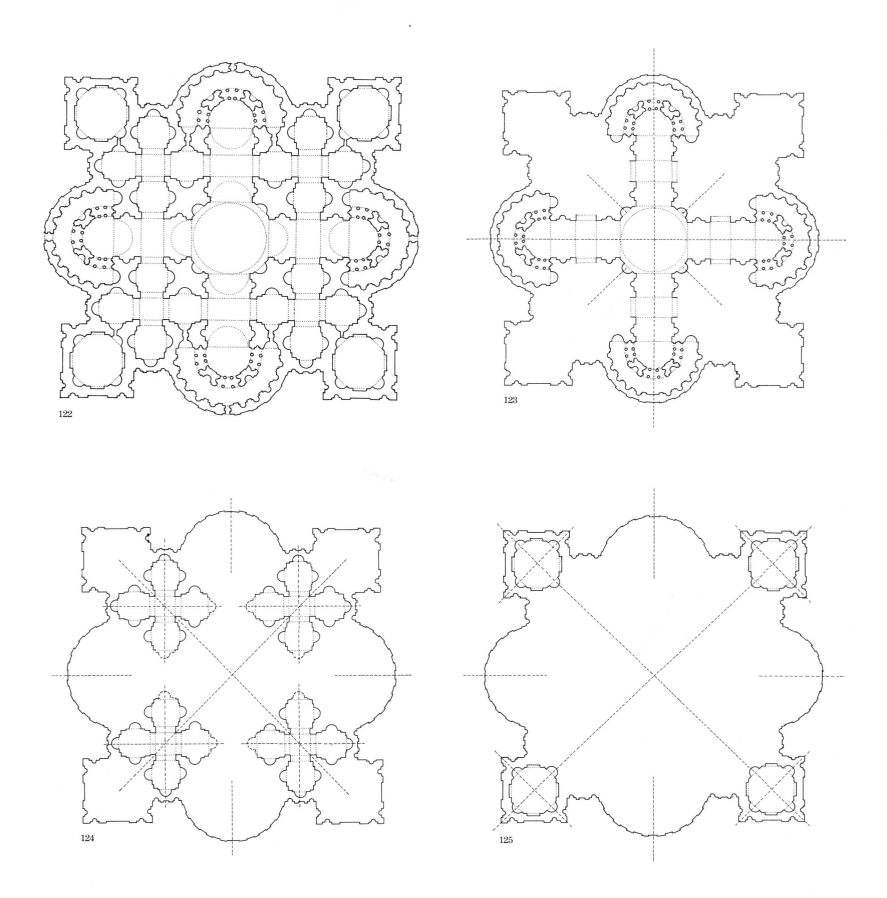

122

123

124

125

of this, the strong plan outline of the side spaces provides a large base, allowing a balanced distribution of masses.

113–114. Geometric scheme with main harmonic relations and sdiagram of the plan (Giuliano da Sangallo project).

115–116–117. Analysis of the three systems that define the polycentric plan based on a square (Giuliano da Sangallo project).
The Greek cross is contained in the overall square-based plan. However, there is no sense of hierarchy in the spatial distribution from center to periphery.

118. Reconstruction of the "parchment leaf" plan by Bramante, c. 1505.
Bramante's design is based on an outline which has much in common with Giuliano da Sangallo's project. There is an octagonal tribune and a continuous, surrounding square ambulatory with side chapels. But here the tribune and ambulatory are not treated so independently; what emerges is the Greek cross as the main element of spatial organization. The tribune is no longer an isolated volume. While it remains the most prominent part of the plan, at the same time it is tightly linked to the different spaces surrounding it. The tribune with its dome marks the center of the Greek cross and becomes the point of reference for the articulation of the whole building. The central space spreads out, extending beyond the sides and thus breaking the compactness of the square base. Moreover, its articulation establishes a typical space model which Bramante iterates in the four corners at a smaller scale: the four diagonally aligned corner spaces thus replicate the articulation of the principal scheme of the church.
This design-by-iteration allows the definition of a series of intermediate spaces, which serve as passages, chapels, niches, or simply as buffers between the scale of the major Greek cross and that of the minor, secondary spaces. As Portoghesi remarks, one of the most fascinating aspects of Bramante's project lies in the simplicity of the design principle and in the clarity of the final form. The result is a church whose complex articulation is based on a play of projections and recesses.

119–120–121. Analysis of the three systems that define the polycentric plan (Bramante project).
This sequence of drawings shows how the plan results from a process of combining three different systems. The

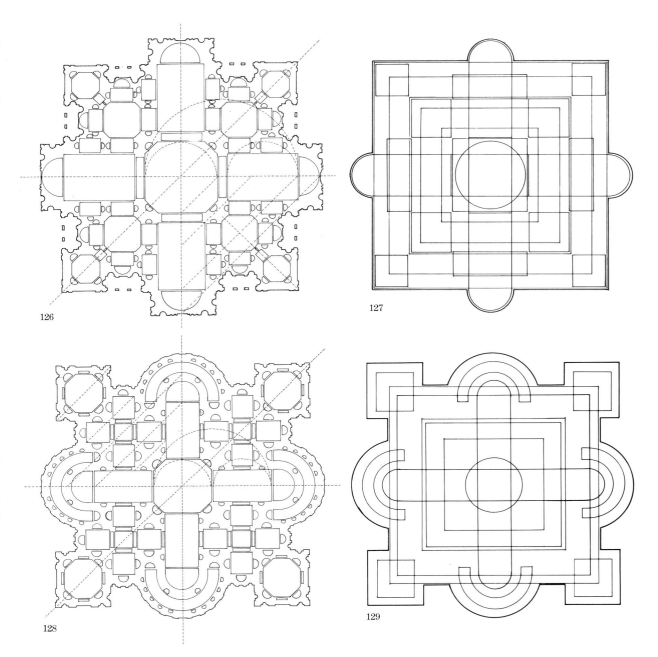

126

127

128

129

first system consists of the main space of the central Greek cross; the second is made up of the four diagonally aligned secondary spaces, which duplicate the scheme of the major cross. The third system is related to the four corner spaces. The four bell towers over the corner rooms of this third system are an important volumetric element, establishing a harmonic whole with the central dome. A series of porticos, function as side atriums, providing an alternative to the ceremonial entrances at the ends of the arms of the cross.

122. Baldassarre Peruzzi's interpretation of Bramante's plan in the reproduction by Sebastiano Serlio, 1520.
This version of the Bramante project

was reproduced by Sebastiano Serlio in the third book of his widely known architecture handbook; the scheme is considered a later version of Bramante's project.
Although the general outline of this new project follows the previous version, the plan has undergone so many changes that the original significance is altered. First, the scale of the major Greek cross has been reduced in order to establish a more appropriate relationship to the side spaces. Second, a new space – an apse shaped as a semicircular ambulatory – now terminates each arm of the cross and creates a more accomplished transition between interior and exterior space. Third, the four diagonally aligned, subsidiary

crosses no longer follow the articulation of the major Greek cross; the original octagonal spaces at their centers have been transformed into squares, and the rows of columns have disappeared; the arms have thus become almost self-contained units. Fourth, the four pairs of atriums which functioned as side entrances in the original Bramante plan have been eliminated. Finally, the four corner rooms are treated as even more independent spaces, being transformed into auxiliary, central-plan chapels.

123–124–125. Analysis of the three systems that define the polycentric plan (Peruzzi project).
The first system consists of the main space of the central Greek cross. In

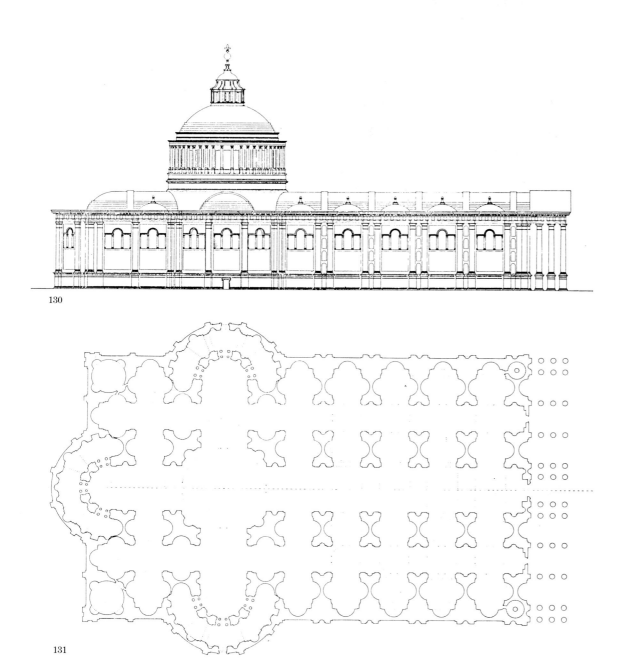

130

131

is based on a project of minor importance; however, it effectively illustrates the architectural principles of its designer and of a whole period of transition in the Renaissance.

Basically, in his project, Antonio da Sangallo the Younger attempts to emend all previous versions. He defines his project as an interpretation of all the controversial details that emerged during the extremely long period of the church's construction. First of all, he tries to solve the disputed issue of central versus longitudinal plan. He maintains Bramante's conception of the inner space articulation, employing the central Greek cross as well as the four diagonally aligned secondary spaces. But, at the same time, he introduces a new volume in order to create a more elongated plan. Thus he establishes a more gradual transition from the entrance towards the center of the church, where the altar would be located. However, the solution is not a satisfactory one. For example, as Heydenreich and Passavant remark, the facade assumes too prominent a position in relation to the church as a whole, and the bell towers are too high, conflicting with the articulation of the central dome. In conclusion, as the two historians underline, with Antonio da Sangallo the Younger the "grand manner" – that magnificent way of designing, typical of the Bramante period and still to be seen in Peruzzi's and Raphael's work – has come to an end once and for all.

133–134–135. Analysis of the three systems that define the polycentric plan (project of Antonio da Sangallo the Younger).

The first system consists of the main space of the central Greek cross, which is now elongated toward the entrance. Unlike the Peruzzi central-plan version, the ambulatories here are attached only to the three short arms of the cross; they again function as atriums, providing an intermediate space between the ceremonial entrances and the inner space of the arms of the cross. The second system is made up of the four diagonally aligned secondary spaces, which have an independent articulation with respect to the scheme of the major cross. Instead of an ambulatory, they almost shape a longitudinal nave, because they serve as side entrances. The third system is related to the four corner spaces and to a series of spaces flanking the elongated lower arm. Two extra rooms articulate the volume of the facade. Four bell towers are placed over the corner rooms of this third system, symmetrically marking the angles of the square base, while two other towers mark the sides of the front elevation.

this design four ambulatories, one at the end of each cross arm, function as atriums, providing an intermediate space between the ceremonial entrances and the inner space of the arms of the cross. The second system is made up of the four diagonally aligned secondary spaces, which have an independent articulation with respect to the scheme of the major cross. The third system is related to the four corner spaces. The four bell towers over the corner rooms of this third system are an important volumetric element, establishing a harmonic whole with the central dome.

126–127. Geometric scheme with main harmonic relations and spatial diagram of the plan (Bramante project).

128–129. Geometric scheme with main harmonic relations and spatial diagram of the plan (Peruzzi interpretation of Bramante project).

130–131. Reconstruction (Frommel-Ray-Tafuri, 1984) of the side elevation and of the original plan by Raphael Sanzio in the reproduction by Sebastiano Serlio, 1514.

Raphael assumes Bramante's Greek-cross scheme as a reference. In his plan, however, the original central, concentric system is transformed into a longitudinal one. The arm toward the entrance is now an elongated nave. The whole plan can be interpreted as an example of what Alberti refers to as a "composite" plan. Such churches can be considered

the result of the superimposition of two schemes: a central-plan system and a longitudinal one. This design may be seen as Raphael's response to the question of completely transforming the original concept of the church. In fact, in opposition to the central plan, the idea of a longitudinal scheme was growing in reputation as the plan best suited to the needs of the most important temple of Christianity, especially regarding the correct setting of the altar from a ceremonial and hierarchical viewpoint.

132. Reconstruction of the plan by Antonio da Sangallo the Younger, 1534, from the wooden model of the project. The model was not really essential for the construction of the church, since it

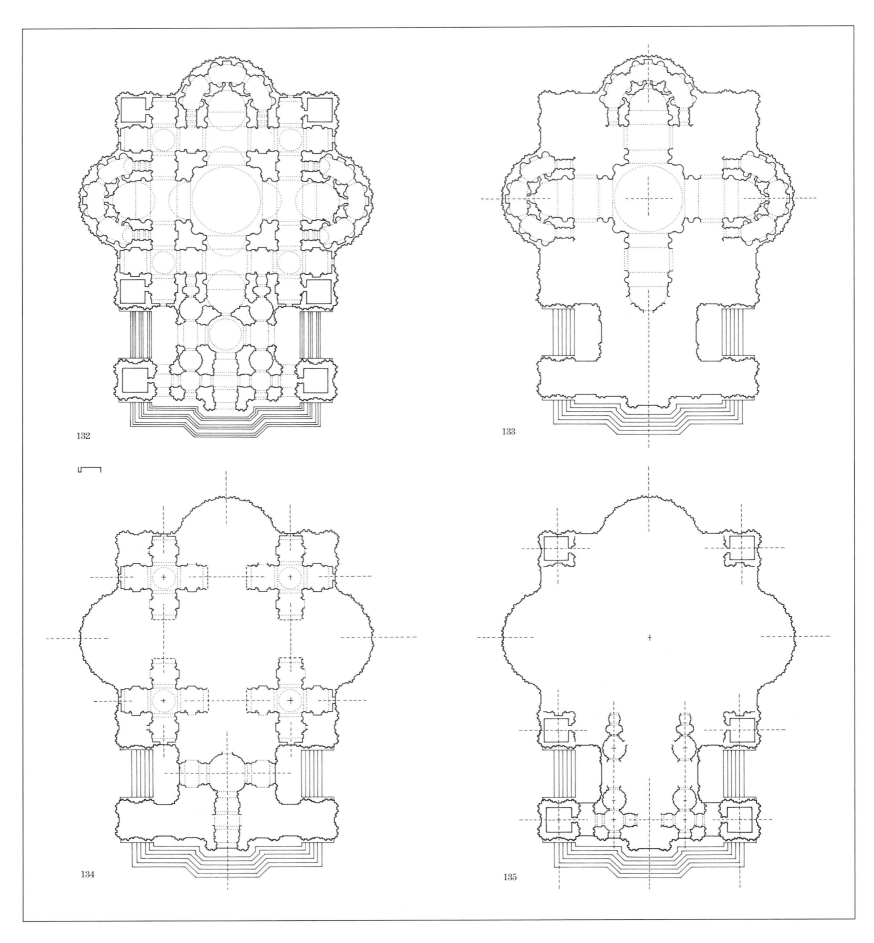

132

133

134

135

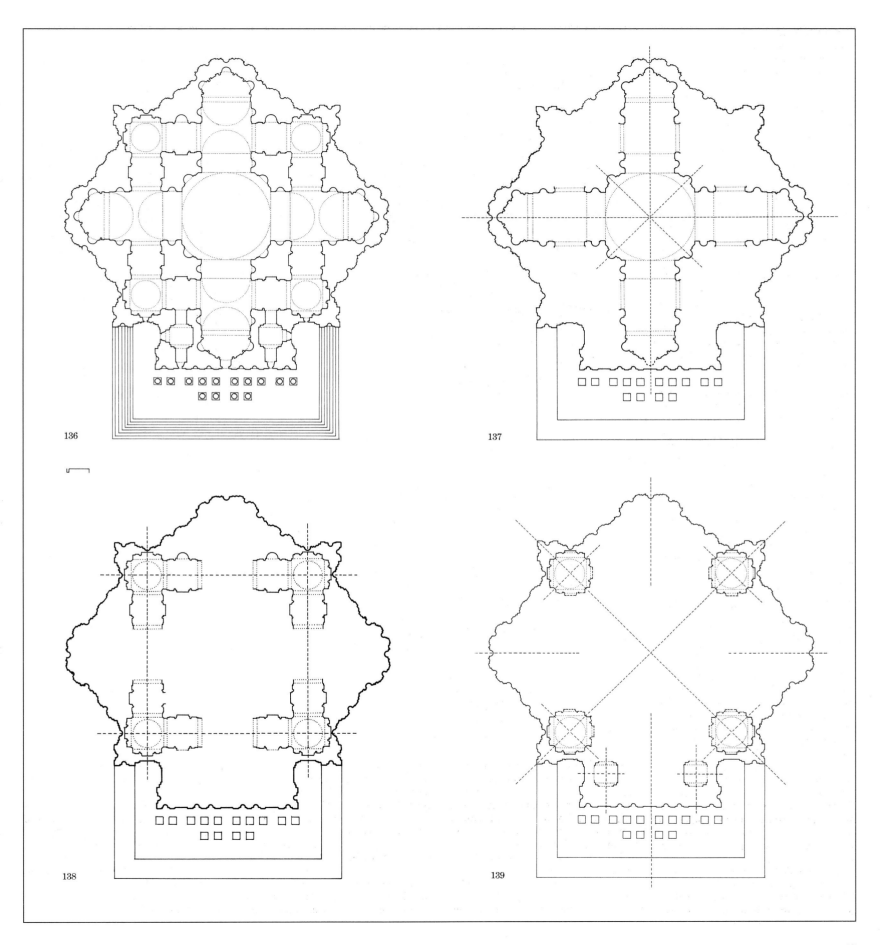

136

138

137

139

136. Plan of the project by Michelangelo Buonarroti, 1546.

Antonio da Sangallo the Younger died in 1546. The construction of St. Peter's now lacked a master architect capable of completing the building. From the very first, Pope Paul III wanted to appoint Michelangelo as master architect. But it was not an easy task to convince him to accept; he repeatedly refused, saying that architecture was not one of his skills, but the pope's insistence finally won him over. As newly appointed master architect, Michelangelo went one day to visit the construction site, and there he saw Sangallo's wooden model. Numerous former assistants of Sangallo were in attendance – Vasari refers to them as "the Sangallo faction." They were obviously curious to hear the artist's comments on their master's design. At a certain point one of them congratulated Michelangelo on his appointment, adding that the model was of such a rich and complex conception as to be like a meadow where one could endlessly graze. "You are indeed right," Michelangelo replied sharply, "but only with regard to cows and sheep, who do not understand Art!" From that moment on, the "faction" did everything in its power to obstruct Michelangelo's work, until the Pope finally granted him exclusive control of the St. Peter's project.

Michelangelo considered Sangallo's plan redundant in style, with too many registers, too many columns, and too many decorative details, and felt that the cost of completing the building as planned would be excessively high. Moreover, there were already some structural problems in the parts that had been built. The four main piers of the tribune, built to Bramante's design, turned out to be insufficient to support the weight of the planned dome, while the side spaces–however beautifully articulated – did not provide enough mass to counteract. Therefore, Michelangelo decided to strengthen the overall structure of the church, and to reduce its complexity, which eventually resulted in a simplification of the plan.

At the time of Michelangelo's involvement, two arms of the cross had already been built, so that the other two could not be modified, out of respect for the overall symmetry. Most of the side and central barrel vaults had been completed as well. Only the exterior perimeter allowed for some changes, as it was still mostly unbuilt. As Ackerman remarks, Michelangelo was able to transform Bramante's original idea of a major Greek cross surrounded by four minor ones into the more bal-

140

141

142

143

anced plan of a major Greek cross superimposed on a square ambulatory. A great dome covers the central space of the tribune, while four minor ones mark each of the corners of the square ambulatory. The principles of Michelangelo's formal design are based on a rigid hierarchy of the parts and on a reduction of the polyvalent use of the parts, while the preceding projects were based on the equality of the parts and on their capacity to assume different uses and roles simultaneous with those of the principal space. With these alterations, Michelangelo manages above all to avoid the dispersiveness of the previous polycentric scheme. In the new plan, every space emphasizes the presence of the central one and contributes to the spatial continuity of the whole church. In Ackerman's opinion, this unity, together with the tight and richly articulated architecture of the exterior wall, constitutes the real contribution of Michelangelo to the construction of St. Peter's.

Michelangelo planned the dome with a double curvature: hemispheric on the inside, and outside with a slightly ogival arch as Brunelleschi had. The dome was completed by Giacomo della Porta and Domenico Fontana between 1566 and 1593. To guarantee the strength of the structure, it was decided to maintain the external profile and

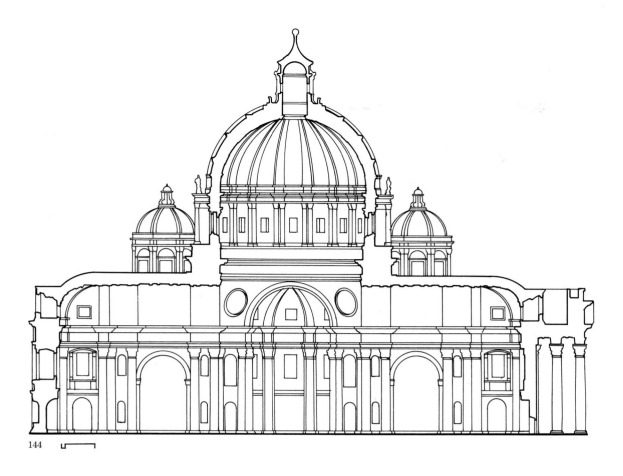

144

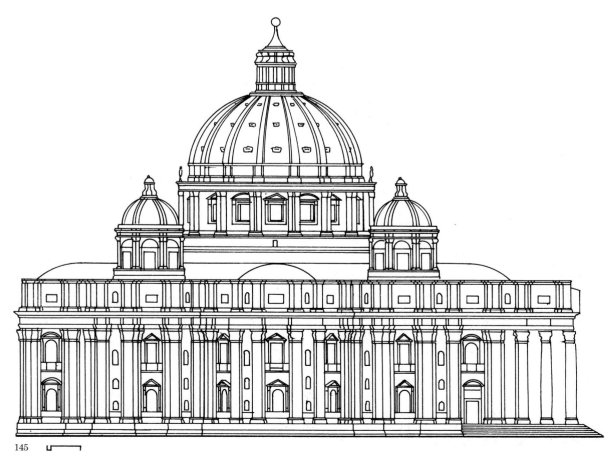

145

adjust the internal profile to the external. A ribbed dome, like that of Santa Maria del Fiore, does not work according to the same static principle. From a visual standpoint, the sixteen ribs represent an independent system but are considered integral parts in the hemispheric structural system of the ribs. The iron rings that contrast the lateral axes play an important role by allowing the use of the elegant coupled columns as detail.

137–138–139. Analysis of the three systems that define the polycentric plan (Michelangelo project).
This sequence of drawings shows how Michelangelo reduced the complexity of the Bramante plan. The first system–the Greek cross–is basically unaltered, but the second and third are significantly rearranged.

140–141. Geometric scheme with main harmonic relations and spatial diagram of the plan (project of Antonio da Sangallo the Younger).

142–143. Geometric scheme with main harmonic relations and spatial diagram of the plan (Michelangelo project).

144–145. Longitudinal section and elevation of the Michelangelo project.
Michelangelo had more freedom in designing the articulation of the church's outer walls. Here, the main architectonic problem was to express on the facades a harmonic relationship between the barrel-vaulted arms of the cross and the square-based volumes of the ambulatory. He chose to connect the ends of the arms to the corners of the ambulatory by means of oblique walls which belong to a square similar to that of the ambulatory, but rotated forty-five degrees. The result is a continuous wall which adheres, like a skin, to the inner structure, with a great sense of sculptural plasticity. Only the entrance facade is differently articulated: here the insertion of two square secondary vestibules flanking the arm of the cross makes it possible for Michelangelo, on the one hand, to create a slight emphasis on the longitudinal axis without weakening the central plan of the Greek-cross scheme, and, on the other hand, to find a solution for the front elevation, which quotes the portico of the Pantheon. Michelangelo's solution would have created a focus on the entrance without compromising the view of the dome from the piazza in front. The later additions made by Maderno and Della Porta not only erased Michelangelo's bold synthesis for the dome but also transformed the central plan into a longitudinal one.

51

Gian Galeazzo Alessi
**Santa Maria Assunta
del Carignano**
c. 1552–70
Genoa

146-147. Geometric scheme with main harmonic relations and spatial diagram of the plan.

148. Transverse section.

149. Plan.
This church is one of the first attempts to replicate the design principles of St. Peter's outside Rome. The architect employs a plan in which a Greek cross contained in a square is surrounded by four similarly articulated, diagonally aligned spaces. As Patetta notes, even if Alessi is forced to reduce the building program and to simplify the space articulation, he still manages to keep as a major reference the idea of the central plan. He thus pursues the equality of every church component–from the arms of the cross to the side chapels of the subsidiary spaces. The four facades are therefore alike, with bell towers each corner (only two were built), and four minor domes with lanterns, marking each right angle of the square ambulatory.
The only variation is on the altar side: a semicircular chorus is added to one arm, thus creating an extra volume that differentiates this side and emphasizes the longitudinal axis.

150–151. Analysis of the two systems that define the polycentric plan.
These two drawings show the Greek-cross plan and the system of the four diagonally aligned side spaces. This church completely lacks a third system of independent spaces, nor does it have any differentiation in scale between the central space and the sides. This results in a loss of articulation of the inner space and a reduced sense of volumetric hierarchy. The only spatial emphasis is introduced by the circular apse added at the end of one arm as an altar recess.

152. Geometric transverse section with main harmonic relations.

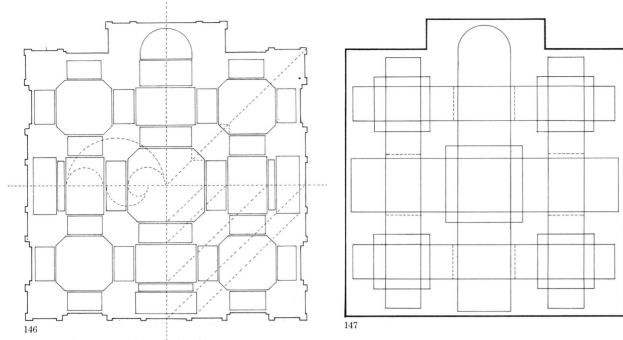

146

147

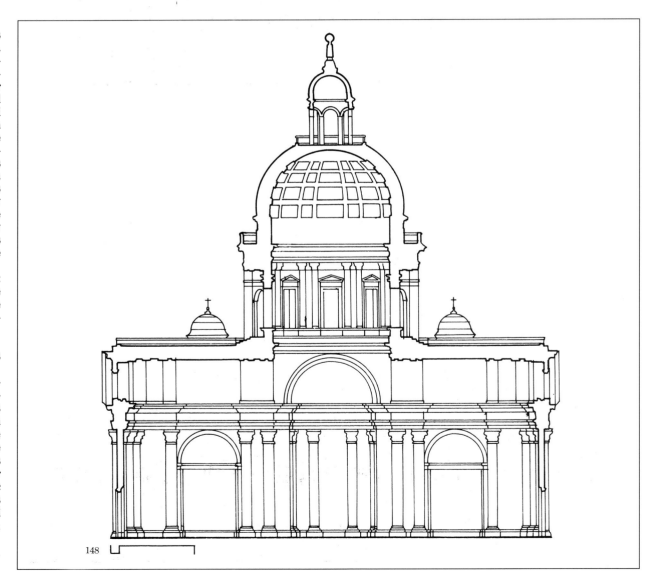

148

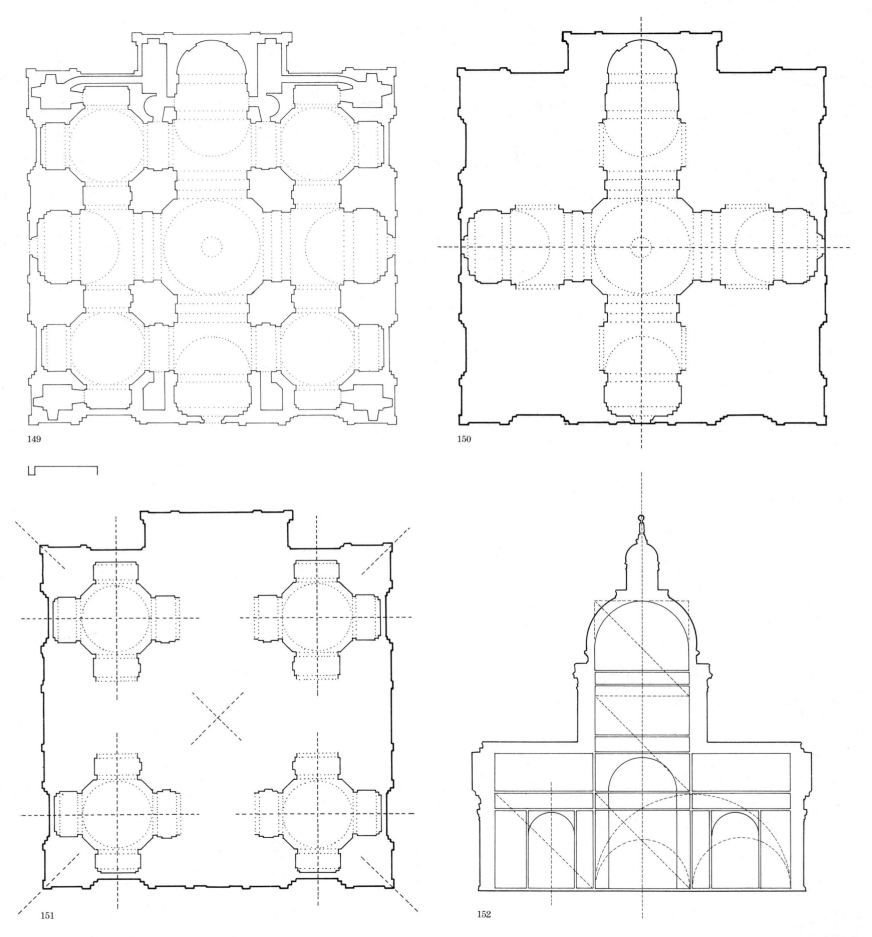

149

150

151

152

1

2

4

6

7

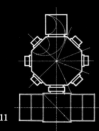

9

11

13

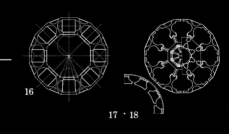

16

17 · 18

14

15

22

21

23

3

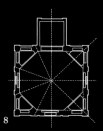

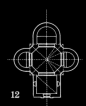

8

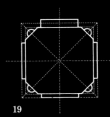

12

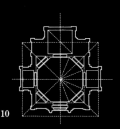

10

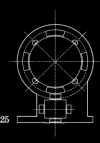

19

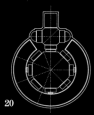

20

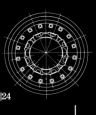

24

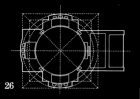

25

26

**Central System churches
on polygonal and
circular based geometry
Chronological table**

1. Dome of Santa Maria del Fiore,
 1418-36, Florence, p. 57.
2. Sacristy, Santa Maria in San Satiro,
 completed by 1483, Milan, p. 58.
3. Trivulzio Chapel, from 1512, Milan,
 San Nazaro in Brolo, p. 60.
4. Sacristy, Santo Spirito, 1489- ca. 1496
 Florence, p. 61.
5. Santa Maria di Loreto, ca. 1507,
 Rome, p. 62.
6. Santissima Incoronata, from 1488 to
 after 1510, Lodi (Milan), p. 62.
7. Santa Maria Incoronata di
 Canepanova, from 1500, completed
 after 1564, Pavia, p. 64.
8. Santa Maria in Piazza, from 1517,
 Busto Arsizio (Varese), p. 66.
9. Church of San Magno, 1504-13,
 Legnano (Milan), p. 66.
10. Santa Croce, end of the 15th century,
 Riva San Vitale (Canton Ticino), p. 66.
11. Santa Maria dell'Umiltà, from 1494,
 completed after 1561, Pistoia, p. 67.
12. Chiesa Tonda, from 1517, Spello
 (Perugia), p. 69.
13. Tribune of Santa Maria della
 Passione, from 1482, Milan, p. 69.
14. Large polygonal temple with eight
 lobed apses, ca. 1490, Paris, Institut
 de France (Codex Ashburnham 2037),
 5v-B 92v., p.70.
15. Central-plan temple on a polygonal
 base, ca. 1489, Paris, Institut de
 France (Ms. B), f. 22r., p. 70.
16. Santa Maria degli Angeli, 1434-37,
 then completed in the 19th century,
 Florence, p. 70.
17. Lantern for the Dome of Santa Maria
 del Fiore, 1436, Florence, p. 70.
18. "Tribune Morte" of Santa Maria del
 Fiore, from 1438, Florence, p. 70.
19. Chigi Chapel, from 1513, Rome,
 Santa Maria del Popolo, p. 72.
20. Church of the Madonna di Campagna,
 from 1559, Verona, p. 73.
21. Santa Maria della Croce, from 1490,
 Crema (Cremona), p. 73.
22. Rotunda of the Annunziata, from
 1444, completed after 1469,
 Florence, p. 76.
23. Sacristy of the Cathedral, from 1488,
 Pavia, p. 76.
24. Tempietto of San Pietro in Montorio,
 from 1508, Rome, p. 78.
25. Pellegrini Chapel, 1527-38, Verona,
 San Bernardino, p. 80.
26. Tempietto, 1580, Maser (Treviso),
 p. 83.

Filippo Brunelleschi
Dome of Santa Maria del Fiore
1418–36
Florence

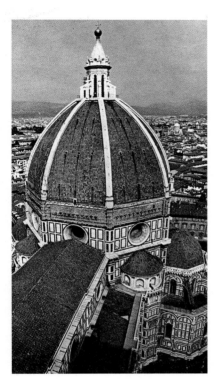

1. Plan.
This view shows the main structural elements of the base octagon: the primary ribs at the angles, the intermediate secondary ribs between them – two per side – the intrados surface of the dome, and the outer roof.

The dome is Brunelleschi's major work and occupied about thirty years of his life. The events of its construction are many and complex, especially regarding the development of an adequate construction technique for such an enormous structure. When Brunelleschi first became involved in the problem of building the dome, the cathedral had been standing unfinished for quite some time – completed only up to the top of the drum, i.e., to the impost point of the dome. It is important to remember, as Sanpaolesi notes, that Florentine civic pride required not only the completion of the cathedral, but its enlargement to the point where the dome would be the largest in existence. The engineering problems inherent in such a vast project were, of course, completely unprecedented. Should the citizens of Florence fail to find an architect capable of finishing the cathedral, it would be an ignominy that the city would never live down.

Finally a competition was held to design and build the dome. The competition was open even to foreigners – an unusual fact for the time – but no one was able to propose a valid solution for a structure whose huge scale precluded the use of traditional construction methods. At the time of the competition, Brunelleschi had just completed one of his many sojourns in Rome for the study of ancient architecture and masonry construction techniques. On the basis of his experience, Brunelleschi declared, to the great surprise and incredulity of the whole city, not only that he was able to build the dome, but also that – contrary to the common knowledge of the time – it could be done without centering. Moreover, he added that there should be a double inner and outer dome instead of a single, lighter one, and that the section should be pointed rather than semicircular.

In order to appreciate the disbelief of his contemporaries, and the enormous gap between Brunelleschi's proposal and the other projects submitted, the ideas of two other competitors should be considered. One had proposed to support the dome on a gigantic central column. Another, even more bizarre suggestion was to fill the church with soil to support the dome during its construction; the soil would be mixed with coins so that its removal would be undertaken by the citizens themselves, at no further expense. For many years afterwards, as Vasari narrates, Brunelleschi claimed to be the only one capable of building the dome, while steadfastly refusing to divulge to the city assembly the details of how he would do it. Eventually, he was named architect of the dome but with a contract to build only a limited, lower portion of it.

During this initial phase of construction, Lorenzo Ghiberti was appointed as associate architect – a direct affront to Brunelleschi, as this was obviously a move intended to monitor and control his activity. He was finally appointed sole master of the work, but only after a series of vicissitudes culminating in a faked illness; Brunelleschi's absence, which left Ghiberti momentarily in charge of construction but without any of the elements necessary to proceed with the work, exposed Ghiberti's incompetence and ignorance of the project.

In the opinion of Tafuri, by taking over the leadership of construction, Brunelleschi breaks with traditional medieval guild practices. He merges in himself the structural skill of the master builder and the artistic competence of the architect, and can therefore guarantee the quality of the whole building from the first moment of conception to its final completion.

1

2

3 ⌐_⌐

4
⌐_

2. Schematic section showing the geometrical construction of the inner and outer surface lines of the cupola.

3. Plan showing the geometric pattern of the structural components.

The process by which Brunelleschi arrived at his conception for the structure of the cathedral dome remains one of the most controversial issues in the study of Renaissance architecture. In principle, as in any masonry structural system, the overall conception of the dome is based on the equilibrium of the thrust of its various component elements. In order to properly react to the enormous loads created by the weight of the dome, all the components may be thought of as a series of wedgelike forms with a common central projection point. The tendency of the major ribs to fall toward the center is counterbalanced by the weight of the paired intermediate ribs plus the connecting surfaces. Therefore all the vertical stresses of the structural system are transformed into horizontal stresses: while the ribs – both primary and secondary – function as wedges, the intervening sail surfaces act as flat arches. Sails and ribs mutually reinforce each other, reacting to a sequence of transverse compression stresses.

A critical detail of the system is the so-called herringbone brickwork construction. This is a self-supporting technique, of Roman origin, which allows the construction of a dome without centering. Brunelleschi employs it in order to overcome the impossibility of building a scaffolding for such an enormous structure. Several authors have speculated that Brunelleschi, during one of his many trips to Rome, might have studied this herringbone technique, so widely used in ancient buildings.

4. Elevation and section (from Steigmann/Geymuller, 1855–1909, vol. I, BL.1b).

The dome today is still an astonishing sight on account of its size, especially when compared to the scale of the surrounding buildings belonging to the same period. Leon Battista Alberti emphasizes the magnitude of the dome in the dedication of his book on painting, when he very poetically describes the magnificent size of the dome as touching the sky, and even capable of casting its shadow over the whole Tuscan population.

Donato Bramante
Sacristy
Santa Maria in San Satiro
completed by 1483
Milan

Introduction

The central-plan Renaissance churches in the region surrounding Milan present many common characteristic features which, as Patetta notes, may be related to a single architectural typology, and to the leading role of a single architect, Donato Bramante. A local historian at the turn of the century has grouped them under the definition "constructions of Bramantesque origin," in order to underscore, on one hand, the role Bramante's buildings played as leading architectural models and, on the other hand, the typical qualities of Bramante's churches: the special atmosphere created by the natural lighting, the orderly relation of the architectural components, and the magnificent symmetry of plan and section. These same qualities inspired a poet to write that these churches were "simple and pure as prayers" (a characteristic often lost due to later additions which have enriched – and at times overwhelmed – the original Renaissance decoration). Before Bramante, the employment of the central plan was due to Michelozzo, the great Florentine architect who designed the Portinari Chapel (chap. 1, figs. 12–16) – one of the first examples of Renaissance architecture in Milan, openly inspired by the plan of Brunelleschi's Old Sacristy. After the completion of this chapel, all new religious buildings in the Duchy of Milan began to relate to its architectonic theme and to other elements belonging to the innovative architecture of Tuscany. Construction began on central-plan churches in Milan as well as in Lodi, Saronno, Legnano, Busto Arsizio, Crema and even in Riva San Vitale and

Pavia, all cities with strong, deep-rooted medieval traditions. Within a few years the central plan became the only accepted outline, the sole possible shape for a church. Leonardo da Vinci even wrote that a building "wants" to be articulated on all sides, and to stand out, desirous of showing its real shape – a statement which soon became a principle for the architectural design of churches, though a contradictory one.

Leonardo's principle worked only on a theoretical level, as an ideal attitude to be developed and pursued throughout the design phase; in most cases, the reality of actual construction was quite different. The sides of many central-plan churches were deeply interwoven into the urban fabric of medieval town centers, where it was a practical impossibility for the building to stand out from its surroundings. In addition, considering the long and complex construction history of these churches, which frequently involved changes or additions, it can be understood how Leonardo's principle was a theme more evident in the interior space than in the exterior articulation of the building. However, it did provide a subtle thread running through the various parts of a single building, also linking these churches to each other.

Whereas in Florence the most frequently employed basic shape for central-plan churches was the square, in the region of Milan polygonal shapes provided the basic geometrical reference. From the early square-based examples, such as the above-mentioned Portinari Chapel by Michelozzo, or the later Colleoni Chapel in Bergamo (chap. 1, figs. 17–18), built to Amadeo's design, architectonic production gradually shifted toward octagon-based plans in which the emphasis lay in the articulation of the corner junctions with respect to niches or chapels in the sides, in the configuration of the sequence of levels in section, and in the shaping of the dome and the lantern. Outside, the appearance of these churches is rather similar. The dome is typically covered by a pitched roof, divided into sectors, with a rather slender lantern topped by a small cupola.

In the opinion of many critics, it was Bramante who adopted a truly new approach to building design. He was able to graft the Renaissance architectural spirit and the traditional Milanese taste for decoration onto a much older tradition in the area, going back to the Early Christian period. The typical religious building of that period had an eight-sided plan with a nichelike opening in each side; alternating niches were rectangular or semicircular in plan. This grafting process represents

5. Plan.

an urge for renewal of outdated medieval architectural models. In this process, ancient monuments were rediscovered and used as inspiration for innovative forms of expression.

5. Plan.
The sacristy belongs to San Satiro, an ancient church that was completely remodeled and expanded by Bramante. Part of the complex is, in fact, the early Christian votive chapel of San Satiro, which was basically left as it was and integrated into the new articulation of the church. In the sacristy it is possible to see how Bramante managed to re-

call a central-plan outline on an octagon base as a symbol of the local medieval tradition and at the same time to achieve a unique articulation of the inner space through the dramatic verticality of the volume and elegant use of classical architectural language. The votive chapel of San Satiro itself may be considered a model, even though its square-based central system produces a lobed plan. In contrast, Bramante, in the sacristy, adds four semicircular chapels and four rectangular niches to the octagonal base, emphasizing the perception of its centrality.

6. Geometric scheme with main proportional relations.
The plan of the sacristy is based on an octagon, which coincides with the space of the tribune, and to which subsidiary spaces are added. A semicircular chapel is added to each of the oblique sides of the octagon, while there are rectangular niches on the remaining sides. Bramante is thus re-proposing the traditional rhythm of alternating curved and rectilinear side spaces. The central-plan system is clearly outlined on the octagonal base; the secondary elements do not influence the overall articulation of the space. The

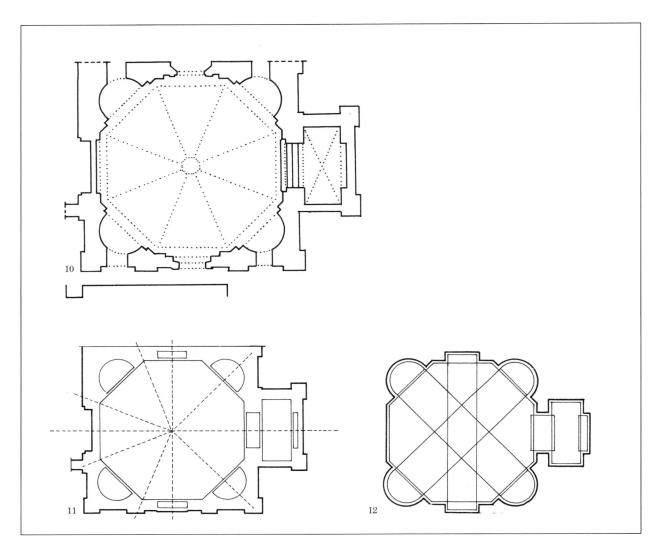

10

11

12

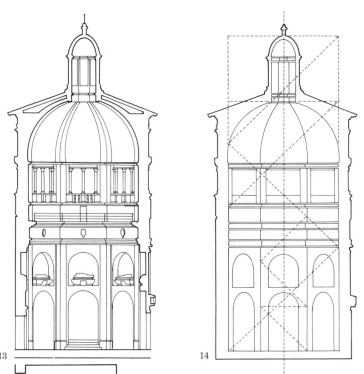

13

14

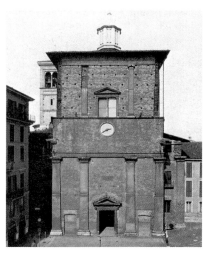

Bartolomeo Suardi,
also known as *Bramantino*
Trivulzio Chapel
from 1512
Milan, San Nazaro in Brolo

10. Plan
The plan of Suardi's chapel recalls models of early Christian origin, like the many baptisteries in the Milan area. At the same time it belongs to the tradition of those Renaissance buildings that had already used such baptistries as a reference, like Bramante's Sacristy (figs. 5–9).

11. Geometric scheme with main proportional relations.
The plan is based on a central octagon which coincides with the space of the tribune, and to which subsidiary semicircular spaces are added on each of the oblique sides. On the remaining sides there are four openings: two lead onto secondary rooms, while the two along the longitudinal axis serve respectively as an entrance and as a connection to the altar recess. The Trivulzio Chapel tribune is thus reproposing the traditional rhythm of alternating curved and rectilinear side spaces. The presbytery has a rectangular form and is defined as an independent volume with respect to the tribune volume. The two are aligned along a common axis of symmetry. However, the central-plan system is outlined clearly on the octagonal base; the secondary elements do not influence the overall articulation of the space, which is characterized by a central volume with strong vertical emphasis.

12. Spatial diagram of the plan.

13–14. Section and geometric scheme with main proportional relations.

church thus consists of a single volume with strong vertical emphasis.

7. Spatial diagram of the plan.

8–9. Section and geometric scheme with main proportional relations.
The section is articulated in three registers. The first corresponds to the full height of the openings that lead to the side chapels. The second is occupied by a gallery that runs around the perimeter of the octagon and whose rhythm in each bay is marked by a pair of arches. This creates a harmonious acceleration of the rhythm, leading to the uppermost level. This third register contains the segmental dome and the slender lantern. Each segment of the dome contains a circular window – a peculiar detail introduced by Bramante to overcome the impossibility of lighting the interior from the sides.

Giuliano da Sangallo,
with later additions by
Simone del Pollaiolo,
also known as *il Cronaca*
Sacristy
Santo Spirito
1489–ca. 1496
Florence

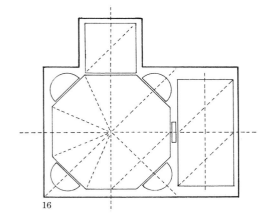

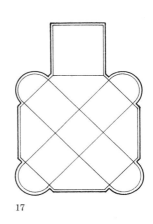

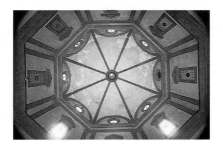

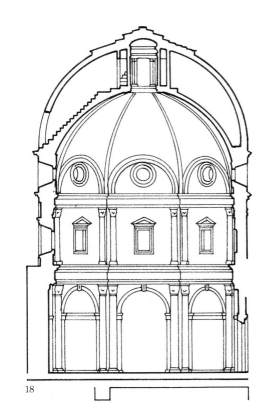

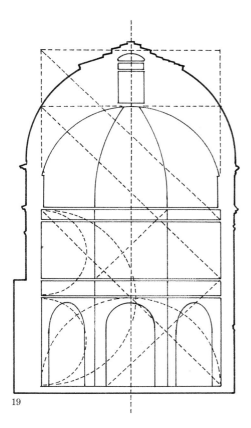

15. Plan.

The sacristy stands to one side of the church designed by Brunelleschi. Its central-plan system is based on an octagonal space covered by a rib-and-sails cupola. The octagon is enriched by the presence, on one of its sides, of a small square where the altar is located, while on the four oblique sides of the octagon there are semicircular niches. The articulation of the sacristy is completed by a rectangular, barrel-vaulted vestibule on the right, connecting it to the body of the church. This vestibule is commonly attributed to Simone del Pollaiolo, though it is likely that the design was influenced by Giuliano da Sangallo himself.

Most of the elements of the sacristy are clearly derived from Brunelleschi, especially the treatment of the wall decoration: the architectonic elements–columns, capitals, entablatures, and moldings–are in gray limestone and stand out from the white plaster surfaces. But the octagonal shape of the plan may have been drawn from the Florentine Baptistry of San Giovanni, which at the time was believed to date from the late Roman period. This archeological intention is even more evident in the vestibule, both in the details of the twelve magnificent Corinthian columns which carry the barrel vault, detached from the wall, and in the overall use of classical decoration.

The space frame defined by the wall moldings, typical of Brunelleschi's architecture, here has a slightly different significance. Whereas in Brunelleschi's buildings there is a strict relationship between the volumetric outline of the space and its geometric definition through the moldings, here the "cage" described by the moldings has a more clearly decorative

character. The flat pilasters do not have a strictly load-bearing function. Instead of a single pilaster at each corner, there are two, displaced from the corner position so as to expose the corner as part of the white wall. Consequently, each side of the octagon can be perceived as an independent and self-contained plane, rather than as a portion of the overall geometric outline. The rich and elegant space frame described on the wall thus appears to be wholly independent of the articulation which the wall itself defines. The white walls lose their constructive value as limiting elements and acquire the role of neutral background: the gray cage of the moldings thus stands

out almost as a visually transparent framework.

16. Geometric scheme with main proportional relations.

The sacristy is composed of three elements: the vestibule, the sacristy proper, and the altar recess. These three spaces are not aligned along a single axis; the axis of the vestibule is at ninety degrees to that of the altar, so that the central space also functions as a pivot between them. The central, octagonal space presents four semicircular niches which expand it diagonally.

17. Spatial diagram of the plan.

18–19. Section and geometric scheme with main proportional relations.

The section is divided into three registers. The first is defined by the height of the paired flat Corinthian pilasters; it is further marked by an entablature running continuously around the sides of the octagon. This entablature also sets the point of the keystone of the full arches at the openings of the niches, as well as the openings of the altar recess and the vestibule.

This homogeneous articulation does not acknowledge the different functions of the various sides of the base octagon. The niches, the opening of the altar recess, the door to the vestibule, and even the two remaining blind

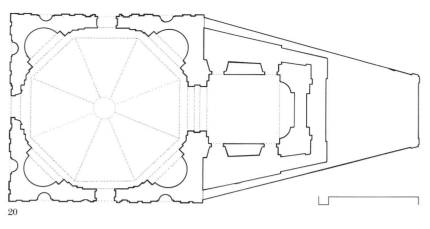

20

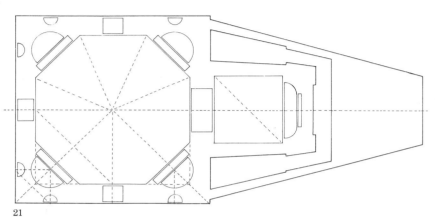

21

22

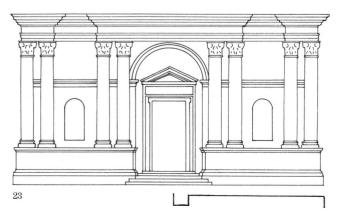

23

walls, are given identical treatment in order to emphasize the centrality of the octagonal space.

The second zone is defined by the height of another order of paired Corinthian pilasters, of smaller scale, and another entablature; there is a rectangular window on each of the eight sides.

The highest level is defined by the rib-and-sails dome, with a series of full arches enclosing circular windows.

The outer dome rises to the height of the lantern, which is thus not expressed on the exterior, though it is fully perceived from below.

Santa Maria di Loreto
ca. 1507
Rome

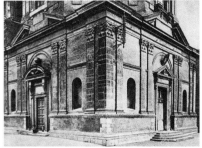

20. Plan.
The attribution of this church is still uncertain. Hypotheses range from Antonio da Sangallo the Younger or Giuliano da Sangallo to an initial intervention by Bramante followed by a project of completion carried out by an unknown architect.

The ground-floor level – probably the only section belonging to the original project – has been shown to date from the Renaissance period. This is an important demonstration of the presence in Rome of an architectonic theme diffused mostly in northern Italy.

21. Geometric scheme with main proportional relations.

22. Spatial diagram of the plane.

23. Elevation of the ground floor of the original Renaissance project.

Giovan Giacomo Battaggio,
with later additions by
Gian Galeazzo Dolcebuono,
Lazzaro Palazzi,
and from 1510,
Giovanni Antonio Amadeo,
before the final transformation during the Baroque period
Santissima Incoronata
from 1488 to after 1510
Lodi (Milan)

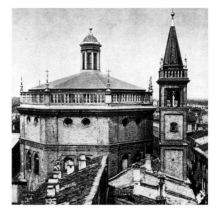

24. Plan.
This church has had a long and complex construction history. It lacks architectonic unity and compactness of articulation on account of the large number of architects involved in its construction over the years and the different styles they employed.

The basic plan of the church can be traced back to a layout composed of a vestibule – conceived as an atrium of Roman derivation – and an octagonal space surrounded by side chapels. These side chapels are all alike, trapezoidal in plan, with strongly converging side walls. This form has interesting consequences for the articulation of the overall volume of the chapels. Since the arch opening onto the central space is larger than the arch of the far wall of each chapel, the barrel vault between them is not cylindrical, but conical in section. This produces a false perspective which some critics relate to the false presbytery of Bramante's San Satiro in Milan. This particular plan introduces an innovative relationship between the central space and the side chapels: by widening the space horizontally, it balances the vertical dynamism of the dome.

Giovan Giacomo Battaggio, the architect who can be considered the principal designer of the church, was certainly inspired by the architecture of Bramante. Many of the decorative motifs used in the Incoronata can be related to the sacristy of San Satiro (figs. 5–9). For instance, following Bra-

mante's example, Battaggio articulates each corner of the church by folding a flat pilaster so that the two halves lie on adjacent sides of the octagon. This creates a continuous spatial link between all eight sides.

25. Geometric scheme with main proportional relations.

26. Spatial diagram of the plan.

27–28. Section and geometric scheme with main proportional relations.
The interior space is divided into three zones. The first is defined by the height of the folded flat Corinthian pilasters. The entablature above, running continuously around the sides of the octagon, is interrupted at each corner by a relieved dosseret – a section of the frieze which follows the shape of the pilaster below; this detail serves to maintain the vertical continuity. The entablature also sets the keypoint of the full arches at the openings of the chapels, with their splayed side walls.
The second register is defined by the height of another order of folded Corinthian pilasters, of smaller scale, and another entablature interrupted by dosserets above them. This articulation frames a sequence of double windows opening onto a gallery that runs completely around the church, above the side chapels.
The third level corresponds to the domelike covering, with the lantern, of the church.
The lower two zones of the church can be interpreted as defined by a geometric grid established by the folded flat pilasters, the entablatures, and the dosserets. This grid marks the principal lines of spatial definition and helps to provide continuity with the segments of the domed ceiling.
On the outside, the church shows a different volumetric articulation. The shape of the dome is not expressed. In fact, the church is seen as an eight-sided volume topped by a segmented, sloping roof, recessed in relation to the outer perimeter of the octagonal volume, with an open walkway, protected by a marble balustrade. This is the actual crowning element of the church volume, which sets an outer impost plane, much higher than the impost of the internal domelike covering. The overall exterior articulation belongs to the same tradition as churches such as the Portinari Chapel in Sant'Eustorgio (chap. 1, fig. 13).

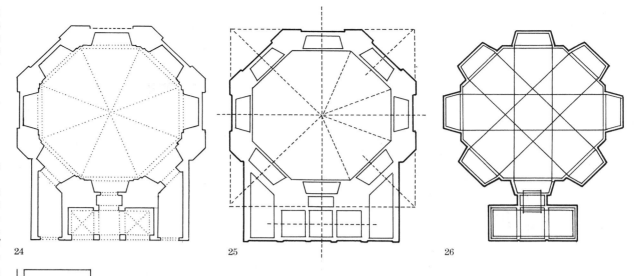

24 25 26

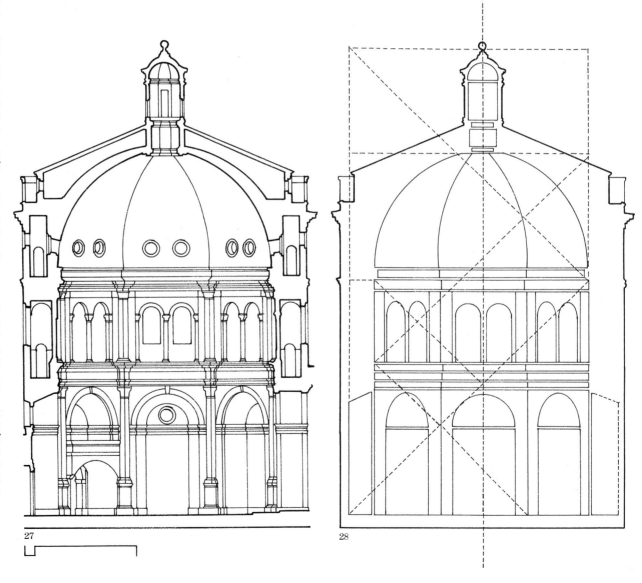

27 28

Giovanni Antonio Amadeo
(among others)
**Santa Maria Incoronata
di Canepanova**
from 1500, then from 1507 with
Amadeo, and finally completed after
1564
Pavia

29–30. Plan and geometric scheme
with main proportional relations.
This central-plan church is based on an
original octagonal space to which a
presbytery has been added, thus em-
phasizing a longitudinal axis of sym-
metry. The overall articulation of the
main space shows an interesting inno-
vation: the octagon, diagonally extend-
ed, is transformed into a square. The
four side chapels lying on the main ax-
es of symmetry are rectangular in
shape and covered by traditional bar-
rel vaults. Although the chapels on the
four remaining sides of the octagon
have diagonally placed openings, their
right-triangle shape in fact modifies
the plan of the octagonal base into a
square.
As a result, the plan is defined by the
superimposition of two different ge-
ometries: the octagon is the basic ar-
chitectonic reference, while the square
serves to extend the space diagonally,
vaguely reminiscent of a cross-shaped
central plan where the arms of the
cross are contained within the oc-
tagon.

31. Spatial diagram of the plan.

32–33. Section and geometric scheme
with main proportional relations.
As in its architectonic prototype,
Bramante's San Satiro sacristy, the
interior of the Canepanova church is
articulated in three zones. The height
of the first is defined by tall Corinthi-
an semicolumns on pedestals. This
detail introduces yet another solution
for the corner connection as com-
pared to the folded, flat pilasters of
Bramante or the paired pilasters of
Giuliano da Sangallo. The continuous
entablature is interrupted by flat
dosserets that maintain the continu-
ity of the column line throughout the
levels.

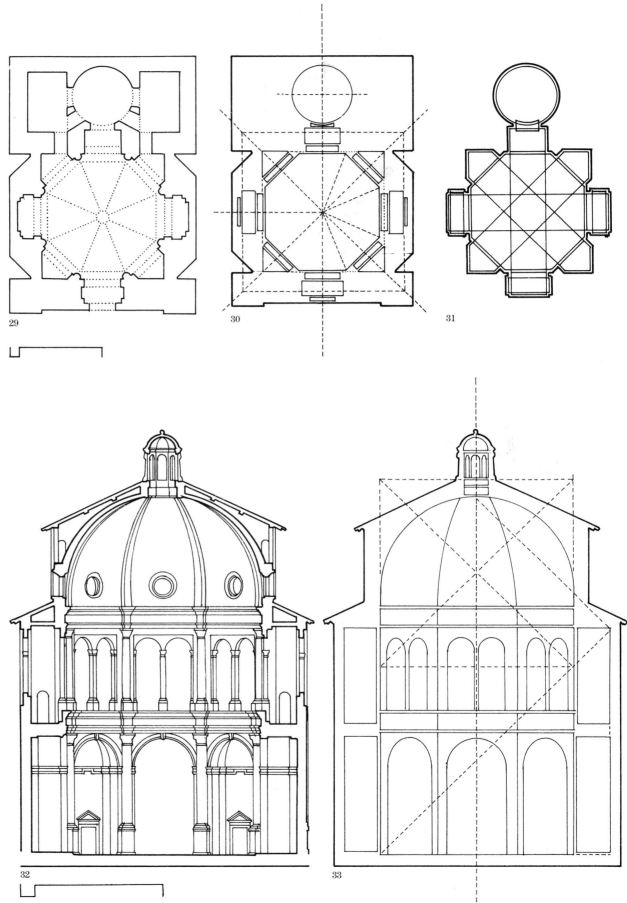

29

30

31

32

33

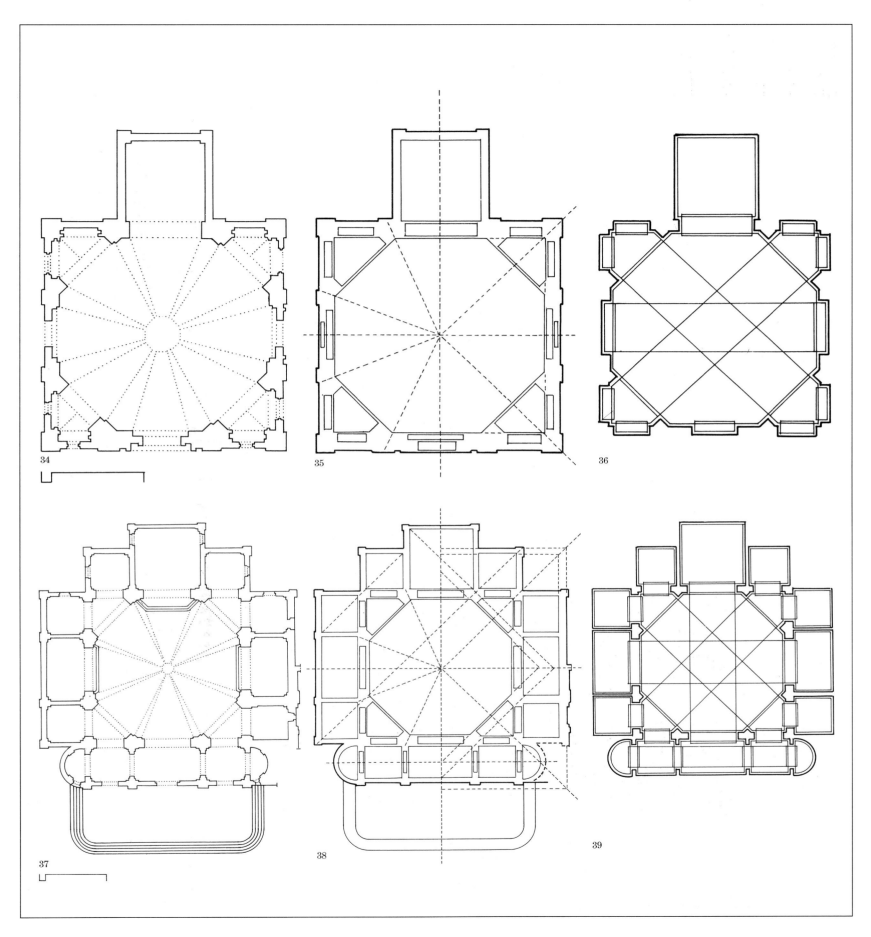

34

35

36

37

38

39

65

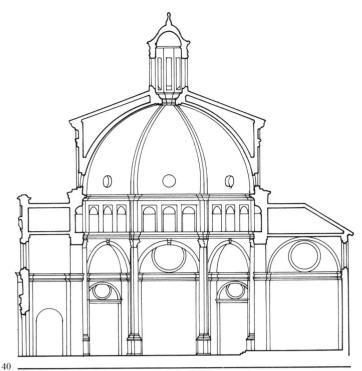

40

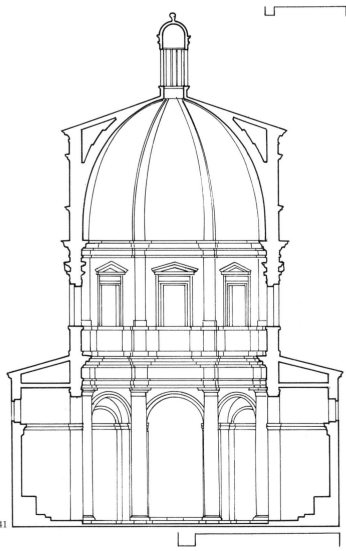

41

The second zone is defined by identical semicolumns, though of lesser height. As is typical in Lombard churches, the second level consists of a gallery. The third register corresponds to the dome and lantern. On the outside, a sloping, segmented roof covers the dome, as in examples such as Bramante's sacristy and Battaggio's Incoronata.

Tommaso Rodari
Santa Maria in Piazza
from 1517
Busto Arsizio (Varese)

34. Plan.
The outline of the plan employs a scheme similar to the one seen in churches such as Santa Maria di Canepanova: a central-plan church on an octagonal base.
As in the Pavia church, the main theme of the composition is based on a central octagon, diagonally extended and transformed into a square through the addition of four triangular corner spaces on the oblique sides of the base octagon. Each of these side spaces is linked to the central one by a pair of pendentives connected in the middle along a reinforcing edge.
The only existing secondary space is located opposite the entrance. It functions as a presbytery and has a square plan. The design idea of the space articulation is therefore based on two volumes – a major tribune and a minor altar recess – aligned along a common longitudinal axis of symmetry.

35. Geometric scheme with main proportional relations.

36. Spatial diagram of the plan.

Church of San Magno
1504–13
Legnano (Milan)

37. Plan.
The plan of this church is based on the relation between an octagon and a square, a theme developed in many of the churches of this region surrounding Milan. Here, however, the insertion of a series of side spaces alters the overall architectonic structure and changes completely the perception of the space. The atrium and the side chapels widen the space so that the octagonal base loses definition.

38. Geometric scheme with main proportional relations.

39. Spatial diagram of the plan.

40. Section.

Lower portion attributed to
Cristoforo Solari
Santa Croce
end of the 15th century
Riva San Vitale (Canton Ticino)

41. Section.

42. Plan.
The plan of this church recalls those of Santa Maria Canepanova in Pavia and Santa Maria in Piazza in Busto Arsizio. Here the plan is articulated following a similar architectonic theme, with a major difference: emphasis on the two side chapels flanking the tribune, which widens the space transversally.

43. Geometric scheme with main proportional relations.

44. Spatial diagram of the plan.

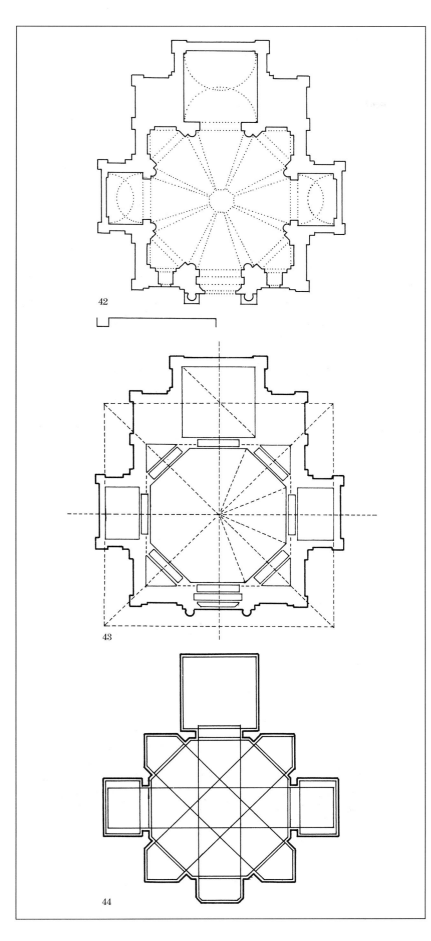

42

43

44

Ventura Vitoni,
completed by *Giorgio Vasari*
Santa Maria dell'Umiltà
from 1494, completed after 1561
Pistoia

45. Plan.

The original design of the church is by Vitoni, who, according to tradition, started his career as a humble carpenter. The completion of the church, however, is due to the later intervention of Vasari, who was involved mainly in the construction of the dome.

It is important to remember that the interpretation in northern Italy of the octagonal shape – a form that goes back to buildings of the late Roman and high medieval periods – arises from local tradition, while in Tuscany the main inspiration is Brunelleschi's dome for the cathedral of Florence. This is a key point for understanding the genesis of the basic design concept of the Pistoia church, which was the first central-plan votive church built in Tuscany.

The church represents an attempt to synthesize the traditional characteristics of a holy site – celebration and commemoration of the miraculous event that led to the church's foundation – with more experimental and innovative architectural issues. However, the church presents a number of contradictory elements that highlight a dichotomy between the architectural typology and its celebrative function.

46. Geometric scheme with main proportional relations.

The main space of the church is outlined on a central plan based on an octagon. A rectangular vestibule and a square-based apse are connected to it. As Leon Battista Alberti prescribes in his book on construction and design, *De Re Aedificatoria*, access to the holy temple is provided by a vestibule. This space is covered by a barrel vault, characterized in the middle by a small dome on pendentives. The whole vestibule is articulated by a sequence of flat Corinthian pilasters which carry an uninterrupted entablature. The central octagonal space is surrounded by rectangular side chapels. It is interesting to note the way the connection between each chapel and the main space is achieved through the use of an intermediate fascia, slightly wider than the chapel itself. The square apse – a large-scale *scarsella* – is covered with a longitudinal barrel vault. This space within the overall church plan counterbalances the vestibule and provides a focus for the ceremonial sequence of spaces. Despite this longitudinal movement, however, the hierarchy of spaces works strongly toward the center.

47. Spatial diagram of the plan.

48. Section.

In order to understand the outline of the interior space of this church, it is necessary to start with the decorative pattern of the walls of Giuliano da Sangallo's sacristy in Florence. In addition to several planimetric analogies between the two buildings – the octagonal shape and the presence of the three elements of vestibule, hall, and altar recess – there is an evident correspondence in the system of proportion and in the articulation of the wall surfaces.

In Vitoni's church, the wall intersections are once again left exposed by paired flat pilasters, so that each side is perceived as an independent plane. Entablatures run continuously along the perimeter, marking the separation between the different zones. There are four levels. The first is the greatest in height and is defined by paired flat pilasters on pedestals. The role of this zone is fundamental to the overall articulation of the church because it carries through in the vestibule and the altar area as well as in the central space, and thus constitutes the most significant link among them. The second and third registers are outlined in basically similar ways; the only real difference is the greater height of the architectonic order in the second. Both levels present double windows, framed in arched openings, on all sides. The fourth register corresponds to the dome system: the drum, dome, and lantern, commonly attributed to Vasari. The design is somewhat different from the articulation of the rest of the church; in fact, Vasari – architect to the Grand Duke Cosimo – made a point of differentiating his work from that of Vitoni. The result, however, is not very successful. The rhythm of the architectonic order in the drum does not fully harmonize with the lower elements, while the almost apple-shaped outline of the dome, according to an anonymous contemporary commentator, was reputed to be inferior to Vitoni's original design.

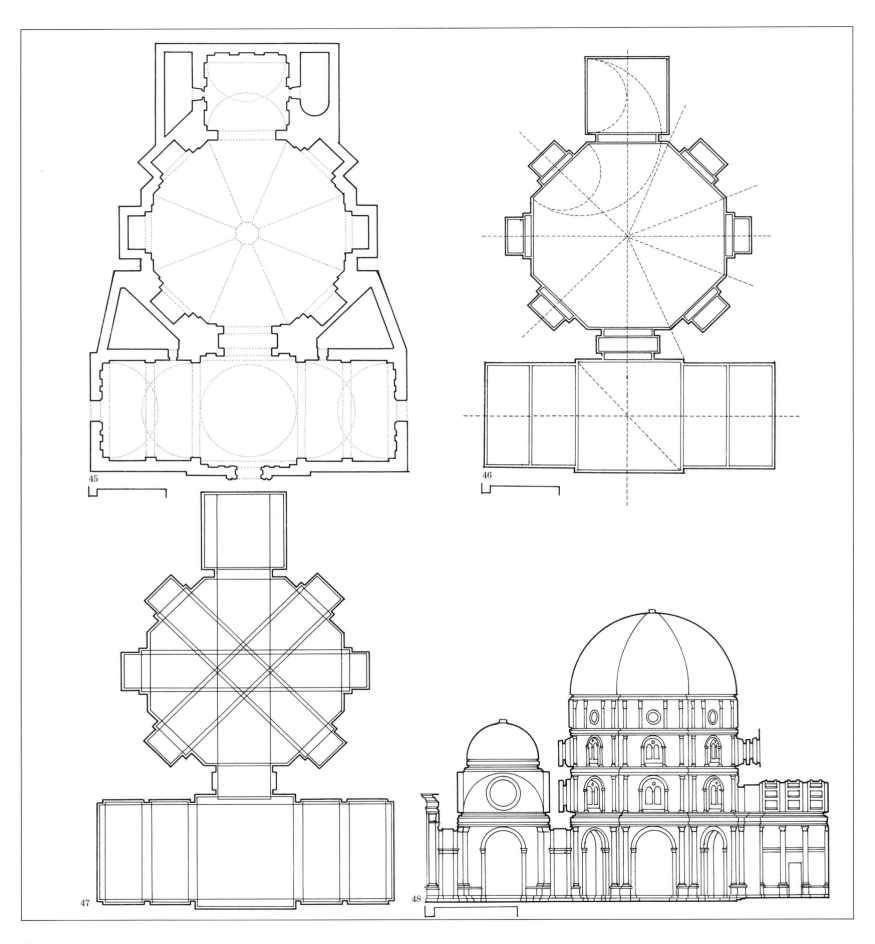

45

46

47

48

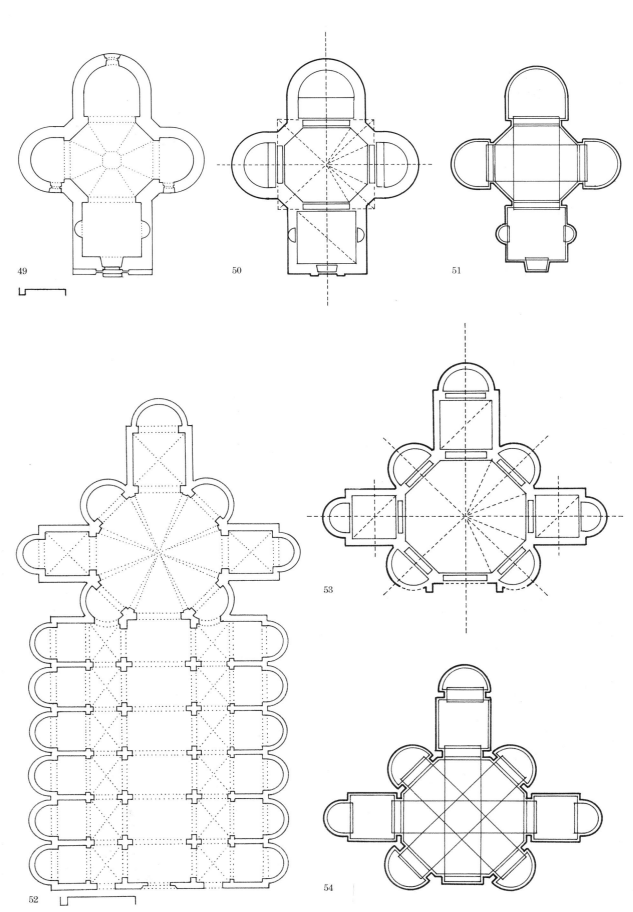

53

Attributed to
Gianni and Bartolomeo da Domodossola
Chiesa Tonda
from 1517
Spello (Perugia)

49–50–51. Plan, geometric scheme with main proportional relations, and space framework outline.

Giovanni Battaggio,
completed by *Cristoforo Lombardi,*
also known *as il Lombardino*
Tribune of Santa Maria della Passione
from 1482
Milan

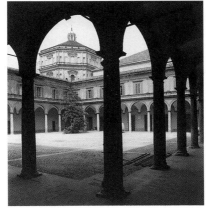

52. Plan.
In this church, Maestro Giovanni da Lodi, as Giovanni Battaggio was also known, faced a problem similar to that encountered by Bramante in his tribune for another Milanese church, Santa Maria delle Grazie (chap. 1, fig. 37): the addition of a new tribune to an existing church. Probably inspired by contemporary research on the central-plan system done by Leonardo da Vinci, Battaggio chose to design the tribune based on an octagon.

53. Geometric scheme with main proportional relations.
The plan is based on a central octagon. There are square chapels on three of the main sides; the fourth provides a connection between the space of the tribune and the central nave of the existing church. Each chapel has a semicircular apse. Four smaller, semicircular chapels are situated on the oblique sides of the octagon. Two of these provide entrances to the lateral naves of the church. The tribune is covered by an octagonal, segmented cupola which, on the exterior, has a tile roof – a traditional motif of the Lombard area.

54. Spatial diagram of the plan.

Leonardo da Vinci
**Large polygonal temple
with eight lobed apses**
ca. 1490
Paris, Institute de France (Codex
Ashburnham, 2037), 5v–B 92v.

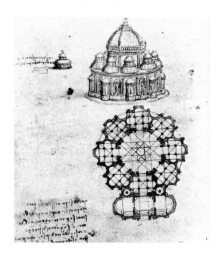

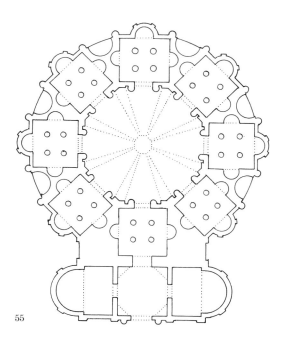

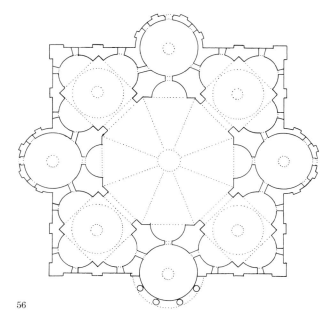

55

56

55. Plan reconstruction.
This drawing for a hypothetical central-plan church based on an octagon is characterized by two main elements: the atrium and the main body. The forceps-shaped atrium – also employed in many early Christian churches – is reminiscent of the architecture of Roman baths. The church itself is based on an octagonal tribune covered by a ribbed dome and surrounded by eight small, independent chapels, each with four central columns, three semicircular niches, and its own dome.

Leonardo da Vinci
**Central-plan temple on a
polygonal base**
ca. 1489
Paris, Institute de France (Ms.B), f. 22r.

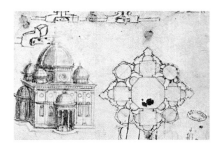

56. Plan reconstruction.
This is one of the most complex plans devised by Leonardo. Three different architectonic themes are present simultaneously: a central, octagonal tribune topped by a ribbed dome; a square-based volume in which the overall space is incorporated; and a se-

ries of independent side spaces which alternately serve as chapels and atriums.

Filippo Brunelleschi
Santa Maria degli Angeli
1434–37, then completed in the 19th century
Lantern
for the Dome of Santa Maria del Fiore (Florence Cathedral)
1436
"Tribune Morte"
of Santa Maria del Fiore
from 1438
Florence

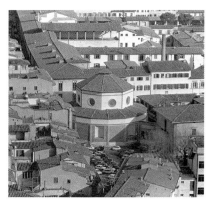

57. Plan.
Santa Maria degli Angeli, and the Lantern and "Tribune Morte" (exedrae at the east end) of Florence Cathedral are linked by a similar design conception concerning the relationship between space, structure, and definition of volumes.

These three works hold a special place in Brunelleschi's production because all three are conceived in terms of volumes rather than geometric planes.
Instead of being composed as a framework of architectonic members expressed on the wall surfaces and defining a space, they are designed as freestanding volumes.
The space is no longer perceived through the relationship between the decorative structural frame – columns, entablature, moldings – and the wall outline. Rather, it is a harmonic relationship of voids, of negative space, that now provides the articulation. The space is created by carving niches and sculpting reliefs out of the wall mass. Brunelleschi manipulates the perimeter walls so as to define the inner and outer space as a continuous whole.
This approach is evident not only in an inner space such as Santa Maria degli Angeli, where the side chapels, outlined on a square-based plan with two flanking semicircular niches, are fully contained in the wall mass, but also in the "Tribune Morte," where the semicircular niches are carved out along the outer edge of the perimeter, and in the Lantern of the cathedral, where the buttresses appear to be shaped as if they were cut out of a single block.
This manipulating process, which can be related to Brunelleschi's study and observation of the character of Roman architecture, is not carried to the limit – as will happen, for example, in Bramante's project for St. Peter's – but it is sufficient to radically redefine the

terms of Brunelleschi's architectonic conception.

58. Geometric scheme with main proportional relations.

59. Spatial diagram of the plan.

60. Plan of Santa Maria degli Angeli with the insertion of the Lantern plan at two different levels (center) and of the "Tribune Morte" (upper left).
In 1439, construction began on four minor tribunes, the "Tribune Morte," located below the impost level of the drum, on the oblique sides of the dome's octagonal base. They rest on a plane used for the storage of materials during the construction of the dome, and, by filling a void in the volumetric articulation of the cathedral, serve two different purposes.
First, they have a structural function: to provide additional buttressing for the four sides of the octagon not counterbalanced by the main arms of the church.
Second, they have an important visual role. They help to establish a more harmonic transition between the volume of the dome and the church's perimeter at ground level.
By the insertion of the "Tribune Morte," Brunelleschi obtained a more balanced articulation of the whole apse area; without them the volumes of the apses would be isolated and out of scale with respect to the enormous mass of the tribune.
The "Tribune Morte" reinforce and structure the articulation of the base, emphasizing the soaring volume of the great dome above.

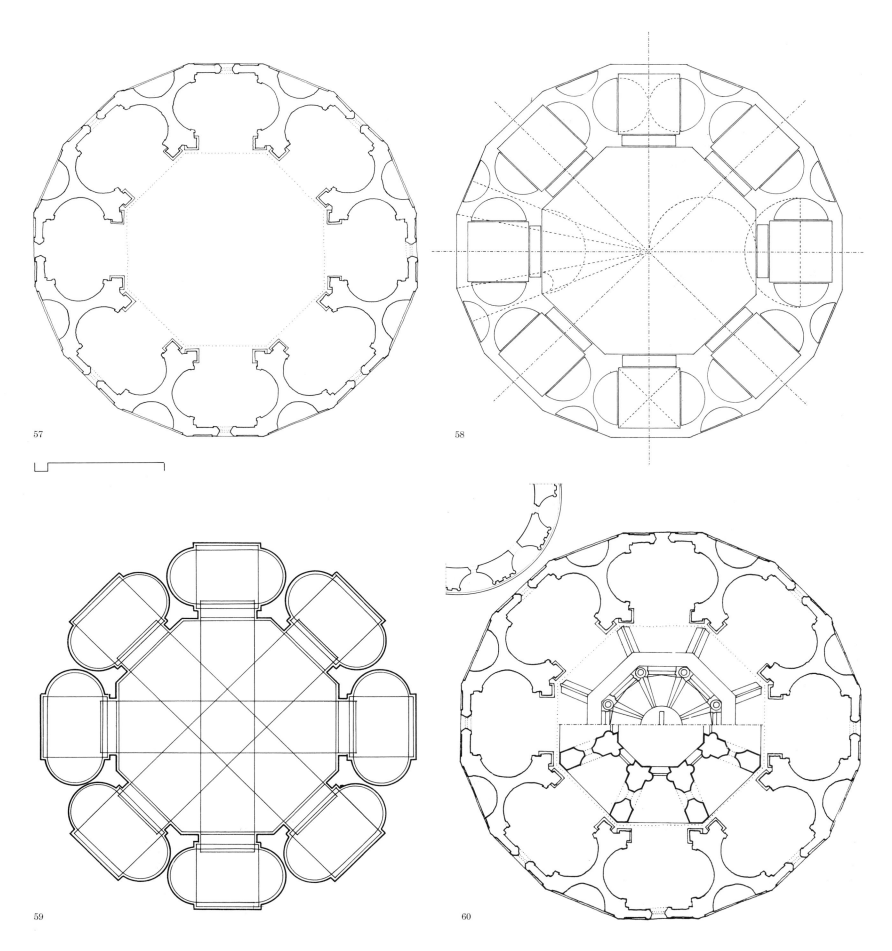

57

58

59

60

Raphael Sanzio
Chigi Chapel
from 1513
Rome, Santa Maria del Popolo

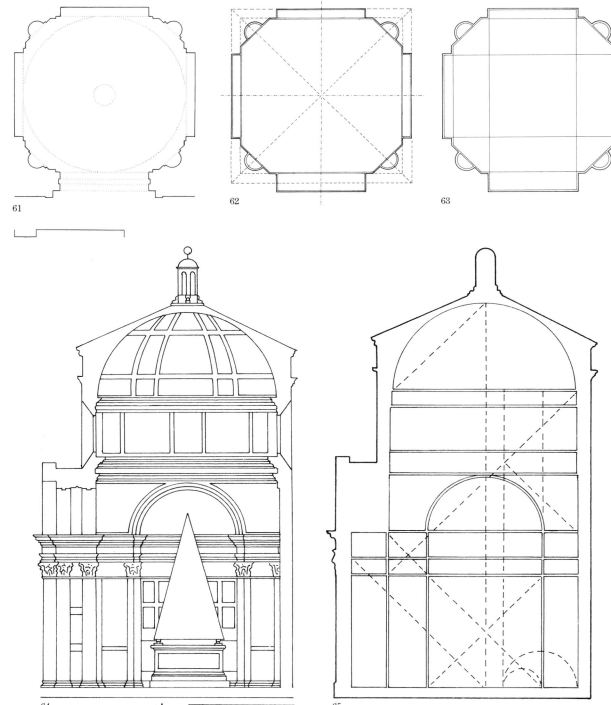

61

62

63

64

65

61. Plan.*

Although this funerary chapel forms a part of the church of Santa Maria del Popolo, it is defined as an independent volume: very simple and severe on the outside, but internally complex and richly detailed.

Raphael's task was to design a mausoleum for Agostino Chigi, one of the wealthiest men of his time, who wished the decoration of his chapel to be as sumptuous as possible. Therefore Raphael was in a position to use the richest materials available, fulfilling his intention of matching the magnificence of the ancient Roman monuments.

The plan of the chapel is based on an octagon; however, the greater length of the orthogonal sides compared to the oblique ones makes the plan appear as a square with cut-off corners.

Four arches frame the longer sides, defining a series of rectangular recesses, while semicircular niches are located in each of the minor sides.

The arch toward the nave of the church is deeper than the other three and provides an element of transition between the two spaces.

The opposite side accommodates the altar, with a painting by Sebastiano del Piombo above, while the right and left sides are characterized by a pair of pyramid-shaped funerary monuments. The pyramids are in polychrome marble, as are most of the wall surfaces.

Other wall sectors are in mosaic with a light blue background, while the architectonic order – folded flat Corinthian pilasters – and the moldings are in white marble.

62. Geometric scheme with main proportional relations.

63. Spatial diagram of the plan..

64–65. Section* and geometric scheme with main proportional relations.

The inner space of the chapel is characterized by a lower level defined by a continuous fascia, mainly in white marble, made up of the entablature above the pilasters and an additional band corresponding to the height of their capitals. From this point upwards, the drum and dome rest on four pendentives rising from the oblique sides.

In the opinion of Ray, this articulation outlines a process of superimposition of elemental geometric volumes: the cube of the lower section, the cylinder of the drum, and the hemispherical dome symbolize the harmonic cosmic order – a clear cultural heritage of the humanistic period of the fifteenth century.

However, the system of wall articulation, pendentives, and dome are clearly linked to the experience of Bramante in St. Peter's.

On a lesser scale, and with elegant variation, Raphael employs in his chapel the same articulation as that of the four giant piers which define the central space of that great church.

** Scale 1 : 5 meters.*

Michele Sanmicheli
Church of the Madonna di Campagna
from 1559
Verona

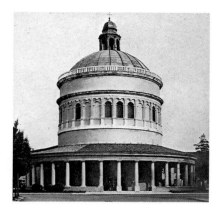

66. Plan.
If the starting point of Sanmicheli's work is the Cappella Pellegrini in San Bernardino, the Church of the Madonna di Campagna is considered his major achievement.
This church presents a series of contrasting elements. It is a central-plan building, circular on the exterior and octagonal on the interior (in the tribune). The major tribune is characterized by a sequence of arches that form, in the thickness of the wall, a rectangular recess on each side of the octagonal base. Four of these recesses accommodate altars, three provide entrances from the peristyle, and one gives access to the presbytery area.
The presbytery has a different articulation, one based on a Greek cross. A small central dome rests on a square tribune with cut-off angles; it is flanked by two arms with semicircular apses, and a rectangular space occupies the far end.
Although this example of a central-plan church can be ascribed to the tradition of sixteenth-century architecture deriving from the Pantheon, when compared with the work of Bramante and his followers in Rome it reveals less absolute principles and at the same time a more contradictory conception.
The lack of formal balance–in a strict, canonical sense – between the fundamental components of the church expresses an attempt to achieve contrasting effects through the juxtaposition of elements of different origin. An example is the unusually high external elevation of the drum, which assumes an imposing presence in relation both to the portico below and to the dome above.

67. Geometric scheme with main proportional relations.

68–69–70. Facade elevation, section, and geometric scheme of the elevation with main proportional relations.
The main space is covered by an octagonal dome which assumes, as it rises toward the lantern, a more rounded shape, so that by increasing the height of the drum on the exterior the dome can be expressed externally as a spherical volume.
This volume tops a cylindrical shape which, like a three-tiered drum, connects the dome to the continuous, lower, Doric peristyle surrounding the church.

71. Spatial diagram of the plan.

Giovanni Battaggio,
Giovanni Antonio Montanara,
and others
Santa Maria della Croce
from 1490
Crema (Cremona)

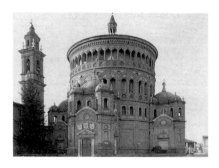

72–73. Section and plan.
The very elegant outline of this plan is based on three different elements: an octagonal central tribune, covered by a ribbed dome; a cylindrical volume with a sloping tiled roof, containing the tribune and the dome; and finally, four side chapels in the shape of a Greek cross, located on the main axes of symmetry, which produce an overall effect of a larger cross.
The three-dimensional configuration of the side chapels – volumes of significantly smaller scale than the tribune – emphasizes the central volume.
On the exterior, this effect is enhanced by the crowning gallery, which increases the height of the drum.

74. Geometric scheme with main proportional relations.

75. Spatial diagram of the plan.

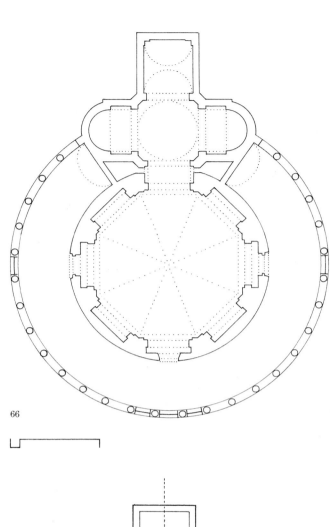

66

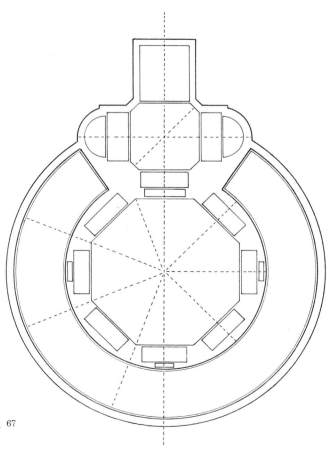

67

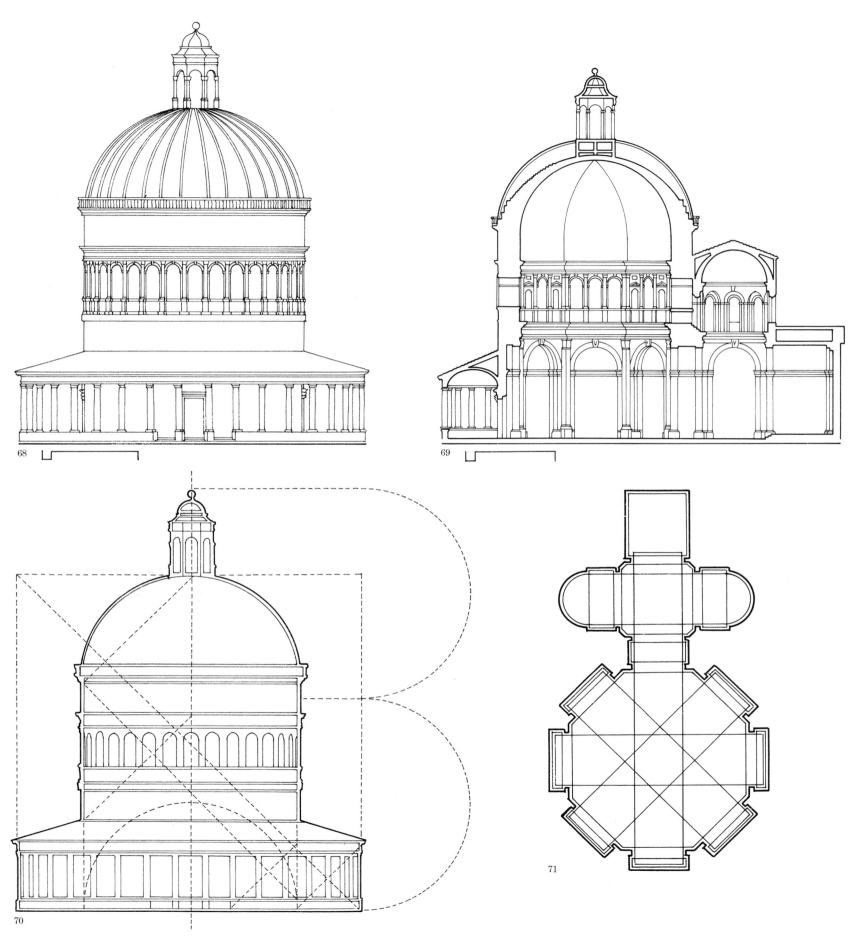

68

69

70

71

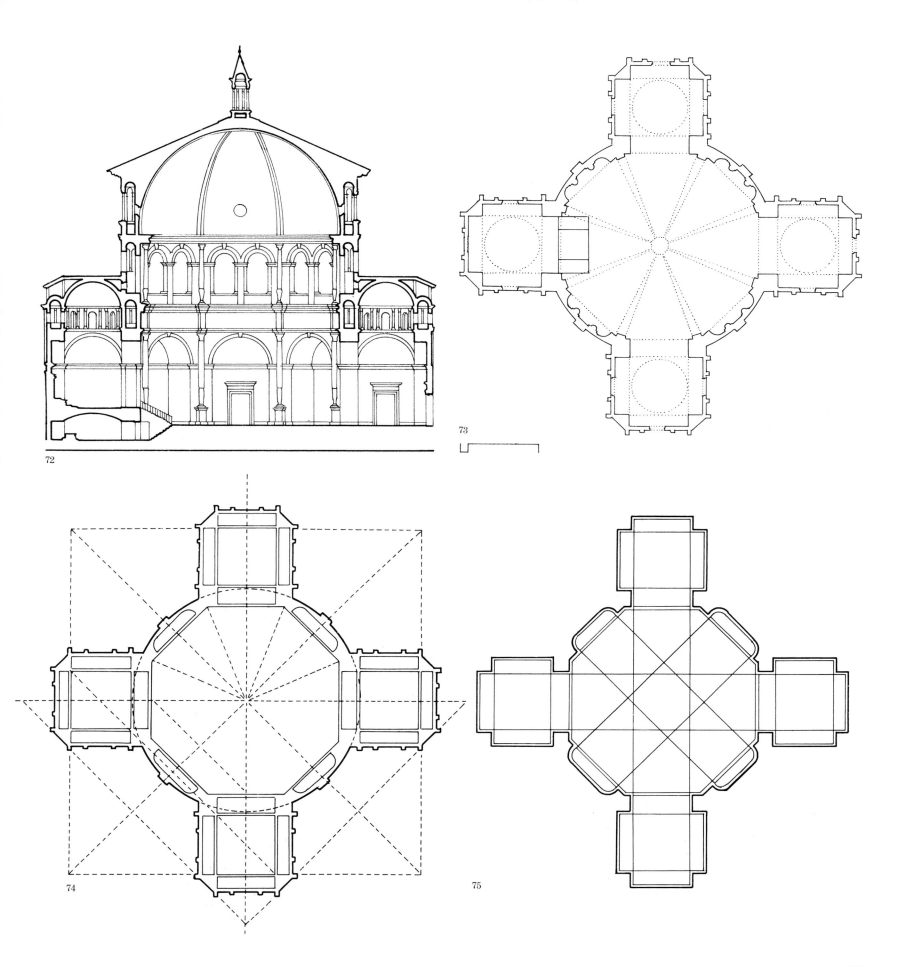

72

73

74

75

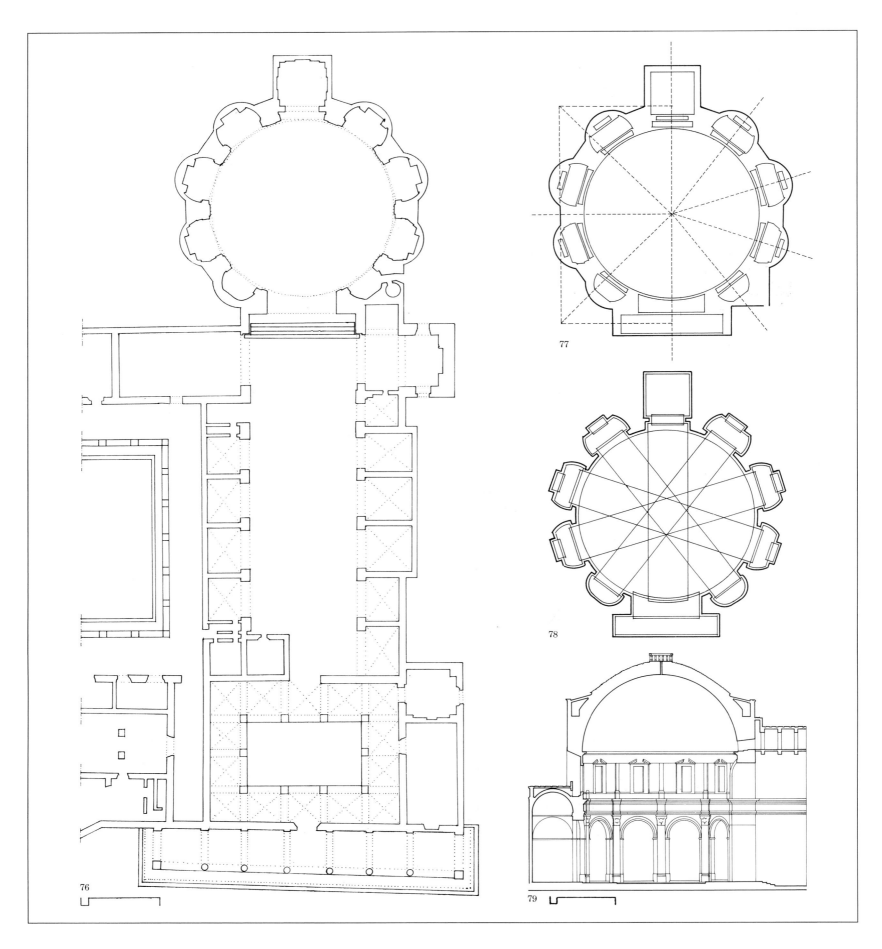

76

77

78

79

76

Michelozzo di Bartolomeo,
Antonio Manetti, and later,
Leon Battista Alberti
Rotunda of the Annunziata
from 1444, completed after 1469
Florence

Donato Bramante
Sacristy of the Cathedral
from 1488
Pavia

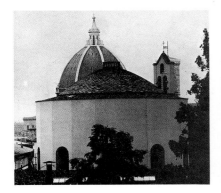

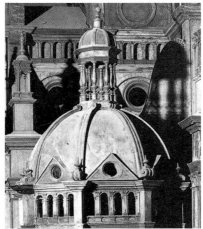

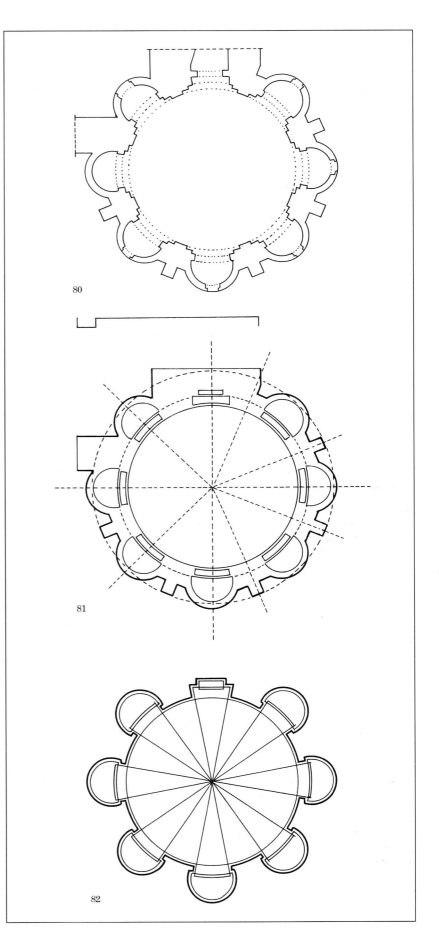

76. Plan of Santa Maria dell'Annunziata.

The Rotunda is situated at the far end of the Annunziata; today it functions as a presbytery, although it was originally conceived as a tribune for the existing church. The original project was probably developed by Michelozzo, but it was a later project by Manetti that was actually used to start construction. In fact, Alberti was obliged to adapt his design to the previous one, in order to make use of the existing foundations. From the beginning, Alberti's decision to design the tribune as a central-plan space based on a circle was questioned both by the citizens of Florence and by the priests attached to the church.

The tribune is designed on a circular plan; it is surrounded by nine side chapels. Each chapel has a semicircular shape, except for the one opposite the arch leading from the main nave of the church, which has a square outline. The tribune is covered with a hemispherical dome built with the same concrete construction technique employed in many ancient Roman buildings.

Although Vasari openly acknowledged the beauty and the difficulties implicit in Alberti's design, he also found a contradiction in the conflict between the circular articulation of the tribune and the rectilinear configuration of the arches linking the central space to the side chapels. Vasari remarks that this detail was particularly evident when viewing the chapels obliquely.

77. Geometric scheme of the Rotunda with main proportional relations.

78. Spatial diagram of the plan.

79. Section of the Rotunda.

80. Plan.

The sacristy shows Bramante's interest in the circular outline. The type of composition was considered a delicate and controversial architectural theme which through the years attracted the attention of architects such as Brunelleschi, in his Rotunda degli Angeli, and Michelozzo and Alberti in the Tribune for the Annunziata.

81. Geometric scheme with main proportional relations.

The plan of the sacristy is articulated by a central, circular tribune, covered by a hemispherical dome and surrounded by eight side spaces–seven semicircular niches plus the entrance passage from the cathedral. In this building Bramante finds another occasion to widen his experience in designing central-plan churches, by challenging the potentiality of the circular geometry.

82. Spatial diagram of the plan.

80

81

82

Donato Bramante
Tempietto of San Pietro in Montorio
from 1508
Rome

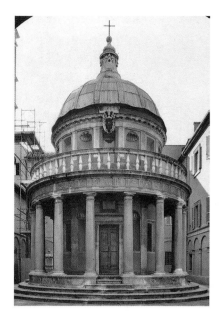

83. Plan.

Pope Julius II's decision to build the Tempietto did not satisfy any practical or functional need; rather it arose from a desire to celebrate the figure of Peter as the first *Pontifex Maximus*. It was Peter who established Rome as the center of Christianity, perpetuating the universal value of the imperial city as *caput mundi*.

The underlying program of the Tempietto was to reconcile, in a new synthesis, Christian and humanistic ideals through the architectural expression of their inherent universal values. According to Arnaldo Bruschi, the significance of Bramante's design, and the solution he proposed, can be correctly understood and interpreted only in the light of this programmatic assumption. The Tempietto is located in the cloister of the church of San Pietro in Montorio, on the site where, according to tradition, St. Peter was martyred. Bramante based his design on three main elements, only one of which, the Tempietto itself, was actually built. The other two elements – an open, circular ambulatory around the Tempietto, and a new, peripheral portico in lieu of the existing rectangular cloister–were never executed. In Bruschi's reconstruction of the original project, it is evident that Bramante's intention was to create a sequence of concentric spaces, moving from the inner, circular space of the Tempietto to the portico, through a peristyle and an open courtyard ringing the Tempietto. As John

Summerson points out, the Tempietto might at first glance be interpreted as Bramante's reconstruction of a typical Roman circular temple. A possible model for it could be the circular Corinthian temple known as the Temple of Vesta, which still stands beside the Tiber. Although the crowning elements of this temple have been replaced by a tile roof, the basic theme of Bramante's project can nevertheless be seen in its cylindrical, walled *cella*, surrounded by a colonnade. Bramante, however, uses the Doric order in the Tempietto and articulates its *cella* differently. Not only is the cylindrical, walled space much higher than the colonnade, and covered by a dome with lantern, but there are three innovative elements in the colonnade as well: first, the colonnade is raised on a circular base of three steps; second, the columns are placed on a continuous plinth; third, a balustrade is added on top of the entablature.

The interaction of these details produces a sense of vertical dynamism in the *cella* and an overall perception of architectural lightness, which aptly expresses the holiness of the site and satisfies the celebratory intention of Bramante's project as commissioned by Julius II. The presence of these innovative details clearly demonstrates that the Tempietto is actually Bramante's original invention, rather than a faithful copy of some ancient Roman model. It was an invention that had great success and was widely imitated throughout Europe on the basis of the project's reproduction, published – albeit with a number of imperfections–by Sebastiano Serlio in his *Trattato di Architettura*.

The Tempietto was also published, in a more accurate form, by Andrea Palladio in his *Quattro Libri dell'Architettura*. In his commentary, Palladio remarks how, before the Renaissance and on account of the decline of the Roman empire and subsequent barbarian invasions, architecture, like the other arts and sciences, had lost its primitive beauty to such a degree that the habit of building according to harmonic proportions had been completely forgotten. As a reaction to this disrupting process, Palladio underscores how those whom he acknowledges as his "fathers and ancestors" were able to shed a new light on principles that had been in shadow for too long. In his opinion, Bramante is the first architect capable of matching the beauty of the architecture of the ancients; in fact, he purposely classifies Bramante's Tempietto among Roman buildings–the sole contemporary building to be included in the collection of ancient examples

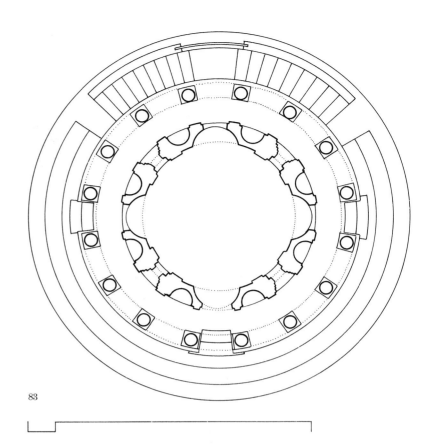

83

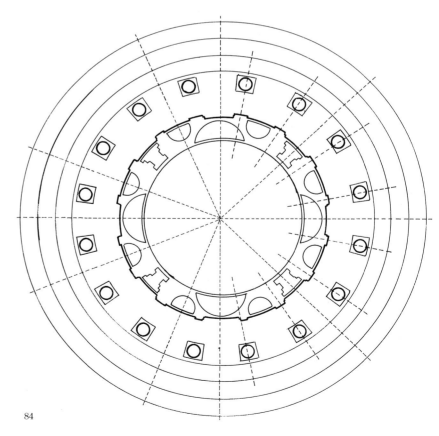

84

85

86

given in his Fourth Book – considering it to be a true continuation of the ancient tradition, rather than simply a contemporary re-elaboration of classical themes.

So full of significance and symbolism as to present almost pagan characteristics, the elements of the Tempietto show great ability in the manipulation of the stylistic themes of classical architecture.

It is important to remember that, as Geoffrey Scott points out, for the first time during the Renaissance the question is raised as to whether or not a form is "correct." It is no longer important for a form to be either beautiful or appropriate; what matters now is whether it represents a harmonic and coherent interpretation of the architecture of the past. Herein lies Bramante's skill, which reveals a broad ability to handle the whole classical repertory of forms. The selection of the typology of the *martyrium* – an early Christian votive chapel, usually

of small dimensions – to recall Peter's sacrifice, the overall spatial configuration, and the precise definition of the details, all demonstrate a highly educated, classical taste.

On the other hand, the typology of the Tempietto, its limited dimensions, the reduced, relatively unimportant inner space, and its lack of functionality, somehow place this building in an experimental area far from the focus of the volumetric configuration typical of the Renaissance central-plan tradition. In the opinion of Franco Borsi, the Tempietto–a symbolic object rather than an architectonic space–should be considered the conclusion of the purest Renaissance research for centrality; however, at the same time, it is an essentially unique episode in the development of central-plan design.

84. Geometric scheme with main proportional relations.
The relationship between the *cella* and the surrounding colonnade is the occa-

sion for a very elegant solution. The colonnade is conceived as a succession of masses and voids – of columns and intervening spaces, or intercolumniations. This articulation is mirrored on the exterior wall of the *cella*: a flat pilaster corresponds to each column, while the intercolumniation is reflected in a sequence of alternating doors, niches, and windows. Inside, four semicircular niches are placed along the two main orthogonal axes of symmetry. The windows between them are aligned on two axes at forty-five degrees to the main axes. Two pilasters frame each window, in correspondence to those on the exterior.

85–86. Section and elevation.

87–88. Geometric scheme of the section with main proportional relations and proportional scheme of elevation.
The overall volumetric outline of the Tempietto is based on a very simple relationship: the colonnade with its

mass defines a rectangle which serves as a base to proportion the body of the *cella*. The volume is the result of a harmonic pattern wherein the width of the portico corresponds to the height of the *cella* up to the impost of the dome, and the portico's height corresponds to the *cella*'s width.

79

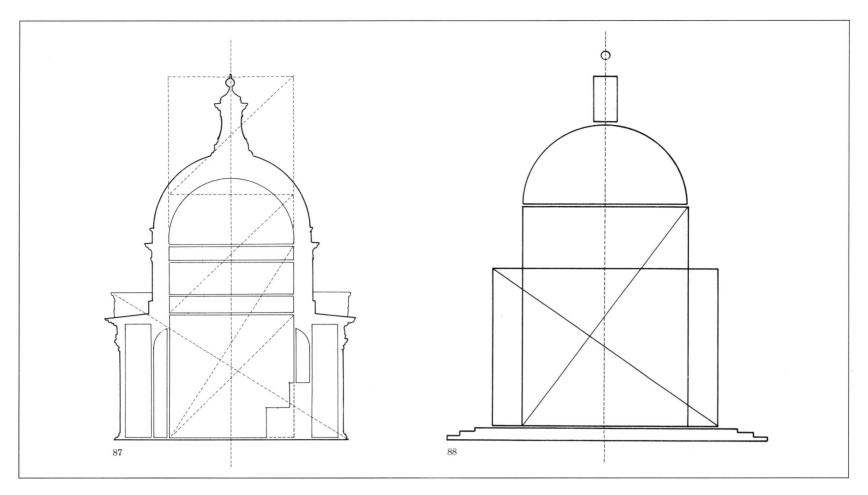

87 88

Michele Sanmicheli
Pellegrini chapel
1527–38
Verona, San Bernardino

89. Plan.
When he designed this chapel, Michele Sanmicheli was known mainly for his military architecture. However, as Vasari remarks, he also began to be appreciated in the city of Verona

as an architect of palaces, such as Palazzo Canossa, and churches, such as the Madonna di Campagna (figs. 66–71). The Pellegrini Chapel is part of the Church of San Bernardino and was commissioned by the Guareschi family.

For its design, Sanmicheli chose a circular plan and the Corinthian order to articulate the wall surfaces; taken together, these constitute a clear reference to the round temple of the classical world.

The architecture of the Pellegrini chapel recalls, in a highly refined way, the atmosphere of the late Roman period. The inner space is characterized by beautiful details in white stone which, according to Vasari, make this chapel a unique building in the panorama of Renaissance architecture. The uniqueness of the chapel lies not only in the details of the decoration, but also in the way it is organized. The architectonic order structures the wall surfaces without any concern for spatial or perspective relationships among the elements. In this sense it represents a departure from the typical compositional processes encountered in Florence and Rome.

The alternating rhythm of openings of different scale and detailing intentionally increases the overall complexity of the architectonic composition, while details such as the spiral fluting on the columns, the festoons hanging below the entablature, and the finely carved grotesques and balustrades seem, in the words of Zevi, to emphasize the play of light and shadow throughout the interior.

90. Geometric scheme with main proportional relations.
The Pellegrini funerary chapel is connected to the presbytery of the church through a small vestibule. This location may partially explain Sanmicheli's decision to build the chapel on a circular central plan, because, as Lotz notes, it is a condition similar to the imperial mausoleum annexed to the original Constantinian basilica of St. Peter.

The vestibule serves only as a transitional space; the chapel proper is intended to be radially symmetrical. Four niches are placed on the two main orthogonal axes of symmetry. They are trapezoidal in plan: the sides converge toward the center of the chapel, while the back wall is curved.

Four semicircular aedicolae are situated between the niches, on axes at forty-five degrees to the main axes. Unlike Palladio's later Tempietto in Maser (figs. 94–97), Sanmicheli here follows the example of the Pantheon, situating niches and aedicolae in the thickness of the wall.

He can thus define the overall volume of the chapel as a perfect cylinder on the exterior–an effect which he further emphasizes by increasing the exterior height of the drum to nearly match the height of the dome and by covering it with a sloping roof.

91. Spatial diagram of the plan.

92–93. Section and geometric scheme of the section with main proportional relations.
The inner space is articulated in three registers. As is traditional, the uppermost corresponds to the dome and lantern, with its impost plan clearly defined by a continuous entablature. The other two zones, however, are less sharply defined. In fact, they are connected through an intermediate fascia consisting of elements belonging to both levels, separated by the balustrade of an open balcony.

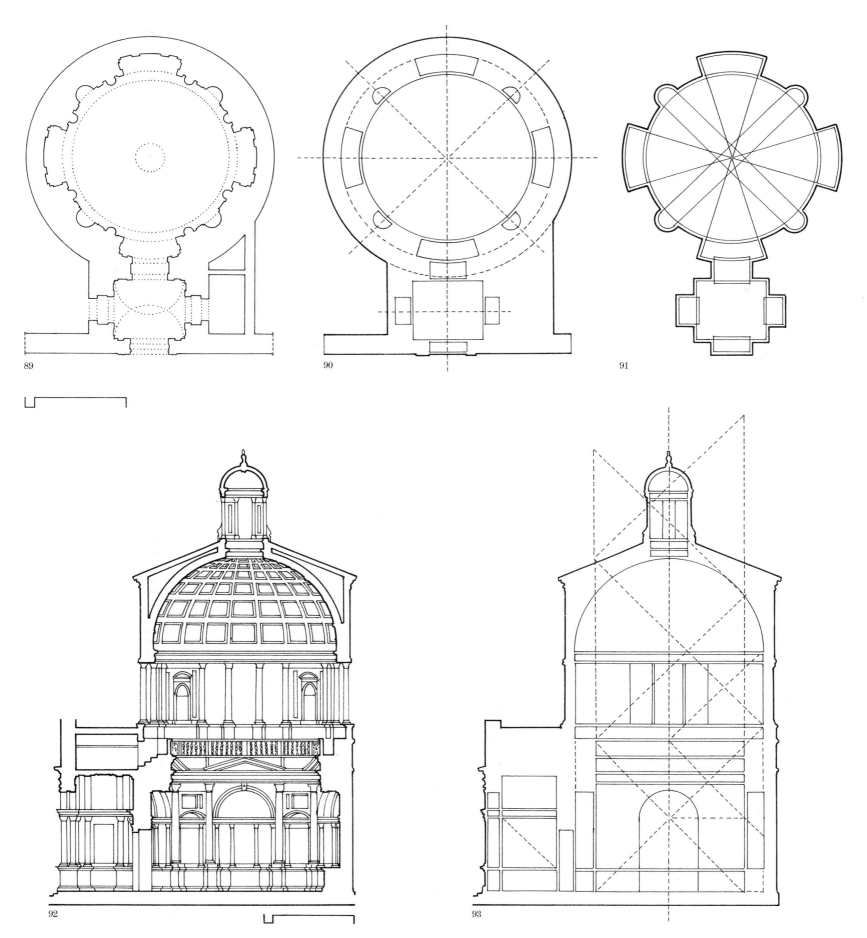

89

90

91

92

93

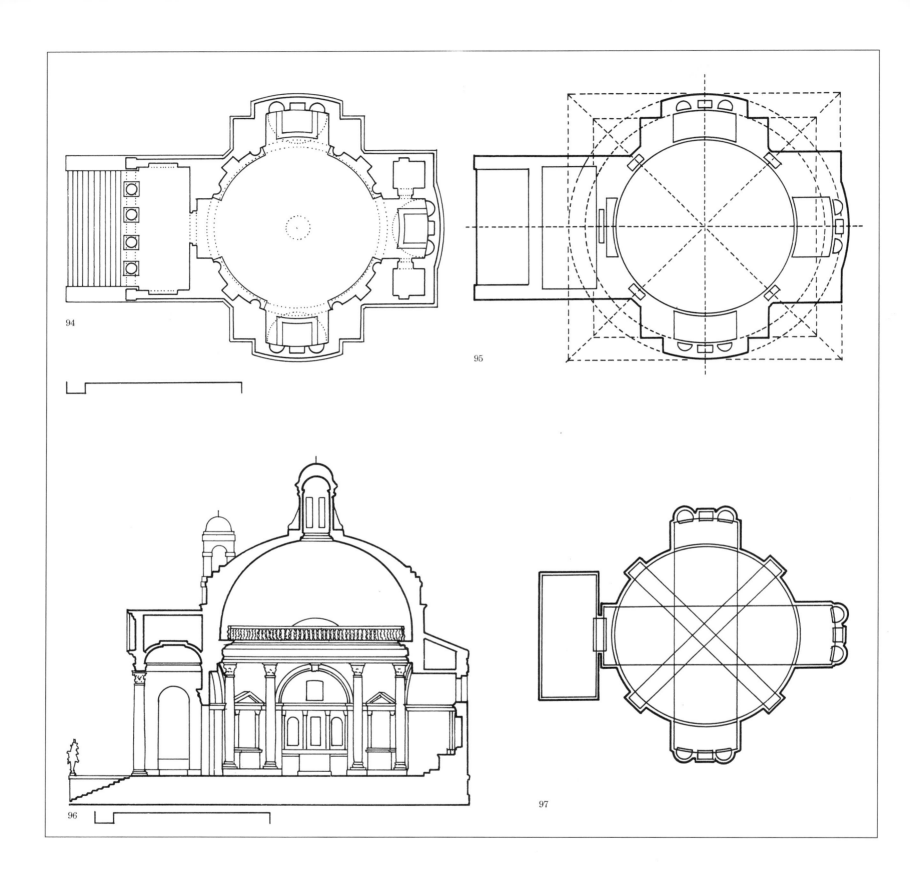

94

95

96

97

Andrea Palladio
Tempietto
1580
Maser (Treviso)

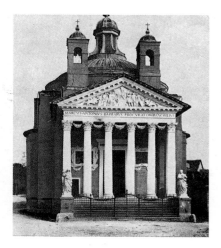

94. Plan.
The Tempietto of Maser is built in strict accordance with the humanistic cultural program of its owner, Marcantonio Barbaro, and his family–the same spirit that inspired the construction, only a few decades earlier, of their villa in the same locality. The architecture of the Tempietto can be interpreted not only as a religious expression, but also as a means of monumentally celebrating the temporal power and glory of its owner. Palladio treats the temple ambivalently–both as a religious building and a secular monument; in a sense, he inverts the design process of his Villa Rotonda, where a domestic structure is elevated by the presence of a religious symbol, the dome.
The obligatory reference for the design of the Tempietto is the Pantheon, both for its overall articulation and for the treatment of its inner wall surfaces. Like its Roman prototype, the facade of Palladio's building is characterized by the presence of a *pronaos,* a solution completely different from that adopted, for example, by Bramante for San Pietro in Montorio. There the exterior colonnade reinforces the centrality of the building; here the pronaos helps to emphasize a longitudinal axis of symmetry.

95. Geometric scheme with main proportional relations.
The central, circular space of the tribune is characterized by the presence of three identical chapels—one on the longitudinal axis and two on the transverse axis. The chapel opposite the entrance functions as an apse containing the main altar, which reinforces the role of the longitudinal axis as a cele-

brative one through the sequence of pronaos-entrance-tribune-presbytery. The other two chapels, containing minor altars, flank the central space. Unlike the articulation of the Pantheon, these chapels are all expressed volumetrically on the exterior. Because they are expressed as rectangular volumes, the plan can be interpreted as deriving from the superimposition of a circular scheme and a Greek cross. Thus, it is the front elevation that synthesizes the whole image of the building. Palladio, in fact, leaves unresolved the relationship between the external volumes of the chapels and the major volume of the tribune, so that the only harmonic perception of the Tempietto's architecture is along the longitudinal axis.

96. Section.

97. Spatial diagram of the plan.

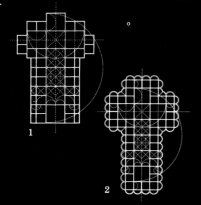

1

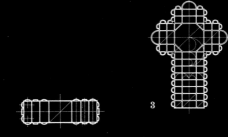

2

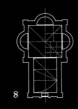

4

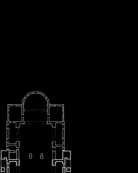

3

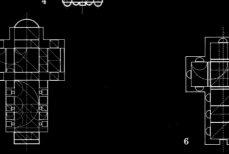

5

6

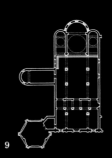

7

8

9

11

**Longitudinal churches
Chronological table**

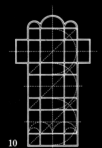

10

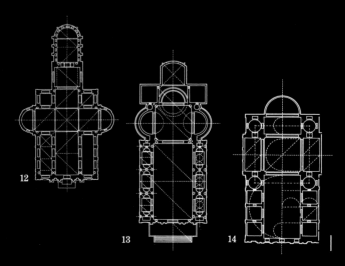

12

13 14

Regarding scale:

Unless otherwise indicated, the scales for drawings in this book are

0 1 10m

Scales are not provided if drawings are based on sources such as sketches, models or reconstructions of original designs.

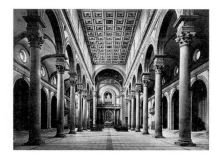

Filippo Brunelleschi
Basilica of San Lorenzo
from 1419
Florence

1. Plan.

The construction of the new basilica of San Lorenzo began in 1419, although the planning phase had begun many years earlier. It is a fundamental event in the history of the urban development of the portion of the San Giovanni quarter known at the time as the "Gonfalone" of the Golden Lion; the fact that today the area is more commonly referred to as the San Lorenzo quarter testifies to the great importance of this magnificent building in this part of the city. The construction of this fifteenth-century church can be seen as the focal point of a broad, massive urban transformation, whose other element of importance is the construction of the Medici family's monumental palace–a building used not only for residential purposes, but also as a center for the family's banking affairs. Both the church and the nearby palace constitute the driving elements for the renewal of the whole quarter.

This process began with the demolition of a number of small medieval houses to make room for the huge mass of the church, which was not completed, however, until several decades later. The great scale of the church and the opening of a new square in front of it served, in the name of the beautification of the city, to keep the population at a distance. By thus thinning out the density of the area, the Medici at the same time made the quarter more secure and removed elements of "indecency" from the neighborhood. The overall transformation gave rise to a true urban planning project, based on the gutting of the medieval urban fabric–a process which was not common in fifteenth-century Florence, but which can be related in scale and intensity to what would happen a century later for the construction of the Uffizi.

The two elements of church and palace–built outside what was considered to be the original center of the

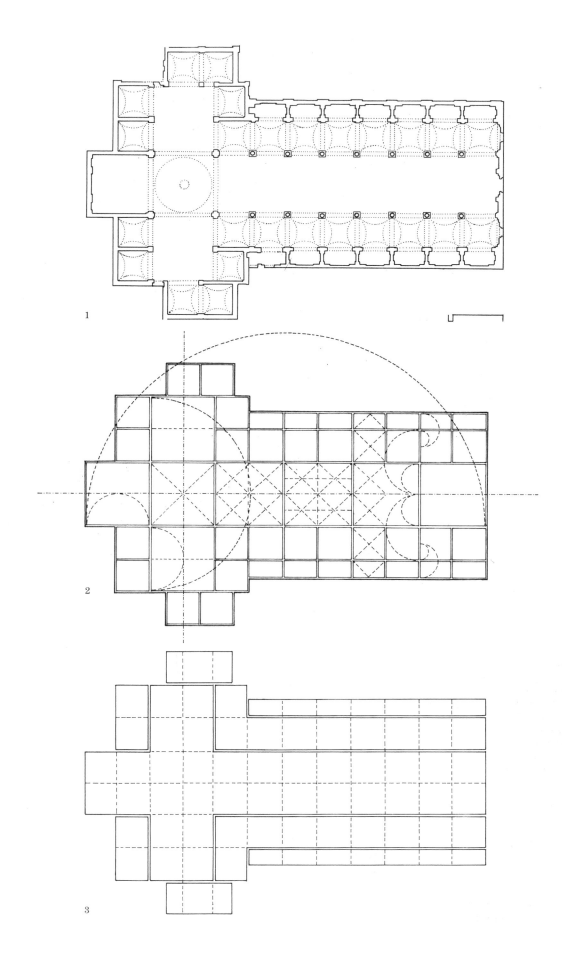

1

2

3

city – represent, from this moment on, the pole of Medici power, not only symbolically but also as an independent organizational center for civic and religious activities.

Brunelleschi's involvement in the construction of the church began with his project for the Old Sacristy, for Giovanni di Bicci de' Medici, and continued with his appointment by Giovanni to readapt the design of the body of the church as built thus far.

2. Geometric scheme with main proportional relations.

3. Proportional grid outline with the three main elements that constitute the plan: the central Latin cross, the aisles, the rectangular side chapels.

Brunelleschi submitted several possible solutions to his patron. The discussion centered on two main schemes: the first was an articulation based on a single great nave surrounded by side chapels, which can still be seen in the transept area today despite many successive alterations; the second comprised a nave and two aisles to serve the side chapels, which corresponds to the nave area of the present church.

The difficulties in choosing between these two outlines were not only of an economic order, but were also related to the social and political atmosphere of the time. In fact, the side chapels would be owned by the noble families of Florence; to avoid rivalry, they would have to be as similar as possible, and at the same time they should not interfere with the principal activities of the church. Thus, at a certain point, Brunelleschi was constrained to build the church on a Latin-cross scheme and "full of chapels"; he selected the nave-and-aisles plan, although he considered such an outline "a poor thing, too banal."

It is uncertain whether the church was completed under Brunelleschi's direct supervision; what is known is that during 1442–45, with the intervention of Cosimo de' Medici, the rows of square side chapels were finally added. Cosimo's financial intervention was essential for the completion of the church; he was also responsible for the beginning of work on the palace.

4. Longitudinal section.

5. Geometric scheme of the longitudinal section with main proportional relations.

6. Transverse section.

7. Geometric scheme of the transversal section with main proportional relations.

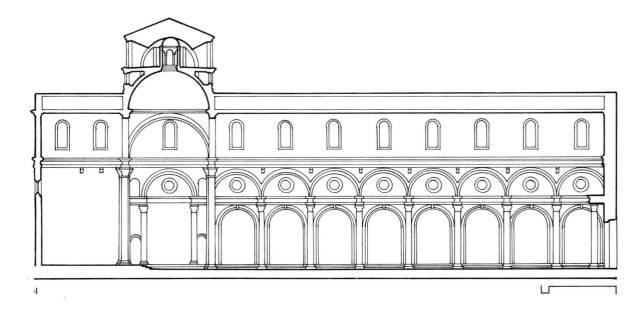

4

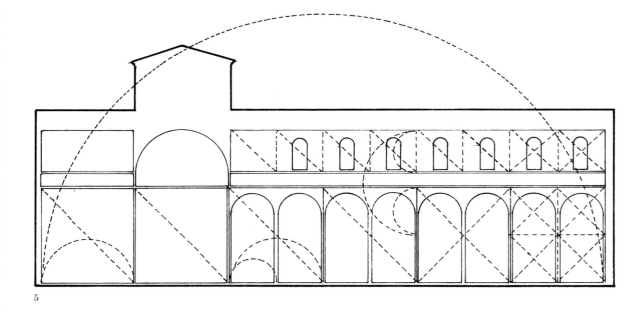

5

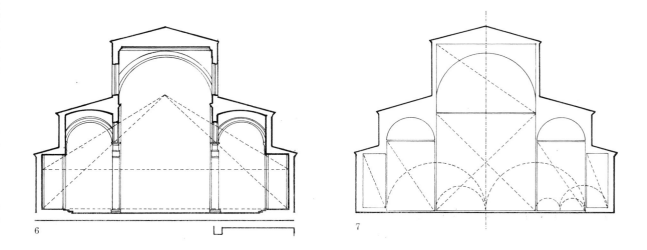

6

7

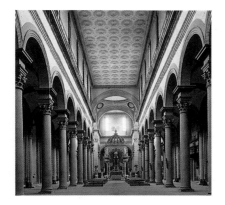

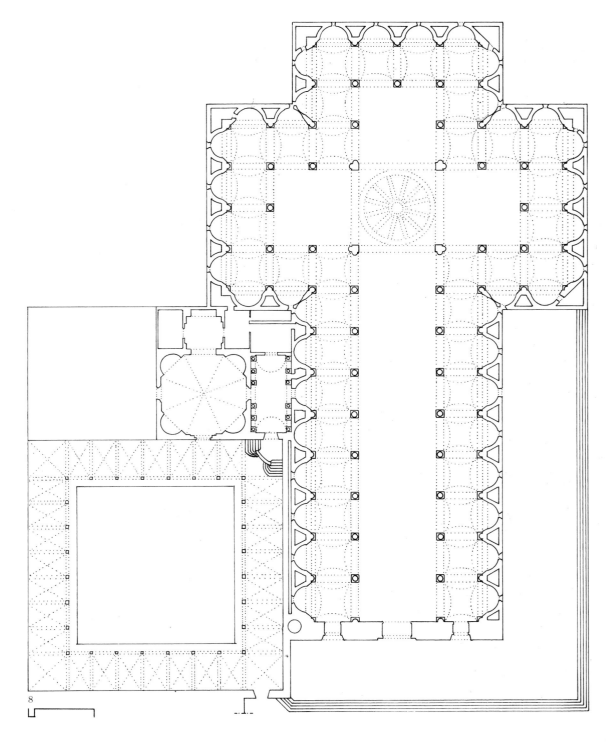

8. Plan of the Santo Spirito complex. The church is by Brunelleschi; the sacristy, to the left, is by Giuliano da Sangallo e Andrea del Pollaiolo.

The church of Santo Spirito is probably Brunelleschi's most innovative project, both in terms of the proportions used in the design and the organization of the longitudinal plan. Comparison with his previous design experience in San Lorenzo is, of course, unavoidable. The principal elements of the spatial outline derive from the same source; both, in fact, develop the theme of the longitudinal church with side aisles flanking a central nave, with a tribune used as a spatial pivot to connect nave, transepts, and presbytery. But the overall outline of the decoration is also similar: there is a direct continuity between the Corinthian order of San Lorenzo and the one employed in Santo Spirito, as well as in the sequence of tiers, the relationship between entablature and arches, the treatment of the fasciae of the arches, and of cornices and moldings.

However, Santo Spirito, even if it is a more accomplished design than San Lorenzo, cannot be considered more perfect than its predecessor. On a common theme, they each develop a different spatial idea. San Lorenzo adheres to a cubic-based spatial idea, while in Santo Spirito, Brunelleschi integrates the orthogonal outline of the central space with semicircular elements which, along the periphery of the building, were intended to elicit a spatial interaction between the inner space of the church and the articulation of the exterior. The two churches present two different solutions to the problem of how to create a geometrically and rationally developed architectonic space.

The church of Santo Spirito is one of

the Renaissance buildings that has suffered most from the many vicissitudes of its construction history. Though Brunelleschi dedicated most of his time after 1434 to the design of the church and to the building of a wooden model, construction did not begin until 1444, only two years before the master's death. A contemporary commentator, Brunelleschi's biographer Antonio Manetti, considered the model not only extremely beautiful, but also of

fundamental importance because of the way the design was developed and the way the building was sited. In fact, one of the many unusual aspects of the design was the decision to turn the main facade of the church away from the historical center of the city, so that the presbytery occupied what would have been the natural position of the main entrance. This may have been one of the reasons why Brunelleschi decided to articulate, with a similar el-

ement, the whole perimeter of the church, refusing the traditional hierarchy between the parts. His intention cannot be fully perceived today on account of the transformations that had already begun to alter the church's outline by the end of the fifteenth century: the semicircular volumes of the side chapels were hidden within a plain, flat wall, and those on the main facade were never built; while a suspended, coffered wooden ceiling was

substituted for the planned barrel-vaulted roof of the nave, transepts, and presbytery.

9. Longitudinal section.

10. Geometric scheme of the longitudinal section with main proportional relations.

11. Geometric scheme of the transversal section with main proportional relations.

12. Transverse section.

13. Reconstruction of Brunelleschi's original plan of Santo Spirito, based on the hypothesis of Sanpaolesi.
The church is articulated in three principal elements. The first is an open, Latin-cross, central space, made up of the nave, the transept arms, the presbytery, and the central tribune. Each of the arms was supposed to be roofed with a barrel vault, with a rib-and-sails dome over the tribune. This space is surrounded by a second element: a continuous ambulatory made up of a series of square bays, each covered by a sail vault. This ambulatory functions in turn as narthex, side aisles, transept extensions, and choir. This space can therefore be perceived both as a local, subsidiary space or as a continuous element linking the various typological components of the church. The third element consists of a chain of semicircular chapels running without interruption around the entire perimeter of the church.
The entire outline can be interpreted as an elaboration on the theme of the three-dimensional conception of the Renaissance, based on the rules of perspective. The overall continuity of the space, obtained through a rigorous proportioning of the three main elements, achieves a composition which blends them into a single whole. This effect is emphasized by the repetition of a single constructive element: two cylindrical columns, with Corinthian capitals surmounted by cubic pulvins, which support an arch marked by a wide stone fascia. The iteration of this unit establishes a sort of framework that generates a sequence of interlinked spaces of different scale.
In section, therefore, the space of the church flows from the nave outward to the peripheral chapels, through the intermediate, sail-vaulted aisles (see fig. 12); in plan, the ambulatory provides a radial transition between the central Latin-cross space and the semicircular chapels (see fig. 15).

14. Geometric scheme with main proportional relations.

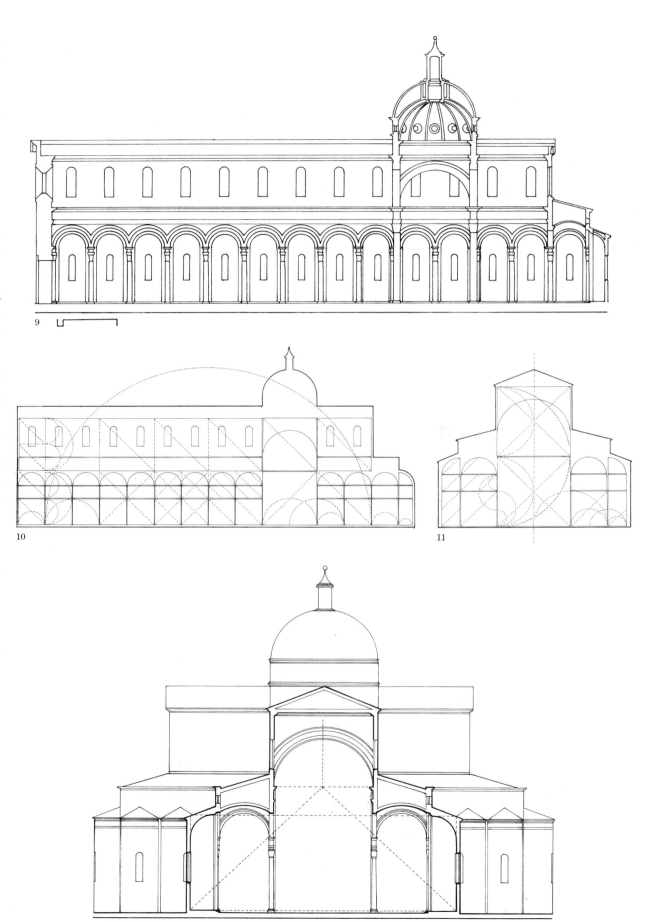

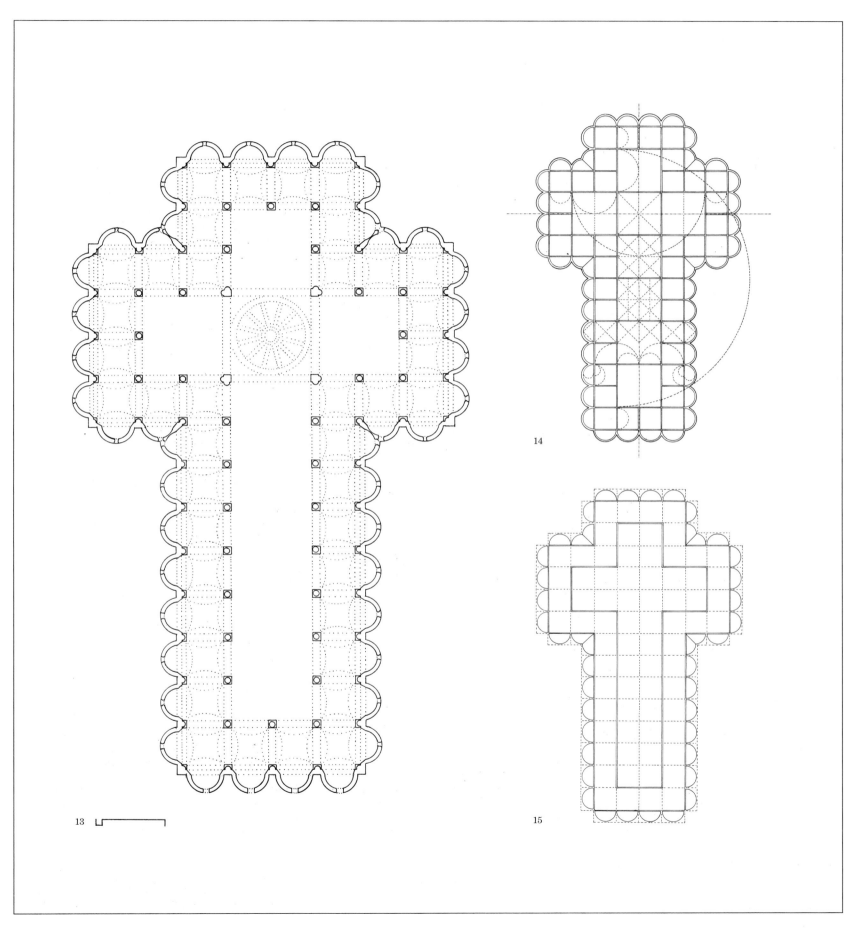

13

14

15

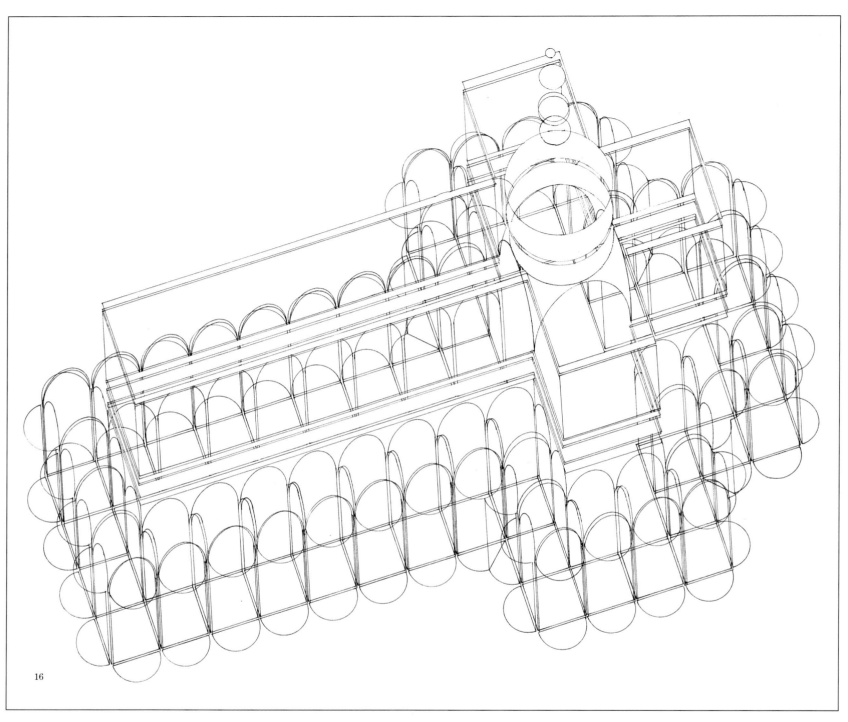

16

In this plan, Brunelleschi develops a complete system of proportion in order to scale every single element of the church.

The basic module corresponds to the on-center distance between columns (eleven Florentine *braccia*). Starting from this length, a harmonic series of dimensions is defined–by multiplication or division–which serves to determine the scale of the principal elements of the church and to control their reciprocal location in plan and in section. The basic module corre-

sponds to the side of the square bay of the aisle. Doubling this dimension gives the module for the central Latin-cross space; halving it gives the radius of the semicircular chapels. In section, the same length is used to define the height of the entablature that runs continuously around the sides of the central, Latin-cross space, as well as to set the impost plane of the major arches of the tribune and to determine the articulation of the connection between aisles and chapels.

This proportional system generates a square-based grid which Brunelleschi uses to control the overall articulation and dimension of the church. Each intersection of the grid is marked by a column, so that from every point of the church a harmonic correspondence of the members defines the architecture of the space. The theme of the column as a space-mark is carried throughout the church and varies according to its position: the column becomes a semi-column between chapels, a three-quarter or one-quarter column at the exte-

rior and interior turning points of the ambulatory, and part of the pier at each corner of the tribune.

15. Proportional grid outline with the three main elements that constitute the plan: the central Latin cross, the ambulatory, the semicircular side chapels.

16. Axonometric projection of the elements that define the space of the building, according to the reconstruction of Brunelleschi's original project.

17. Reconstruction of the plan of the wooden model from Bramante's original project, only partially completed.

In the original project, the giant dome is part of an octagonal-plan tribune, which was intended not only to mark the crossing of the longitudinal nave-and-aisles body and a similarly articulated transept, but also to function as a spatial point of reference for the four circular, central-plan sacristies situated at the outer corners, between the arms of the cross.

The underlying idea of the composition is to reinforce the crossing of the longitudinal and transverse volumes with four equal, symmetrically placed elements, which recalls a central plan. The overall articulation of the interior space resembles previous experiences, especially for the semicircular articulation of the side chapels, which may be related to such examples as the Milanese church of San Satiro and, to a greater degree, the church of Santo Spirito.

It is especially the latter which served as a model for Bramante, particularly in relation to the way the space of the side aisles is carried continuously around the main, Latin-cross space – a solution which itself creates a sense of centrality through the similar outline of the presbytery and the two ends of the transept. Bramante's interest in Brunelleschi's architecture, clear in San Satiro, is both more explicit and more focused in the Duomo of Pavia. Although the spatial reference to Brunelleschi is evident, the decoration and the way the architecture treated are very personal.

18-19. Geometric scheme with main proportional relations and proportional grid outline with the three main elements that constitute the plan: the central Latin cross, the aisles, the side chapels.

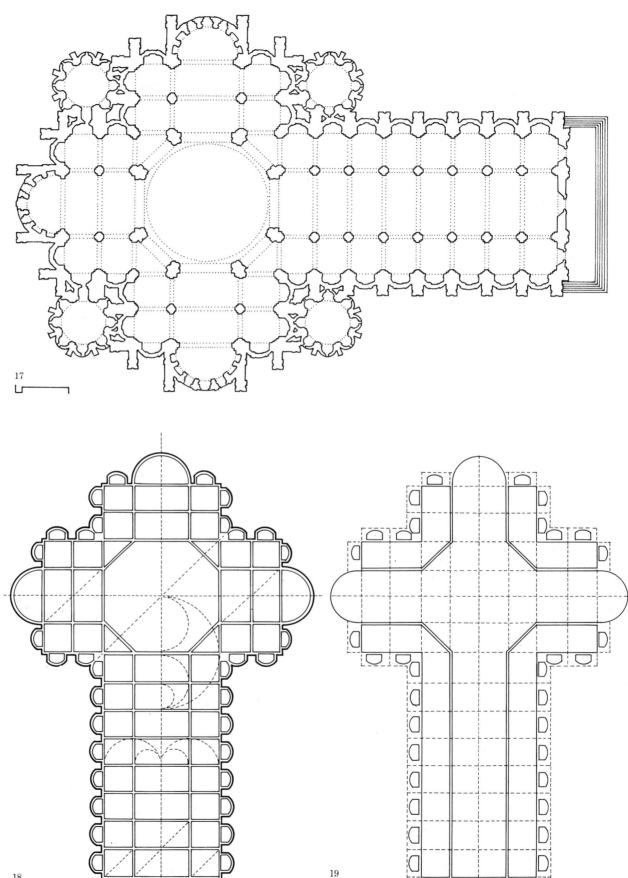

93

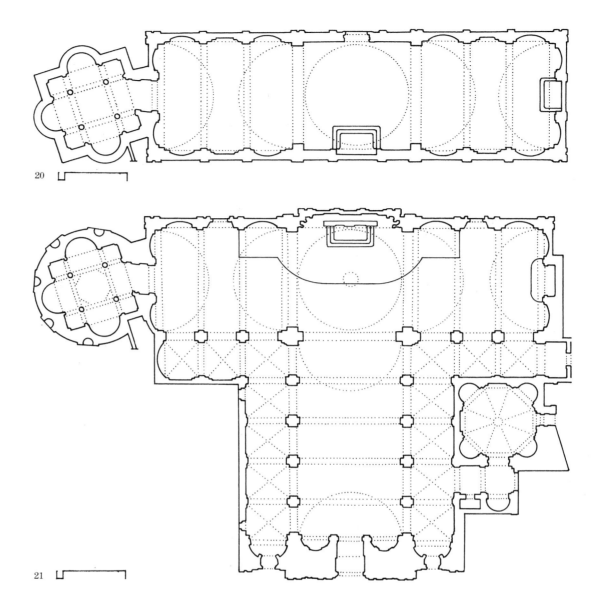

20.

21.

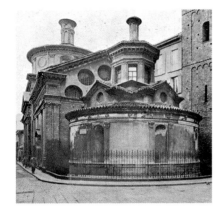

20. Plan of the original part of the existing church.

21. Plan of Bramante's project.
There are many uncertainties relative to the transformation of the church of Santa Maria in San Satiro from its initial, rectangular outline to the final T-shaped configuration. What is known is that in September 1480, Bona di Savoia and Galeazzo Maria Sforza gave their approval to the Confraternity of Santa Maria di San Satiro for the transformation of the church and the restoration of the annexed votive chapel, which dated back to the ninth century. It is not known, however, whether Bramante was originally asked to design only a rectangular hall, on the model of Brunelleschi's Pazzi Chapel, and successively commissioned to expand it, or if the church is the result of a single, integral design.

It is known that the original church, built with one of its longer sides along a public street, the via del Falcone, was extended away from the street by the addition of a second rectangular volume to create a longitudinal outline based on a nave with side aisles. The constraints of the site allowed Bramante to actually build only a portion of what ideally would have been a complete, symmetrical outline; the unbuildable section corresponding to the location of the street was simulated by a series of decorative elements. The presence of a choir or presbytery is rendered by means of a trompe-l'oeil perspective behind the altar, and this perspective illusion is essential to a comprehension of the built sections of the church – the nave, transepts and tribune – for the false choir does more than simply extend the view: it com-

pletes the overall spatial composition by integrating the real space with a virtual one. The design of the choir called into play Bramante's skills as sculptor, painter, and architect. The complex three-dimensional outline of the simulated space was done in bas relief using the methods of perspective that were part of the common language of Renaissance artists.
The plan is based on an ideal Latin-cross scheme, with the nave and transept flanked by aisles. The main space of the nave is covered by a barrel vault, as are the two transept arms. The tribune is covered by a dome, while the aisle bays have cross vaults over them.
A reference model for Bramante's project–especially the aisles conceived as a continuous ambulatory surrounding the main space of the church–may

have been Brunelleschi's plan for Santo Spirito. For Bramante, this idea signifies the possibility of recovering the principle of a centrally planned, cross-shaped space in a longitudinally organized church.

22. Geometric scheme of original plan with main proportional relations.

23. Geometric scheme of Bramante's project with main proportional relations.
The plan clearly shows a square-based grid which, starting from the bay of the aisle, Bramante used to proportion the space of the nave and to harmonize the new extension with the existing body of the church. The basic relationship is ruled by a proportion of 1:2; this can be seen in the side of the tribune, which is twice the width of the aisle.

24. Elevation of the choir area.

25. Modular spatial grid, excluding the thickness of the walls.

26. Longitudinal section.
This church presents a series of solutions of decorative elements and wall articulations that constitute a basic contribution to the evolution of the whole repertory of contemporary Milanese architecture. It is easy to imagine the effect of Bramante's new church, with its classical character, against the background of a city still deeply medieval in its overall structure.
The inner space is ruled by a strict use of the architectural order. The basic motif employed by Bramante is the typical Roman system of an arched opening framed by two pilasters sup-

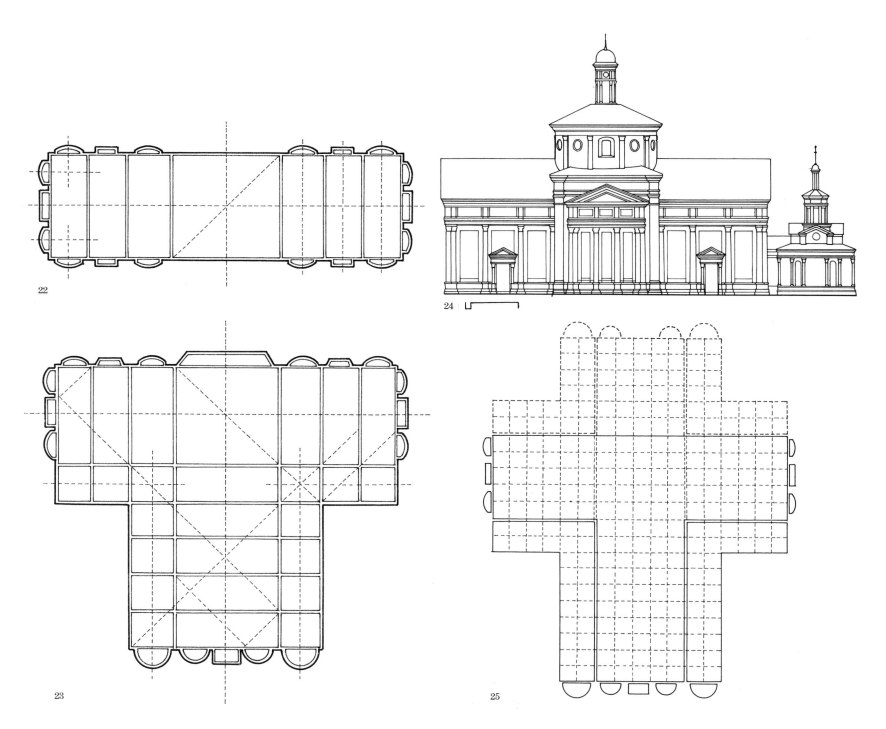

22

24 ⌐⎯⌐

23

25

porting a running entablature that defines the height of the arch. This element may be related to similar solutions adopted by Alberti for the decorative articulation of the wall masses in his churches in Rimini and Mantua.

As Alberti emphasizes the solid mass of the wall in relation to the articulation of the architectural order, Bramante takes up the traditional motif of a series of arches supported on piers in which a major pilaster is flanked by two minor ones.

27. Geometric scheme of the longitudinal section with main proportional relations.

The section is articulated in four registers. The first corresponds to the height defined by the minor order that carries an entablature defining the impost plane of the arched openings between nave and aisles.

The second is defined by the major architectural order and overlaps the first. In fact, these pilasters carry a second entablature–larger than the first, lower one–which defines the height of the keystone of the arches.

The third tier is defined by the space occupied by the barrel vaults over the nave and transepts. Each vault is subdivided into sections corresponding to the width of the aisle bay below by a fascia running between the pilasters on opposite sides.

This fascia introduces an element of continuity that emphasizes the perception of the interior as a unified whole.

The fourth level corresponds to the dome system: a low drum on pendentives, the coffered dome itself, and a high, slender lantern.

28. Transverse section.

29. Geometric scheme of the transverse section with main proportional relations.

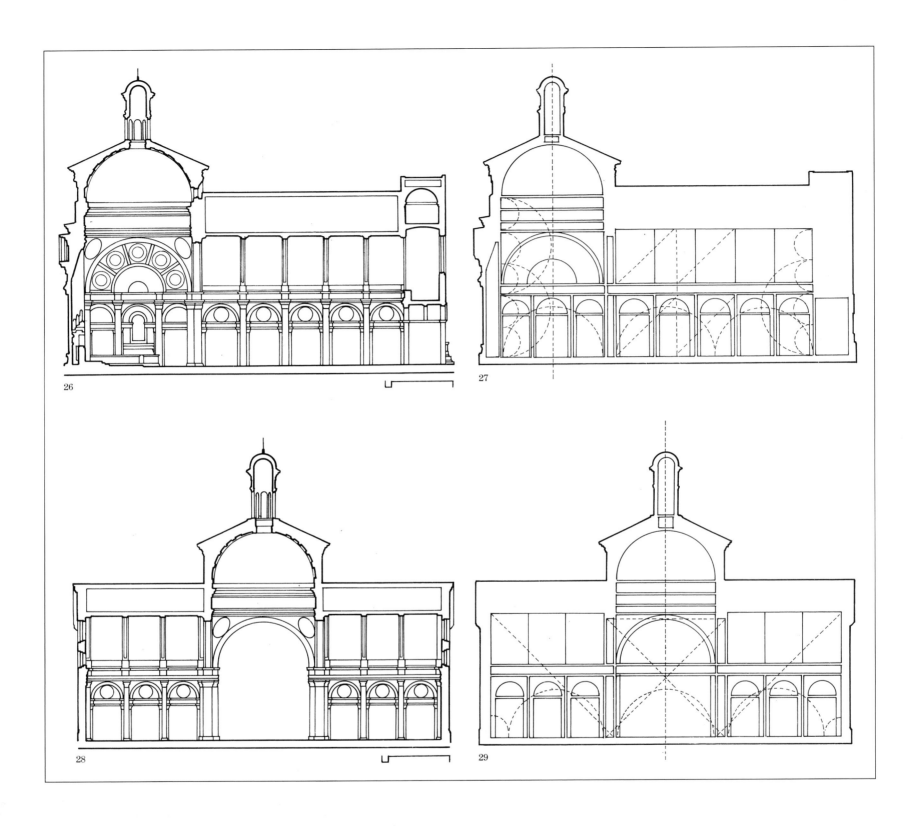

26

27

28

29

Leon Battista Alberti,
completed by *Antonio Maria Viani*
(1597-1600) and *Giulio Torre*
(1697-1710),
dome by *Filippo Juvarra* (1732–82)
Basilica of Sant'Andrea
1472–94
Mantua

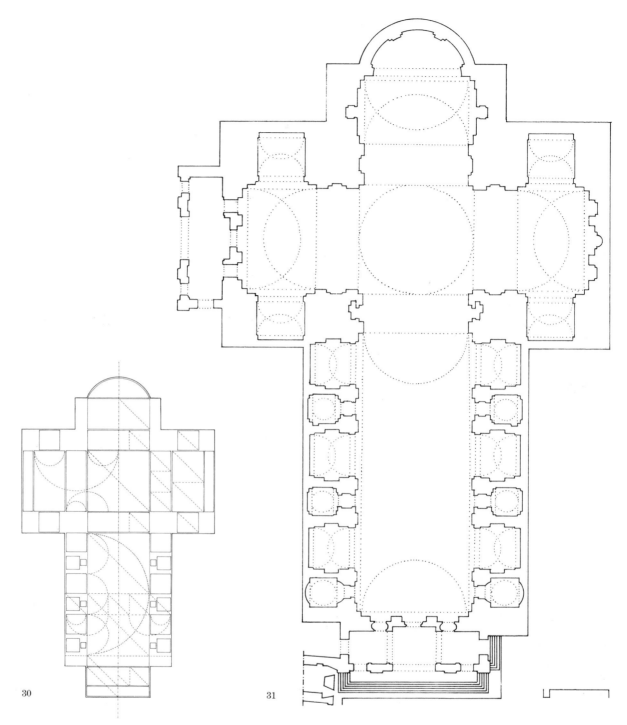

30. Geometric scheme with main proportional relations.

The part of the church belonging to Alberti's original project – the main nave with the alternating chapels – is developed following a square geometrical grid. This orthogonal pattern allows Alberti to size the central hall as well as the two different types of side chapels. A similar grid is also applied in order to proportion the front elevation and the inner section.

31. Plan.

Alberti built the church of Sant'Andrea in the center of the city of Mantua according to a principle stated in his treatise, *De Re Aedificatoria*, on the rules for a "temple" built in the heart of a city. The new church is thus treated as the most important temple of the city, located in the most favorable position, characterized by worthy architecture, in order to be of the greatest majesty and to attract the attention and capture the imagination of the city's population. The church must have that rare architectonic quality capable of drawing people to enter and visit it.

In his treatise, Alberti remarks that a well-built and decorated church might certainly be the pride of a city. At the same time, for religious activities it is important to organize a building so as to allow the congregation to participate in the celebrations in a comfortable manner.

As a base reference for his design, Alberti employs an Etruscan temple whose typology has a long central hall with no side aisles; rather, there is a sequence of minor chapels on either side. The other starting point for Alberti's design is the intention that he states in a letter to his patron, the Marquis Ludovico, to articulate the whole church following basic harmonic rules of proportion.

On the site chosen for the church, there were essentially two constraints. The alignment was determined, on the left side, by an existing bell tower and a row of houses. The presence of these constraints made it impossible for Alberti to light the interior of the church homogeneously; in addition, the position of the houses and the presence of the bell tower obliged Alberti to design a front facade that was smaller than the body of the church.

The most important decision Alberti made concerned the roof with which he intended to cover the main nave of the church. On the model of the ancient thermal buildings of the Roman period, he decided to use a giant, coffered, barrel vault. The use of such a huge vault has a number of direct consequences on the plan of the church, because, from a structural point of view, it requires a series of massive lateral supports. The vault must be flanked by a series of piers in order to counterbalance the enormous thrust

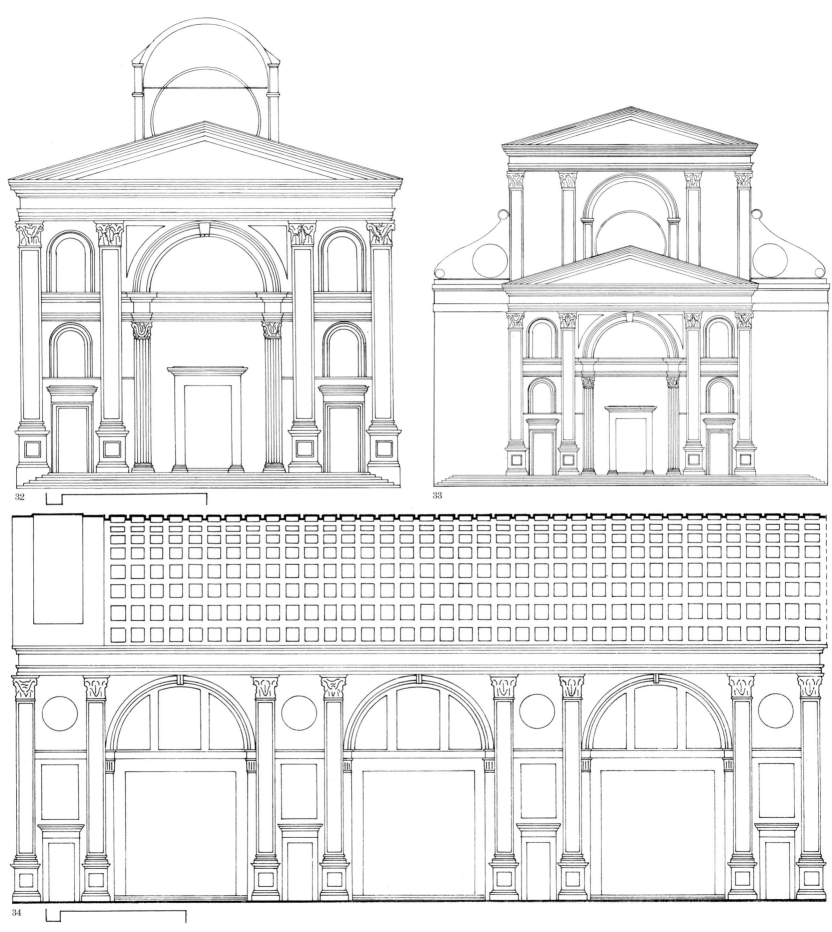

32

33

34

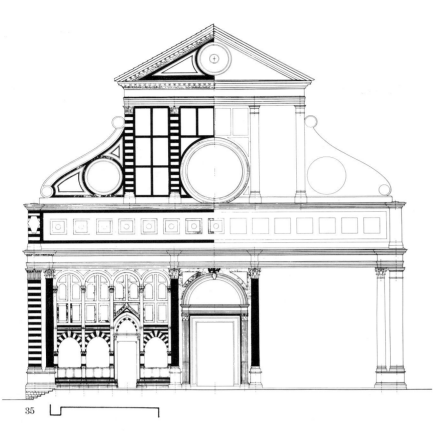

35

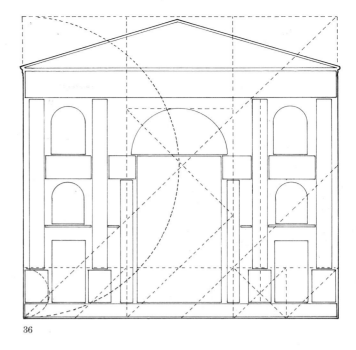

36

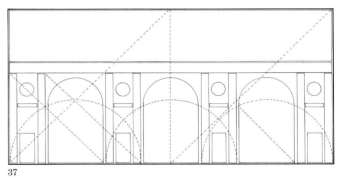

37

and to provide a wide base for the overall structure. With such a constraint, Alberti decided to organize the plan with a series of side chapels of alternating size: the tribunalia–square-based, barrel-vaulted chapels; and the cellae–small, domed rooms. This creates a sequence of paired piers, flanking the smaller spaces, which, placed transversely to the main axis of the central hall, provide the needed lateral support for the barrel vault above.

Unfortunately, as frequently happened in the Renaissance, the church was not completed under Alberti's supervision. In fact, the whole area of the tribune, transepts, and presbytery was finished much later, and the dome was added only in the eighteenth century.

32. Facade elevation.
In the elevation, Alberti develops a volume intended to function as a pronaos, in order to solve the problem presented by the presence of the existing bell tower. The result is a double facade, composed of a projecting volume, the pronaos, attached to the facade of the church proper. While the latter facade was never completed, the former presents an innovative solution in which two traditional models of the classical repertory – the temple and the triumphal arch – are blended together in an unusual manner.
The temple model is used to define a basic grid in which four giant pi-

lasters, placed on high bases, carry a pediment. The pilasters are placed so as to leave twice as much space in the center as at either side. They thus set a ternary rhythm that is typical of the triumphal arch; in fact, Alberti articulates, in the center, an arch supported by a pair of minor pilasters without bases. In the two lateral bays, a small portal, a niche, and an arched window are placed one above the other.
An interesting detail is the entablature corresponding to the minor architectural order, which not only sets the height of the impost plane for the central arch, but also runs through the lateral bays. This creates continuity between the two systems so that the facade is perceived as the superimposition of two interwoven elements.

33. Tentative reconstruction of planned facade elevation based on the example of Santa Maria Novella (Norberg-Schulz 1962).

34. Longitudinal section of the main nave.
The solution for the interior is similar to that adopted for the main facade. Alberti employs the same ternary rhythm of the triumphal arch to organize the sequence of the openings of the lateral chapels.
The wider bays accommodate the arched openings of the square-based tribunalia, while the minor bays con-

tain–one above the other–the entrance portal of the cella, a rectangular decorative element, and, in a space defined by a cornice setting the height of the arch, a round windowlike opening.

35. Elevation of Santa Maria Novella, by Leon Battista Alberti (Florence, from 1458).
This earlier example, a facade that Alberti designed for an existing medieval church, illustrates some of the principles employed in his project for Sant'Andrea in Mantua.
The facade is organized in three tiers. The first, defined by two corner pilasters and by a long entablature, is characterized by the presence of the main portal, encased in an arch on pilasters and framed by a pair of semicolumns on bases. The second register consists of a blind attic storey, on top of which rests the third level. This is characterized by the presence of two different elements. In the center, the front elevation of a tetrastyle temple frames the round window that lights

the interior. On the sides, a pair of finely decorated triangular elements connects the narrower central body to the lower tiers. This solution, together with the innovative facade for San Sebastiano in Mantua, where an arch breaks the entablature of the pediment, and the Tempio Malatestiano, where the triumphal arch motif dominates, constitutes the basis for the complex, unprecedented synthesis of Sant'Andrea.

36. Geometric scheme of facade elevation with main proportional relations.

37. Longitudinal section of main nave: geometric scheme with main proportional relations.

Francesco di Giorgio Martini
**Santa Maria delle Grazie
al Calcinaio**
1485-95
Cortona (Arezzo)

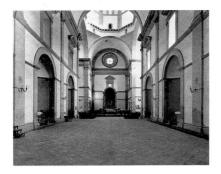

38. Plan.
The church is outlined on a Latin-cross scheme with secondary spaces along the sides, but without aisles. The central space of the Latin cross is covered by a barrel vault, as are the transept arms and the presbytery. The tribune, covered by a slender dome on a very high drum, is characterized by an octagonal structure of pendentives, which replaces the traditional circular connection. Unlike Sant'Andrea in Mantua, where the spaces along the main central hall are articulated as side chapels, in the Calcinaio church the side spaces are merely niches carved out of the thickness of the wall, just large enough to accommodate an altar. The necessary resistance to the thrust of the barrel vaults is thus provided not by a succession of lateral piers, but by a massive wall all along the perimeter of the building. This determines the emphatic longitudinal outline of the church: the central hall is perceived as being flanked by two uninterrupted walls, and the shallow altar recesses do not provide any significant interruption to the solidity of the wall.
The conformation of the wall is similar all along the interior, with a repeated bay module articulating the nave, transepts, and presbytery. This results in a very homogeneous quality in the whole interior space and creates a sense of centrality, especially in the area of the transept arms and the presbytery, where a similar spatial unit is employed by the architect to accommodate different functions. This homogeneity is carried over to the exterior as well, thanks to the structural treatment of the wall. In fact, Francesco di Giorgio Martini, by transforming Alberti's lateral support of the barrel vault into a continuous, longitudinal wall and maintaining a constant wall thickness, achieves a perfect corre-

spondence between the articulation of the interior and the exterior spaces. The Madonna del Calcinaio is therefore one of the few examples of a Latin-cross plan based on a single, central nave covered by a barrel vault to be built without any augmentation of the volume. The structure is so well proportioned that it is also able to carry a fully expressed dome on a drum with no further reinforcement.

39. Geometric scheme with main proportional relations.

40. Spatial diagram of the plan.

41. Transverse section.
The section is articulated in four different tiers whose decoration is emphasized by the use of gray limestone against a background of white plaster. The first tier is defined by the height of the keystone of the arched openings of the niches. This level is characterized by a series of pilasters defining the width of each bay. In this tier, a continuous cornice sets the plane corresponding to the impost of the arches. The second register is again characterized by a sequence of pilasters spaced in correspondence to those in the tier below. Each bay accommodates a pedimented window at its center. This tier is separated from the one below only by a very narrow fascia, while it supports a wide entablature. The first and second registers can thus be perceived as two superimposed elements which together form a single, giant tier.
The third level consists of the barrel vaults, which are characterized by a series of fasciae spaced in correspondence to the pilasters of the bays below. The fourth tier comprises the dome system: the drum – articulated in two secondary registers – a segmented dome, and a lantern.

42. Longitudinal section.

43. Geometric scheme of transverse section with main proportional relations.

44. Side elevation.

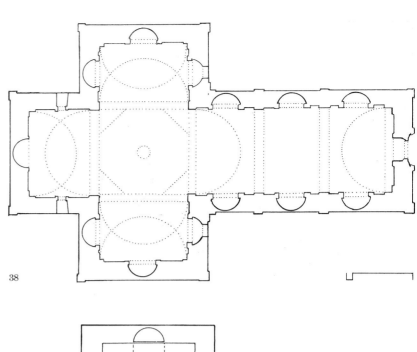

38

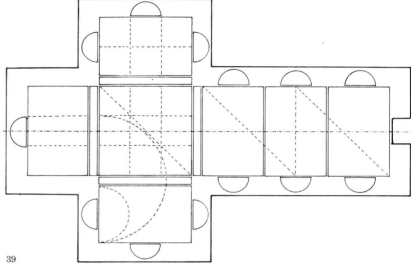

39

40

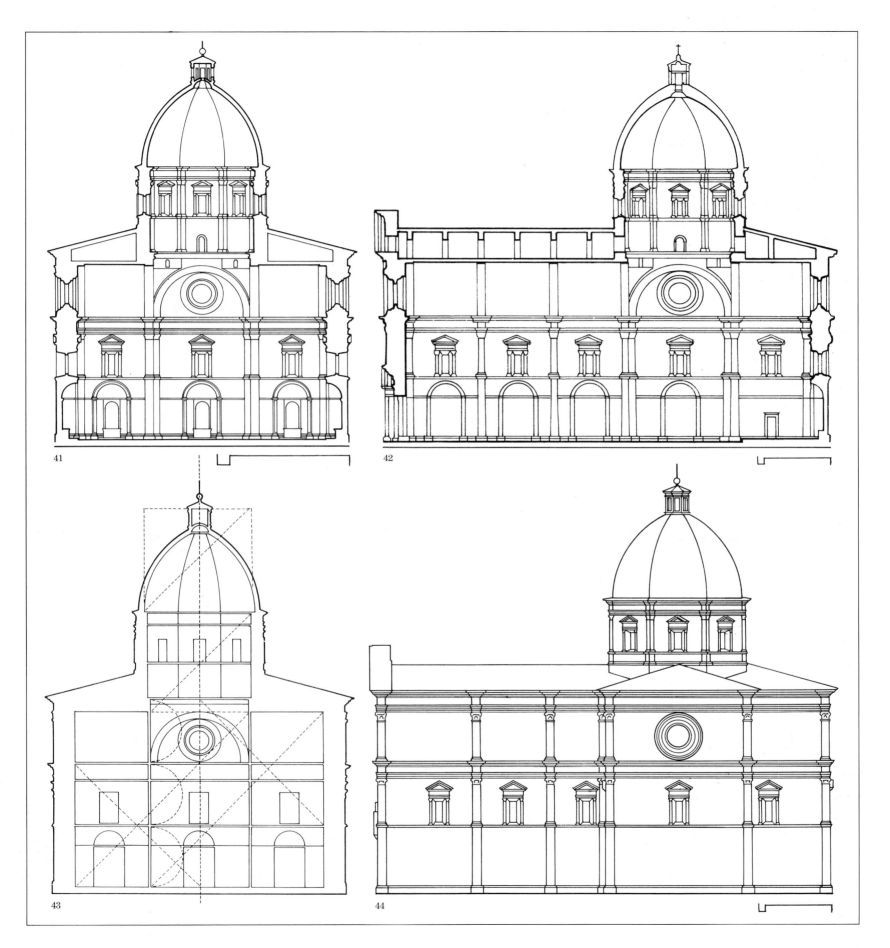

41

42

43

44

Leon Battista Alberti
Tempio Malatestiano
from 1450
Rimini (Forli)

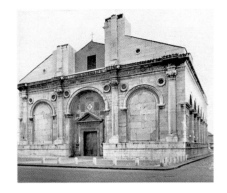

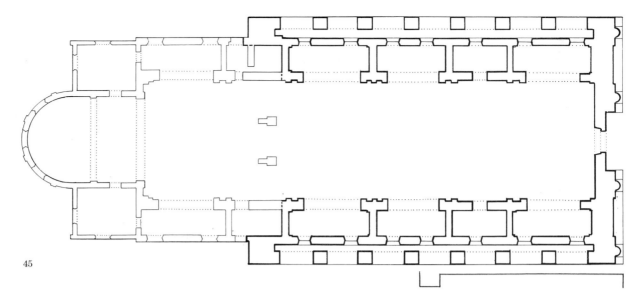

45

45. Plan.
The construction of the building was promoted by Sigismondo Pandolfo Malatesta. Like his rival, Federico da Montefeltro, Sigismondo took it upon himself to sponsor the construction of a building that would match the magnificence of the glorious architecture of the ancient past. But as happened with Federico's Ducal Palace in Urbino, the Tempio Malatestiano remained incomplete.

Faced with an existing, old church, Alberti decided not to remodel or demolish it, but to isolate it and build a new structure around it. By doing so, he clearly set the boundaries of his design field, unequivocally affirming the incompatibility between classical architectural language and a pre-existing, medieval form of expression.

The church was intended to be the celebratory "temple" of the Malatesta family, where its members would be buried. Its plan was to be longitudinal, with one, central nave, flanked by side chapels. In line with Alberti's theories–put into practice in his later church of Sant'Andrea in Mantua–the nave was supposed to be barrel-vaulted. Externally, along the sides Alberti built a series of arches which "contained" the pre-existing structure; each arch housed a sarcophagus, destined for a member of the Malatesta family. The reference for this detail may have been the Florentine church of Santa Maria Novella, or, more likely, the nearby mausoleum of Theodoric in Ravenna. Thus, Alberti's decision to envelop the old church within a building having a totally different architectonic expression does not represent a total break with the tradition of the region. Continuity can also be seen in the design of the facade, where Alberti uses as a model the Roman triumphal arch in Rimini, demonstrating

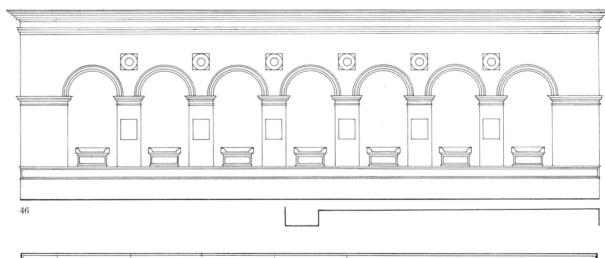

46

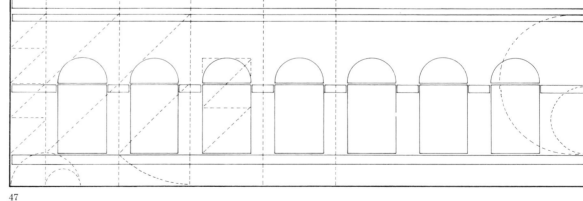

47

that central Italy possessed its own repertory of classical buildings, independent of Rome, but no less valuable. The fact that the Tempio Malatestiano was never completed has always been a source of discussion and speculation; different hypotheses abound regarding the exact nature of the original project, especially because there is only one known image of the project, represented on a celebratory medal attributed to Matteo de' Pasti. The tribune and the dome are particularly controversial. Not only is the solution for the dome uncertain (whether ribbed or continuously vaulted). There are also many uncertainties regarding the plan: one hypothesis is based on a Latin-cross scheme, which suggests that a transept was intended; the other is based on a composite scheme, therefore with a central-plan tribune, on the model of the Annunziata church in Florence.

46. Side elevation of first tier.
On the basis of the principles of his *De Re Aedificatoria*, Alberti designed the

102

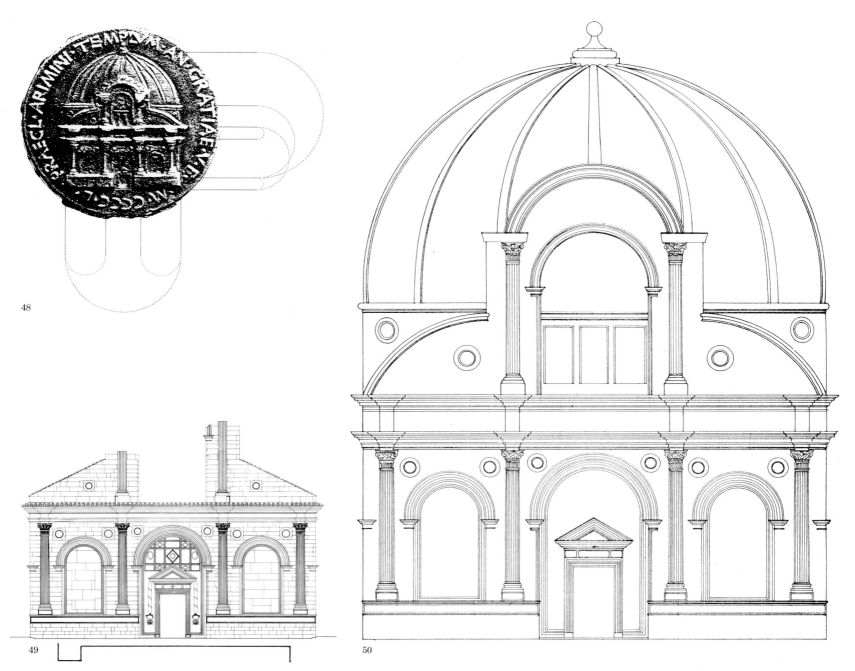

48

49

50

side elevation with arches supported by piers (rather than the columns that, for example, Brunelleschi uses in the Portico degli Innocenti). Only by means of such a detail, in fact, could the lines defining the curvature of the arch be harmonically carried to the ground, along the corners of the pier. The entire elevation is conceived as a massively articulated wall in which a series of arches are opened, following a proportional grid that is independent of the rhythm of the pre-existing building. To Matteo de' Pasti's suggestion that these arches should be slightly displaced in order to correspond to the windows of the original church, Alberti replied that it was impossible to

modify the harmonic rhythm of the arcade: the dimensions and proportions of the piers and arches were so balanced, he maintained, that any modification would have been in discordance with the overall "music" of the composition.

47. Geometric scheme of side elevation with main proportional relations.

48. Matteo de' Pasti, *Medal of Sigismondo Pandolfo Malatesta*, Berlin, Staatliche Museen, obverse, with the original project for the front elevation of the Tempio Malatestiano.
Facades constituted a major problem for the architects of this period. The

difficulties lay especially in the fact that architects attempted to develop, for the facade, a spatial theme – essentially independent of the interior – which would resemble a superimposition, on one plane, of a number of different planes seen as if in perspective. The medal shows an elevation composed of a front facade and a ribbed dome. The facade is characterized by the superimposition of two planes. The first, background plane corresponds to the mass of the wall, which presents a theme similar to that of the side elevations: three arched openings are placed symmetrically, with the central arch, in which the entrance is situated, larger than the

other two. The second, foreground plane corresponds to the framework outlined by the architectural order: four Corinthian semicolumns on a continuous pedestal support the same entablature that defines the register of the side elevations. The two central semicolumns carry another, identical pair of semicolumns. The facade is completed by a crowning arch and two low, lateral semi-arches flanking the central unit, in which a tripartite window is opened.

49-50. Survey of the existing elevation (Borsi 1980) and tentative reconstruction of front elevation based on Matteo de' Pasti's medal.

103

Attributed to
Francesco di Giorgio Martini
San Bernardino
1469–77
Urbino

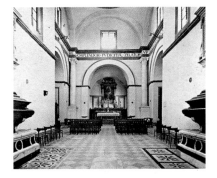

51. Plan.
In this church, which in the past was attributed to Bramante, there are many inconsistencies – a typical symptom, in the Renaissance, of the vicissitudes undergone during the various phases of construction. Today the church is considered to be the work of the Sienese architect and treatise writer, Francesco di Giorgio Martini.
Interpretation of the plan is based on the relationship between the main hall of the nave and the central nucleus of the tribune. In this sense the church can be considered an example of the composite scheme described by Alberti in his treatise. The rectangular hall is, in fact, joined to a lobed tribune whose articulation is based on a central square with a semicircular apse on each side.
The centrality of this space is further emphasized by the presence of four free-standing columns situated in the corners of the tribune. These are linked by arches, projecting out from the wall planes of the square tribune, that define the four pendentives supporting the dome. On the exterior, the dome is characterized by a cylindrical drum, high in relation to the low, conical roof that covers it.
A robust entablature, distinguished from the rest of the interior by its dark color that stands out against the white walls and by the presence of writing on the frieze, provides an element of continuity between the various spaces. Above the entablature are four large windows, one on each side of the tribune.

52. Geometric scheme with main proportional relations.

53. Composite scheme showing the harmony between the central-plan nucleus and the longitudinal arm.

54. Axonometric view.

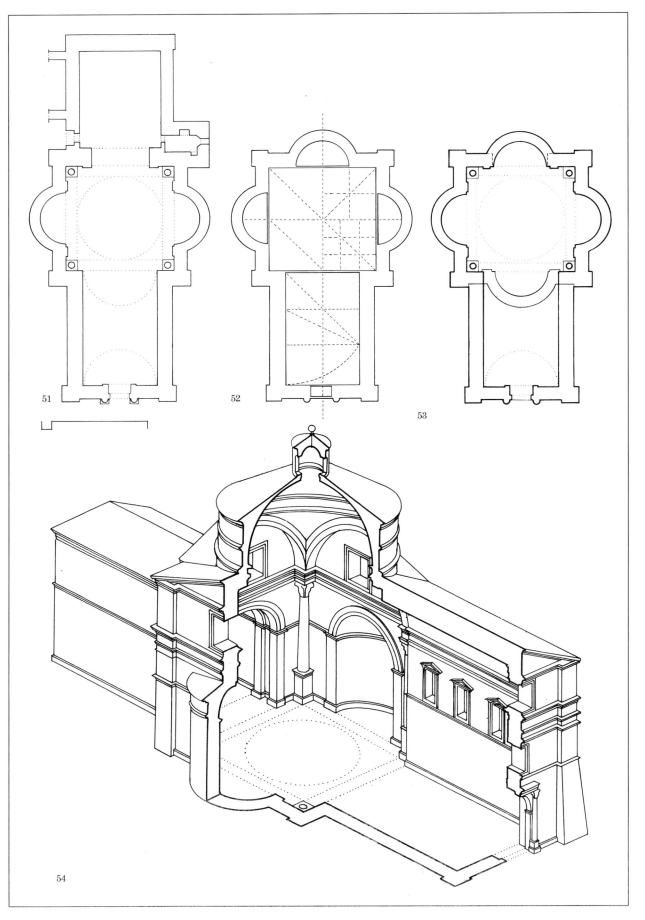

104

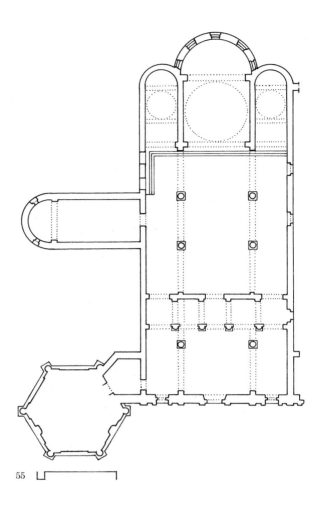

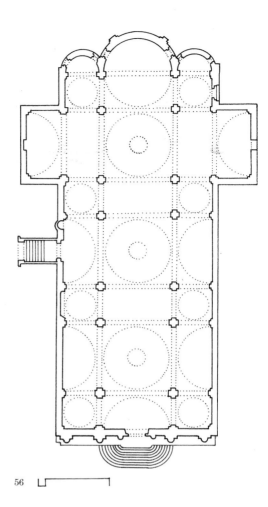

55 |__|

56 |__|

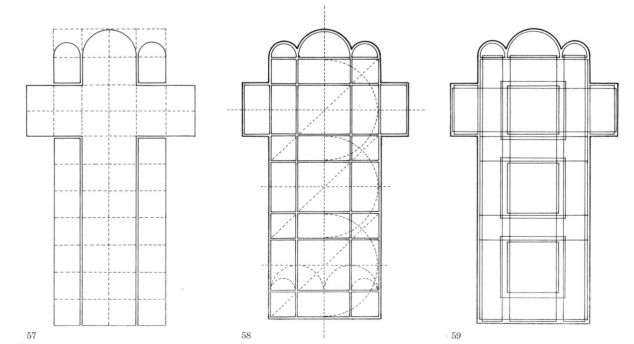

57 58 59

Mauro Codussi
San Michele in Isola
1468–79
Venice

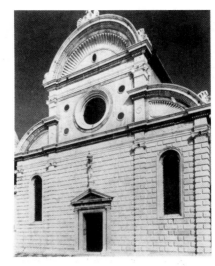

55. Plan.
Although the church presents no innovations in plan, the system of three domes, realized in the presbytery area, shows a Florentine influence totally unprecedented in Venice.
The interior resembles a traditional early Christian type with a central nave and two aisles, each ending in a semicircular apse. The composition of the facade is somehow surprising, especially for its monumental tripartite rhythm and the material texture of the first register.

Project by *Giorgio Spavento*
from 1507
completed by *Tullio Lombardo*
San Salvatore
1506–34
Venice

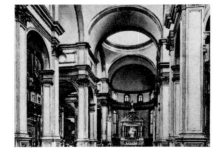

56. Plan.
The plan can be considered as the result of a repetition of an identical spatial unit composed of a central domed square, diagonally flanked by four smaller domed squares. This unit, repeated three times, generates a Latin-

105

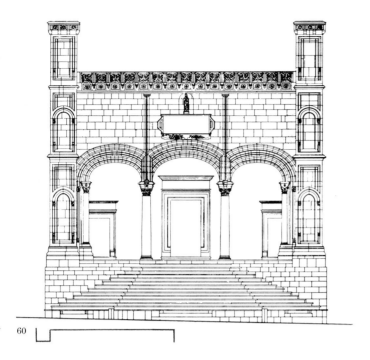

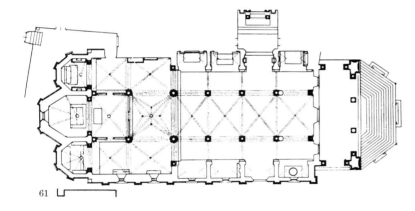

60

61

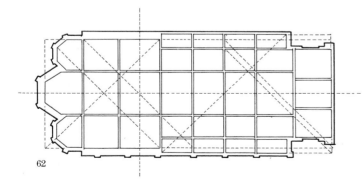

62

cross scheme by the addition of two short transept arms and three semicircular apses. The resulting plan emphasizes the main, central longitudinal axis, which is perceived as a strict sequence of interlocked spaces. Every portion of San Salvatore may thus be divided into simpler units which, conversely, combined together shape all the interior space. This particularity characterizes the church to such an extent that in the opinion of Tafuri it clearly shows a participation in the Pythagorean and Platonic conception.

57. Proportional grid outline with the three main elements that constitute the plan: the central Latin cross, the aisles, and the apselike aisles.

58-59. Geometric scheme with main proportional relations and spatial diagram of the plan.
The entire spatial system of the church is governed by a rigid dimensional proportioning. The basic module is represented by the dimension of the square corresponding to the smaller domed unit. The tribune space is made up of four modules and the transept arms of two, as are the side spaces that flank the domed tribune.

Matteo Carnelivari
Santa Maria della Catena
end of 15th century
Palermo

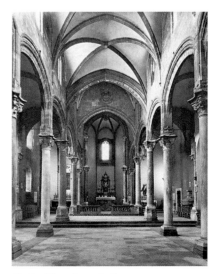

60–61. Façade and plan.
This church is one of the most important examples of Renaissance architecture in Sicily. In this building, elements of Spanish/Catalan origin – plan, arches, roof – are combined with details of classical origin-pedestals, columns, capitals.

62. Geometric scheme with main proportional relations.

Andrea Palladio
San Giorgio Maggiore
1565
Venice

Introduction

The central plan for churches was based on the idea that all religious functions should be concentrated in the tribune area. The equality of all of the sides canceled any form of hierarchy among the parts, granting equal status to nave, transepts, and presbytery. While this disposition was a great innovation from the spatial point of view, it conflicted with the liturgical traditions of the Catholic Church. The liturgy had developed in longitudinally conceived churches, where there was a precise hierarchy among the various spaces. These spatial differences were employed in religious functions not only to emphasize the role of the celebrant at the altar, and the pastoral college, but also to underline spatially the important points of the church, such as the altar under the dome, or the transept wings for secondary altars. The nave, in particular, made it possible to accommodate large numbers of people and emphasized their role as spectators.
In the central-plan church, on the contrary, this type of functional articulation was not possible, for all of the architectonic components were considered equally important, and the tribune space no longer coincided with the real center of religious function, i.e., the altar. By developing an ideal spatial model, the central-plan church introduced a shift of emphasis that substantially altered the role of celebrant and congregation, and which on occasion created difficulties for the day-to-day functioning of many churches. It is no accident, therefore, that the organization of St. Peter's – to give one example – proceeded from the original, highly centralized designs to the final configuration, which can be interpreted as a composite scheme obtained from the progressive

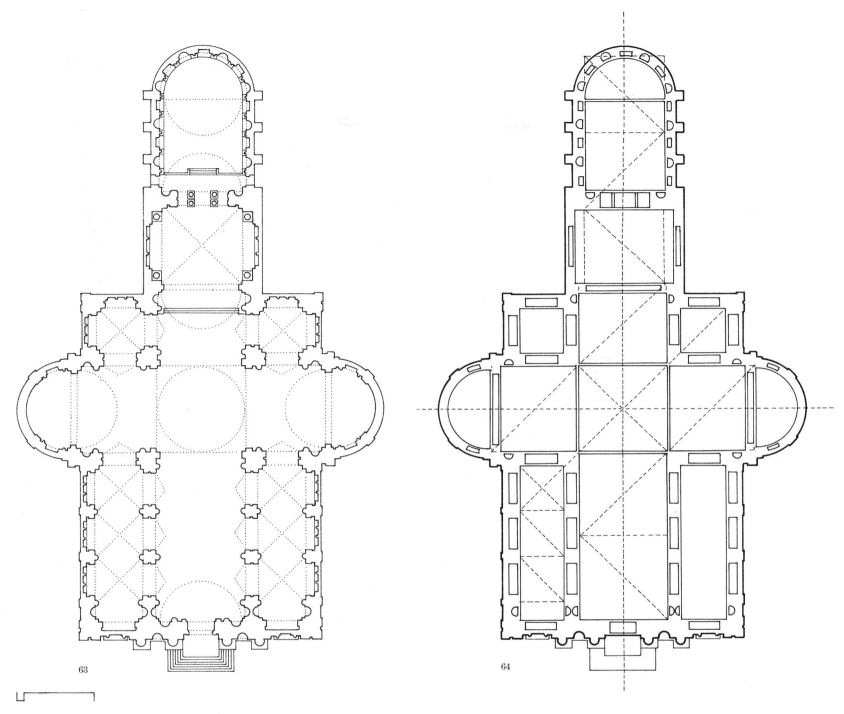

63

64

lengthening of one of the arms of a Greek cross until a Latin cross was achieved (a course that actually goes back to the plan of the earlier Constantinian basilica).

In the second part of the sixteenth century, architects such as Palladio, Vignola, and Alessi faced a similar difficulty. They had to resolve the problem of how to design churches that would express, on the one hand, the Renaissance conception of space but would also, on the other hand, follow a new spatial model that could reconcile space articulation and religious functionality. These architects achieved their goal with the development of an innovative

plan. They found ways to associate a wide nave capable of holding a large congregation, and lateral aisles with side chapels large enough for religious ceremonies, with the great central space of the tribune – a space that represents, as James Ackerman notes, the fulcrum of the spatial and architectonic heritage of the early Renaissance, observable in the works of architects from Bramante to Michelangelo.

The solutions proposed – particularly by Palladio in Venice and by Vignola in Rome – are not due to any reciprocal exchange of ideas; rather, they are the results of independent reflections on the official instructions that the

Catholic Church developed during the long discussions of the Council of Trent, birthplace of the Counter Reformation.

One of the general indications given by the Council was that the whole relationship between the faithful and the ecclesiastical body should be reconsidered. This included an invitation to artists and architects, who were asked to revise their thinking on the connection between clergy and congregation. And although the Council never provided specific directives regulating church architecture, many prelates intervened to clarify this relationship and to establish new criteria for it.

One of the most enterprising prelates was, without a doubt, was the Cardinal of Milan, Carlo Borromeo, who did much to indicate, to architects and their clients, the most suitable configuration for religious buildings. In 1577, in a pamphlet entitled *Instructiones Fabricae et Supellectilis Ecclesiasticae* (Instructions for Ecclesiastical Buildings and Furnishings), he proposed a series of rules for architects and artists, aimed at systematizing the construction and decoration of churches. The Cardinal's many detailed instructions included such things as the correct number of steps upon which the altar should be placed (three). He

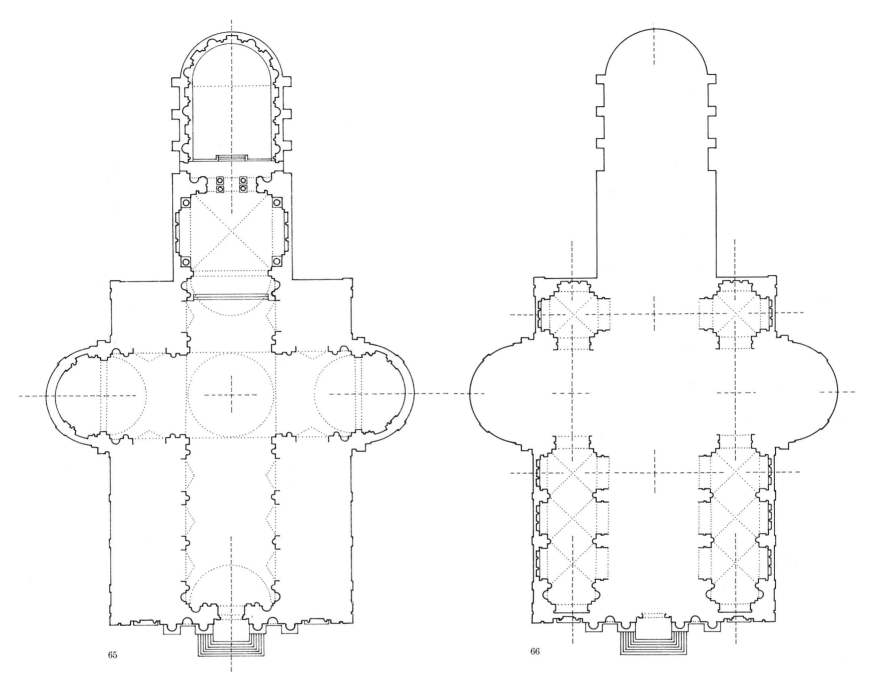

65

66

allowed a certain amount of freedom in the choice of plan and typology of the church; however, he expressed himself decidedly in favor of the Latin cross, judging the Greek cross to be unsuited to liturgical requirements. The Cardinal's pamphlet, in effect, represents a formal approval of the layout of churches that had already been built by Palladio and Vignola and it marked a turning point toward the development of similar schemes.

63. Plan.
Palladio's project for the church of San Giorgio Maggiore was commissioned by the Benedictine monks of the Cassi-

no congregation. It was built on the site of a pre-existing church.
The plan of San Giorgio Maggiore is made up of three main elements: the Latin cross, the presbytery, and the monks' choir. Each of these elements is precisely defined, and, as Wittkower notes, each space is separated from the next by a series of steps, giving even greater emphasis to an articulation that is already very evident in the plan. These three spatial elements – Latin cross, presbytery, and choir – are not, however, connected in a traditional way. The Latin cross is characterized by a nave of reduced length with respect to the size of the church. The transepts are

set back from the presbytery by the introduction of an extra bay between the tribune and the presbytery, creating a pause in the succession of spaces. As in previous tribune arrangements, the dome emphasizes a space that is not the most important from the celebrative point of view; however, this solution provides greater autonomy for the transepts, which can function as independent liturgical spaces.
Palladio treats the other two elements as essentially self-contained spaces, as can be seen in their very different articulation with respect to the nave. In the presbytery, four free-standing columns in the corners support a cross

vault, which greatly differentiates this area from the barrel-vaulted nave. In the choir, the fine articulation of niches and aedicolae, running along the side walls and around the semicircular apse, can only be glimpsed from the rest of the church through the screen of double columns with architrave that concludes the view from the nave area. The whole articulation of the church is conceived so as to dilate the perception of space along the principal longitudinal axis. Perception is freed from any perspective gradualness in depth. Palladio organizes a space that proceeds from the initial, regular rhythm of the first three bays of the nave to

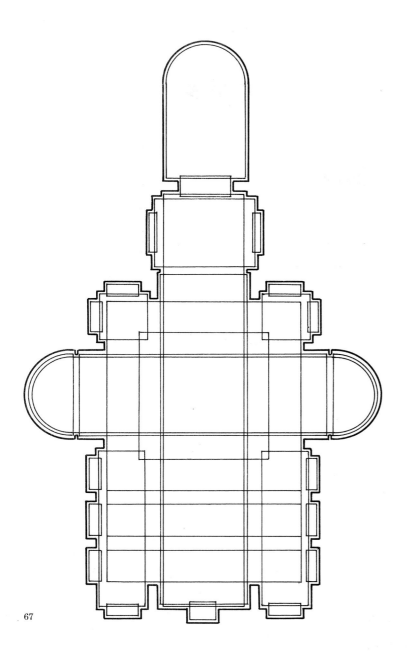

67

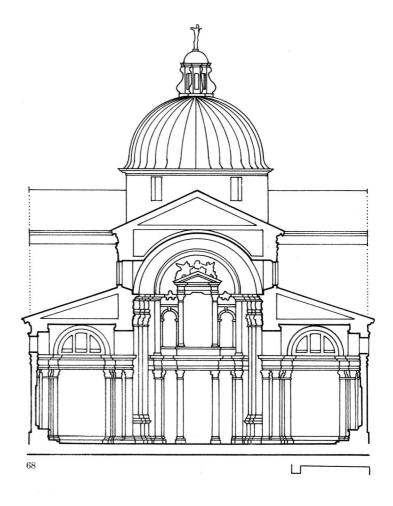

68

the great lateral expansion of the transepts; then to the slight pause of the single bay, the major focus of the presbytery, and, finally, through the screen of paired columns, to the distant view of the choir. Light and materials are the unifying elements of the entire architectonic path thus described: a series of high thermae-type windows provide a constant quality of illumination for the whole interior, and the white of the plaster walls and of the minor architectural order contrasts with the limestone of the giant order. Few other churches have succeeded in giving such prominence to the scansion of the walls through the

architectural order as a spatial reference.

64. Geometric scheme with main proportional relations.

65–66. Analysis of the two systems that define the Latin-cross scheme.

67. Spatial diagram of the plan.

68. Transverse section.
This section shows the spatial relationship between the central, barrel-vaulted nave and the bays of the side aisles, which are covered with independent cross vaults. The double architectural

order – major and minor – provides each type of vaulting system with a support proportional to it in scale and articulation.
Throughout the church, the play of entablatures underscores the presence of these two impost planes for the vaults. In addition, it can be seen how the openings in the far wall, behind the altar, in effect subvert the traditional perception of this end of the church, which usually consists of a solid wall marking the visual arrival point of the whole longitudinal system of the interior.

69. Compositional scheme of elevation.

70. Elevation.
Palladio is perhaps the first architect to produce a facade that does not develop an independent theme of its own, but attempts to communicate the articulation and the relationships of the interior spaces.
(Facades had traditionally been built during the final phases of a church's construction and simply placed up against the main structure of the building; hence, it is not a coincidence that the facades of many Renaissance churches, such as San Lorenzo and Santo Spirito, were never completed.)
Palladio here develops a scheme in which the elements composing the in-

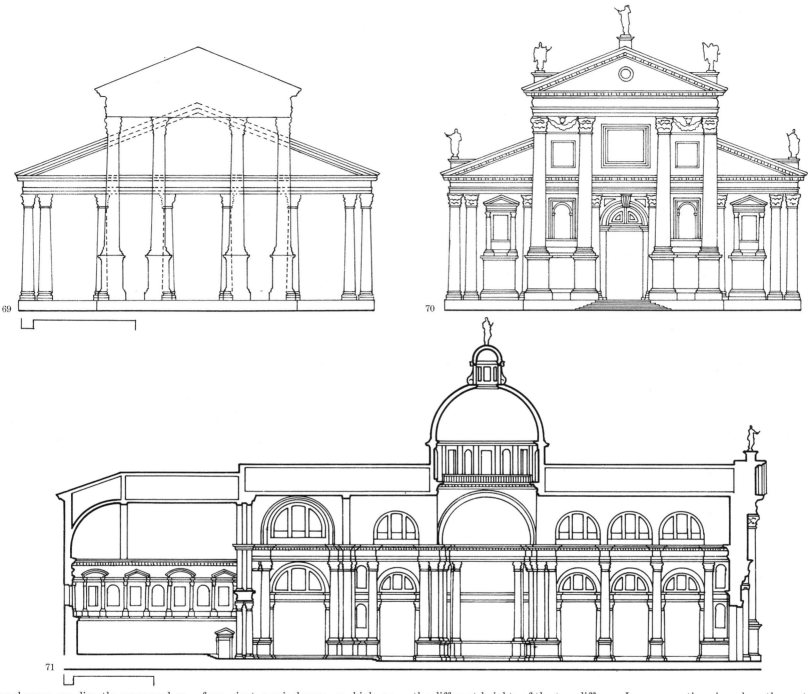

69

70

71

ternal space are directly expressed on the exterior.

Two different systems can be observed: one reflects the minor spaces of the side aisles and the other, the nave. Each of these two systems is expressed as a temple front projected onto a plane, with a pediment supported by columns whose height is proportional to the height of the interior.

The columns supporting the lower, wider pediment that reflects the side aisles are represented by flat pilasters, while the higher pediment, corresponding to the nave, rests on

four giant semicolumns on high pedestals.

The facade is therefore the result of the superimposition of two systems that correspond to the hierarchy established on the interior. Just as the barrel-vaulted internal space of the nave predominates over the lateral spaces of the aisles, so the central "temple facade" is perceived as superimposed upon the massive body of the church.

71. Longitudinal section.
The articulation of the interior space of San Giorgio Maggiore is based on

the different heights of the two different types of vaults used in the church: a giant architectural order is associated with the barrel vault of the larger spaces, while a smaller order supports the cross vaults that cover the aisles.

Thus each pier is finely articulated in order to clarify the relationship of scale between spaces with different functions: facing the nave, the larger order consists of semicolumns on pedestals; the smaller order, on the aisle, is made up of semicolumns rising from ground level; the thickness of the piers is marked by pairs of flat pilasters.

In a perspective view along the central axis, in fact, Palladio gives preference to the perception of the rounded volumes of the semicolumns both in the principal and in the secondary spaces, while the flatness of the pilasters serves to reinforce the junctions of the arches.

110

Andrea Palladio
Il Redentore
1567–77
Venice

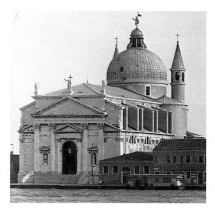

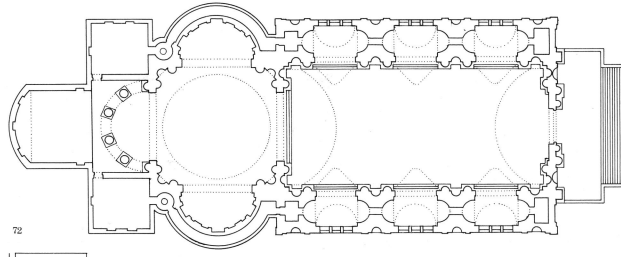

72

72. Plan.

The organization of the Redentore is
substantially different from that of
San Giorgio Maggiore. As Wittkower
points out, this church also has three
distinct sectors – nave, presbytery,
and choir – but the connection be-
tween them, together with their con-
figuration, gives rise to a more com-
pact spatial scheme, with greater lon-
gitudinal emphasis than in San Gior-
gio. The nave is covered with a barrel
vault, as in San Giorgio Maggiore, but
there are no aisles nor true transepts.
In fact, the nave recalls the halls of an-
cient Roman baths – vast, longitudi-
nal, barrel-vaulted rooms flanked by
secondary spaces that Palladio trans-
forms into side chapels. The chapels
are rectangular in plan, with trans-
versely situated, semicircular niches,
and are linked only by a series of small
passageways.

The presbytery, in contrast, is articu-
lated as a part of the space of the tri-
bune and is provided with two semicir-
cular wings that expand the space in a
transverse direction; a semicircular
screen, formed of four columns with
architrave, separates it from the choir.
Four corner piers, cut at a forty-five
degree angle and articulated in a re-
fined play of semicolumns and niches,
emphasize the articulation of the tri-
bune as an essentially self-contained
space; this perception is further em-
phasized by the steps that separate
the presbytery from the nave.

Finally, behind the semicircular screen
is the choir. Its far end is rounded,
somewhat like a shallow apse, but this is
certainly a less elaborate space than its
counterpart in San Giorgio Maggiore.

Light acts as an essential element of
the composition; variations in the qual-
ity of illumination harmonically under-

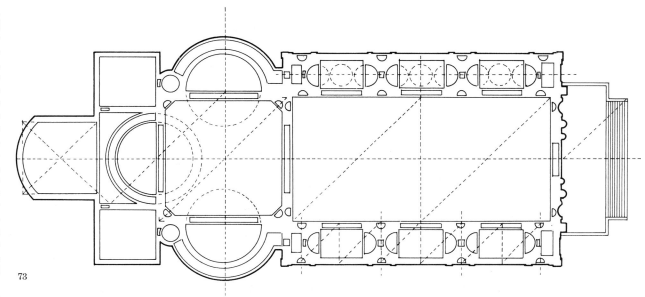

73

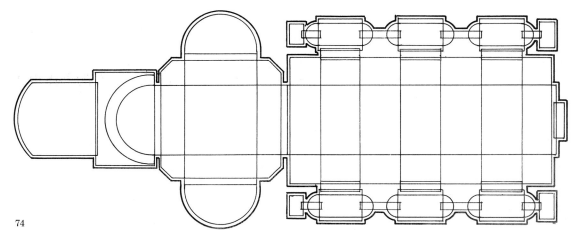

74

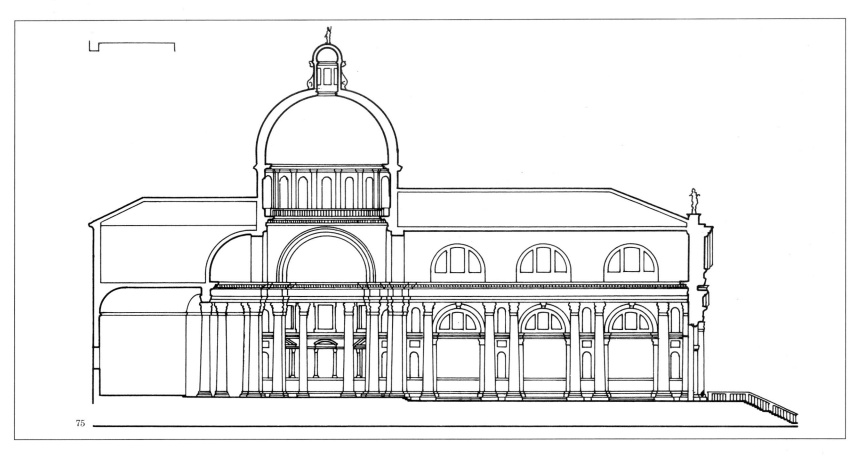

75

score the differences between the three main spatial components. The thermae-type windows of the nave provide a diffuse light, while abundant light enters the tribune area from the drum windows and becomes even stronger in the choir, emphasizing the screen function of the columns at the back of the presbytery. On one hand, the light underscores the individuality of the spaces; on the other hand, it provides a vigorous unifying element that is further emphasized by the uniform whiteness of the interior walls.

Once again the perception of axial perspective becomes a fundamental reference element in the articulation of Palladio's architecture. The three spaces, their decorative elements, the connections between them, are all conceived as a succession of stage sets. Nor is this conception extraneous to the celebrative function of the building: once a year, in fact, there is a grand procession that enters the Redentore after crossing, from the opposite side of the canal, a bridge of boats aligned directly to the internal axis of the church.

This sequence of clearly defined spaces can be seen as another response by Palladio to the problem of connecting a longitudinal nave to a central-plan tribune. Here, compared to the solution in San Giorgio Maggiore, a greater balance is achieved between the dimensions and

the articulation of the spaces, and the sequence of spaces is more gradual.

72. Longitudinal section.

73. Geometric scheme with main proportional relations.

74. Spatial diagram of the plan.

75. Longitudinal section.
Articulating the nave is a giant order composed of paired semicolumns against the walls; there are two niches, one above the other, between each pair of columns. These units frame the openings of the side chapels, whose entrance arches are supported by a minor order. Unlike the columns in San Giorgio Maggiore, the columns of both orders in the Redentore rise from floor level.
The play of the two entablatures, corresponding to the different impost heights of the vaults of the nave and the "aisles," is even more elegant here than in San Giorgio, because the space between the pairs of giant columns allows the lesser entablature to appear with greater continuity along the wall. With this detail, whose origin can be found in certain works by Alberti and Bramante, the church interior is perceived along a double, intertwined system that continuously provides an element of scale and connection between

its two main dimensions.

76. Compositional scheme of elevation.

77. Transverse section along main nave.
The section shows how the central, barrel-vaulted space is conceived as essentially autonomous with respect to the lateral spaces: there is a marked difference in height; and the transverse disposition of the barrel vaults in the side chapels, with respect to the main axis of the nave, emphasizes the chapels' role as auxiliary spaces (see fig. 72).
Finally, it can be seen how, in spite of the great difference in articulation, the play of the minor entablature running around the entire internal perimeter of the church provides continuity for the whole space.

78. Elevation.
As in San Giorgio Maggiore, Palladio develops in the Redentore a solution for the facade that expresses on the exterior the relationships between the various internal spaces. Thus there are the same two systems, one related to the nave and the other to the minor spaces of the side chapels. Each is expressed as the front of an *in antis* temple projected onto a plane, with a pediment supported by columns whose height is proportional to that of the interior.

In San Giorgio Maggiore, the lack of coordination between the minor order, which stands at ground level, and the major order, which rises on pedestals, created a problem of connection, both with the base of the building and with the entrance steps. In the Redentore Palladio places both orders on a common base that serves to absorb the presence of a monumental staircase in the form of a large landing. This common base allows greater coordination between the larger scale front with semicolumns and the smaller scale front with pilasters. Moreover, Palladio does not emphasize the continuity of the architrave of the minor order's pediment. Thus, the superimposition of the major order relative to the nave is even clearer.

This facade is massive and severe; many of the decorative details present in previous buildings have been eliminated. The final effect is more monumental, even though the entire facade resembles a series of spatial planes that suggest the axial perspective of a stage set.
The Redentore and San Giorgio Maggiore serve, in any case, to establish the characteristics of a highly successful model that will be used innumerable times, with infinite variations, in the course of centuries to come.

79. Transverse section along transept.

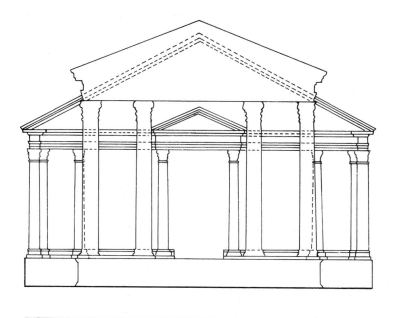

76

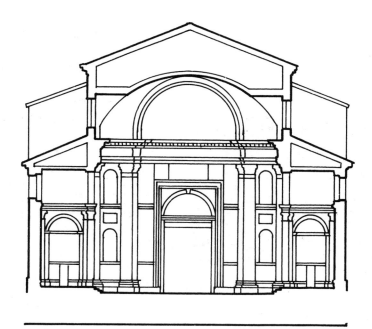

77

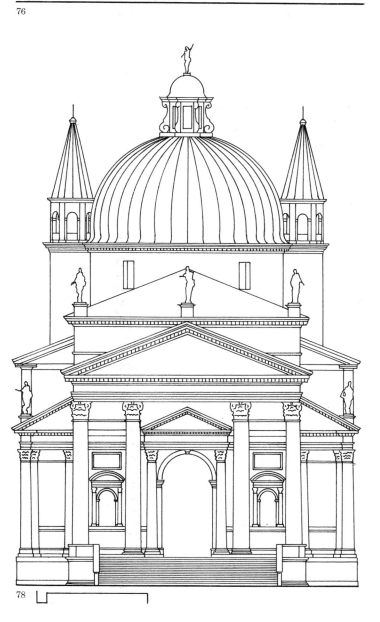

78

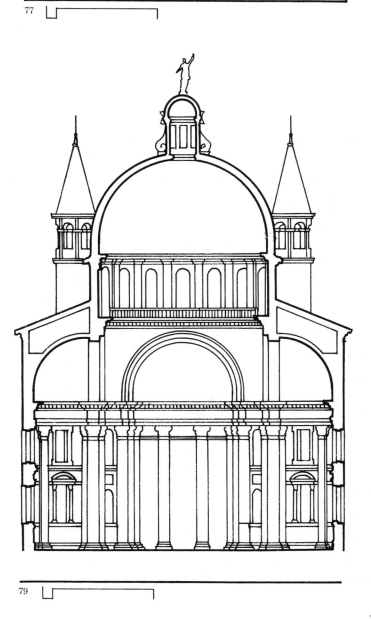

79

Jacopo Barozzi da Vignola
Il Gesù
from 1568
Rome

80. Plan.

The *Chiesa del Gesù* represents a profound change in the architectural tradition of Rome and marks the beginning of the Counter Reformation tradition. In the course of only a few years, this new tradition completely revolutionized the characteristics of churches and gave rise to a series of constructions that all have common features: a nave conceived as a great hall; side chapels organized as precisely circumscribed and spatially defined secondary spaces; a centrally located presbytery, closely connected to the tribune and often even integrated with it; transepts of limited extension or, in some cases, assimilated into the tribune space.

Vignola's Gesù exemplifies this transition, setting out some of the elements that will later become the common characteristics – at times excessively common, and even identical – of so many churches; as Ackerman notes, this new organizational model was not accompanied by an architectonic vision or by spatial principles worthy of the name. In the end, an entire generation of architects began to limit themselves to the reworking of a constant model. The few variations that they introduced were incapable of producing the variety of results so typical of the Renaissance.

Vignola's architectural skill was extraneous to the drawing up of the functional and organizational program for the church. In fact, Cardinal Farnese wrote to the architect about a meeting he had had with a certain Father Palonco, the representative of the Society of Jesus, during which certain characteristics of the church were dictated. First of all, it was established that, in accordance with Renaissance tradition, the church should be well proportioned in length, width, and height. It was to be longitudinal in plan, with a great,

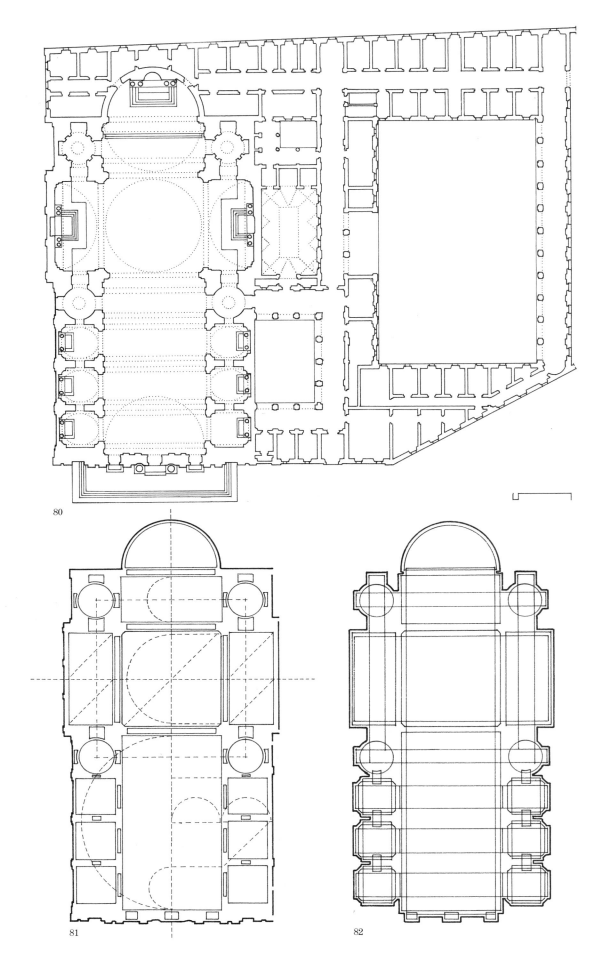

80

81

82

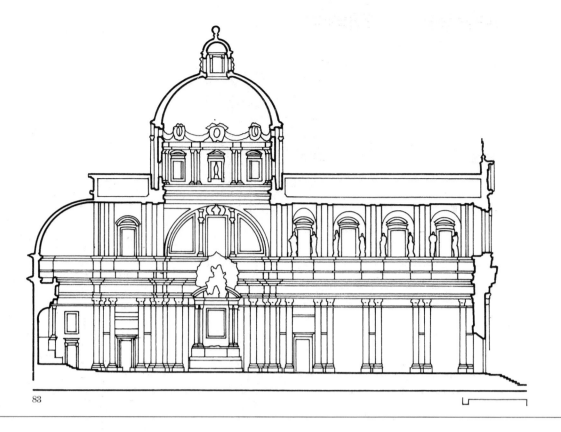

83

84

hall-like nave, but no aisles. The nave would be barrel-vaulted–despite criticisms of certain members of the Society of Jesus concerning the acoustic problems inherent in this type of structure–and there were to be a series of chapels along each side of the nave. A number of specifications were also made for the siting of the church: the facade was to be oriented on axis with the street leading up to it.

Vignola had no choice but to follow these requirements. His project, as Tafuri notes, combines a centrally planned tribune – defined by the diagonal, oblique faces of the piers and by the four circular chapels situated at its four corners – and a longitudinally planned rectangular hall. Yet this combination of spaces no longer possesses any of the controversial tension that an entire generation of Renaissance architects had attempted to resolve. Here, the tribune and nave of Vignola's project are simply juxtaposed without any particular articulation or conflict; the space flows freely, without obstacles but also without emphasis, from one element to the other.

81. Geometric scheme with main proportional relations.

82. Spatial diagram of the plan.

83. Longitudinal section.
Compared to the churches of Palladio, Vignola's Gesù shows a complete lack of any attempt to mark the connecting points between spaces. The perception of a single, unified space prevails, emphasized by a uniform sequence of architectonic members along the length of the whole church.
The giant architectural order – there is no intermediate, lesser order as in San Giorgio Maggiore – supports a continuous entablature around nave, transepts, and presbytery. The entablature, whose articulation is further emphasized by the addition of a pulvin with a fascia above, is thus transformed into a true, full register, with the principal function of homogenizing the relationship between spaces of different form and use.

84. Original elevation as designed by Vignola (represented in an engraving by Cartaro).
The facade of the Gesù represents the definitive break between the external reality of a church building and its internal space. The elevation is conceived as an autonomous piece of scenery, with principles of articulation and decoration that are completely independent of the interior.

1

2

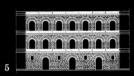

4

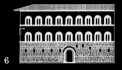

5

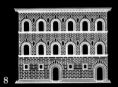

6

7

8

9

10

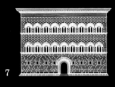

11

12

13

14

23

24

Civilian buildings - Palaces
Chronological table

3

15

16

17

18

19

20

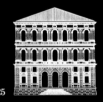

21

22

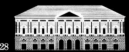

25

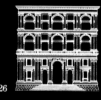

26

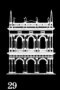

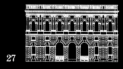

27

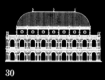

28

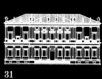

29

30

31

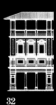

32

Filippo Brunelleschi
Ospedale degli Innocenti
1419–27
Florence

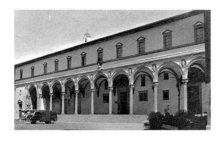

1. Plan.
The presence of a portico as a part of this foundling hospital complex exemplifies a tradition found in many Italian cities. Porticos or loggias provided spaces along the side of a street or piazza, where the population could meet and talk; often they were the scene of important decisions and power struggles. The private and public loggias of fourteenth-century Florence – for example, in Piazza della Signoria or at Orsanmichele – as well as the loggias of other hospitals, such as the Lupi and Balducci hospitals, may be considered as possible references for the decision to include such a structure as part of the main facade of the new building.

In the portico of the Ospedale degli Innocenti, however, the loggia is not, as was usually the case, an element unto itself, i.e., an unrelated part of the building or an isolated episode in the urban context. Rather, it is an essential part of the building, belonging to the order that governs the relationships and proportions of all the contextual elements into which it is inserted. In a totally innovative way, the portico defines the setting of the entire piazza, by imposing an element of order on the whole space. Thus it does not belong exclusively to the building to which it is attached, nor is it seen only in relation to the square (as is the case in the loggia of Piazza della Signoria, for example); rather, it creates an interaction between the two.

Brunelleschi's project, in fact, delineates the first Florentine piazza to be conceived as a space of its own–not merely the result of widening the street or a series of unrelated projects, as was usually the case in medieval cities. Thus, it is not an accident that the construction of a single side should lead to a succession of consistent solutions for the piazza over the centuries, from the loggias by Sangallo and Baccio d'Agnolo to the fountains by Tacca

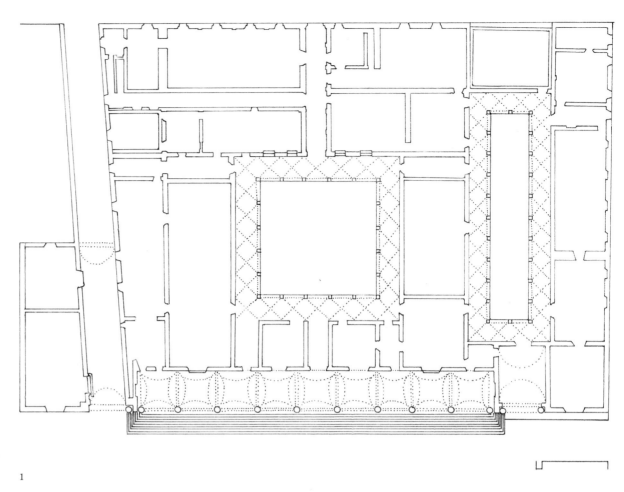

1

and the statue by Giambologna. As Fanelli points out, this project is inserted into the urban fabric in front of the ancient church of the Serviti, which was approached by the Via dei Servi – a "new" street, dating from the thirteenth and fourteenth centuries, that Brunelleschi transforms into an important urban axis between the Piazza del Duomo and the new, symmetrical piazza to be named after the church of the Annunziata.

2. Axonometric view.
The hospital building, together with its portico, introduces a new architectonic design of clean, clear lines and surfaces, with its own characteristic cadence. The rectangle of the plan can be seen as a definite succession of square spatial units. In effect, as Zevi notes, Brunelleschi breaks the rectangle of the portico recess into squares, just as on the facade he breaks the surface plane, which corresponds to the overall front elevation of building and portico, into harmonically related registers.

3. Facade elevation.
The elevation reflects a new Renaissance spatial conception that seeks to

give depth even where it would not naturally be appropriate, for example, on a wall surface that would normally be destined to be flat.

The facade can, in fact, be seen as the superimposition of a series of planes. This superimposition is present not only vertically, in the two registers; Brunelleschi also applies it in the direction of the depth of the facade, through the theoretical definition of a sequence of three planes: the plane of the portico, with the parapet above it; the theoretically set-back plane of the windows themselves; and the plane of the back wall of the portico. Although the back wall does not actually belong to the plane of the principal elevation, its depth provides a perspective background that gives body to the portico itself. An eloquent detail connected with this conception is the pilaster that "covers" a portion of the Della Robbia glazed terra-cotta medallion placed in the spandrel. The theoretical distance to the pilaster is different from that to the medallion, thus suggesting a vertically partitioned structure of set-back planes. This serves to visualize the ideal spatial framework in which these planes are arranged,

one behind the other, like the receding wings of a stage set.

4. Geometric scheme with main proportional relations.
The proportional module that governs the entire composition of the portico is not, as might be expected, the distance between the centers of the columns (equal to 10 Florentine braccia). It is, in fact, slightly smaller, being based on the space between consecutive columns – the intercolumniation–i.e., on the relationship of solids and voids established by the succession of columns and arches. The height of the intermediate supports (the columns with their bases and their pulvinated capitals) corresponds to the measure of the intercolumniation. In fact, it is not the capital but the pulvin that provides a decisive, horizontal upper limit to the supporting elements.

The height of the arches is in direct relation to the basic module, being equal to one-half the dimension of the intercolumniation; and the total height of the first register, which includes the whole portico up to the molding of the window sills, is twice the basic proportional module.

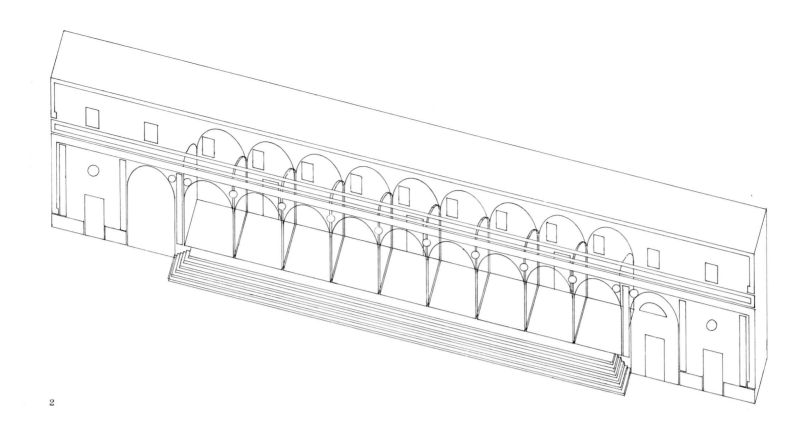

2

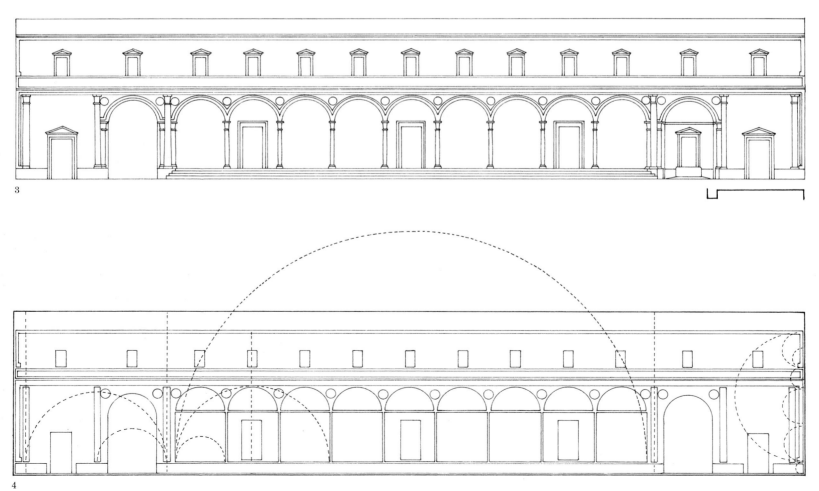

3

4

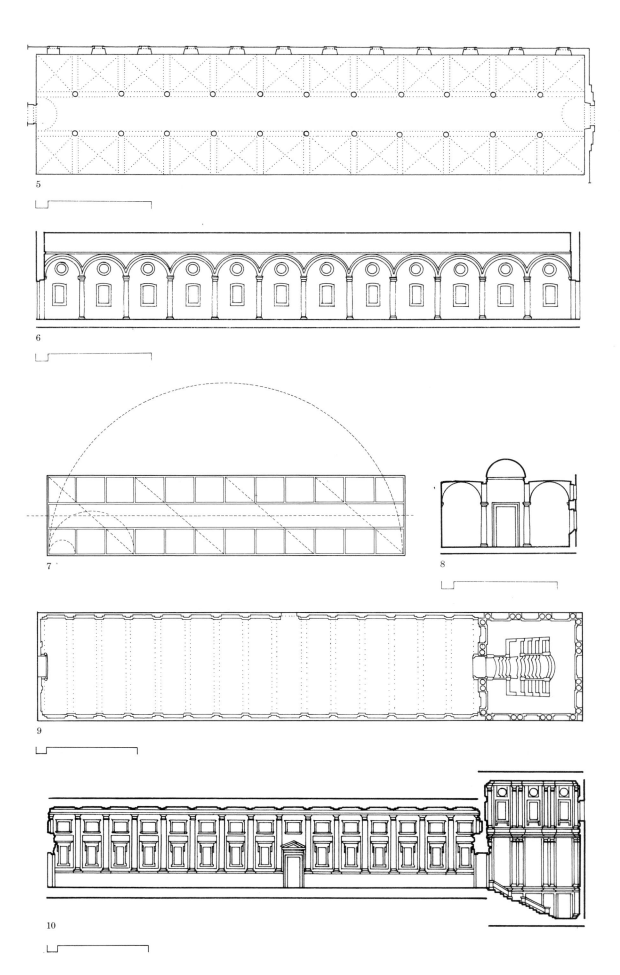

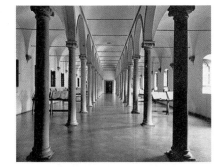

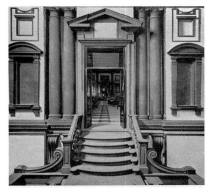

Michelozzo di Bartolomeo
Library
in the Convent of San Marco
1436–43
Florence

5. Plan.
The articulation is dictated by the functional need of accommodating a series of reading tables where the monks could work and study, while leaving a central corridor for circulation.

6. Longitudinal section.

7. Geometric scheme with main proportional relations.

8. Transverse section.

Michelangelo Buonarroti
Laurentian Library
1523–59
Basilica of San Lorenzo, Florence

9. Plan.
The Library is one of the most intriguing works of the whole Renaissance period; to visit it is a dramatic spatial experience. The contrast is striking between the verticality of the entrance hall and the horizontality of the reading hall. The first is characterized by an absolutely innovative bi-colored wall treatment; the second assumes a more traditional appearance thanks to the wood finish of walls and reading tables–a material. The entrance hall contains a staircase, which is a unique piece of sculpture, commonly attributed to Bartolomeo Ammanati.

10. Longitudinal section.

Michelozzo di Bartolomeo
Palazzo Medici-Riccardi
from 1444
Florence

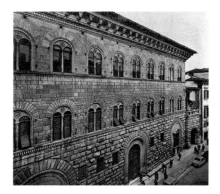

11. Elevation.
The facade is based on a triple horizontal division, emphasized by horizontal moldings and a gradual lessening in the rustication of the wall surfaces in the higher stories. The monumental crowning cornice is proportioned not to the single register of which it is a part, but to the facade in its entirety.

The rows of blocks of *pietra forte* – the typical Florentine construction stone – in the ground-floor level are only slightly variable in height; the blocks of varying dimensions rise from a stone bench, which functions as a sort of base, to a weak cornice with dentils. The rustication of the *piano nobile* is slightly less, with the blocks projecting only a few centimeters. On the top floor the stone has an almost smooth finish, with an imperceptible projection that resembles a stone wall face.

The biforate windows of the top floor are identical in size to those of the *piano nobile*, although the lower height of the register creates the optical illusion that they are wider. The round-headed biforate window inscribed in an arch, with its central, tangent "eye" decorated with the Medici coat of arms, is the humanistic version of an analogous theme at Palazzo Vecchio. Finally, the heavy cornice above sets the boundaries of the facade volumes and with its great weight serves to bind the three superimposed registers compactly together.

It had been so long since rusticated stonework began to be employed for important buildings that by this time it had become a characteristic of the city of Florence; thus, it is certain that its use in Palazzo Medici-Riccardi is a clear reference to the local building tradition. But, as Preyer notes, the type of rustication used here differs

for two important reasons: first, the reference to ancient Roman architecture is more explicit, whereas in the Middle Ages it had been only implied; second, it confers a degree of power and expressiveness unprecedented in any other Florentine palace.

The reference to classical antiquity is an important, recurrent theme throughout the building, for example in the semicircular arches that frame the openings at ground level and the windows on the two upper floors. Semicircular arches are also found in

Palazzo Vecchio, but here they appear for the first time in a private Florentine palace; before this the arches of private residences were always acute or segmented.

12–13. Plan and longitudinal section.
The typology is that of the house with courtyard. This type, with distant roots in the Roman *domus*, is characterized by rooms built on a single functional band, facing outward onto the street and inward onto the courtyard.
On the ground floor level and in the

basement, close to the portico used for business transactions, were the storerooms for goods and provisions. Above, on the *piano nobile*, were rooms for receptions and entertainments, and there was also a chapel where the family could attend religious ceremonies in private. On the upper floors were the private apartments and accommodation for servants and staff.

The square courtyard at the center of the palace served an important function as a transition space between the public area of the city and the private area of

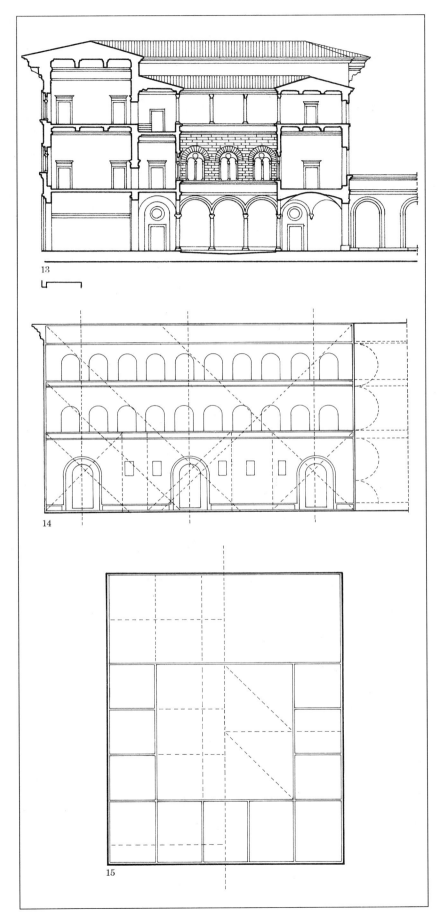

13

14

15

16

17

18

the house. The courtyard is surrounded by columns with composite capitals; there are three arches per side, their highest points tangent to a high entablature with architrave. This recalls Brunelleschi's scheme for the Portico degli Innocenti, although here, because of the square plan, Michelozzo had to "fold" the line of arches at every corner–a detail which results in a rather weak effect. The biforate windows, which correspond to the level of the *piano nobile*, are identical to those on the facade.An open loggia forms the uppermost storey of the courtyard.

14. Geometric scheme of elevation with main proportional relations.

15. Geometric scheme of courtyard with main proportional relations.

Project attributed to
Filippo Brunelleschi
Palazzo Pitti
from 1442
Florence

16. Elevation of the part corresponding to the seven bays attributed to Brunelleschi.
The residence of the Pitti family was built beyond the Arno, outside of what at that time was the center of the city of Florence.
Construction on the palace began only after Brunelleschi's death. Its mass is enormous; built completely of stone, it contains some noteworthy design solutions. The composition is based on a series of great, projecting horizontal cornices with balustrades at each level, marking the three registers that make up the facade. The plane of the facade is marked by the rhythm of the large niches that contain the enormous windows of the upper two floors; on the ground floor there are three large entrance por-

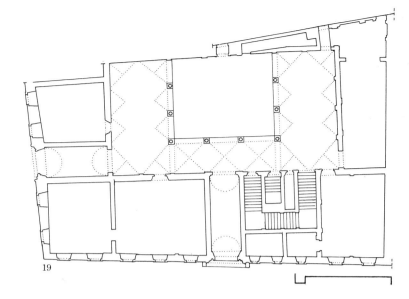

19

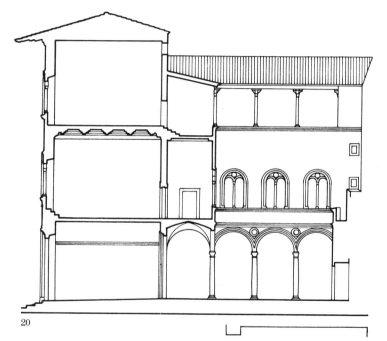

20

tals, with small, rectangular windows between them. This is the first private building to have full-length windows on the two upper floors, rising from floor level with an external terrace connecting them. On the *piano nobile*, the three central arches are open to a loggia that overlooks the city.
The standard elements – rusticated stonework, narrow bands separating the various registers at the level of the window sills, large biforate windows contained in round arches and cut into the wall with no special treatment of the side-posts – the standard elements – into an architectonic whole that is unique in its mass and its effect.

17. Geometric scheme with main proportional relations.
The elements of the facade are governed by a square-based, harmonic grid. The entrance portals, the semicircular and rectangular windows, the cornices, and the balustrades are all proportioned and positioned according to the basic geometric alignments generated by the grid.
The three registers are similar in height. The cornices provide an interval between floors and mark the base line of the plane of each register. On all levels the same proportion – a 1:2 ratio – determines the height of the windows and the space separating them from the cornice above.

Attributed to *Filippo Brunelleschi* and built by *Giuliano da Maiano*
Palazzo Pazzi-Quaratesi
from 1462
Florence

18. Elevation.
The organization of the facade is similar to that of Palazzo Medici-Riccardi. It is, first of all, a tripartite scheme, with narrow, dentilled cornices marking the different registers. Secondly, the entrance portal is characterized by rusticated stonework that follows the entire outline of the door like a frame. Finally, the biforate windows are very similar to those of Michelozzo's building. Completely new is the use of stucco on the two upper registers; this demonstrates the influence of Brunelleschi's architecture, where the contrast between white plaster walls and the dark color of the architectural members was one of the main architectonic themes. The use of stucco marks the introduction of an innovative theme: the liberation – partial and limited though it might be – of the two upper floors from the heavy stone that had been the principal construction material (brick was also used, but only rarely) for all Florentine palaces throughout the thirteenth and fourteenth centuries. The white stucco modifies the relationship between the various floors with respect to the light and introduces greater contrast with the pale stucco and the dark, stone window frames. The white wall reflects light strongly and acts in opposition to the rusticated stone wall, which absorbs light in the play of shadows on its surface.

19–20. Plan and transverse section.
The inner courtyard is approximately square, with a graceful portico on three sides. Above runs the architrave-like fascia, the band marking the register, and finally a row of biforate windows. On the top floor there is a loggia. The fourth side of the courtyard is closed, up to the height of the *piano nobile*, by a wall made up of three blind arches resting on pilasters, surmounted by the same horizontal elements as are found on the other three sides.

Project by *Benedetto da Maiano*
alternative project by *Giuliano
da Sangallo*
completed by *Simone del Pollaiolo*,
called *il Cronaca*
Palazzo Strozzi
1489–1507
Florence

21. Plan.

Two architects collaborated in the design of Palazzo Strozzi: Benedetto da Maiano and Simone del Pollaiolo. Their collaboration was close and continuous, so that today it is difficult to determine which aspects of the building can be attributed to one or the other.

Palazzo Strozzi is located in the center of Florence, in the nucleus corresponding to the original city founded in Roman times. The corner site is open on three sides, one of which is on one of the main streets of the center, and another on a small square. The palace, however, is detached from its neighboring buildings on the fourth side as well, thanks to a small street that made it possible to open a series of windows on a "service" side. The building thus seems to have been conceived with two main facades. This impression is confirmed by the biographer of Filippo the Elder, who points out that Filippo desired to build a palace in the midst of the quarter occupied by other members of the Strozzi clan and, at the same time, to create something that would "bring renown to itself and to the entire family, both in Italy and abroad."

This urban context presents, therefore, two aspects: on one hand there is the more public "facade" relating directly to one of the main streets of the city; on the other hand, on the opposite side, there is a more private facade, which has links with the old quarter of the Strozzi family. Later there will be a third aspect, as Elam points out, which will assume greater importance toward the end of the fifteenth century, i.e., the presence of the nearby piazza of the Old Market.

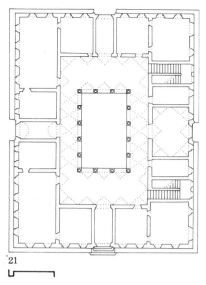

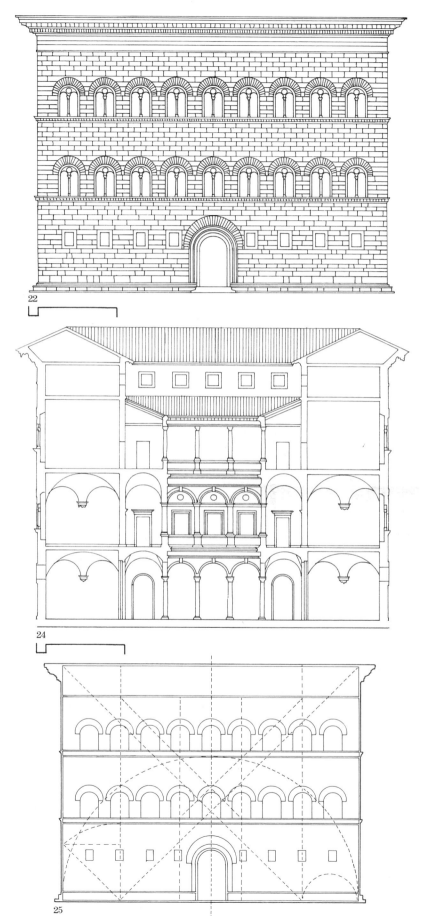

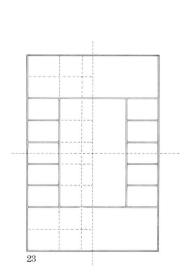

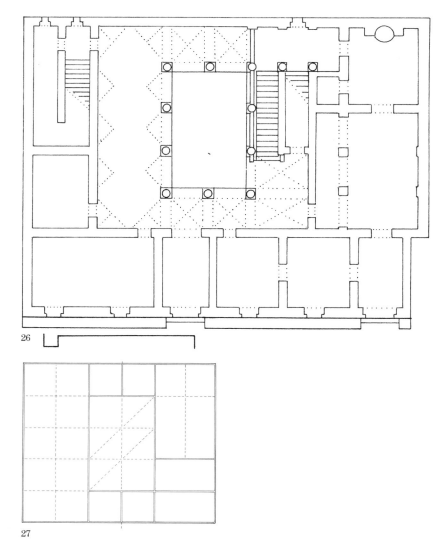

26

27

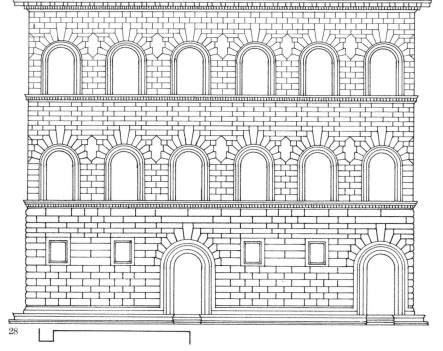

28

22. Elevation.

The facade of Palazzo Strozzi is definitely original, even though it once again takes up the traditional theme of rusticated stonework. The precedent is not Palazzo Medici-Riccardi (heavy rustication on the ground floor, less rough on the *piano nobile*, smooth stone on the top floor); nor is it Palazzo Pazzi-Quaratesi (white stucco on the upper two floors) or Palazzo Rucellai (superimposed architectural orders–unique, in any case, in fifteenth-century Florence). The only possible precedent for the facade of Palazzo Strozzi is Palazzo Pitti, which is entirely covered in rough-hewn blocks; however at Palazzo Strozzi the work is smoother, more refined and almost elegant, reflecting in a certain sense the spirit of the late fifteenth century. (But it should also be kept in mind that Filippo Strozzi had returned to his native Florence after a long sojourn in Naples, where Palazzo Cuomo had been built between 1464 and 1490: its facade is completely rusticated, and the blocks in the ground-floor register have the same "swollen, hammered" aspect that is encountered in Palazzo Strozzi.)

Upon completion of the windows of the *piano nobile*, Simone del Pollaiolo must have realized that the molding marking the upper boundary of the top floor would have to be raised in order to avoid a flat impression, especially along the longer facade on Via Strozzi. An even bolder heightening was achieved by the insertion of an attic – as distinct from a molding or cornice – between this molding and the crowning cornice, so that the height of the third register corresponds exactly to that of the first, i.e., the ground floor. This ingenious variation presages the analogous variation in height introduced by Michelangelo in the top floor of Palazzo Farnese in Rome.

Equalizing the height of the registers in this way – as had been done in Palazzo Pitti – shows a classical influence, as opposed to the medieval practice of emphasizing the ground floor (which resulted from the use of vaults to cover the rooms within). In the original project, the height of each of the upper floors was to be less than the height of the ground floor; this would certainly have made the facade less full and robust than it is in the form that was finally constructed. The cornice, as designed by Pollaiolo, is prepared for by a smooth zone below it, almost like the cornice of an entablature above its frieze. This has a powerful effect on a viewer's perception of this vast building, which despite the play of multiple rhythms on the fa-

cades, is perceived as a single enormous block.

23. Geometric scheme of courtyard with main proportional relations.

The courtyard has a twofold organization which relates to the presence of two opposing main entrances–one to the street and one to the square. Therefore, the typical utilitarian space for horses and carriages is placed at both ends of the courtyard. The articulation of the courtyard bays follows a proportion of 3:5, which is a simplified proportion of a golden section series such as that of Fibonacci (1, 1, 2, 3, 5 . . .).

24. Transverse section.

In order to preserve the typical vertical organization of portico, *piano nobile*, and loggia, the top mezzanine service floor is transformed into an attic floor. By doing so, the sloping roof can also shorten the height of the third floor – the loggia – thus reducing the overall dimension of the courtyard sides and allowing a better illumination of the entrance floor.

25. Geometric scheme of elevation with main proportional relations.

The overall proportion of the rectangular facade is based on a grid generated by two overlapping squares, which are shifted by one bay with respect to each other. The width of the facade is therefore equal to the sum of the side of a square plus a bay; its height corresponds to one side of the square.

Giuliano da Sangallo
Palazzo Gondi
from 1490
Florence

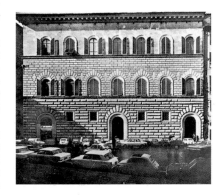

26. Plan.

The plan of Palazzo Gondi does not present as clear and pure an articulation as Palazzo Strozzi. It is constrained by the pre-existing urban situation; nevertheless, all the typical elements–courtyard, portico, staircase–are forced into the

site. The result is a rather uncommon articulation.

27. Geometric scheme of courtyard with main proportional relations.

28. Elevation.
The original elevation makes a direct reference to Palazzo Strozzi, though Palazzo Gondi originally had only one facade, on the piazza in front of it.
The overall scheme recalls Palazzo Medici-Riccardi; however, a series of innovations are to be found here. The planned loggia, intended to crown the building above the level of the present roof, was an entirely new feature, though it was never built. In the middle of the century, Alberti had built a loggia on the top floor of Palazzo Rucellai, but it was set back from the plane of the facade and thus not visible from the street, being reserved for private family use. However, in Palazzo Gondi, the loggia becomes an integral part of the facade. The windows are not biforate, nor, given their dimensions, could they have been, but simple, arched openings – a sign of almost imperceptible, but definitive liberation from the model provided by Michelozzo.
But the most personal characteristic is the rustication. Its language is new, clear, and purposefully decorative. On the *piano nobile* the stonework is no longer in relief, and it forms decorative curves from window to window, with a special cross motif marking the passage between the arches. On the top floor the rustication is even smoother: it retains the elegant design of the continuous arched lintels of the windows.
The inventiveness of Sangallo lies in the fact that he does not define the composition of the facade through the use of the architectural order, nor through the repetition of the same module of solids and voids. The texture of the facade is enhanced by the decorative value of the various types of rustication employed. Moreover, the way that the horizontal courses are lined up with the wedges in the arches of the portals creates a new design motif that will be used by Bramante and Raphael, and by countless others after them. The courtyard, off-center as in Palazzo Rucellai, adopts a rectangular plan based on the golden section, although there is no discernible need for this solution; it is evidently influenced by Palazzo Strozzi.

Biagio Rossetti
Palazzo dei Diamanti
from 1493
Ferrara

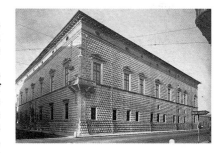

29–30. Elevation and plan.
The palace was built for Sigismondo d'Este as part of the greater project for the expansion and reorganization of the city of Ferrara. It is situated outside of the central nucleus of the walled city and, unlike many of the Florentine palaces of the period, does not present a proportional, ordered organization in plan. Although built around a central courtyard, the various parts of the building do not follow a unified design, but are arranged in an almost random fashion, particularly in the rear section. The elevation, in contrast, has a very coherent design and thus functions as a screen, covering and "homogenizing" a rather disorderly internal disposition.
In spite of a very elaborate appearance, the elevation is composed of a small number of elements. A marble molding defines the height of the lower wall section, which is slightly inclined up to the level of the ground floor windows. Another, egg-and-dart molding, together with a fascia and architrave, separates the two main floors and serves as a base for the windows of the *piano nobile*. The crowning cornice is given greater emphasis by the wide band beneath it, pierced by a series of oval windows. At each corner of the two facades, terminal pilasters are covered with delicate bas-relief carvings. A pair of similar pilasters also flanks the entrance door. The door has a very linear decoration, with a pair of narrow, recessed pilasters at each side, supporting an arch. The windows are rectangular, with a simple cornice on the ground floor and a classical pediment on the *piano nobile*.
The entire facade is covered in marble, with the exception of the entablature beneath the uppermost cornice, which is finished in brick. The most characteristic feature of the facade is the "diamond" cut of the individual stones: they are shaped as regular pyramids. In order to avoid an excessively heavy

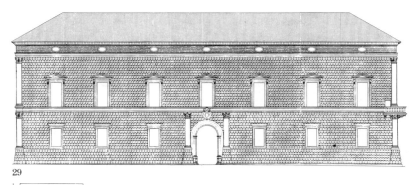

29

30

and monumental effect in this marble facade, Rossetti avoids the wide junctions that are used between the blocks of a typical rusticated wall surface and makes the eight thousand five hundred stones of the facade project much farther from the wall. Thus, by transforming the facade into a uniform plane in low relief, he obtains a twofold effect: the facade appears lighter and the volumetric mass of the building more compact and vigorous.
Thanks to the tightly interconnected play of shadows created by this particular type of rustication, the facade of the palace is perceived homogeneously in its entirety. The surface treatment emphasizes the volumetric mass of the building without particularly stressing the division of the facade into registers. In contrast to Florentine palaces such as Palazzo Medici-Riccardi, the Palazzo dei Diamanti follows the tradition of unified treatment for the facade, used for the first time in Palazzo Pitti.
As Zevi notes, optical corrections and other devices make the succession of individual stones less mechanical; otherwise, the parallelepiped volume, covered with such a "violent" surface

treatment, would have been static and oppressive on the street corner.
For example, Rossetti sets the *piano nobile* slightly back from the vertical plane of the ground floor; the shift is noticeable, though not, perhaps, to the casual observer. The compositional layout of the building makes it, so to speak, "more sculptured than constructed." In spite of the modernity of the aesthetic achievement, the solution of the facade emanates a sense of castlelike solidity, a suggestion of the antique, of power, that lends itself to the tradition of dominance that the Este family had in Ferrara.
Finally, the crowning cornice is detached from the rigid geometry of the diamond points; it floats elegantly above the block of the facade without becoming involved in the complex rustication below. This recalls the cornice of Palazzo Strozzi, which is similarly removed from a lower mass of rusticated blocks.

Leon Battista Alberti
Palazzo and Loggia Rucellai
from 1446
Florence

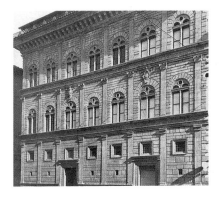

31. Plan of Largo Rucellai, with the palace and the loggia.

Vasari informs us that the projects for the palace and the loggia facing it were prepared simultaneously by Alberti for Cosimo Rucellai. In order to understand the reasons for the form of the facade, originally based on only five bays, it is necessary, as Sanpaolesi notes, to consider the layout of the streets and the way the facade would be viewed.

In the narrow, winding streets of the time, the facade was seen at the end of the Via del Purgatorio, a narrow street that nevertheless allowed a view of the full height of the facade. In addition, the axis of the street was aligned, albeit obliquely, with the central bay of the palace, i.e., with the main entrance portal. This created the illusion that the facade, which was actually quite small, extended farther to either side of the doorway than was really the case.

The facade was thus originally only five bays in width, with the door exactly in the center, symmetrical with respect to the mass of the building. But when the small houses at the end of Via del Purgatorio were demolished in order to open up the piazza, give more light to the palace, and make room for the construction of the loggia, it perhaps became evident that the five-bay format was insufficient and inappropriate for the new space in front of it. It is likely that at this moment the decision was made to extend the facade, whose ground floor had already been completed.

Thus the design and construction of the palace were directly influenced by the urban situation in fifteenth-century Florence. Whoever desired to construct a large palace was obliged to buy up a good number of medieval housing lots, which were typically very narrow on the street, but also very deep. The construction of a

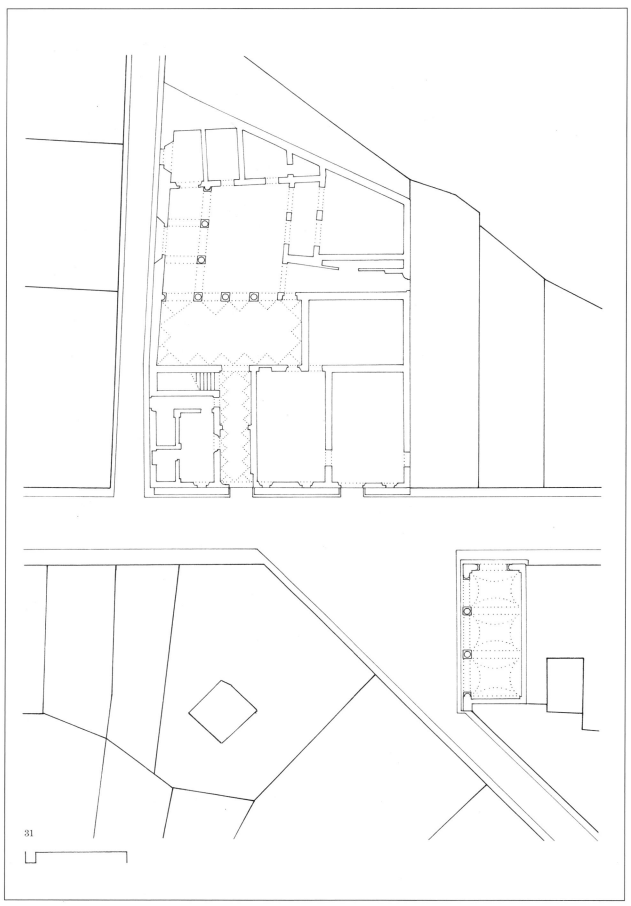

31

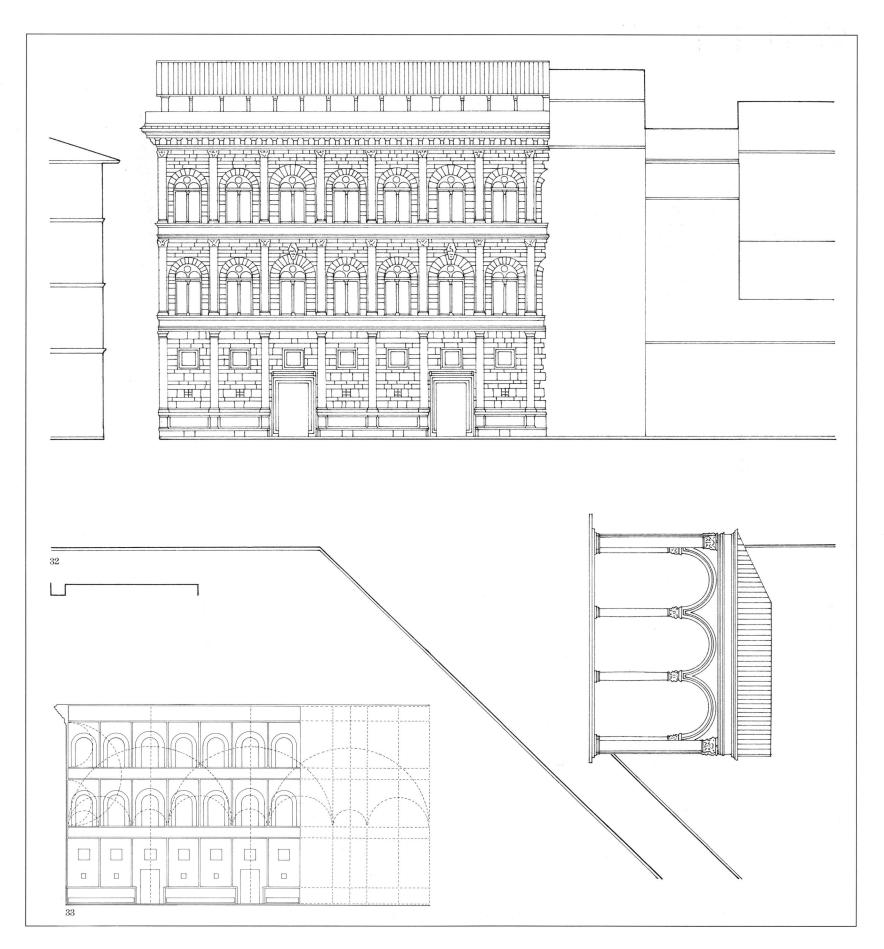

32

33

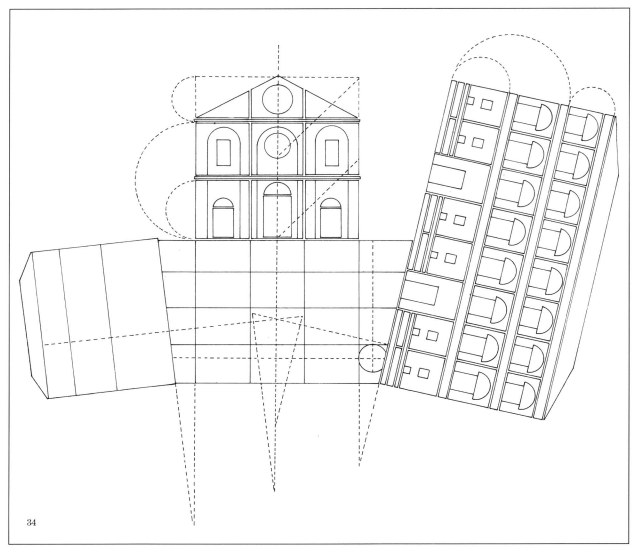

34

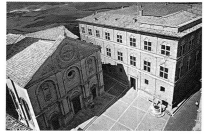

34. Geometric scheme of the square and of the tilted elevations with main proportional relations.

35. Plan of Piazza Piccolomini and surrounding buildings.

The piazza was created by demolishing the church of Santa Maria and the houses of the Piccolomini family. The duomo and Palazzo Piccolomini were constructed in their place, and other buildings were transformed so as to obtain a palace to the left of the duomo (Palazzo Borgia, later the bishop's palace) and a small municipal building facing it. Continuing along the street were the smaller palaces destined to be the residences of the most important cardinals and other personages of the court of Pope Pius II (Aeneas Silvius Piccolomini). In order to give greater emphasis to the facade of the duomo and to create a kind of natural scenic backdrop by opening up a view of the landscape behind it, the architect sets the two main buildings, to either side of the duomo, at right angles to the street; since the street approaches and leaves the piazza at an angle, the buildings' axes are thus not aligned with that of the duomo.

The result is an irregular trapezoidal piazza which, according to Finelli and Rossi, is perceived upon approaching it to be much wider than it really is, and upon leaving it, to be much deeper. The position of the fountain on the right, near Palazzo Piccolomini, creates a break in the possible compositional symmetry and further accentuates the divergence of the two palaces that open toward the landscape background beyond the duomo. Although it would be premature to speak of scenographic effect in the full sense of the term, it is undeniable that these buildings are not positioned in any random way. This is confirmed by observing a number of significant details: the slight shift of the duomo towards Palazzo Borgia; the paving design that

palace was therefore linked, on one hand, to the possibility of acquiring the necessary, contiguous building lots, and, on the other, to the family's requirements and the traditional practice of adding on to the building whenever the family needed new rooms. Palaces were therefore subject to expansions and additions; because of this continuous development, the facade had a secondary function as a screen, that is, it masked the differences in the various residential units that existed behind it. The five-bay design of Palazzo Rucellai's facade implies a cubic proportion that does not correspond to the overall dimensions of the plan but must be understood as a "front," that is, a self-contained decorative plane.

32. Plan of the Largo Rucellai with tilted elevations of the palace and the loggia.
As Borsi remarks, Palazzo Rucellai – or rather, the facade of Palazzo Rucellai –

presents Alberti with the opportunity to take the accepted Florentine formulas (*pietra forte*, rustication, biforate windows) and enrich them with the "novelty" of the grid of superimposed architectural orders, which is both a proportional structure and a classical reminiscence. That the stones of the facade were not differentiated according to the logic of the composition, but were cut independently of their position and of the overall design of the rustication (a single stone might be shaped so as to form part of a pilaster as well as a rusticated block in the wall next to the pilaster), demonstrates that for Alberti (and for Rossellino, who constructed the wooden model) the facade was considered merely a decorative screen, and the only rule to follow was the craftsman's "rule of art": the sandstone blocks must above all be carefully selected, with a consistent grain, and well joined together.

33. Geometric scheme of elevation with main proportional relations.

Given that architectural design was founded on principles such as symmetry, alignment, and harmony of the various parts of a building, the dynamic urban evolution of a city like Florence created some complex problems for the architect. If it was difficult to predict the future growth and development of a palace, it was an even more complicated matter to design a facade that would allow for successive additions without destroying the balance of the overall scheme.
The facade of Palazzo Rucellai was expanded in the course of its construction from the original five bays, with symmetrical entrance portal, to seven bays and two portals. The eighth, unfinished bay implies an ideal, symmetrical composition; however, in order to recreate the symmetry of the original concept with its central portal, the scheme would have had to be extended to a total of eleven bays. While this was theoretically possible, it was incompatible with the nature of the site.

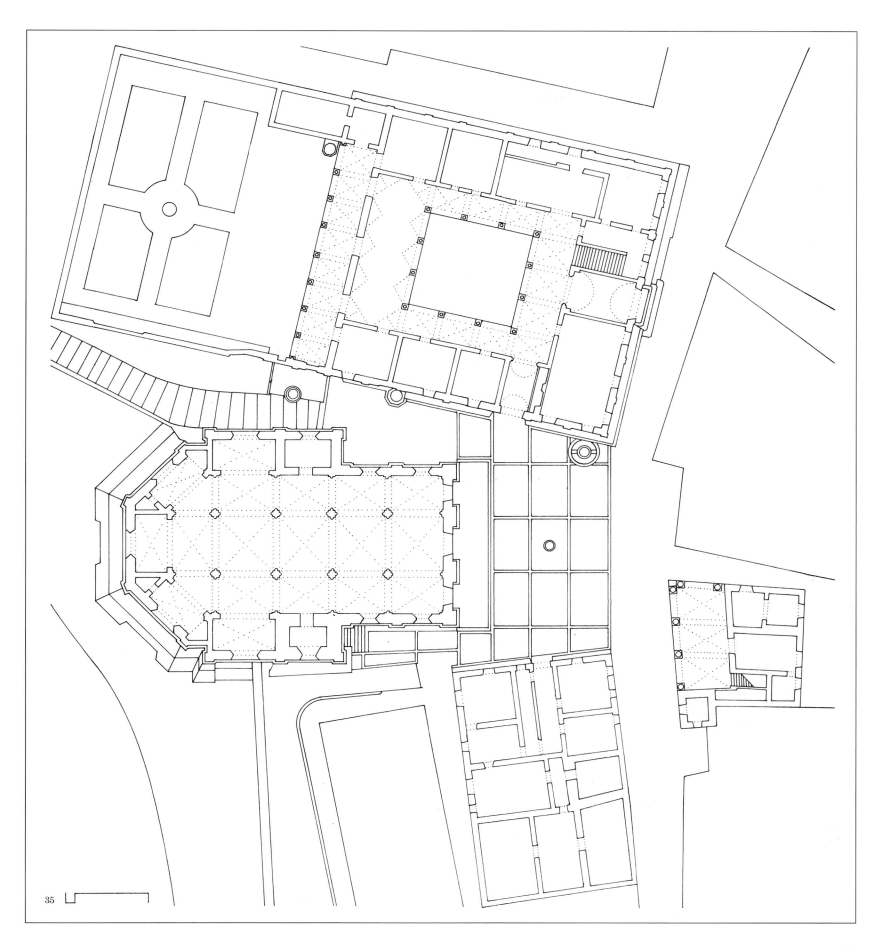

35

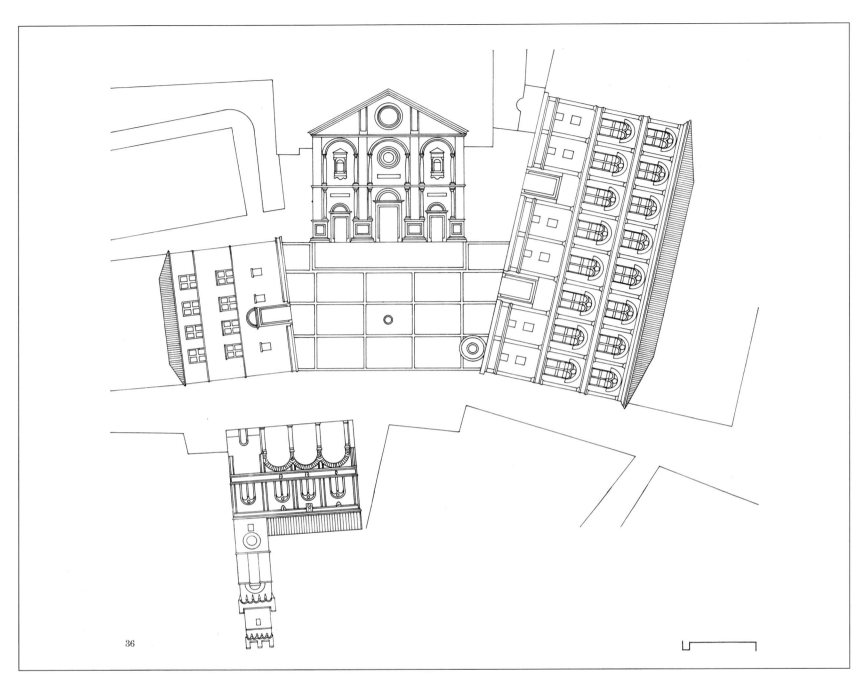

36

accentuates the irregular shape of the trapezoid; the wider opening between the duomo and Palazzo Piccolomini. The use of landscape as a distant, perspective background was somewhat new in architecture, but it is a theme that was highly developed in the painting of the fifteenth century in central Italy.

36. Plan of Piazza Piccolomini with tilted elevations of the duomo, the Palazzo Piccolomini (on the right), the Palazzo Borgia (on the left) and the City Hall.
The geometric law of the enclosed space can be seen in the grid design in the pavement of the piazza: areas of brickwork outlined by bars of traver-

tine. The basic module of this grid relates directly to compositional elements in the facades of the duomo and Palazzo Piccolomini: the long side of each unit corresponds to the width of the bays of the church facade; the short side relates to the width of the bays of the palace and – only partially – also to the smaller palazzo on the third side. The interplay of the horizontals of the piazza paving with the corresponding verticals of the church and the palace creates a three-dimensional grid that confers on the piazza itself the spatial substance of the buildings surrounding it.
After outlining the geometric rule that governs the overall composition, the ar-

chitect positions the well – which normally would be the obligatory, central element of such a scheme – not in the center of the piazza, but off to the side, near the corner of the papal palace.
From the main street tangent to the piazza, the visitor arrives in the empty space that has thus been created: the medieval access to the area has been maintained, together with the sightlines of the approach to the piazza. As one arrives from Porta al Prato, the facade of the bishop's palace, with its Guelphic windows, is gradually revealed, announcing an interruption in the continuous row of houses that line the street. The approach from the op-

posite Porta al Ciglio is characterized by the fountain. This element is in fact the first thing to be noticed, and from it attention moves to the corner of the palazzo, articulated with an architectural order. Palace and fountain function together, each one reinforcing the presence of the other. The fountain is an "exceptional event" in the piazza, which asymmetrically stands out against the ordered background of the facade of Palazzo Piccolomini, whereas the palace itself, with the architectural order, introduces the design element that proportionally governs the whole. The key to understanding the space of the piazza lies in the relationship be-

tween these two elements and in their relation to the free-standing volume of the church. Proceeding toward the piazza, the viewer forms the impression of entering an open-ceilinged room whose walls are formed by the facades of the buildings and whose proportions are clearly revealed by the general rhythm of the composition. The relationship with the landscape is present in the vanishing sight-lines – opening to infinity at the sides of the church. These create another impression; upon first entering this space, as Finelli and Rossi note, the viewer perceives only two objects, the church and the fountain, because it is these two that are surrounded by open space.

The piazza thus represents one of the first real applications of the rules and laws of perspective vision that had been experimented with by Brunelleschi and later given a theoretical basis by Alberti. In addition, the strong presence of the distant landscape background evokes an almost pictorial attitude and provides an experience that typically belongs to the Renaissance style of painting.

Ackerman compares the piazza of Pienza to Michelangelo's Piazza del Campidoglio in Rome. Similar means are employed in both piazzas: a geometrical definition of the plan, arranged symmetrically with respect to the entrance of the principal building, an organization of the access streets, and a special paving design—all serve to coordinate the various buildings. The result, however, is entirely different: the buildings of Pienza differ among themselves in dimension and scale, but above all in style, and the only monument existing in the piazza, a well, has an off-center, even peripheral location.

Luciano Laurana
Ducal Palace
1468–74
Urbino

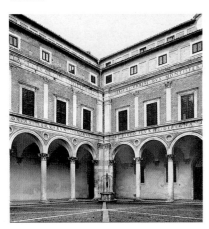

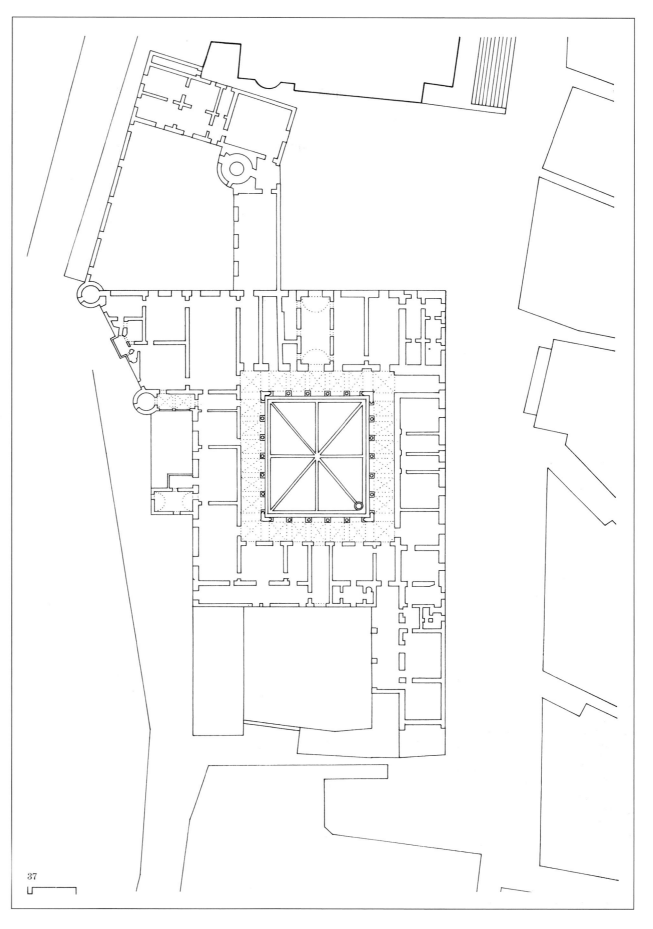

37

37. Plan.

In Baldassare Castiglione's famous book *Il Cortigiano* (The Courtier), the definition of the ideal man is given in a conversation that takes place in Urbino in 1506. The treatise opens with a eulogy on the marvelous site of the city, in the heart of the Apennines, where two worthy *signori*, Federigo da Montefeltro (1422–82) and his son Guidobaldo (1472–1508), decided to establish themselves. Castiglione writes that "among the many other praiseworthy things he did, Federigo built, in the ridgy site of Urbino, a palace that was in the opinion of many the most beautiful to be found in all of Italy, and so well provided with everything suitable, that it seemed not a palace, but a city in the form of a palace." As Chastel points out, this praise refers more to the vastness of the building than to its style: construction went on for thirty years and required the collaboration of a series of architects. Begun as an enormous Gothic edifice, it developed on the basis of increasingly classical motifs, culminating in the admirable "court of honor." All things considered, the impression is of a composite style, also in the decoration, which includes Florentine and Lombard-Venetian influences. A glance at the plan reveals the difference in conception between the south-central part, corresponding to the main courtyard, and the north-central part of the building, comprising the block situated behind the facade with the towers.

The first part is clearly much more regular and more complex than the second. Room follows room, and all are strictly aligned along one of three directional lines. The first of these lines proceeds from north to south in the long east wing. The second goes from east to west along the south wing, where another, parallel block was added at a later date. Finally, in the west wing, three rooms are arranged south to north; here, on the west facade, there is a rectangular tower connected by means of the Terrazza del Gallo to the southernmost of the two round towers. These three wings–arranged very regularly around the space where the court of honor would later be built–are made up of a number of standard, intercommunicating rooms. In the north-central part of the building, in contrast, there is a completely new articulation in the passage from one room to the other. The sensation of space, so vivid and evocative in the area created by the architect as an entrance court, accompanies the visitor as he crosses the threshold and finds himself, suc-

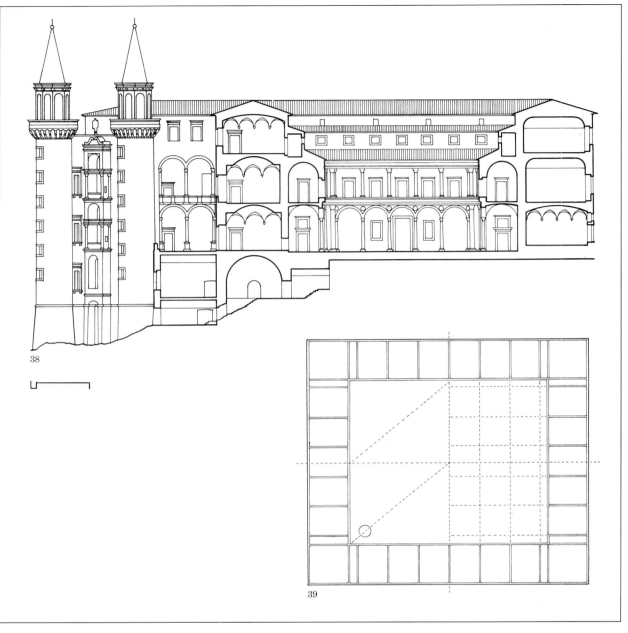

38

39

cessively, in the courtyard, the library, the main staircase, the loggias, the throne room.

38. Transverse section.

Although the so-called facade "dei torricini" (of the slender towers) has a primitive, almost medieval character, it presents abundant Roman motifs in its windows and in the central loggias: thus the columns of the loggias are classical, with their lovely Corinthian capitals, as are the traditional rose-decorated coffers of the barrel vaults covering the loggias of the individual floors. This motif of the loggias has often been compared to the Triumphal Arch of Alfonso I in the Castel Nuovo in Naples, which is also attributed to

Laurana. It shows a development of superimposed registers in which the articulation of the individual elements follows a careful, homogeneous theme.

39. Geometric scheme of courtyard with main proportional relations.

The courtyard space is conceived as the center of articulation of the whole palace. It provides access both to the large underground service spaces and to the *piano nobile* hall through an enclosed staircase of magnificent scale. In one corner a beautifully detailed well, which relates to other typical Renaissance projects, stands as an isolated object in the space defined and proportioned by the courtyard elevations. The rhythm of the colonnade is remi-

niscent of Brunelleschi; however, the columns have rich capitals, and corner pilasters are used to define the geometric scansion of the various sides. The architectural purism of Laurana is also felt in the detailing of the numerous doors and windows. One detail that should be noted is the elegant treatment of the corner pilasters in the court of honor: not only is there the traditional motif of semicolumn backed by pilaster, but there is also a new element, a quarter column in the internal angle. This extremely refined detail allows the architect to maintain the harmonic correspondence of the parts within the portico of the courtyard.

Attributed to *Donato Bramante*
with *Andrea Bregno* and others
Palazzo della Cancelleria
1486–96
Rome

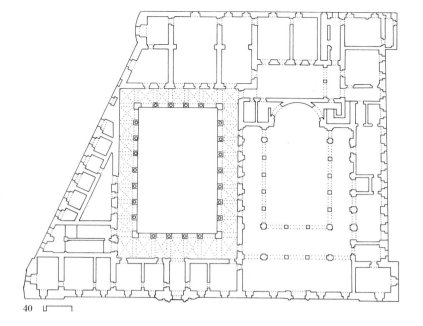

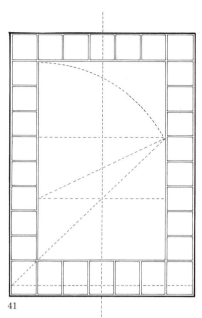

40

40. Plan.

The building's construction history does not make it possible to clearly distinguish its various components or the exact time they were built. The palace is much larger today than it was originally, and the perception of the facade has been completely altered by work done, in the nineteenth century, as part of ample urban restructuring of the area.

According to Borsi, the archeological "quotations" to be found in certain elements of the palace are not characteristic of Bramante's work, whereas they are considered typical of humanistic culture. The model for the first order, on the ground floor, is a simplified form of the minor order of the Portico of Octavia. This was a widely used model in the second half of the fifteenth century in Rome; it had already been employed, for example, in the painted pilasters of the house of the Knights of Rhodes. The repertory from antiquity is not limited to Roman examples, however: the window frames of the *piano nobile* clearly derive from the Borsari gate in Verona, which was later introduced by Sebastiano Serlio into the *Third Book* of his treatise. The two great models for the palace are the Palazzo Rucellai in Florence and the Palazzo Ducale in Urbino: significant elements of both are present here. The influence of Palazzo Rucellai can be seen in the use of the architectural orders superimposed on a regular, rusticated wall surface. Urbino supplies the general conception of the courtyard and the monumental entrance stairs, although the effect is again more Roman than in the model. The simultaneous presence of diverse functional elements in the same building block–in this case, the church of San Lorenzo in Damaso – regularized and homogenized in a uniformly treated volume recalls Palazzo Venezia, a great cardinal's residence that incorporates his titular church.

The courtyard is organized according

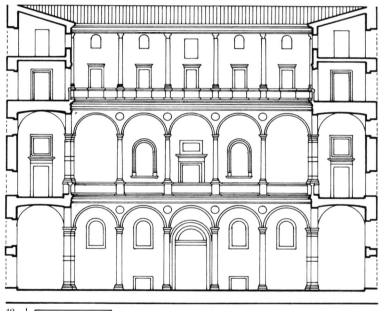

42

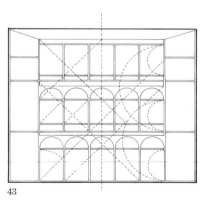

43

to a rectangular plan that refers to the proportions of the golden section–five bays by eight, a harmonic relationship that was very much in fashion at the time. The solution of the corners of the courtyard would be difficult to attribute to Bramante, particularly if it is compared to his cloister of Santa Maria della Pace: the motif of the horizontal decorative fascia, which recalls the metal band employed in archeological sites to frame collapsing columns and interrupts the vertical continuity, is too "artificial" (almost a graphic element) and different from the rhythm of the columns, whereas in the cloister Bramante chooses a solution that continues the motif of the articulation of the bays.

41. Geometric scheme of courtyard with main proportional relations.

The overall outline is based on a proportion–5:8–which is not an even relationship. A similar relation between minor and major side approximates the proportion of the golden section series of Fibonacci (1, 1, 2, 3, 5, 8 . . .). In this series each number is calculated by the sum of the two preceding numbers.

42. Transverse section.

The courtyard has two orders of arcades, the uppermost supporting a top floor that repeats the motifs of the facade. This is lightened by the dichromatic effect of the contrasting colors of travertine and brickwork. Bramante

certainly conceived it on the basis of what he had admired and studied in his youth during the survey of ancient Roman buildings.

43. Geometric scheme of courtyard elevation with main proportional relations.

44. Elevation.

In Rome it was common to use stucco to simulate rustication on the facade of a building. In the Palazzo della Cancelleria this is not the case, for the facade is in stone, but it nevertheless presents a decorative, "pictorial" rustication: the pattern of rough blocks is in fact a simulation, being carved out of the much larger blocks that make up

135

the true structure of the wall. Analogies with the type established by Palazzo Rucellai are immediately clear, but the subtleties of the proportions used in the Palazzo della Cancelleria show a much more advanced design than, for example, the less convincing solution applied by Rossellino in Pienza, in which the elements are not fully attuned to one another.

First of all, the horizontal division into three parts is simpler and more linear than is the case in Palazzo Rucellai, thanks to the omission of the pilasters on the ground floor. The rustication and the relatively small windows of the ground floor thus form an impressive base for the upper floors, which have a different type of rusticated treatment. The *piano nobile* has larger windows, while the top register, which includes a mezzanine level, has two windows per bay, one above the other, instead of the single large window of the floor below.

In Palazzo Rucellai, as Murray notes, Alberti had used an extremely simple system of bays, with identical windows separated by single pilasters, each of which rises from the cornice of the pilaster beneath it; the cornice thus functions both as base for the pilasters and sill for the windows. In Palazzo della Cancelleria, the rhythm is more complex: narrow, blind bays alternate with the wider bays containing the windows, and the bases of the pilasters and the window sills are distant from the cornice of the register below.

45. Geometric scheme of elevation with main proportional relations.

46. Detail of elevation.
The pilasters are paired, and they are elongated and flattened against the wall, with no real structural function. The cornices, entablatures, and capitals are no longer true load-bearing elements; they are shallow steps in the plane of the facade, pauses in a more structured overall rhythmic pattern. Simple, thinly framed, arched windows are situated in the ground floor wall above the elegant base. The windows of the *piano nobile* are set into a characteristic module, framed by a pair of pilasters that stand out against the rusticated travertine blocks and reach up to the entablature. In the top floor, once again there are pairs of pilasters that divide the register into rectangular sections. There are two series of windows here: the lower ones are simple rectangles; those above are smaller versions of the arched windows of the ground floor.

47. Geometric scheme of elevation detail with main proportional relations.

44

45

46

47

136

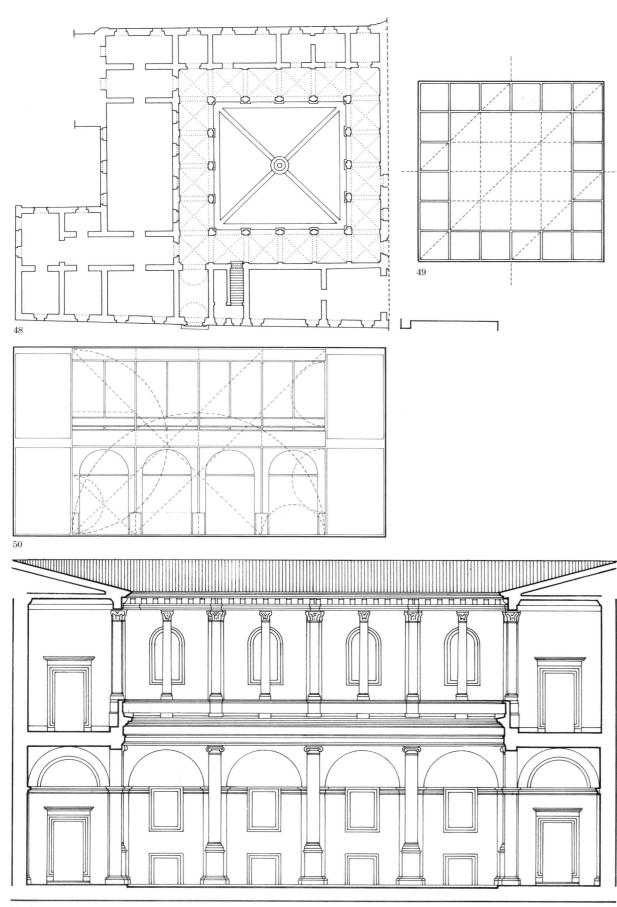

48

49

50

51

Donato Bramante
Cloister
of Santa Maria della Pace
1500–1504
Rome

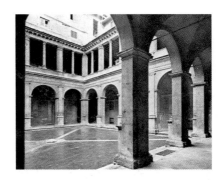

48. Plan.
The cloister is a part of the Santa Maria della Pace complex, later completed by Pietro da Cortona. Bramante was called upon to design the cloister on an irregular trapezoidal site.

49-50. Geometric scheme of courtyard and elevation, with main proportional relations.

51. Elevation.
The elevation of the cloister is governed by a harmonic grid, based on the square, that determines both the articulation into registers and the arrangement and proportions of the various component elements. The inner face seems to belong to two different planes. There is an "outer frame" of Ionic pilasters, on pedestals, in the first register, and Corinthian pilasters, resting on the parapet, in the second; its horizontal components are in two bands–the entablature between the two registers and the crowning cornice at the top. Set back behind this, the "inner frame" is formed of a series of arches on Doric pilasters in the first register and a series of Corinthian pilasters, alternating with small Corinthian columns, in the second. Together with traditional elements the facade displays a number of "discords". On the upper floor, Bramante used both the composite and the Corinthian orders for the cruciform-plan piers above the Ionic pilasters on the lower level and for the intermediate columns, with their "wrong" position directly above the keystone of the arches below.

Antonio da Sangallo the Younger
and later *Michelangelo Buonarroti*
Palazzo Farnese
begun 1513, expanded 1534–46
Rome

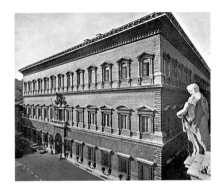

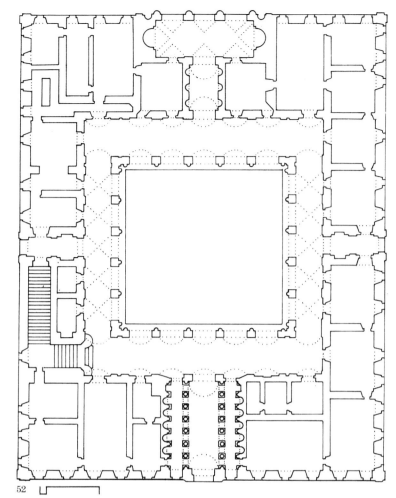

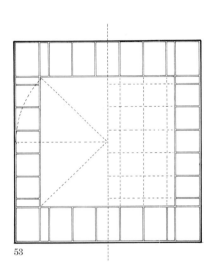

52. Plan.

The plan of Palazzo Farnese shows a typical layout: the central courtyard, the great staircase, the monumental entrance on the principal axis, and the paired service entrances on the secondary axis might almost amount to a standard format.

The main entrance, from the piazza, consists of a central passage covered with a barrel vault resting on two rows of columns; on either side, a lateral trabeated passageway opens onto a dense sequence of semicircular niches. This is a characteristic element of Roman bath architecture. Another typical feature of the thermae is to be found in the "forceps-shaped" atrium, preceded by a second barrel-vaulted passage, that connects the courtyard to the garden.

The articulation of the courtyard presents composite-order piers, finely articulated by attached semicolumns: a robust articulation that in section allows a particularly harmonic relationship between the larger order supporting the entablature (the semicolumn) and the minor order that marks the impost level of the arch (the pilaster on the side of the pier). The mass and articulation of the corner pier recalls the solution adopted in the courtyard of the Ducal Palace in Urbino. The corner is not defined by a single element–column or pilaster–common to both wall planes, but rather by an empty, negative space between two semicolumns belonging to different planes; the corner pier is in fact a combination of two single piers joined at right angles to each other in such a way that there are no elements in common between the two adjacent sides.

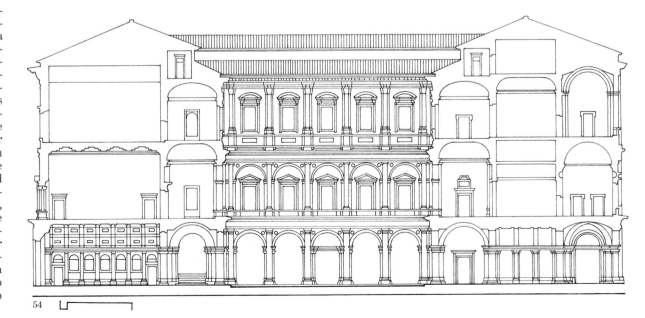

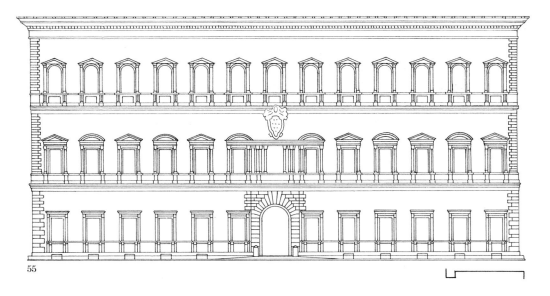

55

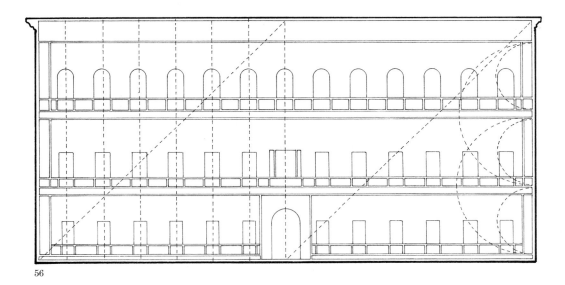

56

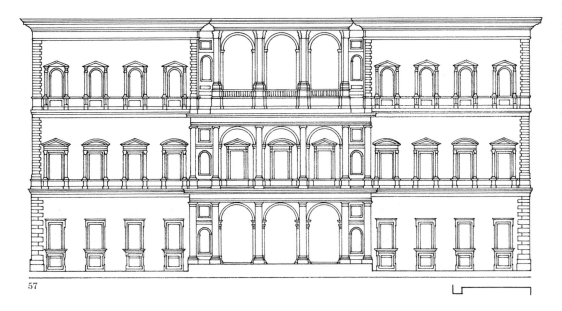

57

53. Geometric scheme of courtyard with main proportional relations.

54. Transverse section.

When Michelangelo became involved in the construction of the palazzo, the internal part of the courtyard was without doubt the least advanced, for Sangallo had built only the first two floors – the portico and the *piano nobile*. The model that he followed was the most classical and correct in the Renaissance sense of the term that could be found in the architecture of the early sixteenth century; it could only have been the construction system of the facade of the Coliseum: semicolumns and arched openings, closely linked together. Altering one of these elements would completely disrupt the facade as a whole. Both rest on a parapet at the level of the *piano nobile*, and both rise to the entablature above; the system is precise in every detail. The arches frame windows outlined with moldings that thus float within a perfectly defined portion of wall. Michelangelo, however, refused to follow this system on the top floor: he does not accept the interrelation between arches and entablature, just as he does not accept the roundness of the semicolumns. He introduces a series of pilasters from the parapet to the entablature, like the semicolumns of the two lower registers.

55. Elevation.

Vasari tells of how Pope Paul III had started the palace with Sangallo as architect, and how, upon Sangallo's death, he desired Michelangelo to take over the work. The facade was completed with the great window above the main entrance portal and the enormous marble Farnese coat of arms above it. Work then proceeded on the interior of the palace.

Sangallo's project (which shows the influence of Raphael's Palazzo Pandolfini in Florence and, in part, Sangallo's own design of the same period for Palazzo Baldassini) represents the antithesis of Michelangelo's organic conception, as well as a reaction against the pictorialism and the variety of articulation of the facades of Bramante's and Raphael's Roman palaces. Sangallo treats the facade as a neutral, two-dimensional brick surface, inserting the stone moldings of doors and windows like sculptured reliefs. However, the moldings are not pure ornament. They constitute the only vertical movement of the facade, applied as they are symmetrically with respect to the central axis. This generating scheme, which could be defined as one of modular addition, replaces the old propor-

tional principles in determining the overall form: the facade could have one window more or less without appearing unbalanced. This radical change with respect to the geometric and harmonic outlines of the fifteenth century allowed Michelangelo and his successors to modify the incomplete parts of the design without creating evident discontinuity. What differentiates Sangallo's approach from Michelangelo's is the lack of an expression of the tensions at work in the building. The neutral, plane surface of the wall conceals every sign of balance–or struggle, as Michelangelo would have it–between loads and the reaction of the supports that bear them. There is nothing that suggests the mighty weight of the building. Horizontal motifs prevail over vertical ones, as can be seen particularly at the corners, where the ascending line of the quoins is interrupted at every new register, diminishing the effect of the only element of vertical continuity present on the facade. When Sangallo died, the facade was complete up to the beginning of the top floor. Michelangelo was immediately put in charge of the project, with instructions to complete the facade before proceeding with the lateral wings and the rear part of the building. As Ackerman notes, Michelangelo made only three variations with respect to Sangallo's original project: he designed a new cornice, increased the height of the top floor, and changed the form of the central window. The first two variants were closely connected to each other: Michelangelo greatly increased the dimensions of the cornice, and to avoid the heavy effect this would have created, increased the distance between the base of the cornice and the pediments of the windows below, making this distance equal to the height of the cornice itself. In this way the top floor became equal in height to the other two. The central window was modified in order to give a more sculptural character to the facade.

The cornice shows the influence of ancient Roman architecture as well as that of fifteenth-century Florence in that its proportions relate to the whole facade rather than to the top register only. However, the significance is profoundly different. The cornice does not rest on the mass of the building like an isolated element, but is conceived as a dynamic swelling of its mass, above the tight, beltlike band of the frieze. This contrast of forces between the encircling frieze that compresses the mass and the gradual distention of substance above it, is clearly symbolized in the progressively greater volume of the constituent elements: the dentils, the egg-and-dart motif, the corbels, and the upper cornice. At the same time, the projection of the upper cornice sets a limit to this process of movement. Taken all together, the cornice has a crowning effect. Moreover, its mass is not isolated from the volume of the rest of the building, but "releases" its weight to the ground through the quoins at each extremity of the facade. Cornice and quoins together form a frame that unifies and homogenizes all the different elements of the facade, and provide a unified impression; the emphatic presence of the coat of arms at the center, three meters high, is another element in scale with the building as a whole.

56. Geometric scheme of elevation with main proportional relations.
The basic outline of the facade, in Michelangelo's final intervention, derives from the sum of two squares placed side by side.

57. Rear elevation.
The garden facade shows the simultaneous presence of the architectonic themes of the two architects who worked on the building. Here, in what was intended to be an open loggia toward the garden, the intervention of Michelangelo can be clearly distinguished above that of Antonio da Sangallo. Vasari recounts of the discovery at that time of the statue of the Farnese Bull, an enormous mass of marble representing Hercules holding a bull by the horns, aided by another figure and surrounded by various nymphs, shepherds, and animals. The statue was so extraordinarily beautiful that it was deemed worthy to be used for a fountain. Michelangelo recommended placing it in the second courtyard (i.e., the garden) in order to restore it and convert it into a fountain–an idea that met with the approval of all. The statue was thus restored, and took its place in the overall arrangement of the area behind the palace. Vasari goes on to tell of how the Farnese family intended – on Michelangelo's suggestion – to build a bridge across the Tiber, aligned with the main axis of the palace, which would provide access to a smaller palace, surrounded by a large garden, already under construction in Trastevere. (Construction of the Villa Farnese, or Farnesina, designed by Peruzzi, began in 1509.) The idea of this project was that from the main entrance portal of Palazzo Farnese there would be a vista that would take in, at a single glance, the courtyard, the fountain in the garden behind the palace, the bridge across the river, and the beauty of the other garden, all the way to the gate opening onto the street in Trastevere.

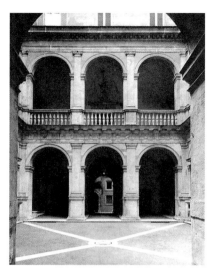

58. Elevation.
In Palazzo Baldassini, Antonio da Sangallo created, with great technical skill, a suitable and very up-to-date building typology for the needs of the rising bourgeois through the use of a number of specific design devices, most important of which is a strong proportioning system. Rustication, typical of the Florentine tradition of Brunelleschi and Michelozzi, is not used here; nor is there that element of division and measure, provided by the architectural orders, characteristic of so many palazzi by Bramante, Alberti, and others.
Rather, Sangallo clearly expresses the wall as a mass. It is finished with smooth, small-scale brickwork, and within it he positions the openings and the few elements that mark the division between registers. The composition relies on a proportioning system that is simple, clear, and definite enough to be perceptible even without being directly expressed.
The facade is thus conceived as the union of perfectly identifiable, harmonically defined bands, decreasing in height toward the upper floors. The first register is noticeably higher, though an emphasized parapet line serves visually as a raised ground line, thus lowering the height somewhat. The two top registers differ in their articulation: while the windows of the *piano nobile* rest on the cornice defining the upper limit of the ground-floor register, the windows of the top floor are detached from the cornice and appear isolated in the wall surface.
The necessary continuity is provided only by the succession and alignment of the vertical elements. The corner quains define the volume, and the tall doorway emerges as the only element on a monumental scale.

59. Geometric scheme of elevation with main proportional relations.
The facade design is based on a square – the side is equal to the height of the elevation – whose diagonal is used to dimension the overall width. The decreasing height of each floor gives the elevation an effect of lightness toward the top. This effect is also emphasized by the proportioning of the top cornice, which, contrary to the situation in buildings like Palazzo Medici-Riccardi or Palazzo Farnese itself, is attuned not to the overall dimension of the facade but to the third register only.

60. Plan.
The building has a typical, orderly, sixteenth-century plan: the entrance-way leads to a section of portico that forms a T with the entrance and leads to the square courtyard; the staircase begins to the right of the portico and turns at a right angle, ascending parallel to the side of the courtyard; the rooms are arranged all around, toward the street and toward the courtyard; the original garden in the rear has been transformed into a vestibule, with a spiral service staircase.
The illumination of the staircase comes partly from the courtyard and partly from a small secondary courtyard corresponding to the landing, given the indication "air" in the original plan. Access to the rooms of the *piano nobile*, on the street side – the most important part of the building – is obtained by means of the gallery above the ground-floor portico.
What is unusual about Palazzo Baldassini is the disproportionate height of the ground floor register of the facade. This is explained by the fact that, the main area of the ground floor was destined to house collections of antiquities; thus it assumed greater importance than would be the case in an ordinary residence.

61. Geometric scheme of courtyard with main proportional relations.
A grid governs the articulation of the courtyard. The space of the court is not flanked by a continuous portico on all sides. Instead, there is only a typical deep space used as a vestibule for the main staircase, which is connected to the barrel-vaulted entrance atrium.

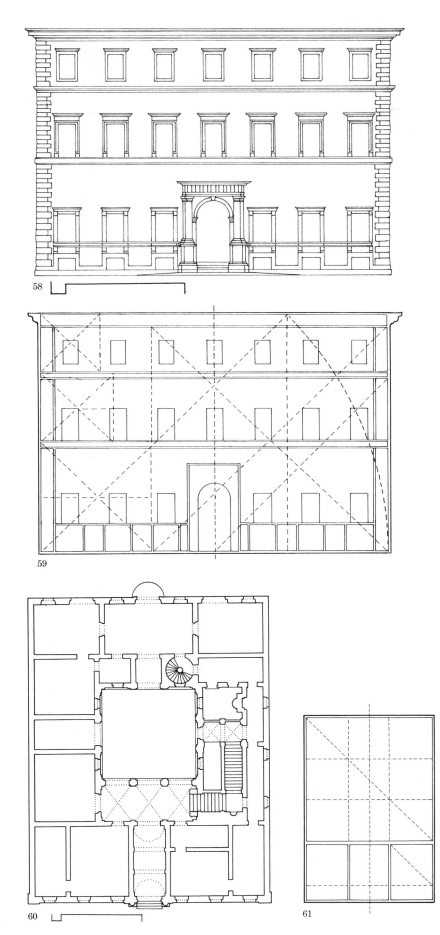

58

59

60

61

Project of Raphael Sanzio
completed by *Giovan Francesco
da Sangallo*

Palazzo Pandolfini
from 1516
Florence

62–63. Facade elevation and geometric scheme with main proportional relations. When Raphael designed Palazzo Pandolfini, Palazzo Farnese was already under construction and thus may have had some influence on him. Conversely, after 1517 Raphael's project may have influenced certain details of Palazzo Farnese, such as the aediculae and the central window of the *piano nobile;* it would have been possible for Sangallo to redesign such elements up until the moment of their actual execution. Nevertheless, as Pagliara affirms, Raphael's character is evident in the design of Palazzo Pandolfini. He is intimate with ancient architecture, in particular the

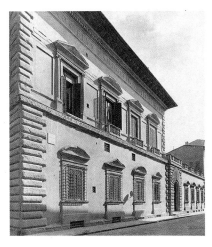

Pantheon, which is not only the source of the aediculae, but of other elements as well. His profound knowledge of the proportional schemes of this and other ancient buildings, in fact, allows him to be freer with the traditional schemes than his contemporaries can be.

In Palazzo Pandolfini, Raphael expresses fully his preference for a prevalently horizontal layout; unlike the palaces that he designed for Rome, here there is only one floor above the ground floor. Nor is there any articulation in the form of architectural orders as there had been in his Roman buildings. The surface of the facade, defined by rusticated quoins at the corners and divided horizontally by a molding that separates the two floors, is articulated only by a double order of aediculae containing the windows; all of these elements, as well as the rusticated entrance portal, stand out strikingly from the wall surface. The architectural orders appear only in the aediculae, with Tuscan pilasters on the ground floor

and Ionic semicolumns on the *piano nobile.* The continuous entablature that connects the pediments of the aediculae on the *piano nobile* is another detail that testifies to the influence of the Pantheon. The cornice derives from the Florentine tradition of Palazzo Strozzi, whereas the entrance portal, the rusticated quoins, and the use of the simple molding to divide the two registers are reminiscent of the work of Antonio da Sangallo the Younger in Palazzo Farnese. Palazzo Pandolfini thus illustrates certain parallels existing between the styles of the two architects.

In this palazzo, the fundamental matter of the articulation of the facade is connected with Raphael's decision to forego the architectural orders in favor of a solid wall with harmonically arranged windows. As Ray mentions, the question concerns the function of the architectural order itself, and whether its role as a "load-bearing element" that visibly indicates an orderly scheme can be replaced by an equally rigorous proportioning system that is not, however, specifically discernible as such. This theme is similar in many ways to the situation encountered by Antonio da Sangallo the Younger in Palazzo Baldassini. The compositional problem is to establish a scheme of such "strong" proportional relationships that an open manifestation of the scheme is not required.

The wall's load-bearing function is therefore fully expressed, and the task of generating a "local" system of measure and proportion is left to the architectural members in the window aediculae. Considering the facade in its entirety, Raphael must, like other architects, once again solve the problem of finding an overall frame for the whole facade, using elements such as corner quoins, an inter-floor molding, and a cornice. By separating the entrance portal from the surrounding wall surface through rustication, he is able to include the door in this general, overall proportioning of the facade as a whole.

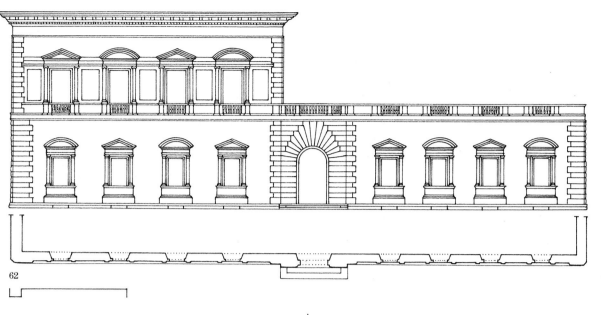

62

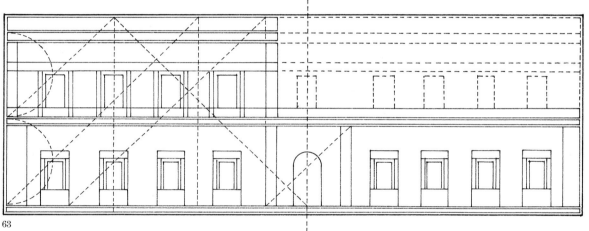

63

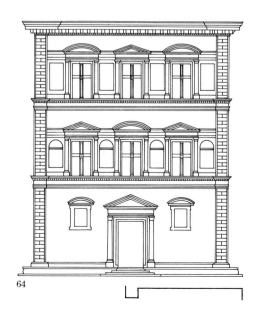

64

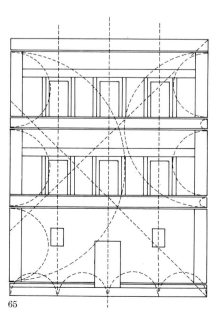

65

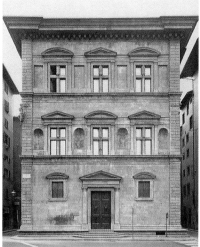

64. Elevation and geometric scheme with main proportional relations.

This building, designed by Baccio D'Agnolo for Giovanni Bartolini, and located in the Piazza della Santa Trinità, is described by Vasari as having a sumptuous interior. Vasari goes on to tell of the reaction created by the facade, however. It was the first building not to use the traditional arched biforate windows (characteristic of Florentine palazzi and often cited as an element of continuity with the many medieval buildings of the city); instead, it had rectangular, pedimented windows, divided into four sections by a cross-shaped element formed of an intermediate architrave with small-scale columns above and below it. The windows are outlined by a continuous frame.

These details were loudly criticized, even in verse, by the Florentines, who went so far as to adorn the facade with leafy branches, like a church on a feast day, saying that the building looked more like a temple than a palazzo. Vasari says that the poor architect was "on the point of losing his mind" as a result of all the furor. Vasari considered the cornice to be excessively large for the rest of the facade, but – in spite of everything – he concludes by stating that the building had, for its other aspects, "always been highly praised."

The building has the customary three floors, and the main facade is entirely in stone. A finely shaped seat, extending from the entrance portal across the width of the facade and around one of the corners, forms a base that corresponds in a certain sense to the overhang of the great cornice above.

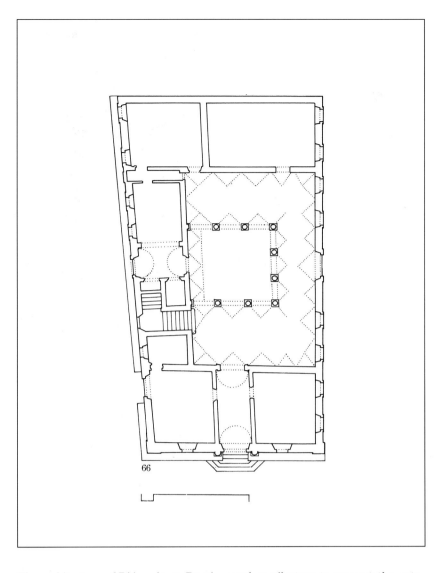

66

The architecture of D'Agnolo, as Bucci and Bencini point out, reveals clearly the mark of the new sixteenth-century architecture, with its medieval reminiscences, that had become established in Rome. It is important to remember that Palazzo Bartolini-Salimbeni was conceived shortly after Raphael's Palazzo Pandolfini, which served D'Agnolo as a model for the portions that link the windows of the *piano nobile*. To these he added niches, inspired by Bramante, thus creating an alternation of solids and voids above the continuous, solid surface of the ground floor register, which is interrupted only by the magnificent, Roman-proportioned entrance portal and the two small aedicula-windows.

Correspondingly, on the second floor, there are rectangular niches set into the wall, but with less of a chiaroscuro effect than is created by the deeper semicircular niches on the *piano nobile*. The quoins at the corners, apparently a medieval reminiscence, are

used as pilasters to support the entablatures–a structural motif also dear to Raphael. The frieze running beneath the windows of the two upper floors is finely decorated with a poppy motif, recalling the Bartolini family crest. Alberti had similarly used the sails of the Rucellai in the decoration of Palazzo Rucellai and in the frieze of Santa Maria Novella, and Raphael had incorporated an inscription in Roman letters in the cornice of Palazzo Pandolfini.

66. Plan.
The palace is based on the traditional outline with a central court, even though, here, the constraints of a rather narrow, irregular site force Baccio D'Agnolo to adopt an asymmetrical plan. The portico is on only three sides of the courtyard, to leave room on the fourth side for the main staircase.

Donato Bramante
Palazzo Caprini (in the engraving known as the "**House of Raphael**")
1512
Rome

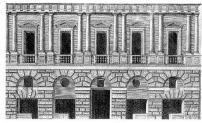

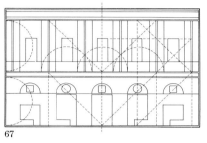

67

67. Reconstruction of the governing proportional elements of the facade, after an engraving by Lafréry.
Destroyed in the eighteenth century, this building by Bramante is known only through a small number of drawings and engravings, such as Lafréry's; it is nevertheless a noteworthy example of civilian architecture. Although Bramante probably built Palazzo Caprini for himself, it was subsequently the residence of Raphael. Vasari mentions the building, and from his description it is known that the wall of the second register was in brick and that the columns were cast in molds. The order was Doric, and the whole building, says Vasari, was "a thing of great beauty and a new invention."
The palazzo refers directly to a classical prototype, namely the block of apartments constructed over a row of shops. Such buildings were very common in ancient Rome, and the format is still seen down to the present day. The shops on either side of the central axis are all identical. A smooth molding separates the rusticated ground floor from the *piano nobile*, which features a Doric order and aedicula windows; the presence of a single upper floor gives greater emphasis to the contrast between the shops below and the dwelling spaces above.
In the rustication of the base, Bramante makes reference to the Florentine palazzi of the previous century as well as to many ancient buildings of imperial Rome. However, it is beyond doubt that the differentiation of the two floors mirrors Bramante's desire to express their diverse functions in a way different from

the schemes proposed by Alberti, Michelozzo, and Giuliano da Maiano. As compared to the evolution of the Florentine palazzi, what is new here is not so much the presence of the ground floor shops as the overall simplicity of the design and the rigorous symmetry of the scheme. Symmetry, repetition of identical elements, and clarity of function: these principles constitute Bramante's principal contribution to the architecture of the palazzo. The entire composition is governed by a square grid that dictates above all the reciprocal height of the two registers, while an interplay of shifted squares seems to have determined the relationship between the center line of the windows and the median line between the paired semicolumns. The strict two-part division of Palazzo Caprini represents a juxtaposition that resolves the traditional contrast between the naturalistic articulation of the rustication and the more rational as well as artificial articulation of the architectural order, all the more so because the ground floor is given over to shops, and is therefore dedicated to a "lowly" activity, while the other floor is treated as *piano nobile*. There is a complex attitude towards the classical sources: a desire to define the classical order while simultaneously exploring its untried expressive possibilities in an exclusively pictorial way. These are, in effect, the principles laid down so carefully by Vasari. Palazzo Caprini, in Borsi's opinion, represents a desire to evoke the ancient residential ideal in the light of contemporary urban realities. The delicate chromatic contrast between the brick wall and the stone semicolumns and rustic-work, as well as the vibrant chiaroscuro of the semicolumns, the ground-floor rustication, and the frieze with triglyphs are all clear demonstrations of the pictorial aspect of Bramante's mature work. This "pictorialism" of Palazzo Caprini explains its subsequent influence (for example in the Veneto area, in the work of Sansovino, Sanmicheli, and Palladio). As Murray points out, the importance of Palazzo Caprini – the "House of Raphael" – with respect to the later development of sixteenth-century palazzo architecture is similar to that of Bramante's Tempietto di San Pietro with respect to central-plan churches. It is no exaggeration to state that in the next two centuries, and for perhaps longer, all the palazzi built in Italy are inspired by this one building, even when they represent a reaction against it.

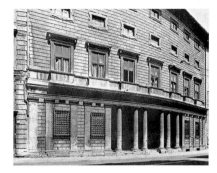

Baldassarre Peruzzi
Palazzo Massimo
from 1532
Rome

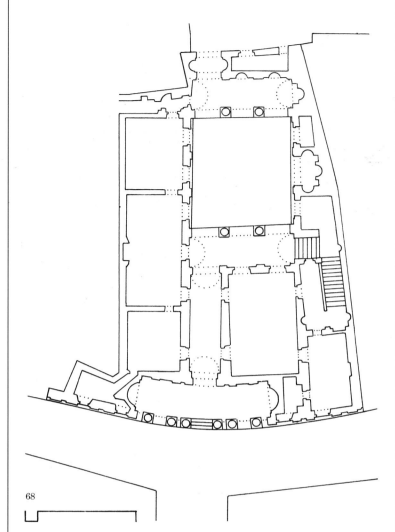

68

69

68–69. Plan and geometric scheme of the courtyard with main proportional relations.

Peruzzi's design for Palazzo Massimo contains a number of elements that are uncommon in the architecture of sixteenth-century palaces. First of all, the facade is not set apart in isolation; together with its neighbors on either side, it forms part of a continuous series of buildings along the existing street. In order to follow the curve of the street, the central portion of the facade is also curved. The result is that the entire facade appears to be curved, but the segments from the outermost columns of the portico to the corners of the building are actually straight.

The first register thus consists of columns, in the portico, as well as pilasters at either end. Four rows of windows correspond to three actual floors: the ground floor, the *piano nobile* with its mezzanine level, and the attic floor. The facade is finished in a stucco imitation of rusticated stonework.

The symmetry of the facade is not carried through to the interior. Evidently, Peruzzi's main concern in laying out the facade was not the facade's relationship to the interior, but the whole building's relationship to the urban context around it. Thus, the facade was aligned with a street that led straight up to the main entrance, forming a T with the street on which the palazzo itself is located.

70–71. Detail of entrance atrium, section and plan.

On the interior, Peruzzi is forced to take into consideration the constraints of a site conditioned by the surrounding buildings. The space is "cut out" of the existing volume, as it were. The entrance is articulated not as a single great space, as in Palazzo della Cancelleria, nor according to a central axis,

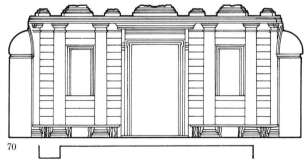

70

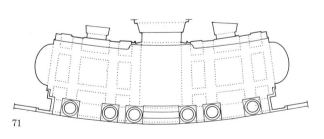

71

as had been the case for all the various spaces of Palazzo Farnese. Instead, there is a sequence of small spaces that are perfectly proportioned and connected to each other.

72–73–74. Elevation and geometric scheme with main proportional relations, and longitudinal section.

Palazzo Massimo is an imposing, compact block, with a rich and severe facade, containing a splendid entrance portico that proceeds along a visual

axis toward an elegant courtyard. According to Frommel there is a sophisticated ambiguity in the vertical relationships of the facade. Whereas in the facade of Palazzo Farnese, for example, there are "vertical axes" of aediculae reaching from the ground floor to the level of the roof, in Palazzo Massimo, Peruzzi places the pairs of columns and pilasters under the weighty, projecting aediculae of the *piano nobile*, as if they were really being supported by the order of the low-

er register. He does not, therefore, attempt to establish clear, linear axes, but rather he expresses the structural relationship between load and support – a fundamental principle of ancient architecture. He contrasts the horizontal, "muscular" zone of the ground floor with the high, "passive" *piano nobile*. The latter has no architectural order and no intermediate moldings; it is closed like a suit of armor, articulated exclusively by three rows of windows. Frommel notes that no architect

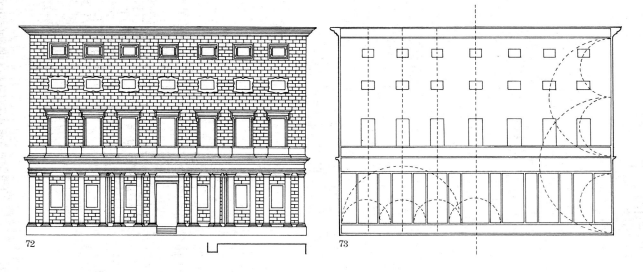

72

73

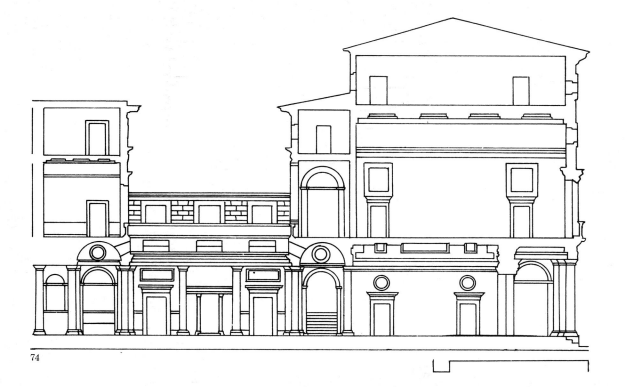

74

75. Plan.

When the pope decided to transfer the equestrian statue of Marcus Aurelius from the Lateran to the Capitoline Hill, he commissioned Michelangelo to undertake the project of siting the statue. Since the statue was to be a symbol of both the city and the state, it was to be located in a context that was at the same time isolated, like the summit of a hill, and connected to the urban space. To satisfy this request, Michelangelo conceived of the splendid site at the top of the hill, a regular, isolated architectural block detached from and contrasting with the houses built right up to the foot of the Capitoline Hill. The space that would become the piazza was at the time a rather vague, ill-defined stretch of terrain. There were, however, two existing buildings, the old Senate building and the more recent Palazzo dei Conservatori. These could certainly not be removed, but only modified, especially on the fronts that would face the piazza. They were not situated at right angles to each other: there was an acute angle between the facade of the fifteenth-century Palazzo dei Conservatori and the facade of the ancient Palazzo Senatorio. The site where the third building would be built was dominated from on high by the Franciscan church of Santa Maria d'Aracoeli. The long staircase leading to the church also gave access to the Capitol buildings. As the centerpiece of this complex, the statue obviously had to be situated on the main axis of the piazza. Michelangelo further emphasized the statue by placing behind it the great double ramps of stairs leading into the Senate building. The surrounding space was symmetrical, but open in all directions, with oblique sides and a great staircase connecting it to the city below. The concentrated centrality of the statue's position was counteracted by

had ever dared forego horizontal subdivisions completely and give the columns of the order the structural function of "bearing" the weight of the whole facade. Light also has an important part in this refined approach to design: it is especially dramatic in the portico and along the longitudinal axis. The solution of the facade is distant from both Florentine and Roman models. No attempt is made to create a gradually differentiated articulation through use of different materials, as

Michelozzo had done in Palazzo Medici-Riccardi, nor is the surface treatment handled "volumetrically," as was the case in many buildings beginning with Palazzo Strozzi.
There are also differences compared to Palazzo Baldassini and Palazzo Farnese, where the windows are situated in facades that lack any articulation by means of architectural orders, but where each floor is marked as a horizontal plane and the overall composition is framed by a large-scale

system (cornice, moldings, quoins, and heraldic crests in the case of Palazzo Farnese) which serves to homogenize the various elements appearing there. In Palazzo Massimo, on the other hand, the rusticated three-floor wall is conceived as one plane with neither division nor partitioning. Only the geometric alignments of the windows somehow suggest a series of horizontal and vertical lines, but what prevails is the perception of the building mass.

145

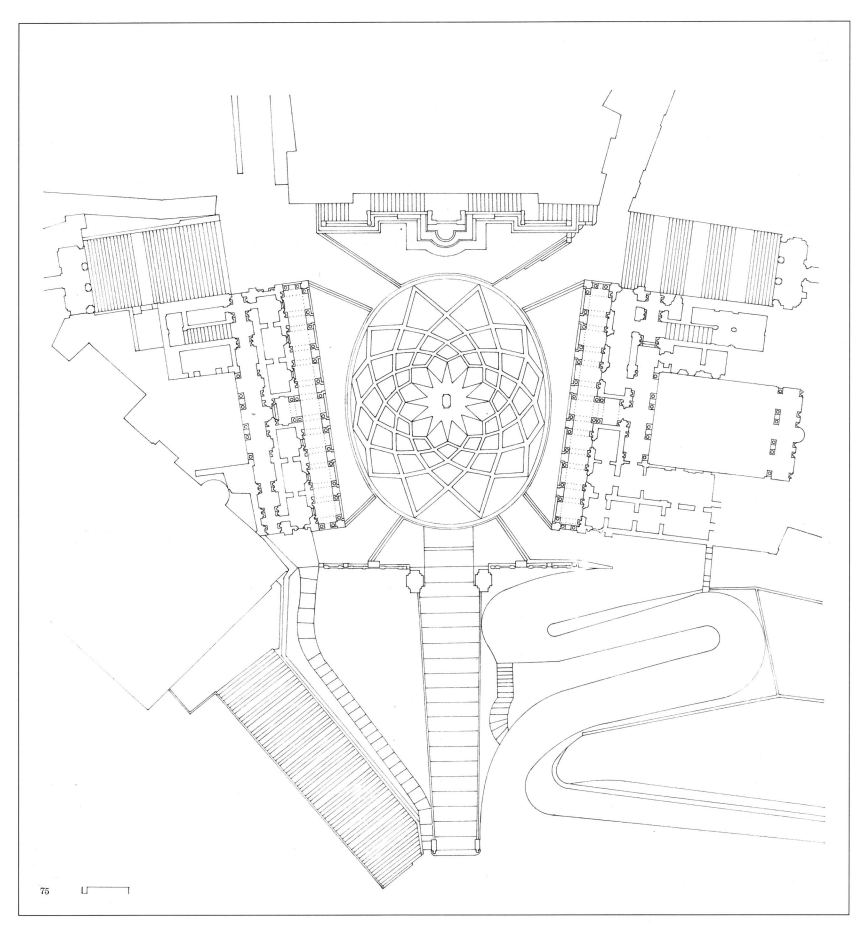

75

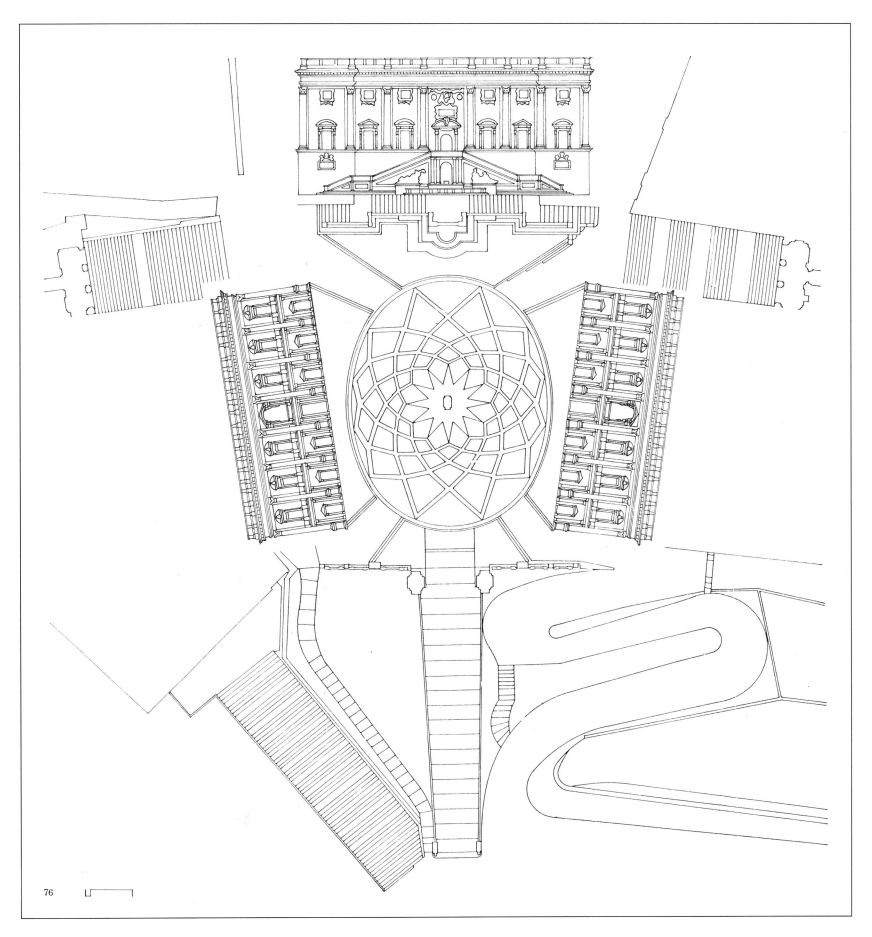

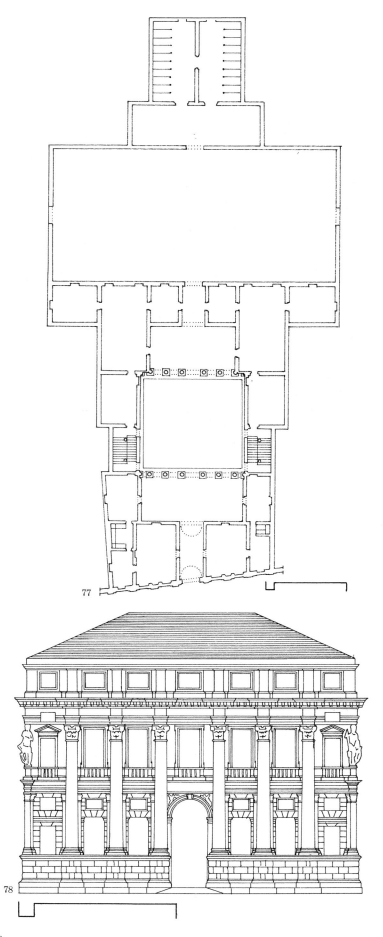

77

78

the spread-out perspective lines around it. The Palazzo dei Conservatori needed a symmetrical twin; its function had yet to be established, but the use of these buildings was secondary to their role as components in an overall scheme transcending their specific function.

Giving them the same oblique front created a widening perspective that brought the high facade of the Senate building closer and further emphasized the link between its stairs and the equestrian monument before it. At the center of the piazza, the problem was to establish a scheme that would emphasize the midpoint, where the statue was to be situated, without compromising the longitudinal axis of the piazza and of the statue itself; this was admirably resolved by the oval paving motif.

The layout of the piazza also resolved a number of different problems; for example, the staircase of the Senate building utilized a minimum of the surface area of the piazza; it led directly to the great entrance hall located on the *piano nobile* and formed a more appropriate frame for the statues of river gods that previously obstructed the entrance to the Palazzo dei Conservatori.

The porticos of the lateral buildings form part of the piazza as well as of the buildings themselves. They accentuate the main longitudinal axis of the whole complex.

As Ackerman notes, the intention to unify the three palazzi by means of continuous horizontal motifs led naturally to the use of a structure with architraves and marked cornices; however, in the final design it seems that Michelangelo desired to contain the effect of these horizontal accents by means of equally intense vertical elements.

76. Plan with tilted elevations of Palazzo Senatorio (top), Palazzo dei Conservatori (right), and Palazzo Capitolino (left).

The facades are articulated with a giant architectural order: colossal pilasters on pedestals stretch from the ground line to the top cornice, therefore including two different registers as one. The entablature, which marks the division between first and second register, is treated as recessed with respect to the ideal plane containing the giant architectural order. The window openings are conceived as belonging to a third geometric plane that is even further recessed. The whole facade is thus the result of the superimposition of three different planes: the first rules the overall rhythm and proportion; the second articulates the two registers; while the third dictates the succession of the openings.

Andrea Palladio
Palazzo Valmarana
1566
Vicenza

77. Plan.

The plan is based on a longitudinal sequence of open and closed spaces. From the barrel-vaulted gallery of the entrance, a rectangular space leads into the main courtyard. The square courtyard is flanked by two staircases and, on the remaining sides, has two sequences of columns. Proceeding along the axis, another rectangular space and gallery then connect to the service section of the palace, characterized by a large yard and stables.

78. Elevation.

As Forsmann notes, if a pediment were added above the giant order of this facade, it would be clear that there is a very strong family relationship with the facade of Palladio's Venetian churches. However, in keeping with the residential theme of the palazzo, the pediment is replaced by a crowning attic story.

The physical plane that coincides with the front of the building is conceived as a geometric plane similar, for example, to that of a painting: planes belonging to different spatial depths are superimposed. The composition of the facade thus involves creating an orderly organization of theoretical planes that ideally are separated, but in reality coincide.

The entire front of Palazzo Valmarana can be read, as Tafuri suggests, as the superimposition of two different structures: one is defined by the giant order pilasters; the other, consisting of a single floor, crowned with a balustrade, and corresponding to the lower floor of the building, is incorporated in the first. If the second structure is "liberated" from the facade, it can be seen as an ideal, single-story front, marked by paired pilasters and terminated by statues on top.

Mauro Codussi
Palazzo Corner-Spinelli
from 1480
Venezia

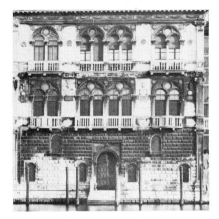

79. Elevation.

Palace architecture in Venice derives from a mature Gothic tradition and is characterized by the grouping together of elements. This places it in direct contrast with the kinds of solutions typically found in Florence. Usually in Venice, instead of the central courtyard with rooms arranged around it uniformly on all sides, it is the canal facade that dictates the organization of the interior. Each of the typical three floors of the palaces is characterized by a single large central room that passes through the whole building, opening onto the canal on one end and a street or piazza on the other. This is flanked on each side by a series of smaller rooms. On the ground floor, the street entrance and the canal entrance are located at opposite ends of the large central space, and the secondary, lateral rooms serve in part as storerooms. On the two upper floors the main room consists of a continuous hall with a loggia or grouped windows at either end; doors located symmetrically give access to the side rooms, each with two windows. The windows are provided with balconies. The stairs are mainly located in the secondary rooms and are not particularly important.

Palazzo Corner-Spinelli provides a good example of this arrangement. Its facade is characterized by two upper floors, which are equal in height and in architectural articulation. The ground floor is not only of greater height, but also its rusticated facade gives it the appearance of a strong supporting element. This wall has a smooth finish, with alternating square and rectangular blocks. This detail, characterized by a gentle alternating rhythm between ashlars and joints, recalls another

building by Codussi: the church San Michele in Isola.

The windows are inserted in the ground floor in a novel way: of the three windows on each side of the entrance portal, the middle one is raised almost to the level of the balconies above, leaving only a narrow band of wall to function as a support. According to McAndrew, this generates a triple rhythm, accented on the second beat–A-A'-A–which will be found with many variations throughout the building as a whole as well as in its parts. On this floor of the palace, the pilasters are high, wide, and ornamented with panels, again like those of San Michele. Slightly raised from the wall surface, they cast enough of a shadow to break the insistent chiaroscuro grid of the rusticated blocks.

Above this rusticated ground floor there are two identical upper floors, crowned by a cornice that provides a frame for the whole facade. The detail of the biforate windows with their central, upside-down pear-shaped roundels, and the curious element of the projections on the first-floor balconies, recalls the picturesque chiaroscuro effects characteristic of Venetian art of the previous period. The elongated, pear-shaped "eye" may be seen as a reminiscence of the flamboyant and ogival structures seen in the windows of Gothic Venetian palaces. According to Puppi and Olivato, the inspiration for this element almost certainly comes from Palazzo Rucellai, for Codussi had visited Florence in his youth. Those windows provide an element of lightness in contrast to the weighty ground floor.

80. Geometric scheme of elevation with main proportional relations.

The facade can be interpreted as the superimposition of four different geometric planes harmonized and proportioned by a common grid.

The first rules the overall composition and can be identified in the corner pilasters, which span uninterrupted from the water-line base to the top cornice, and in the top cornice itself. The second refers to the rusticated base interpreted as supporting the two upper floors. The third corresponds to the four wall sections, which divide the facade and dictate its basic rhythm. Finally, the fourth relates to the plane of the biforate windows.

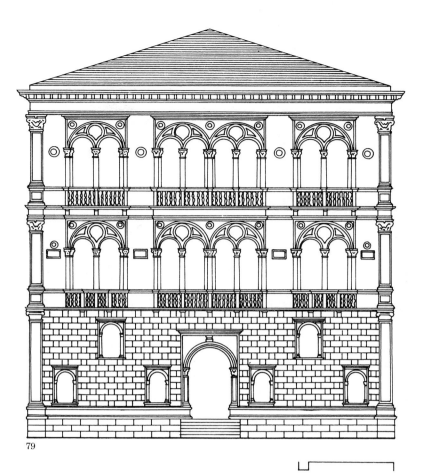

79

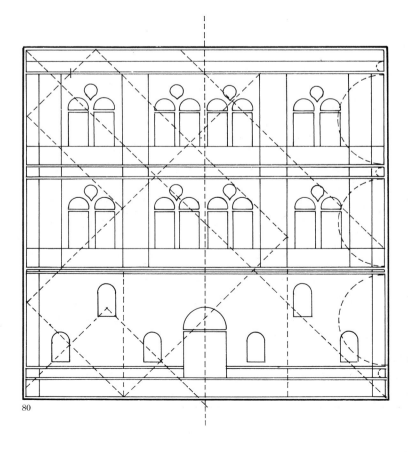

80

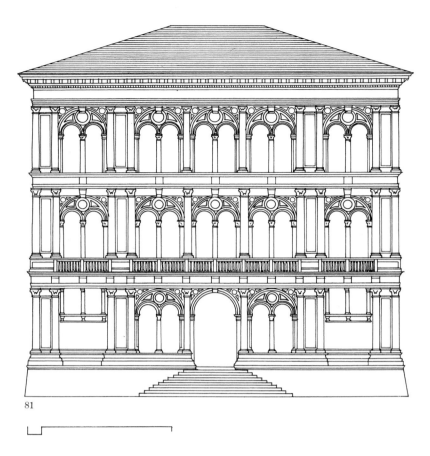

81

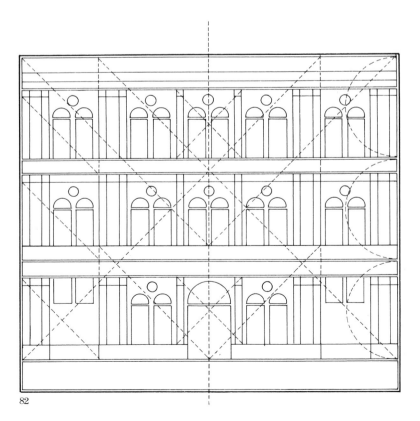

82

Mauro Codussi
Palazzo Vendramin-Calergi
1500–1509
Venice

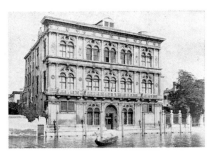

81. Elevation.
The palace is located on the same side of the Grand Canal as Palazzo Corner-Spinelli, and the two buildings have a number of features in common. However, there are differences in their structure and surface treatment.
The points in common include, first of all, the arrangement of the facade. The two palaces not only have a horizontal subdivision into three registers (as was common for the majority of palaces of the period), but the vertical scansion of their facades is also similar. Both can be seen as a superimposition of two planes: the principal, "outer" plane has an A-B-A rhythm and is marked by large pilasters; the second is an ideally set-back, "virtual" inner facade, with a series of bays defined by the biforate windows. But whereas in Palazzo Corner-Spinelli this rhythm appears "supported" by the massive rusticated base, here the scansion reaches the level of the water; it is raised up only on a low base. In addition, instead of only two pairs of windows in the central section, here there are three; this detail gives greater magnificence and lightness to the facade.
The similarities stop here, however. The two facades differ both in the articulation of the architectural order and in their overall sculptural details. In Palazzo Vendramin-Calergi, three superimposed orders form an orthogonal grid that outlines a close succession of very wide biforate windows. On the ground floor the central part is emphasized by the use of rectangular windows rather than arched ones. This solution simultaneously reinforces the building's connection with the ground as well as the articulation of the base register. Only the *piano nobile* has a balustrade. The top floor has neither the infill to be found on the ground floor nor the balustrade of the *piano nobile*, with the result that it is the

most open of all–a detail that lightens the whole facade.
As McAndrew notes, the three superimposed orders appear to be a kind of independent scaffolding behind which a half-hidden, arcaded facade can be perceived. The facade is highlighted by a dense network of chiaroscuro effects. Every detail appears as proportioned on the basis of a common rule so that the whole facade seems characterized by a homogeneous texture.
The scenographic accent provided by the overall details of the facade is continued in an apparently secondary feature: the short flight of semicircular steps that lead up to the entrance portal. As Puppi and Olivato note, this is an eloquent note in the overall design; it can be traced back to the architectural conventions of stage design.
The motif of the biforate window contained in an arch appeared in fifteenth-century Italian architecture (Palazzo Rucellai in Florence dates back to 1446). Nevertheless, as Angelini points out, here its use is highly original with respect to Palazzo Corner-Spinelli. Codussi's genial use of fluted columns in Palazzo Vendramin-Calergi recalls the facade of Alberti's Tempio Malatestiano. These columns and projecting moldings highlight and give unusual strength to the superimposed architectural orders of this palace; refined elegance and classic grandness are combined. This solution creates an illusion of perfect continuity, one that was certainly appreciated by the architects who successively operated in Venice and who adopted it profusely.

82. Geometric scheme of elevation with main proportional relations.
This facade is the result of the superimposition of two different geometric planes.
The first plane corresponds to the framework defined by the semicolumns and the entablatures. Horizontally, the facade is divided into three registers. Vertically, two different rhythms articulate it: four paired semicolumns establish a basic B-A-B division, which can be related to the Corner-Spinelli basic module; the central bay is then subdivided into three similar bays, whose dimensions are equal to those of the side bays (B) but are defined by a single semicolumn instead of the pair. The second plane corresponds to the biforate windows. The windows can be seen as contained by the same wall, which provides a background for the articulation of the architectural order.

Jacopo Tatti, called Sansovino
Ca' Corner
1533–c.1560
Venice

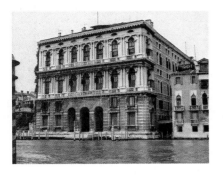

83. Plan.
The sequence of interior spaces has by now been consolidated by the Renaissance tradition; however, here it is conditioned by the presence and the extreme shape of the lots. The great depth and limited width of the lots results in a reduced facade with respect to the bulk of the building. The sequence of atrium-long access corridor-inner courtyard is, as Tafuri notes, noticeably "diluted" to a series of framed perspective views only weakly connected together. If they are compared with contemporary palaces in Rome, it is clear that the difference is not only expressive but involves the very relationship of architecture with the society that it represents.

84. Geometric scheme of elevation with main proportional relations.

85. Elevation.
A contemporary commentator wrote that in terms of architectural magnificence, fine stone construction, size, and cost, there were a number of outstanding palaces along the whole Grand Canal: Sansovino's Ca' Corner, Sanmicheli's Grimani at San Luca and Codussi's Corner at San Mauritio. It is natural that the work of these architects should be thus compared: among them they occupied much of the fifteenth-century architectural scene in Venice.
The continuity of the Grand Canal, once a functional matter, was now purely scenographic. The image of the Canal was enriched by the pure and perfect volumes of these palaces. The juxtaposition of the palaces alongside the Canal created an interesting contrast between the lines of the rigorous perspective construction of the buildings and the winding and organic curves which the Grand Canal follows inside the body of Venice. Taken together in this sense, they form a series

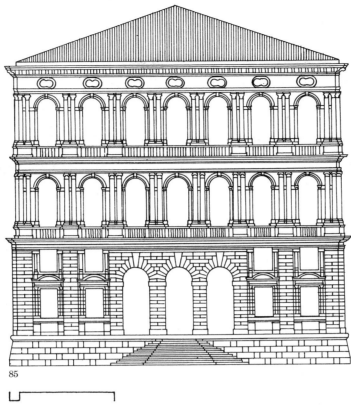

85

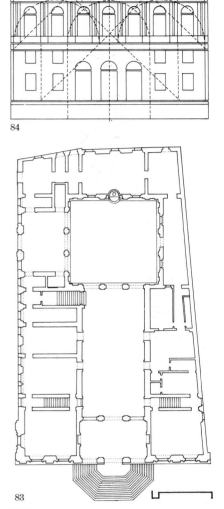

84

83

of theatrical settings–"pictures," in a strict sense–because they do not alter the continuity of the space. As purely figurative, visual decorations, they openly declare their character as a kind of veneer, a "perspective fiction": they are clearly additions independent of the real structure behind them.
In spite of this, it can be said that in Ca' Corner Sansovino takes up the division between registers typical of the scheme introduced by Palazzo Caprini and also reproposes its contrast between the rusticated lower part and the ordered upper part. The influence of this prototype is evident in the subdivision between the rusticated section and the section articulated with the architectural order, although here there is an extra floor. A similar subdivision had previously been proposed by Codussi in Palazzo Corner-Spinelli,

though with notable differences and other cultural references.
Naturally the difference is great, if only because of the different refinement of details and composition. Here the facade has a triple opening at the entrance, which perhaps, as Brandi notes, derives from Palazzo del Te; the rustication is flat on the ground floor and the mezzanine windows are flanked by brackets. The palace is splendid; the decisively massive character of the facade is maintained and reinforced by the two floors with paired columns. There is ample illumination of the interior, a characteristic of many of Sansovino's Venetian buildings. With respect to Sanmicheli's Palazzo Grimani, for example, built twenty years later, Ca' Corner is certainly more luminous; however, it is less articulated. Although Sansovino and Sanmicheli

come from a common cultural background, Sansovino's characteristic use of full, detached columns and his preference for "sculptural" rhythms show an interest in the "dialectic" use of the architectural forces of directly opposite elements.
The proportions of the front of Ca' Corner are those of an almost perfect square, but no element of the architectural framework emphasizes this geometric figure; indeed, it is disguised. The square is not assumed as a reference for its intrinsic properties, but only as the figure that creates the fewest "problems" when it is adopted as a pure supporting outline, providing an abstract order to the composition.

151

Michele Sanmicheli
Palazzo Grimani
1556–57
Venice

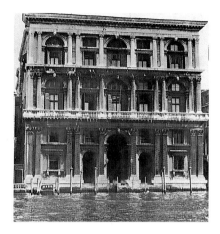

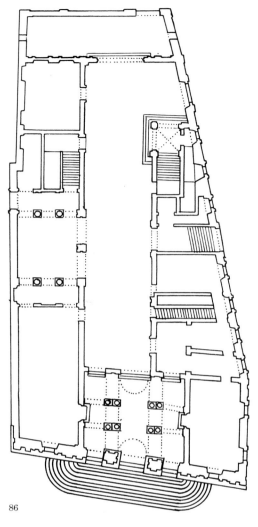

86. Plan.

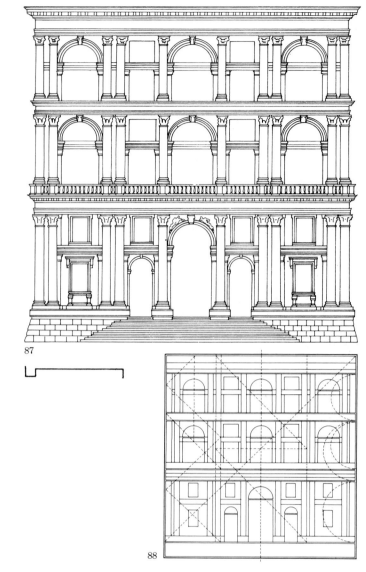

87

88

In his *Venetia Nobilissima*, Sansovino speaks at length of this palace. Together with Palazzo Loredano at San Marcuola, Palazzo Delfino at San Salvatore, and Palazzo Cornaro at San Mauritio, he considers it to be one of the four most important palaces on the Grand Canal. Sansovino writes that "the palace designed by Michele di San Michele is very rich in prestigious finishings, with magnificent floors and splendid details, even on the lower floor." He considers it to be far above one's expectations, but also states that the expense was disproportionately high. The plan of the palace is approximately trapezoidal because of the extremely irregular shape of the site. There is a long gallery situated at the center, marking the axis of the building. This leads from the entrance to an internal courtyard, located halfway down the length of the building on the left-hand side of the gallery. The entrance is characterized by an imposing atrium with paired columns.

The organization of the whole palazzo is influenced by this particular shape. The articulation of the interior is particularly conditioned by it, for Sanmicheli reduces the whole layout to the succession of entrance stairs, facade, atrium, internal courtyard. Palazzo Grimani, as Tafuri notes, is perhaps the only palazzo on the Grand Canal that manages to introduce a different tridimensional element that goes beyond the pure bidimensional appearance of the facade. The atrium, articulated on the Vitruvian model, with paired columns, provides a setback, transitional space between the canal and the courtyard, and not merely a service area, as was usually the

case in other examples, both earlier and contemporary.

In addition, the corner position of the building introduces another element of variation and acceleration of the spatial organization, for the courtyard also serves as an element of continuity between the two different entrances: the main entrance on the Grand Canal, and the secondary, service entrance on the lateral canal. It is interesting to note, even in the case of the secondary entrance, Sanmicheli's habit of emphasizing the function of the entrance with a separate space rather than a mere widening of the corridor.

87-88. Elevation and geometric scheme with main proportional relations.
For Sanmicheli this palace is an important point of arrival in his architectural evolution. Every relationship, direct or indirect, with Florentine or Roman palaces has disappeared in favor of a layout that is still characterized, in

the Venetian fashion, by three floors, including a lower, base level that contains a mezzanine level in addition to the ground floor.

Unlike Ca' Corner, there is no longer any distinction between the base and the upper floors. The articulation is very similar to the type used by Codussi; the two parts, above and below, differ in appearance, but their intention is the same. There is no longer a contrast between solids and voids, of surface and depth. Rather, there is a play of curves and straight lines that compete for predominance in the articulation of the walls. Palazzo Bevilacqua comes to mind, as Tea points out, in the long, continuous balustrade used to mark the division between floors, with its rhythm emphasized in correspondence to the pilasters and columns. This delicate detail blends together the two great blocks of the first two floors (it is possible that Sanmicheli did not intend to include the

third). The facade is based on three large central windows flanked by lesser openings.

Once again there is the theme of superimposed planes – main framework in the foreground, windows in the background – but the distinction between them is not as evident. In addition, the windows are no longer biforate, and their form alternates between arched and rectangular. Familiar elements characterize the upper floor; however, there is a novelty in the lower floor: a triple opening instead of a simple triumphal arch. This forcefully announces the presence of the atrium within and provides a firm connection with the pairs of Corinthian pilasters that strengthen the corners of the facade.

Michele Sanmicheli
Palazzo Canossa
1530–37
Verona

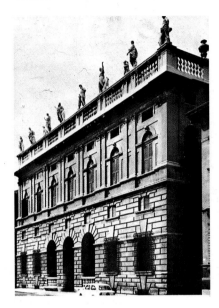

89–90. Plan and geometric scheme of courtyard with main proportional relations.
The plan is based on a typical element of Sanmicheli's architecture: a sequence of enclosed spaces leading to an open courtyard. The front atrium is formed of a group of three different spaces that lead to the transitional element of the courtyard, and reinforce the principal axis that governs the plan of the whole building.

91. Geometric scheme of elevation with main proportional relations.

92. Elevation.
The inevitable reference, as Puppi notes, is in the residential model proposed by Bramante in the so-called "House of Raphael," Palazzo Caprini. The lowest register is divided into ground floor, expressed by rectangular windows corresponding to the rooms of the interior, and mezzanine. In the center, access to the splendid atrium is through a central arched portal, flanked by two lateral arches that are closed off by balustrades. These three openings, with their obvious archeological derivation, once again introduce a typical element of Sanmicheli's architecture: the entrance atrium. On the upper floors, above the rustication, the articulation of the facade is based on the superimposition of two planes.

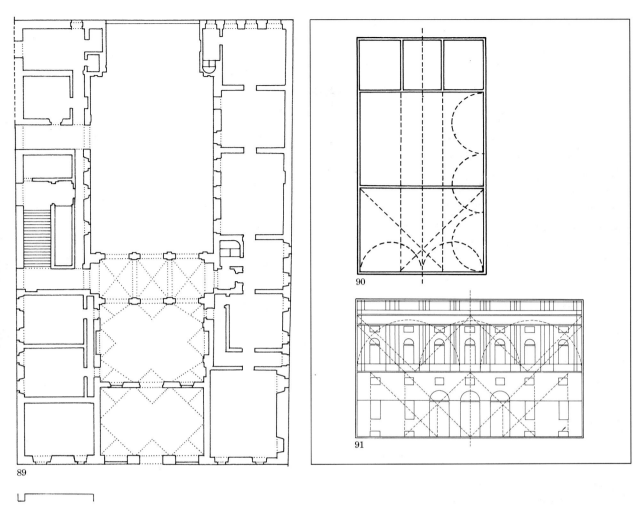

89

90

91

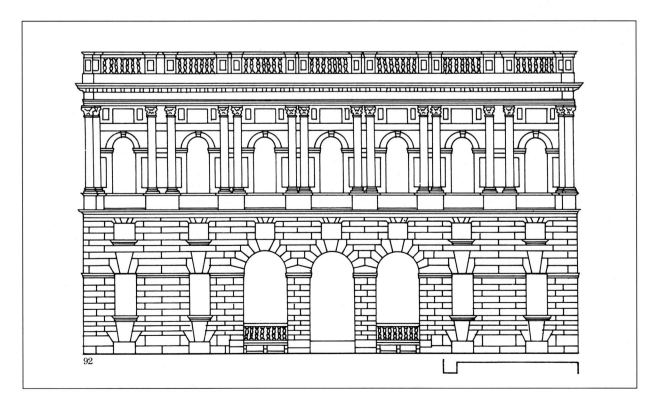

92

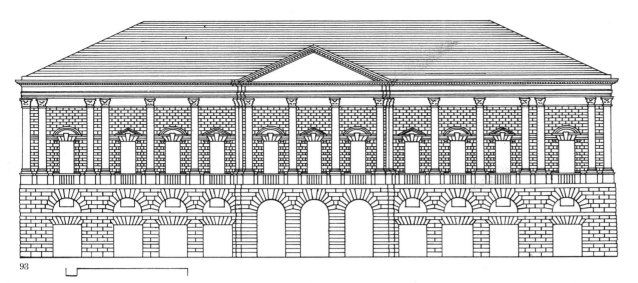

93

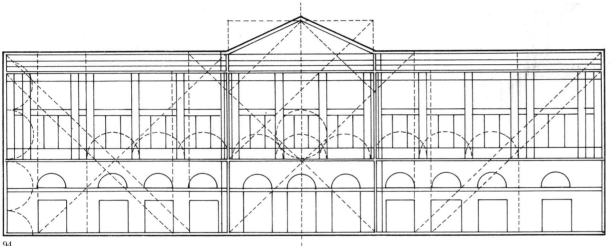

94

Jacopo Tatti, called Sansovino
completed by *Vincenzo Scamozzi*
Libreria Marciana
1537–88
Venice

95–96–97. Plan of the Library, and plans of Piazza San Marco before and after Sansovino's project (Lotz 1989).

The design and construction of the Library of St. Mark, by Sansovino, must be considered in the context of the concurrent reorganization of the whole Piazza San Marco, when the overall definition of the piazza underwent radical changes. In typical Renaissance fashion, the building presents two interrelated aspects: the articulation of its own architecture and the definition of an urban space.

As Lotz points out, the piazza as we know it today owes its appearance to Sansovino. The building that previously occupied the site of the Library was aligned with the side of the campanile in such a way that to an observer positioned on the long side of the piazza the two buildings might appear to belong to the same complex. But Sansovino introduces a new spatial sensitivity to San Marco: the campanile, true to the Renaissance spirit, is transformed into an isolated object that stands out against its background, now formed by the new facade of the Library. A stretch of the facade runs directly behind the campanile, providing it with an element of spatial connection that augments the perception of its scale and further emphasizes its volume. Moreover, Sansovino also transforms the point of connection of the Library to the other buildings of the piazza. The conversion of what had been an acute angle into a right angle emphasizes the irregular shape of the piazza. Not only is it now trapeziform, but it also contains within it two elements, one regular and one irregular, that reciprocally reinforce and enhance each other. The final transformation introduced by Sansovino is the so-called Piazzetta, the area in front of the Doge's Palace, which is now given definition by an additional facade opposite the Palace. The fine articulation of the new building's facade is clearly evident

Andrea Palladio
Palazzo Thiene
1542–46
Vicenza

93. Elevation.

The palace was never completed by Palladio.

Careful examination of the unfinished facade shows a direct affinity with the architecture of Giulio Romano and, at the same time, a series of motifs that can be considered new to the architecture of Palladio. The building follows the Roman and Florentine model. However, as Forsmann points out, the vestibule, with its archeological overtones and rustic columns, is derived from the atrium of Palazzo del Te.

As for the courtyard, the corner that was in fact built gives rise to discordant impressions: on the one hand, the ground floor porticos, with their rustication, may be related to corresponding elements in a number of palaces by Sanmicheli; on the other hand, the porticos of the upper storey recall the courtyard of Palazzo Venezia in Rome. In the elevations, which have a much more imposing, mature articulation than Palladio's other early buildings, as well as in the atrium, almost all the characteristic elements are to be found in Mantua – in Palazzo del Te, the Ducal Palace, and in the house of Giulio Romano himself.

On the whole, the building provides an interesting variation on the theme of Palazzo Caprini. The facade presents an initial division between base and upper part, but there is also an attempt to create greater integration between the two. Like the model, the lower register has a rusticated articulation, with no use of architectural orders. In the upper register, the smooth pilasters of the order are not superimposed on a basically smooth wall, but, once again, there is a form of rustication. It is certainly less pronounced than that of the lower floor, but it is "rustic" nevertheless; this would seem to indicate an attempt to the two levels in a case such as this, where there is no differentiation in function between the two floors of the building.

94. Geometric scheme of elevation with main proportional relations.

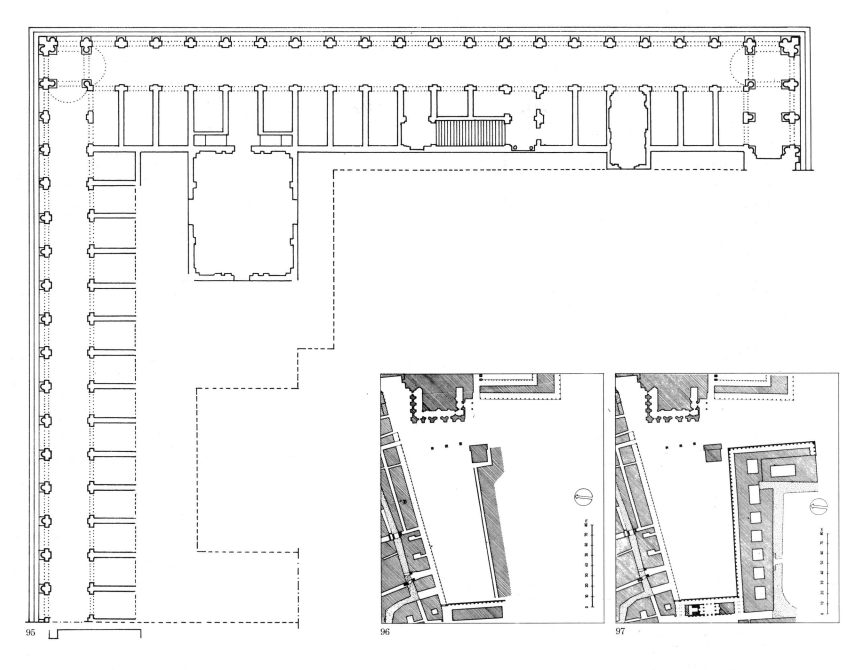

95

96

97

in the plan, whose aggregation of semicolumns and pilasters into piers recalls the interiors of many central-plan churches.

98–99. End elevation and transverse section.
Sansovino's Library is on two floors. The reading rooms are located on the upper floor; the ground floor is characterized by an open loggia that gives access to a series of spaces used as shops and offices. A very rich sculptural decoration is matched by an equally rich treatment of the architectural elements. The Doric order stands on the ground floor, while the *piano nobile* is Ionic: this respects the sequence of the classical canon, although

there is no third (Corinthian order) floor.
Once again, the conception of the facade is in terms of an interrelationship between two ideal, superimposed planes, with the added complexity of the continuous portico on the ground floor. The theoretically external plane corresponds to the larger order; the semicolumns rise the entire height of each register, with the difference that those on the ground floor rest on the steps of the loggia, while those of the *piano nobile* rest on pedestals with balustrades between them. The rhythm of the order is doubled at the corners, for structural as well as visual reasons. The ideally internal plane, as usual, can be pictured as a wall with

windows in it, set back behind the "outer" framework of the large semicolumns; the "windows" are represented by the arched openings. Once again, as in so many buildings of this period, the molding at the impost level of the arches provides continuity between the bays of the "inner" plane. Here it is present in the loggia arches, as well as those of the *piano nobile*, giving the impression of passing behind the larger semicolumns. Small oval windows transform an imposing entablature above the *piano nobile* into an attic storey. This is surmounted by a continuous balustrade, with statues, that crowns the entire building. The statues emphasize the vertical alignments of the building, thus reinforcing its

rhythm and contributing to the impression that the mass of the building "fades" into the sky.
Sansovino faced a specific structural problem in the Library. The Ionic order forms part of the supporting system designed to counterbalance the thrust of the vault above the *piano nobile* of the building; it was necessary to reinforce the exterior walls in order to support the vault.

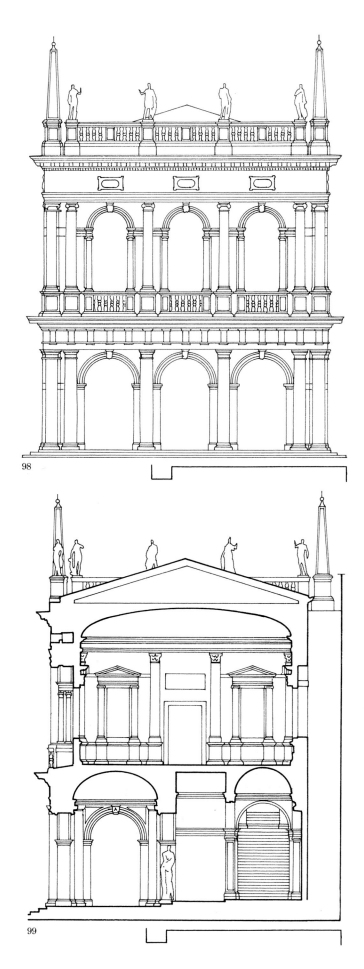

98

99

Andrea Palladio
Palazzo della Ragione (Basilica)
from 1549
Vicenza

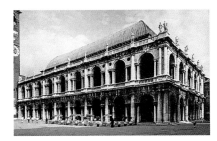

100. Plan.
Palladio's intervention in the restoration of the medieval Palazzo della Ragione involved the design of the loggias that had been added to the original nucleus, a late Gothic building by Domenico da Venezia, which was originally conceived without loggias, in a completely different stylistic language. This building housed an institution typical of the communes of northern Italy, particularly during the Middle Ages; as town hall, it was the place where justice was administered. Together with the cathedral, the town hall was often the most architecturally prominent building of the city; it also provided a concrete symbol of the rivalry and conflict between sacred and secular authority. This type of building, whose depth was often relatively limited, was usually covered with an imposing keel-like roof, which over the years would often begin to show signs of structural instability: the enormous wooden structure created lateral thrusts that the walls, which did not have adequate external buttressing, were incapable of resisting. It became common practice to gird such buildings with loggias. This served a twofold function: on one hand, loggias provided additional, subsidiary spaces that augmented the useful area of the building; on the other hand, they provided the necessary resistance to the thrust of the main roofing structures.
This was the nature of Palladio's project. His intervention on the existing building was exclusively structural; he concentrated his efforts on the articulation to be given to the new loggias. In Vicenza, the situation was made even more interesting by the presence of streets passing through the main body of the existing building, with the Basilica itself forming a link between the main, formal piazza of the city and the architecturally less formal and less organized market place.
In creating the forms of his project, Palladio acts with a certain dialectic

intent; although he designs an independent construction, he nevertheless establishes a relationship between the old medieval structure and the new elements of his facade.

101. Elevation.
The high walls of the existing building by Domenico da Venezia were articulated by pilasters; however, the bays defined by these pilasters were irregular, varying greatly in width. For this reason, Palladio could not simply arrange a simple framework of architectural orders around the perimeter: it would have interfered with the existing articulation and would not have respected the existing pattern of windows, doors, and passageways. Moreover, there was also the structural problem of the roof thrusts to contend with, particularly at the corners, where the concentration of forces from two sides of the building produced greater loads than those absorbed by a normal bay. Palladio draws on his compositional experience in the design of church facades, and, in particular, on the articulation of the facade as an ideal superimposition of a number of geometric planes at different depths. He arranges a principal framework of semi-columns–a detail that only in its form recalls Sansovino's Library–reaching from the ground to the first-register entablature and from the pedestal/balustrade to the entablature of the second register, which is surmounted by a balustrade and statues. This grid is rigorously constant in its scansion and in the dimension of the bays, thus introducing what could be called an abstract theme in that it does not take the pre-existing situation into account. Within this grid Palladio introduces a theme dear to Renaissance architects ever since Bramante: the serliana, a type of opening deriving from the ancient Roman thermae, composed of a central arched opening flanked by lateral openings with horizontal architraves. However, this motif does not have a purely decorative function; it allows Palladio to absorb any differences in the width of the bays by varying the width of the lateral openings while keeping the arch constant in its central position. Thus any irregularity is spread over two different elements and becomes difficult to perceive because the eye naturally rests first on the principal, outer grid and then on the central motif of the set-back geometric plane.

102. Transverse section.

103–104. Main grid and geometric scheme with main proportional relations.

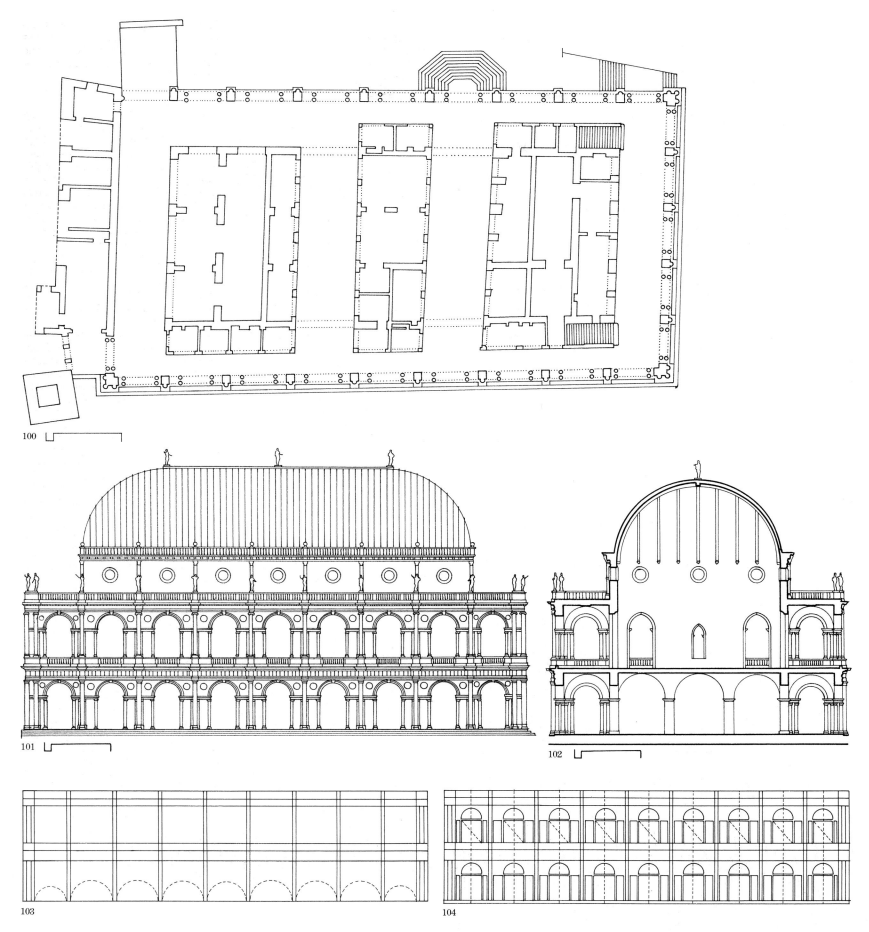

100

101

102

103

104

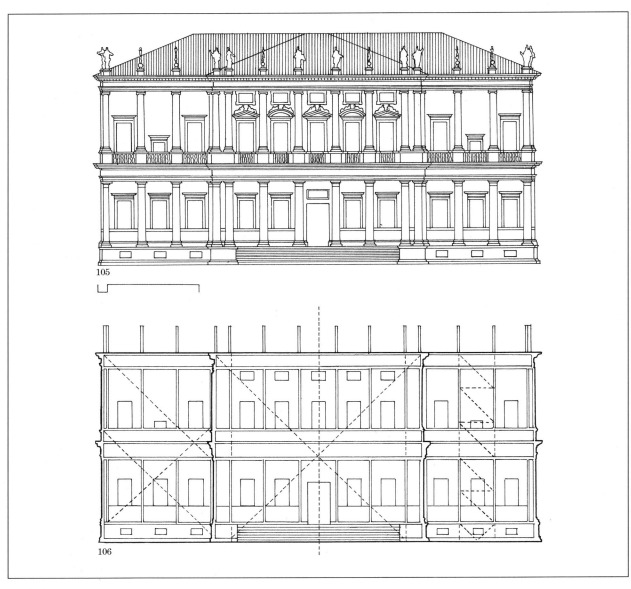

105

106

107. Plan.
Construction of the Uffizi (Offices) was part of a large-scale urban restructuring scheme aimed not only at providing new spaces for the administrative offices of the city of Florence but also at improving the local urban situation between Piazza della Signoria and the bank of the Arno.

The architecture of this complex apparently signals a return to a design concept that had been codified, for example, by Alberti in his treatise – the openings are all based on the classical rule that prescribes architraves, not arches, for colonnades – but it also demonstrates advances in the technique of load-bearing wall construction. Vasari himself states that his choice of architraves for the openings is linked to technical considerations: he had developed a system for using architraves in such a way that "all remains solid and secure." At the same time, it may be observed that this type of articulation recalls the example of Michelangelo's Laurentian Library, also in Florence, though here there are different accentuations and a less audacious use of the architectural order relative to the wall surface.

Vasari's scheme is based on two long blocks of different lengths, each characterized by a portico on the ground floor and an articulation reminiscent of a loggia on the top floor. The two blocks are joined by a bridgelike structure that performs two functions: on one hand, it serves to maintain physical and architectural continuity between the two parts of the building; on the other hand, it gives the street a unified, homogeneous aspect by acting as a theatrical backdrop, framing the Arno and transforming it into a scenic element visible from Piazza della Signoria. The portico, in this case, focuses on an existing element, to highlight its presence.

The architecture of the facades is a consciously classicistic version of Ro-

Andrea Palladio
Palazzo Chiericati
1550
Vicenza

105. Elevation.
The design of Palazzo Chiericati was probably influenced by the trips that Palladio made to Rome in 1541 and 1545–47. The articulation of this building is unique, and constitutes one of the most important, and most surpris-

ing, episodes in Palladio's whole architectural production.

Palladio liberates himself, so to speak, from the typical elements of Bramante's Roman architecture, which by this time had become constant features in the work of an architect like Falconetto; here he creates an architecture equal in dignity to that of contemporary buildings by Peruzzi and Antonio da Sangallo. Perhaps the Doric colonnade of Palazzo Chiericati can be compared to the portico of Palazzo Massimo in Rome. Its facade can be seen as two superimposed loggias, since the solid portion is limited to the five central bays on the *piano nobile*. The sense of transparency and airiness differs entirely from the massiveness of Palladio's earlier buildings and thus represents a complete innovation. This is almost a suburban villa, located as it is away from the center of Vicenza. The main body is of limited

depth, with more emphasis being given to secondary elements such as the portico, the courtyard, the two staircases, and the loggias, than to the enclosed living spaces. In the three-part composition of the facade, the central part projects slightly from the plane of the loggias in the flanking wings. The connection to the wings is achieved by an unusual pairing of interpenetrating shafts that strengthen the corner, in line with a construction method that goes back to ancient models. In the middle sector of the *piano nobile*, five windows, with alternating triangular and curved pediments and five horizontally-oriented rectangular windows above them, provide abundant lighting for the main reception hall.

106. Geometric scheme of facade with main proportional relations.

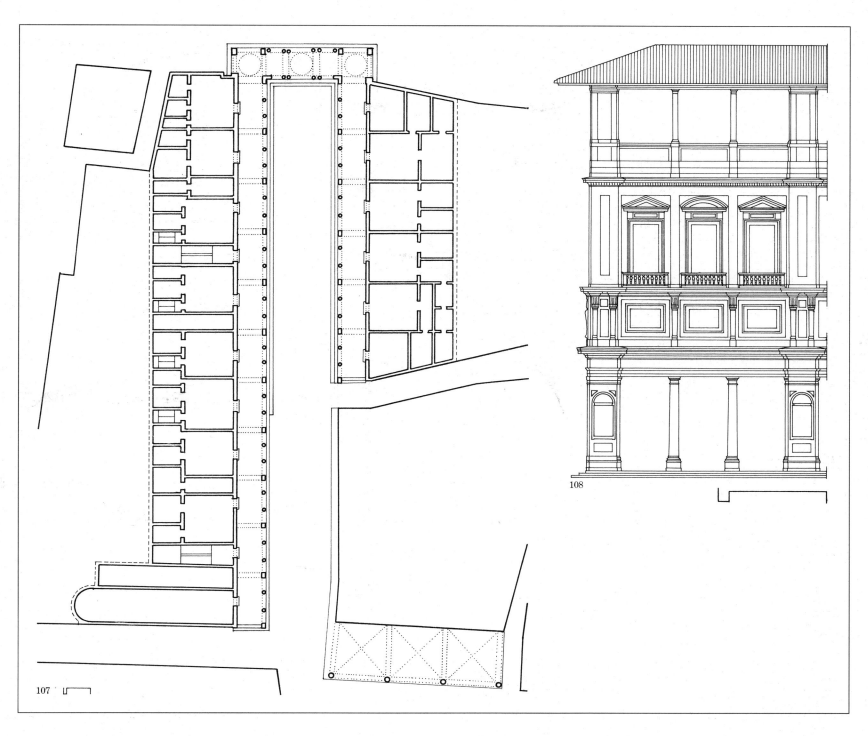

107

108

man models that nevertheless shows respect for the traditions of the Florentine Renaissance; the cool tonality of the Fossato limestone furthers the architect's intentions. An extensive barrel vault, classicistically carved, follows the straight line of the portico; it is characterized by a succession of alternating vertical elements – piers and columns – which constitute a repeating module that confers a strong rhythmic scansion on the entire composition. The alternating rhythm of flat and round elements – columns and piers – is repeated in the false loggia of the top floor.

The false attic above the entablature of the first register, created to provide illumination for the barrel vault of the portico, makes excellent use of Michelangelo's dramatic square motif. However, the same cannot be said for the mechanical repetitions that cover the facades of the wings, especially on the first floor. The most critical point is represented in the elevations parallel to the river, where this preoccupation with detail is more exposed and the oc-

casional delicacy present in the main wings becomes constant.

108. Detail of elevation.

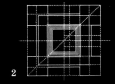

1

2

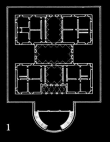

3

**Civilian buildings - Villas
Chronological table**

1. Villa Medici, from 1480, Poggio a
 Caiano (Florence), p. 163.
2. Villa di Poggioreale, ca. 1489, Naples,
 p. 164.
3. Villa della Farnesina, 1509-11, Rome,
 p. 164.
4. Villa Madama, from 1516, Rome, p. 166.
5. Palazzo del Te, 1526-ca. 1534, Mantua,
 p. 167.
6. Villa Giulia, from 1660, Rome, p. 169.
7. Villa Barbaro, from 1557, Maser
 (Treviso), p. 171.
8. Villa La Rotonda, 1566-67, Vicenza,
 p. 172.
9. Villa Farnese, completed in 1573,
 Caprarola (Viterbo), p. 173.

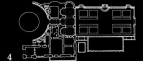

4

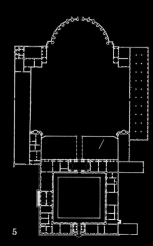

5

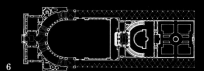

6

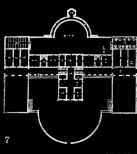

7

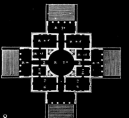

8

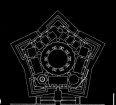

9

Giuliano da Sangallo
Villa Medici
from 1480
Poggio a Caiano (Florence)

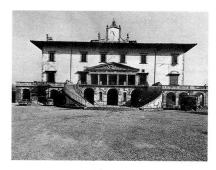

1-2. Plans of ground floor and first floor.

This villa is one of a series of country residences built by the Medici family in the surroundings of Florence. The tradition of country estates goes back to medieval times; the earlier structures, characterized by towers and enclosed farm buildings, were constructed with the double purpose of residence for agricultural work and fortified residence for the military control of the territory. Later villas, such as Poggio a Caiano, in contrast, were more dedicated to recreation, relaxation, and the contemplative life. Thus the *Signore* could pass from the active city life of a typical businessman to an atmosphere of refined contemplation that was more conducive to the life of a gentleman of culture.

The villa at Poggio a Caiano presents a mixture of elements that, on the one hand, demonstrates a continuing connection with the land and the rural function of the country seat (e.g., the service spaces on the ground floor: cellars, storerooms, etc.), and, on the other hand, introduces certain elements that are typical of an urban residence (the great staircase, the entrance atrium, the central reception room). The three characteristic elements of the building that immediately strike the observer are: the articulation of the ground floor, the entrance portico, and the raised block of the central volume of the living quarters.

A gallery of open arches on the ground floor forms a kind of base. This gallery is built to a square plan and, with the terrace above it, completely surrounds the villa. A balustrade reminiscent of the style of Donatello sets off this rather austere element. At the center of the main facade, a projecting structure with three openings–different from the arches typical of the rest of the

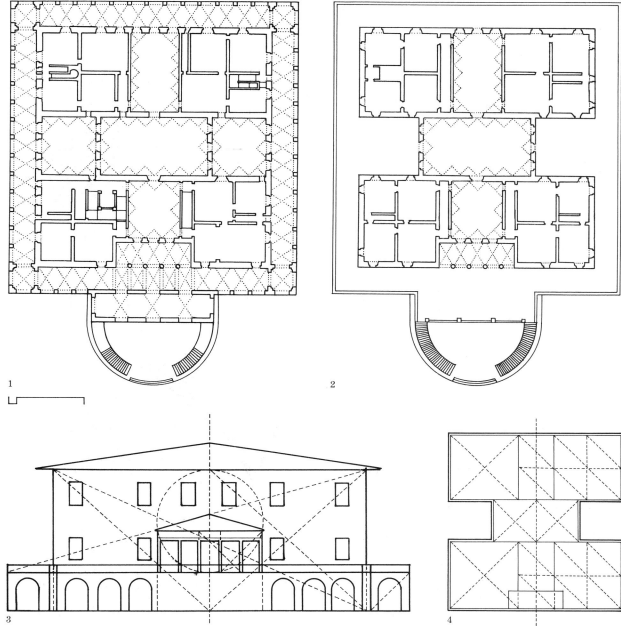

1

2

3

4

gallery–originally provided support for straight flights of stairs.

The villa proper is articulated in three rectangular blocks: two parallel ones to the front and rear, which serve for the many rooms of the residence, connected in the middle by another which accommodates the main hall of the building. The volumes are transversally aligned so that one of the long sides of the base "H" forms the main front of the villa. Thus this upper part of the building appears as a massive block, also built to a square plan, divided in extremely regular fashion. The large rectangular room at the center is oriented parallel to the main facade and receives light from windows in its shorter sides. The disposition of the windows reinforces this

perception, adopting a differentiated rhythm for the central part and the lateral areas of the main facade. This articulation almost suggests the presence of corner towers, a detail possibly recalling a medieval traditional outline of a blockhouse. This volume is covered – without an intermediate cornice – by a very low, Italian-style roof; this arrangement precludes any pretense the building might have of being a palazzo, in spite of its size and monumental character.

At the center of the complex, directly above the staircase unit, which visually serves as a stylobate, is the new motif of the portico. The five intercolumniations provide a precise, elegant rhythm in the center of the facade.

The portico is a sort of *pronaos*, which does not, however, project from the plane of the facade; it penetrates inward like an open vestibule.

The building shows the influence and taste typical of Alberti's architecture: harmonic divisions dominate the plan and the facade, producing a powerful impression of strength, calm, and sobriety. The temple theme of the entrance, as Chastel notes, inserts an element of elegance into this robust celebration of country life.

3. Geometric scheme of elevation with main proportional relations.

4. Geometric scheme of first-floor plan with main proportional relations.

Giuliano da Maiano
in the reconstruction of
Sebastiano Serlio
Villa di Poggioreale
ca. 1489
Naples

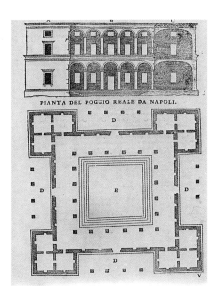

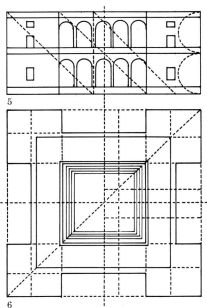

5. Geometric scheme of elevation with main proportional relations.
The facade is characterized by a typical classical element, an Ionic portico opening like a loggia between the two sober, symmetrical masses to either side, which in turn frame it. This building presents the most complete type of composition because it has not one but four facades. This detail is intended to suggest an idea of centrality for the whole composition, a theme that will be supremely emphasized by Palladio's La Rotonda.

6. Geometric scheme of plan with main proportional relations.
Today this villa no longer exists (some commentators report that it was already in ruins at the beginning of the eighteenth century), and even its location, in the periphery of Naples, has been identified only through a series of ancient views. The villa is therefore known through paintings, especially the beautiful seventeenth-century paintings by Viviano Codazzi, and its original project is known mainly from the mostly unprecise version given by Serlio in his famous treatise on architecture.
In his drawing, showing a schematic plan plus an elevation and section, Serlio, true to the concept of absolute centrality, defines a perfect square as the basis of his interpretation of Maiano's villa. Moreover, the square is repeated in the four corners, to accommodate three rooms in each corner unit. There is a loggia on each of the four sides of the square, formed by a series of four "pilastri" between each pair of corner towers; these correspond perfectly to the four intermediate piers in the courtyard. However, in the opinion of Pane, there are also a number of inconsistencies in Serlio's design. Perhaps the most conspicuous of these is the curious treatment of the stairs. Evidently Serlio could find no appropriate place for a staircase in this rigid geometric context, which was more a symbolic than a structural concept. The solution was to insert spiral staircases in the crossing point of the walls, at the very center of each of the towers, contradicting the most basic structural requirements and reducing the staircases to absurdly small dimensions.
The scheme of this villa, in the opinion of Chastel, can be seen as the Tuscan interpretation of an ancient type, handed down via the Venetian tradition, and adapted to contemporary taste. The four corner volumes may, in fact, be interpreted as a reminiscence of the fortress towers of medieval tradition. But compared to a fortified structure, Poggioreale is more complex: it is set up, on a base, in the middle of a park, and treated like a palace for the rustic life, with a private garden and a whole series of amenities for the Signore, among which there is even a fish pond. The porticos hollowed out of each side make it a complex of four towers, with the four porticos opening onto a central, square courtyard. This completely new scheme was perfectly appropriate for a villa that was intended to be a place of pleasure and entertainments, with balls and banquets held in the courtyard.

Baldassarre Peruzzi
Villa della Farnesina
1509–11
Rome

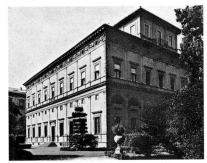

7. Plan.
The site of the villa is in the Trastevere section of Rome, directly across the Tiber from the Palazzo Farnese (by Antonio da Sangallo and Michelangelo). This is not a mere coincidence: in fact, there was originally to have been a bridge connecting the two Farnese properties on opposite banks of the river, creating a single complex that would have joined the official, urban palace to the more private, secluded, "getaway" residence, located in a Trastevere that, at the time, was largely dedicated to orchards and vegetable gardens, and could for all intents and purposes be considered a rural area.
The theme of suburban villa that Peruzzi developed here was somewhat unusual in the context of the early sixteenth century, but was destined to become more widespread in later years. This building type maintained certain characteristics of the rural dwelling, closely linked to its productive activities, while incorporating aspects more associated with a life of recreation and contemplation. Thus the architectural theme involves "ennobling" the rural house, making it worthy of the Signore who will occupy it.
In this case the rural connection is not emphasized; perhaps because of the planned bridge to link it to the palace, the villa is treated more like a garden pavilion. The plan, in fact, is characterized by ample reception rooms and a magnificent portico contained within the volume of the villa. The plan is rather unusual: a rectangle with two equal, projecting units at either end of one of the long sides, resulting in a U shape. The elevations rise uniformly, in two registers, each articulated by the pilasters of an architectural order, and are terminated by a frieze in relief that runs beneath the line of the roof. The building appears to be symmetrical with respect to an axis at right angles to the long sides; however, the loggia to the left, overlooking the river, does not have a corresponding ele-

ment on the right, toward Via della Lungara.
Peruzzi's choice of this particular building type is not the result of a random decision, but makes reference to specific classical models. The fundamental decision is to forego the well-established interior courtyard in favor of a more compact configuration in which the void is not carved out of the center, but is defined as a subtraction of mass from one side of the basic volume. In this sense, Peruzzi's choice of typology reveals his Tuscan origins and the villa's derivation from models typical of the court at Urbino, perhaps due to the influence of Francesco di Giorgio Martini and his treatise. At the same time, however, the articulation of the walls shows an evident interest in the new examples of Roman architecture, especially Bramante's Palazzo della Cancelleria, as well as the design of Palazzo Rucellai.
Peruzzi goes beyond these references, accentuating, for example, the aspect of "subtraction" of mass: by placing projecting wings on either side of the portico that is "carved out" of the main block of the building, he provides even more emphasis to this feature of the villa. As Portoghesi notes, an important aspect of this articulation is the differentiation of the facade facing the Tiber from the corresponding facade on the opposite side of the building.

8. Geometric scheme of plan with main proportional relations.
The proportions of the plan derive from a square-based grid; the two projecting wings are obtained by adding a certain number of squares to the main block of the building, and the portico results from an analogous process of subtraction. This proportional grid provides the architect with a means of controlling the relationships between all parts of the building, allowing him to articulate in the most appropriate way the various components of this particular typology.

9. Geometric scheme of elevation with main proportional relations.
Peruzzi uses another proportional system, again based on the square, to establish the proportions of the different parts of the facade. Unlike the plan, where the square module supplies the main reference for the dimensions, here the principal element is the diagonal. On the basis of parallels and right angles between diagonals belonging to similar geometric figures – in this case, squares – it is possible to draw a series of principal alignments that can be utilized to establish the position of the main entrance portal and the win-

dows, or the vertical development of each of the two registers. A sequence of diagonals intercepts the dividing line between the registers, setting a proportional correspondence between the double-bay module of the ground floor (which includes the mezzanine) and that of the *piano nobile* (which includes the attic level).

10. Elevation.
In the scansion of the two registers of the facade, Peruzzi takes another step toward the affirmation of a classical architectural language typical of Rome and this early sixteenth-century period. Features such as the way the two orders are related (the lower incorporates a mezzanine; the upper supports an attic floor), or the different proportions of the balustrade supporting the pilasters in the two registers (the larger element, on the ground floor, emphasizes the strength of the base; the smaller one in the second register gives a sense of lightness to the facade), are all details that contribute to a body of architectural experience that will serve as a model and a reference for generations of architects.
Vasari has words of highest praise for this villa, saying that it brought great fame to Peruzzi. He describes the terra-cotta frieze, sculpted by Peruzzi himself, the main reception room, and the loggia onto the garden, painted with the story of Medusa and decorated "in a most natural and lively way" with perspective views in stucco.

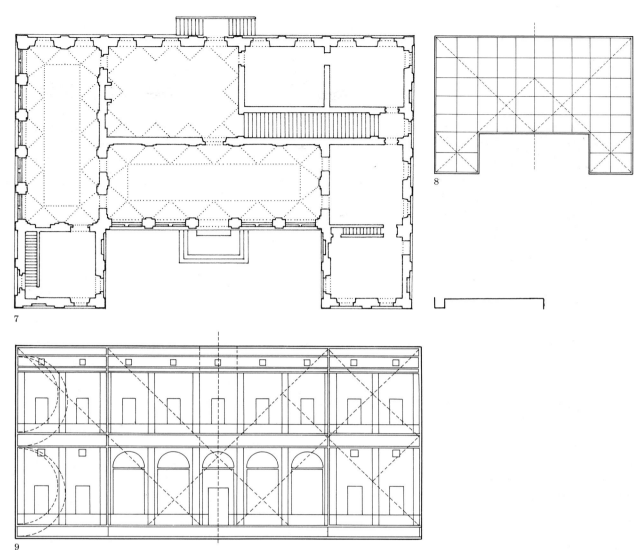

7

8

9

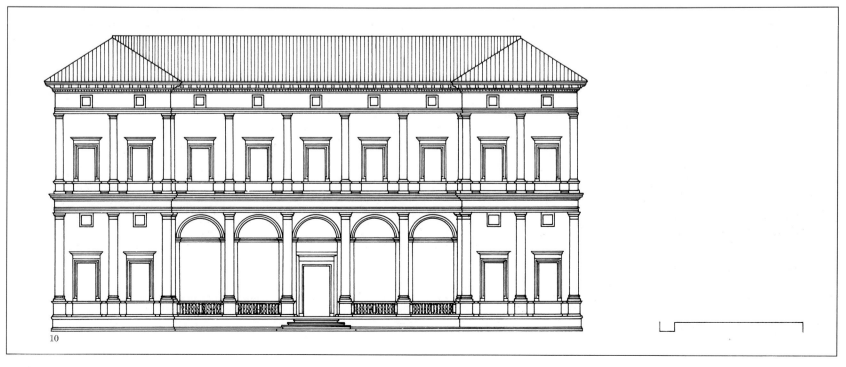

10

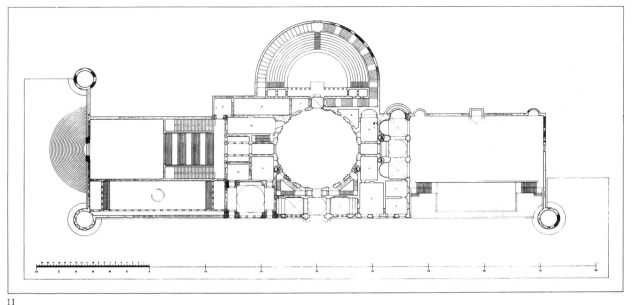

11

11. Reconstruction of the original project, plan of the main floor (Dewez 1990)

Compared to previous examples, such as the Villa Medici at Poggio a Caiano or the Villa Farnesina, this villa defines more specifically the concept of the suburban villa as an ideal place to which the *signore* could retire for recreation and contemplation. The link with the productive activity of the fields was still present at Poggio a Caiano, but had already disappeared in the Farnesina. Here it is rejected completely in favor of a model that aims to re-establish the reality of the villas of imperial Rome. This explains the presence of a number of typical elements whose only function is to provide relaxation and recreation, such as the garden, the nymphaeum, and the fish pond; such elements had, for example, characterized the villa of Poggioreale.

Raphael's purpose is to create a collection of elements and judiciously compose them into a single architectural complex. The project, as Frommel notes, started rather modestly, but was gradually expanded in an attempt to produce a perfect example of classical architecture. A church could never have the exact form of a pagan Roman temple, and there was no contemporary requirement for public buildings such as theaters, thermae, circuses, or triumphal arches; however, the intimate, isolated atmosphere of a suburban villa allowed for an exact duplication of the ancient models. Raphael thus designed a complex that combined the comforts of the Tuscan villas of the Medici with all the possible structural elements of antiquity. In a famous letter to his friend Baldassare

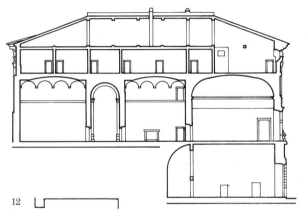

12

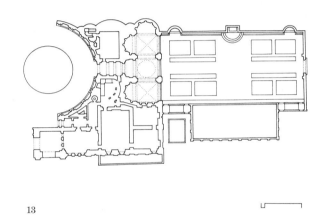

13

Castiglione, Raphaèl describes the belvedere in the left tower (*dietae*), the nymphaeum, the secret garden (*xystus*), the round courtyard (*oraculum*), the terraces for dining al fresco (*cenationes*), the summer and winter apartments, the theater, and the hippodrome—extraordinary fruits of years of archeological studies. Unfortunately, only limited parts of the planned structures were eventually built.

As Dewez notes, the reconstructed plan shows traces of the influence of Giulio Romano and doubtless also contains a certain number of references to Antonio da Sangallo. The villa is situated halfway up the side of the hill of Monte Mario, overlooking the city. The original design shows a villa sited on a sloping hill, on a great podium partially stepped into the hillside and partially standing out from it. The central part of the podium contains the ground floor and the superstructure mentioned above. The volumes are organized around a circular court situated beneath a great open-air theater that

dominates the entire complex. On the southeast side of the superstructure, the podium encloses a sunken entrance court and carries a walled garden; on the northwest side it provides space for a elevated garden and then descends to another sunken area with a fish pond. Since the podium is inserted diagonally into the hillside, only two sides are completely exposed, to the northeast and the southeast. These sides are provided with round-towered bastions at the north, east, and south extremities.

12–13. Section and plan of the built part.

Raphael translates forms and motifs from antiquity (in this case the villa, with its constituent elements) into a completely modern structure – modern not only in the composition of its parts, in the new significance of the axes, in the perspective conception of space, and in the centralization of the whole villa, but also in the functionality of the entire structure. In certain

ways, this more closely resembles the structure of contemporary palazzi – for example, in the sequence of atrium-courtyard-stairs – than the structure of ancient villas. Such a synthesis between modern functionality and ancient style can also be noted in a description that Raphael made of the villa, in which he "accompanies" the visitor on a long trip around the villa and its various parts. He points out the comfortable aspects of each area, the beautiful views of the Tiber valley, the pleasant climate, and so on. In spite of all the ancient elements, Villa Madama remains in the end a building that is not ancient, but one enriched with motifs taken from the architecture of the fifteenth century, and Bramante in particular. Although Villa Madama does not have any direct "heirs," it was of great importance for the typology of the Italian villa, influencing, for example, Palazzo del Te, Villa Imperiale in Pesaro, Villa Garzoni in Ponte Casale, Villa Giulia in Rome, and various plans by Palladio.

Giulio Romano
Palazzo del Te
1526–ca. 1534
Mantua

14. Plan.

The overall layout of the villa is based on the composition of a series of differentiated spaces, open and closed, covered and uncovered, all organized along a longitudinal axis. This axis is not, however, used as a true axis of symmetry, but only as a reference line to balance the building masses to the right and left. The sequence followed by the entering visitor – atrium, courtyard, vestibule on the garden, bridge over the fish pond, garden, exedra – is distinguished by the great variety of spaces encountered. The general scheme is further enriched by a number of additional "events," such as the secret garden to one side of the exedra; these constitute independent centers of attention, whereas a more canonical articulation would most likely have called for a greater harmonization among the various elements.

The main axis is contradicted in a sense by the presence of another axis at right angles to it, associated with the second atrium, known as the Duke's Entrance. It is this characteristic alternation of spaces – without for the moment making any reference to the immense differences in the treatment of the wall surfaces – that gives the visitor a perception of rich variation on the theme of the canonical sequence of spaces. The usual Renaissance sequencing of gradual spatial changes is replaced by a sequencing based on juxtapositions and alternating perceptions. Giulio Romano's characteristic love of the varied, the unexpected, and the unusual is clearly in evidence.

No other architect knew so well the latest developments in the field of the construction of palazzi and villas, and no other had the ability to bring together the taste for "luxurious" living and the splendor of the classical age. Some of Giulio Romano's best "inventions" were the direct result of

14

15

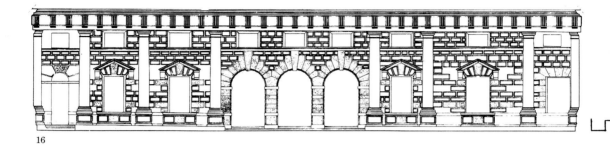

16

his use of classical construction elements.

15. External facade elevation of the north side (Carunchio, Bernardini, and Tamburrini 1989).

16. Facade elevation of the courtyard, north side (Carunchio, Petroni, and Tamburrini 1989).

The four-sided structure of Palazzo del Te follows the ideal of the classical house on one floor. In the structuring of the exterior and courtyard facades, as Frommel points out, the procedure–different from that followed on Giulio's house in Rome–emphasizes the rusticated blocks in contrast to the smooth shafts of the Doric order. The keystones project from the wall surface even more than in his house in Rome, so that the natural energy of the rustication is held in check by the rational structure of the Doric order. Here too this energy is gradually attenuated in the upper part of the facade, and the whole facade is crowned by a slightly articulated attic. The articulation of the elevations is not based on the typical composition of the architectural order alone; the wall itself acquires an important role because of its finely rusticated treatment, created not with stone but with carefully executed stucco work. The "fake" stone blocks thus define a plane strongly characterized by shadows produced by the incident light, which emphasize even more the articulation and the rhythm of the pilasters.

Giulio Romano adds another element that contributes to the overall composition: the openings. These voids "subtract" material from the mass of the wall, inserting a further rhythm in the rusticated wall and giving rise to variations in the form of cornices and architraves. The overall effect is thus not one of a simple relationship between framework (the architectural order) and plane (the rusticated wall surface), but a complex system of visual weights and thrusts whose center of gravity lies in the entrance portal. However, as Gombrich points out, there is a perception that the composition of these facades is based on a representation of a harmonic relationship between these elements and not on an effective "conflict" between them. In the end, the facade is transformed into an elegant ornamental motif, whose components maintain an almost illusory relationship to each other, and in every element of the facade it is possible to recognize an essentially decorative aspect. Such details lead to an assessment of Giulio Romano's architecture as being based fundamentally on forms whose primary, original meaning is modified, and which are then adopted in a new system that not only completely alters their value and their role, but in the end creates an absolutely new and original formal balance.

Almost everywhere it is possible to observe an extreme attention to producing variations on the theme of contradicting the standard rules,

through the introduction of details that are new and original either in form or in function. Giulio Romano's aim is to create in the observer a constant sensation of surprise, of contrast with what he might have observed in contemporary or slightly earlier buildings. It is in this context of "astonishment" that many otherwise inexplicable solutions can be understood.

All of this has devastating effects on the architecture as a whole, of course. With the work of Giulio Romano the complex grammar of the classical architectural language that had been codified ever since the early Renaissance starts to be dismembered, and its fundamental principles are completely undone. In the courtyard, for example, the irregular rhythms of the north and south facades are set by semicolumns, while on the other two facades the canonical regularity of the architectural order is fully respected, being based on a series of equally spaced pilasters. Another example, as Tafuri notes, is the alternation of metopes and triglyphs: where this rhythm could become too "serious" the architect intervenes to make some of the triglyphs slip downward, introducing a facetious element that lightens the entire composition. Thus, within this system, any irregularities encountered by Giulio Romano in the parts that were to be restored or built anew, are allowed to emerge without compromising the harmony of the overall layout of the composition.

As Capeggiani and Telini point out, Giulio Romano detaches himself from classical orthodoxy, but his methods do not underlie the drama of an existential crisis or the violence of an iconoclastic attitude. Rather, it is a sense of skepticism that guides the artist in his challenge to the body of rules and canons that governed the underlying ideas of classicism. Giulio reacts against the dogmas generated by humanistic certainties and claims the subjective right to a full freedom of expression, manifested in formulas of ambiguity, irony, and playful joking.

Jacopo Barozzi da Vignola
with *Giorgio Vasari*
and *Bartolomeo Ammanati*
Villa Giulia
from 1550
Rome

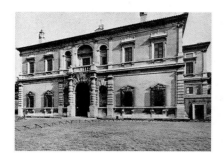

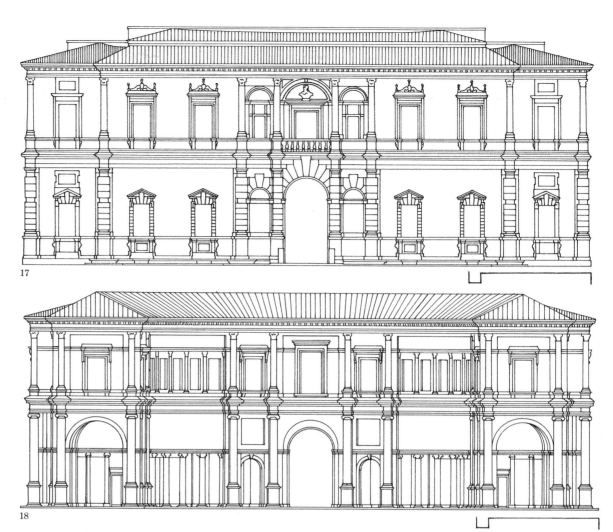

17

18

17–18. Front and rear elevation of main volume.

The architecture of this villa constitutes a further development of themes typical of Roman architecture. In addition to quotation and development of many details from buildings by Michelangelo or Antonio da Sangallo the Younger, there are also many new elements. A novel element, which Vignola introduces in this villa, is the accentuation of the central part of the facade. The three bays that make it up are arranged on the triumphal arch scheme and are executed in stone blocks, so that this section of the facade stands out with respect to the flat brickwork to either side. The position of the villa, outside the city walls, explains both the hints of fortification and the triumphal arch motif. Like the Vatican, this papal residence is ringed by a wall, with the portal as the only entrance. Although certain details recall Giulio Romano, and the treatise of Serlio, on the whole there is nothing similar in Roman architecture in 1550: the facade represents a new and carefully studied solution for the requirements of the situation.

The overall conception of the building develops around a spatial pivot: the horseshoe-shaped portico upon which the building rests, without overpowering it, leaving the end bays open. The facade turned toward the city seems ostentatiously severe, as if to hide and compensate for the lightness of the internal space.

A comparison of the facade of Villa Giulia with the facade of Sangallo's Palazzo Farnese illustrates the different conception that guided Vignola here. Sangallo's design continues, on a vaster scale, the structure of the fifteenth-century Florentine palazzo. A precise, linear subdivision of the constructive modules–in the exact alter-

nation of floors and windows, in the eurhythmic relationships of the rustic-work–allows it to reach a harmony and balance typical of Renaissance architecture. In Villa Giulia, on the other hand, Vignola purposely breaks Sangallo's clear metrical series of planes and windows. In a procedure that is the exact opposite of Peruzzi's approach for the Farnesina, the central block, instead of being carved out, is made to project from the main body of the building. In contrast with Peruzzi's definition of volumes by means of individual lines of demarcation, the most important, characteristic feature of Villa Giulia's architecture is the play of masses and chiaroscuro. Vignola intentionally designs each elevation by organizing every element around the dynamic contrasts of projections and recesses in the entrance portal, to deliberately accentuate the predominance of this part over the rest of the facade.

19–20. Plan and geometric matrices of plan.

The villa was situated outside the walls of the city of Rome, at a certain distance from the Via Flaminia, which leads out from the Porta del Popolo. At the time of its construction, the site was completely rural. This allowed Vignola to follow the tradition of the classical Roman suburban villa–the country seat dedicated to relaxation and recreation–even though this was a papal residence. The architect incorporates in the complex a series of elements characteristic of this tradition, such as the garden, the porticos, and the presence of water in pools and fountains. The overall plan is then laid out along a main axis, as a sequence of spaces of various forms and–an important innovation–at different levels.

The theme of juxtaposition is even more obvious in the plan: the meeting of the semicircle of the portico and the right-angle elements of the outer facade produces a series of unusable, curiously shaped spaces and excessive wall thicknesses. This kind of "double face" program was common to many of Julius III's construction projects, Portoghesi remarks. The idle pleasures of the court must be covered by a decorous facade, and so the light-hearted

openness of the interior portico is countered by the serious, forbidding, defensive exterior. The extroverted and articulated character of the Farnesina or Villa Madama is replaced by the principle of complete introversion, of "hortus conclusus."

21. Longitudinal section.

In the opinion of Lotz, Villa Giulia cannot properly be compared with Villa Madama, because it is located in a valley rather than on the side of a hill; however, differences in level are an essential design element here also. After leaving the main building, crossing the courtyard, and arriving in Ammanati's portico, it is possible to see the sunken nymphaeum. This lower level, the "secret fountain" of the Acqua Vergine, can be reached only by descending one of a pair of curved staircases incorporated in the massive retaining walls.

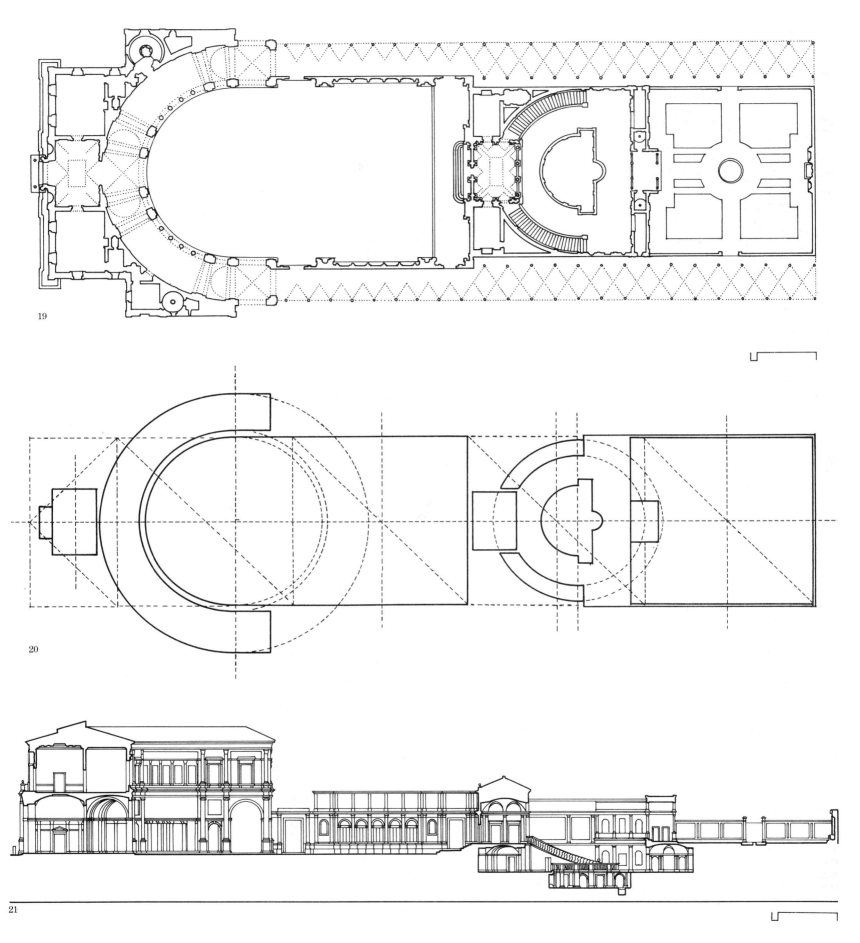

19

20

21

Andrea Palladio
Villa Barbaro
from 1557
Maser (Treviso)

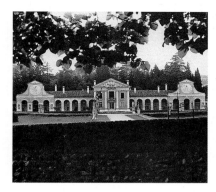

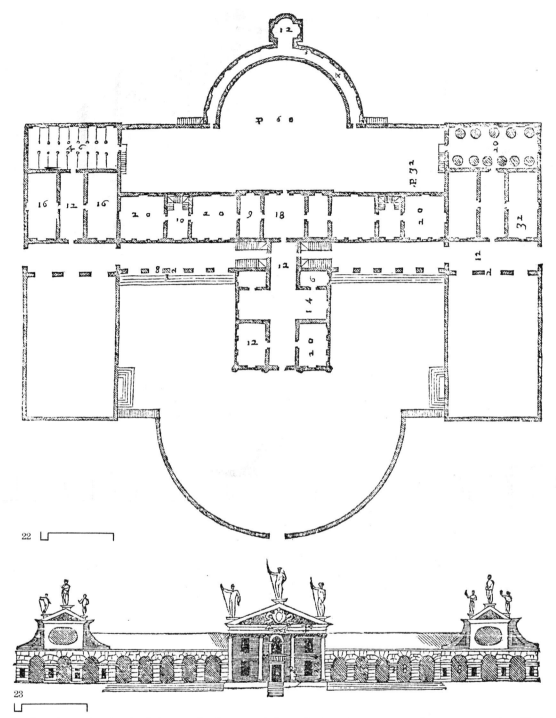

22–23. Plan and facade from the *Four Books on Architecture* (1570) by Andrea Palladio.

Villa Barbaro is to be considered alongside the Villa Rotonda as one of Palladio's most important villas. Cardinal Daniel Barbaro, who commissioned the building, was one of the most prominent men of culture, both in Venice and in Rome. Palladio had collaborated with the cardinal in the literary field, in the preparation of the architectural texts of Vitruvius. Therefore, as Rigon notes, it is not unreasonable to suppose that the cardinal may have had a role in the development of the spatial concept of his country villa. In spite of the poor quality of the reproduction of the villa in the *Quattro Libri*, the articulation of the various parts that made up the magnificent building can be appreciated. The central block extends out into the garden. In plan it is characterized by a cruciform central space. Left and right of this central block, the porticos of the long *barchesse* – the units containing all the service spaces – connect it to the three-arched units at either side. The rear portions of these lateral elements extend back to form two wings that enclose the rear garden, accommodating the stables on one side and the cellars and storerooms on the other, in a very complex articulation.

The central body has two facades, each with a triangular pediment. The rear facade includes the ground floor, *piano nobile*, and an attic floor, and overlooks the nymphaeum. The other includes ground floor and *piano nobile*, and faces south onto the open access court. The Ionic order on this facade features two central semicolumns flanking the main entrance and two three-quarter columns on the corners, that "wrap around" to the sides of the

unit. In plan, the stairs that lead from the *barchesse* to the *piano nobile* seem to divide the forward section of this main element from the important, transverse part of the building that forms the south boundary of the rear garden. Two axes cross at this point: the north-south axis of the central body and the east-west axis of the rest of the building.

This villa is important not only because of its architecture, but also because of the decoration by Paolo Veronese in the interior. In this case,

the beauty of the paintings does not conflict with the architecture; nevertheless, as Canova suggests, it should be noted that although these paintings are very important, even exceptional, they remain in some way dependent on, and conditioned by, the architecture that surrounds them. This depends, evidently, on the different intentions of architect and painter: the one aims to maintain stable proportions and harmony of volumes, while the other seeks to abolish the walls in a quest for infinite spaces

and new perspective illusions. In the context of the villas of the Veneto, this is certainly the clearest case of such a union.

Andrea Palladio
Villa La Rotonda
1566–67
Vicenza

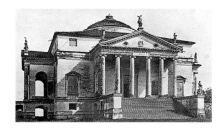

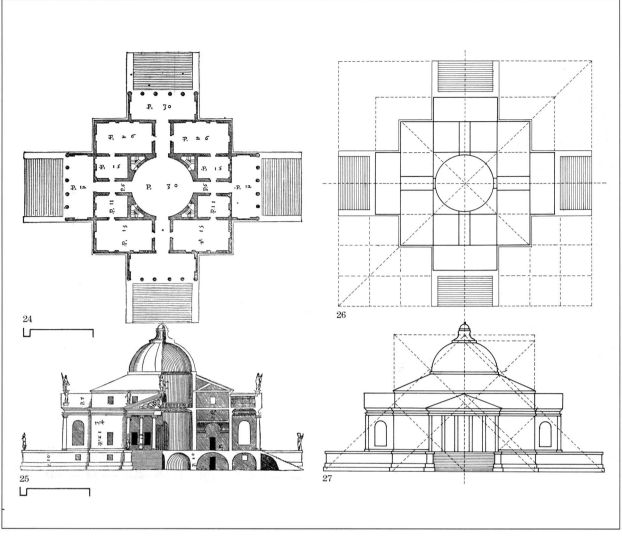

24–25. Plan and elevation-section from the *Four Books on Architecture* (1570) by Andrea Palladio.

As Wittkower puts it, La Rotonda is the Palladian villa par excellence. This villa can be considered a secular version of the kind of central-plan church to be found in Todi (Madonna della Consolazione) or in Montepulciano (Madonna di San Biagio). "Amongst many honorable Vicentine gentlemen," Palladio writes of his patron, "there is Monsignor Paolo Americo, an ecclesiastic, who was referendary to two supreme Popes, Pius IV and Pius V, and who for his merit deserved to be made a Roman citizen with all his family." The villa is located "less than a quarter of a mile distant from the city . . . (on a site) very pleasant and as delightful as can be found, because it is upon a small hill, of very easy access, and is watered on one side by the Bacchiglione, a navigable river."

The use of the dome reveals a new concept of the villa itself–it becomes a kind of monument. Palladio's own description of the villa leaves no room for doubt: the four *pronaoi*, the square plan, the four flights of stairs, the siting of the building–all these are characteristic of a self-contained monument, and, like a sacred structure, this monument requires a dome.

Needless to say, no previous villa combined all of these elements. The Villa Medici at Poggio a Caiano has a single facade, reached by means of a double staircase; it has a ground-floor portico and pediment. The villa of Poggioreale in Naples, now destroyed, had an internal courtyard; the exterior was probably very simple, more similar to a medieval castle than a fifteenth-century villa. Nor can La Rotonda be compared to villas derived from the type of Villa Madama in Rome. It presents an entirely new concept in the history of the type of structure referred to by the name of villa. As outstanding innovations of this building, Lotz enumerates: the new concept of

villa as a detached, free-standing monument, visible from all directions; the use of the typology of the monumental domed sanctuary for a civilian building; and the choice of the hilltop site, which was another innovation with respect to previous villas.

For the use of the central plan, Palladio could refer back to a long theoretical and practical tradition. Alberti, Leonardo, Bramante, and Michelangelo all expressed their preference, in religious buildings, for this type of plan. Neo-Platonic philosophy had granted it special significance, evident in the exemplary rationality of the form itself.

26–27. Geometric scheme of plan and elevation with main proportional relations.

A number of ancient buildings may have offered inspiration for La Rotonda. First of these would be the Pantheon, the most famous central-plan building of the past and an essential

part of any study of ancient architecture. Another, perhaps, is the mausoleum of Romulus. Yet another possible source could be a drawing made by Palladio of the so-called Temple of Hercules Victor at Tivoli. This drawing may predate the design of La Rotonda; it represents a temple that existed more in the artist's imagination than in reality; however, it possesses a porch with pediment, repeated four times, which would seem to indicate the germ of the basic idea of La Rotonda.

Semenzato argues that the solution was suggested to Palladio not only by the natural position of the villa, but also by a desire to perfect a building type that had always been subject to some form of compromise. Even the Pantheon is imperfect in its central-system structure: the portico introduces an axis that detracts from its centrality; in addition, there is no resolution to the difficulty of linking the rectilinear portico to the cylindrical

body of the temple, and there is a contrast between the two roofing systems, the pediment and the dome, as the latter flows over the former. Not only did Palladio multiply the number of *pronaoi*, making them perfectly symmetrical and thus establishing the centrality of the building; in addition, he inserted the circular element into the square block so that only the dome emerged and no longer contrasted with the porches (though it was related to them, being of the same width). By inserting the circle into the square, by uniting these basic, even archetypical geometric forms, Palladio resolved the problem of the coexistence of curved and straight lines, and effectively overcame the difficulty of relating a rectilinear front to a curved volume. A new building type was thus created, a central-plan structure that had never existed previously.

Jacopo Barozzi da Vignola
Villa Farnese
completed in 1573
Caprarola (Viterbo)

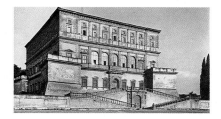

28. Plan.

This building, located in a small town not far from Rome, provides another variation on the theme of the suburban villa. In fact, its classification as a villa derives from its intended use and from its location; however, it maintains many of the characteristics of a fortified palace, a protected outpost.

The urban structure of the town of Caprarola is greatly conditioned, like that of all the ancient settlements of the area, by the morphology of its site. A long, downward-sloping spur on the south side of the Monti Cimini, flanked by gorges on either side, is subdivided into three small hills; Villa Farnese is the crowning feature, at the highest point of the town.

In order to accentuate this position, Vignola subjected the entire town to a radical restructuring. The result was not only the creation of a perspective, scenographic setting for the villa, but also a visualization of the neo-feudal hierarchy of lord and vassals that characterized the Papal States at that time. This operation started at a good distance, with the construction of a road to approach Caprarola from Monterosi, sixteen miles away. As the road gradually approaches the gates of the town, following the configuration of the terrain, it offers to the arriving visitor multiple views of the distant villa/palazzo rising above the surrounding houses. Seen as one approaches Caprarola, the palazzo's multi-storied facade appears at first to be like that of a "normal" palace with a rectangular plan. Within, the regularity of the polygonal arrangement is given by the circular courtyard. The association of circle and polygon occurs several times in the plan: one of the corners of the main facade houses the famous double spiral staircase; the other corner is occupied by a circular chapel.

The ground floor is treated on all sides as a base. The *piano nobile* is decorated on the exterior with single pilasters; on the external piers of the circular courtyard loggia are paired semi-columns, with corresponding paired pilasters on the internal part of the passageway around the loggia. The chapel likewise has paired pilasters. The great loggia on the main facade once again has single pilasters. The arrangement of the individual architectural members is governed by an A-B-A scheme, which, as Lotz remarks, represents a predominant motif in Vignola's architecture.

The Farnesina and Villa Madama were built in the countryside, surrounded by gardens and without any relation to the city. Villa Giulia had adopted, in spite of its isolation, an aspect both of suburban villa and urban palazzo. Caprarola, in contrast, acquires meaning through its structural relationship with the town below. The arrangement of the great open square in front of the building, with its ramps and complex access system, works as an urban piazza by which the palace establishes a dialogue with the town.

29. Geometric scheme of plan with main proportional relations.

30. Section.
Vignola's building rises above an existing fortress by Sangallo. In transforming the typical military layout into a residential villa, he first of all modified the character of the five robust corner bastions, cutting them off at the height of the *piano nobile* to create terraces from which to fully enjoy the views of the town and the surrounding countryside. He foregoes the traditional alignment along a single longitudinal axis (which would have allowed him to focus only on the center of the facade) and, taking inspiration perhaps from the Temple of Fortuna Primigenia in Palestrina, designs the stairs according to a variety of compositional modules (ellipse and rhombus), achieving a solution whose "effect" results from the richness of the multiple points of view that are presented along the approach.

"Doubtless Architecture is a very noble Science, not fit for every Head. He ought to be a man of a fine Genius, of great Application, of best Education, of thorough Experience and especially of strong Sense and sound Judgment, that presumes to declare himself an Architect. It is the Business of Architecture and indeed its highest Praise, to judge rightly what is fit and decent: For though Building is a matter of Necessity, yet convenient Building is both Necessity and Utility too: But to build in such Manner, that the Generous shall commend you and the frugal not blame you, is the work only of a prudent, wise and honored Architect." (Leon Battista Alberti, *Ten Books on Architecture*, 1485, trans. J. Leoni, London, 1755).

"The design of a temple depends on symmetry, the principles of which must be most carefully observed by the architect. They are due to proportion, in Greek, *analogia*. Proportion is a correspondence among the measures of the members of an entire work and of the whole to a certain part selected as standard. From this result the principles of symmetry. Without symmetry and proportion there can be no principles in the design of any temple, that is, if there is no precise relation between its members, as in the case of those of a well shaped man . . . Similarly, in the members of a temple there ought to be the greatest harmony in symmetrical relations of the different parts to the general magnitude of the whole . . . Therefore, since nature has designed the human body so that its members are duly proportioned to the frame as a whole, it appears that the ancients had good reason for their rule, that in perfect buildings the different members must be in exact symmetrical relations to the whole general scheme". (Marcus Vitruvius Pollio,*The Ten Books on Architecture*, 1st century B.C., trans. M. H. Morgan, Cambridge, 1914.)

The first half of the fifteenth century marks the rediscovery of the classical tradition as part of the cultural heritage of Italian architecture. Making a considerable leap back in time, a contemporary generation determines to look to the past for a model from which to draw inspiration. In architecture, this means a rediscovery of the ruins of imperial Rome. Temples, basilicas, and baths become the objects of study and artists' reconstructions, and the classical language of the architectural orders is once again proposed as the principal element of articulation for the surfaces that define architectonic space.

The revival of Vitruvius's theoretical opus, *De Architectura Libri Decem*, after so many centuries, gives rise to an impressive array of reflections on the art of architecture, beginning with the *De Re Aedificatoria* of Leon Battista Alberti. The production of treatises, from Filarete to Palladio, provides the conceptual foundation – as indispensable as the physical foundation – for the architecture of the Renaissance. At the same time, experiments in painting and developments in philosophy create the premises for a profound change in the spatial conception of the physical environment and, as a consequence, of architecture as well.

Painting – from Lorenzetti to Piero della Francesca, to Leonardo and Raphael – is a proving ground for the application of the laws of perspective to the representation of reality. Philosophy, ranging from Hasdai Crescas's early reflections on the infinity of the universe, through the work of Telesio, Patrizi, and Giordano Bruno, to Descartes' later theories of the *res extensa*, contributes to the evolution of thought with concepts that are decisive for the definition of perspective space.

During the Renaissance period, architectonic experimentation is mainly concerned with two types of buildings: churches and palaces. Churches are developed either according to a central-plan system – which can be monocentric or polycentric, constructed on a square, polygonal, or circular base – or according to a longitudinal scheme resulting from a synthesis of the central plan and the basilican form. Palaces are organized on the traditional typology of the house with courtyard, paying particular attention to two elements: the composition of the facade and the layout of the building around a central courtyard, conceived as an open space between interior and exterior.

In developing his idea, the architect investigates with his drawing instruments the infinite alternatives and possible solutions for the definition of the form and organization of a building. To this end he draws on known typological and formal references, all belonging to the tradition of classical architecture, and he makes use of a body of pre-established proportional and dimensional rules that enable him to harmonize these elements and join them all together. This process of architectural construction, which proceeds through the selection and organization of known elements, can be identified with the discipline of "architectural composition"; the latter can be defined, more precisely, as a process capable of ordering and harmonizing, in a closed system, a series of limited architectonic elements defined in form and structure. The process of final design – the composition – as first outlined in the Renaissance, remains today a major reference for the architect's daily practice.

The adoption of the compositional method radically transforms the process of planning a building, as well as the architect's attitude toward that process. The architect now lays claim to complete independence in the development of his idea, and thus becomes an intellectual, definitively removing architectural composition from the domain of the mechanical skills of the master mason. The definition of architectural composition as an intellectual process apart from the practice of the builder's yard leads to the development of a veritable "language." The plan, the section, the elevation, and even the perspective view become the articulations of a specialized, technical vocabulary. The architect, furthermore, may take control exclusively of the conceptual processes, delegating to others the responsibility for actual construction. Leon Battista Alberti can thus set down his compositional specifications for the Tempio Malatestiano in a letter to Matteo de' Pasti, delegating the supervision of the project–with no need to follow the construction in person. The paradoxical consequence is that from this moment on there will be great numbers of buildings designed but never built, breaking definitively with the traditional integration between a building's conception and its material realization.

And even if construction generally continues to be considered as important as conception, the essence of building no longer lies in the secrets of the guilds: the central role from this moment on belongs to one who knows – the architect – and not to those who make – the builders. As a result, the pool of knowledge increases decidedly beyond the scope of the master mason's purely practical notions. The architect can no longer be only an expert on construction or the most appropriate organization of spaces; he must also satisfy a requirement for beauty. It is necessary,

therefore, for him to know Vitruvius's three principles of *firmitas*, *utilitas*, and *venustas*, and he must know how to compose architecture correctly, according to the rules of the canon of the classical architectural orders.

The knowledge of these "design instruments" and the ability to use them become from this moment a recognized, common heritage of experience representing a language that is available to all architects. Far from being a mere repertory of forms and rules, they are an indispensable part of an architect's skills – indeed, in some periods, the only skill required of him. These rules and instruments, which allow the mastery of the classical language of architecture, live on today as principles of reference for the widest design practice of contemporary architecture.

Thus, even today, when an architect, working on an idea for a building, reasons in terms of harmony between parts, balanced symmetry, and modular relationships, or uses perspective alignments between objects or harmonic and reference grids to place and relate architectonic elements, he is applying in his project some of the characteristic features of the operative method of Renaissance architecture: composition.

Definition of Space

Around 1420, Brunelleschi became involved in the construction of the sacristy and the church of San Lorenzo. In keeping with the tradition of monastic basilicas, the church is laid out longitudinally, according to a Latin-cross scheme based on three elements: a presbytery, a transept, and a nave. The nave in turn includes two side aisles onto which the side chapels open. This scheme was very widespread, having been used consistently as a reference for the design of buildings such as the twelfth-century abbey of Fossanova and the Florentine churches of Santa Maria Novella and Santa Croce.

The differences among the plans of these churches lie only in the dimensions of their individual elements and their reciprocal proportions. At Fossanova, the longitudinal conception of the plan is emphasized by the closely spaced bays. In Santa Maria Novella, the wide span of the central nave and the expansion of the transept give the plan greater balance. Finally, in Santa Croce, the greater width of the nave and the close succession of chapels in the transept alter once again the proportions of the plan, accentuating the importance of the central spaces. The nave and the transept, the tribune and the presbytery, the overall length and width of the three churches, are each governed by widely differing proportional relationships, which do not even belong to a single, general scaling system or regime of proportioning.

In San Lorenzo, on the other hand, the separate parts are not proportioned individually; rather, their dimensions and reciprocal relationships tend to be attuned to a general rule. The nave and the transept, for example, are linked by the common dimension of their span, and their size results from the reiteration of a single, identical unit – which also defines the size of the presbytery. A common set of proportions – both in plan and in section – determines the size and the hierarchical role of every element. Through a process of multiplication, addition, or division, a single common module provides all the necessary measurements. Thus the overall scheme of the building is the result of a series of rules that establish the dimensions of all the structural components as parts of a single chain of proportions.

San Lorenzo is the result of a complex evolution, rooted in at least three centuries of tradition, in the construction of architectural spaces. In Romanesque churches, the presbytery, transept, and nave were characterized by solid masonry wall masses, prevalence of the round arch, and use, for the first time, of ribbed vaults. Internally, wood-trussed roofs were gradually replaced by vaults made of a single material – stone – while cross vaults were employed for wider spans. The transition points from one unit to another were marked by heavy reliefs in the architectural structure so that the passage from the bays to the contiguous areas was achieved with a formal articulation that limited the continuity and

the homogeneity of the inner spaces. The vast interiors of these churches are the sum of a certain number of spatial units defined by the structural bays, but there is no overall, regulating discipline in their layout: the general compositional rule is based on a principle of simple aggregation of spaces.

Indeed, it is the search for greater continuity that marks the transition from Romanesque to Gothic space. In the cathedrals of the French tradition, the vaults are more daring, the wall masses are emptied, and the architectural members – the articulations which define the structure – become light and slender. The plastic continuity of the structural units resolves itself in a greater homogeneity of the internal spaces. The use of the pointed arch, in which the height of the arch is independent of the width and depth of the bay it covers, allows for greater freedom of construction. The volumetric proportioning of the individual structural units no longer depends on their span, as was the case with the round arch. In fact, the spatial outline of the Gothic cathedrals is regulated by the tension between two main dimensions: the axial length of the overall plan and the verticality of the section of the main nave.

Though the systems used for proportioning the architectural elements only partially affected the organization of the building, various methods were employed during construction to control its development in plan and in height. These included geometrical layouts of a symbolic, as well as of a mathematical-proportional, nature. In Villard de Honnecourt's sketchbook, for instance, numerous geometrical outlines are drawn over figures of people and animals. Using an inverse principle to that of the zodiac, where stars are united to reveal the shape of a figure, in Villard's sketches the tracing defines the characteristic points of an image, linking a geometrical figure to it. For example, the five-pointed star recalls an eagle, with the head, wings, and claws corresponding to the five vertices. This relationship, as Bechmann remarks, endows the star with a special symbolic content beyond its simple geometric representation.

There are also other systems used for proportioning, such as modular grids, which help to establish certain characteristic points of the plan as well as of the principal sections of the nave. One of the most famous and widely used of these is the so-called *vesica piscis*, in which the dimensions of the body of the church are determined according to a construction having as its point of departure an equilateral triangle drawn on half of the diameter of a base circle. This determines two portions of circumference, whose intersection establishes, among other things, the two extremes of the longitudinal development of the plan.

There are, in addition, systems of graphic dimensioning, used to resolve construction problems. As Wittkower points out, these include section grids typically used to establish the height of nave, aisles, and roof coverings – such as the one designed by Stornaloco for the Duomo of Milan – and countless outline drawings for the definition of the thickness of walls. And there are numerous geometric constructions used for the disposition in plan of the bearing points of cross vaults and for defining the structural schemes both of the lobed pilasters supporting them and of the ribs of the vaults themselves.

The Infinite Dimension of Space

From a conceptual point of view, Gothic space does not have an existence of its own, independent of material objects: space exists as an "accident," as a peculiar characteristic of physical things. Without things, without objects, without buildings, space as an entity does not exist. Nor can it be represented. It was inadmissible that anything could exist beyond the precise boundaries of the known world, and this restrictive idea of space precluded any possibility of conceiving of empty space as extending to infinity.

It was a very old question. According to Benevolo, Lucretius in his *De Rerum Natura* uses the paradox of the winged dart to cast doubt on the idea of limited physical space, maintaining that the universe is limitless in all directions; for Lucretius, "the fact itself shouts it out in a loud

Villard de Honnecourt, studies of proportions with geometrical figures, XIII Century. (ms. n. 19093), fol.18 v., Bibliothèque Nationale, Paris.

Cesare Cesariano, example of "Ortographia" employed for the section of the Milan cathedral. From his notes to the "Ten Books" by Vitruvius, 1521.

voice, and unfathomable nature declares it." In part, Lucretius follows Epicurus, who had also expressed a belief in the infinite reality of the world. Many others followed, until, in the sixteenth century, a definition was finally reached of infinity as an entity in its own right – first, in part, by Nicola Cusano and then by Giordano Bruno. However, it is only in the subsequent transition from the Ptolemaic-Aristotelian world to the Copernican that the transformation of the idea of the universe is reflected directly in the physical construction of human spaces. At last, space is conceived as a great, infinite container – autonomous and with its own reality separate from the objects contained in it.

Before it was formally theorized as an entity, however, space was the object of a variety of representations. As Erwin Panofsky has noted, in painted images, the infinite had been materialized in an axis or in a vanishing point – the place where all straight lines meet. Although objects were still parallel to the plane of vision, they acquired the dimension of depth by means of a foreshortened view of the lateral surfaces. And while in architecture this point of arrival was not sufficient in itself to modify the conception of the building, in painting the acquisition of a volumetric representation of objects opened the way – beginning with Giotto and Duccio – toward the concept of the painting as a unitary, three-dimensional, spatial box.

The definitive leap from the continuous, homogeneous space of the Gothic period to the three-dimensional, infinite space of the Renaissance takes place at the beginning of the fifteenth century: it can be seen in a comparison between Ghiberti's and Brunelleschi's panels depicting the *Sacrifice of Isaac*. Ghiberti's version must be read analytically in a narrative sense, like a book, from left to right. Brunelleschi's, on the other hand, requires a synthetic, overall reading, in which the scene is perceived simultaneously, as a whole. As Brandi notes, "the turning point – the point of no return – is here."

Space becomes a unitary container, within which dwell people-objects, building-objects, and so on. It remains impalpable in its infinity, but perceptible in the continuity and homogeneity of the surfaces that limit and define it. And when, nearly a century and a half later, Descartes defines this aspect, describing spatial reality as *res extensa*, mankind will find itself the protagonist in a space-environment expanding unitarily and infinitely in all directions around it. Three-dimensionality cancels out the static simultaneity of the ancient conception of space, and the conquest of depth transforms it into a place where infinite spatial sequences follow one another according to a compositional principle which, in architecture, has passed from being additive, i.e., based on the two axes (longitudinal and vertical) of Gothic architecture, to comprehensive: structured on the three "Cartesian" axes (longitudinal, transverse, and vertical) found in churches with a central-plan system .

The Three-Dimensional Model

Arnheim explains that the two-dimensional space of early art is characterized principally by a scheme of horizontal and vertical lines, situated parallel to the frontal plane of the painting, with very little tension. Isometric perspective adds to these basic coordinates one or two series of parallels oriented toward them; in addition to a number of new relationships and angles, these lines create a sense of depth by means of their obliqueness. Central perspective superimposes, onto the verticals and horizontals of the frontal plane, a system of converging lines that create a central focus and provide a complete range of angles.

The corresponding three-dimensional image is an empty space structured like a framework, an endless network made up of straight lines at right angles to each other. Within, all the relationships between these elements are governed by Euclidean geometry. The square framework extends homogeneously in all three dimensions–height, width, and depth–and can be compared to an immense filing cabinet where the position of each compartment cannot be specified in an absolute sense, as would be the case in a gigantic checkerboard with known boundaries,

but only in relation to the position of another compartment. Like the idea of infinity, a space of this kind lies completely outside an individual's direct experience. Both are theoretical constructions that must first be imagined and then represented mentally. In an abstract place of this kind, only the laws of Euclidean geometry are valid, and there can be none of the references typical of real psychological-physiological space. There are no longer any absolute systems of positioning, but, as Cassirer notes, everything becomes relative.

Oppositions (right-left, above-below, etc.) are canceled, for the element as such does not possess specific content, and its significance derives exclusively from the relative position that it occupies in the total system. The principle of the absolute homogeneity of spatial points eliminates all differences, such as the difference between above and below.

This space-environment is absolutely equal in all of its parts and exists independently of the things within it. The characterization of the network's points of intersection, or of the cells of the framework, occurs only thanks to the objects which, with their presence, mark certain places within the space. Their collocation makes them identifiable and distinguishable from the other objects present in the space, in other positions. In architecture, therefore, every characteristic point of the composition will be marked, so that, as Benevolo expresses it, "the form of each element can be deduced from the position it occupies in the scheme: elements in equivalent positions must be equal, and every formal exception must be justified by a corresponding articulation of the general scheme; every unforeseen anomaly must be banned."

Perspective as a Means of Control and Representation

In a space-environment conceived in this way, the method of perspective offers not only a means for representing the three dimensions, but also an instrument for verifying the relationships among the objects contained within. Its utilization in the conception of architecture allows for a control of volumes that goes beyond the traditional two-dimensional verification of measurements, which the architect usually carries out in plan and section. Perspective drawing is, at one and the same time, a simple technique for representation and a complex methodology of research into the volumetric potential of spaces.

However, perspective constructed with Alberti's technique, on the "base square," provides a rather partial view of reality. Panofsky has demonstrated that the representations obtained through the application of Alberti's rules do not correspond to a real vision of things; rather, they are verisimilar images of three-dimensional space. In a perspective portrayal of a given space, the distance of the viewer from the scene is unchanging; it is fixed once and for all. Vision is monocular; conditioned by the succession of volumes imposed by the viewing point, it does not account for deformations due to the sphericity of the eye which exist in natural vision. Perspective is thus not a perfect imitation of human reality but reflects, on the contrary, the choice of a mode of conceiving and seeing natural space.

In painting, in fact, correct perception always occurs along an axis and a succession of spaces that are suggested and immovably fixed, once and for all, by the painting itself. Francastel points out that in a painting by Masaccio or Piero della Francesca, the relationship between the observer and the image is definitively established with the selection of a single one of the infinite possible viewing points. An observer may move nearer to or farther away from the plane of representation fixed by the plane of the painting; in this way the viewer's perception will vary with respect to that single real point, situated outside the perspective image and from which the image is seen in proportion and in scale. However, his vision depends in any case on the subjective choice made by the artist in composing the image.

The question is somewhat more complex in architecture. First of all, unlike a painting, where the observer stands outside the scene, here one is a part of it. Secondly, the perception of a volume is not limited to a single

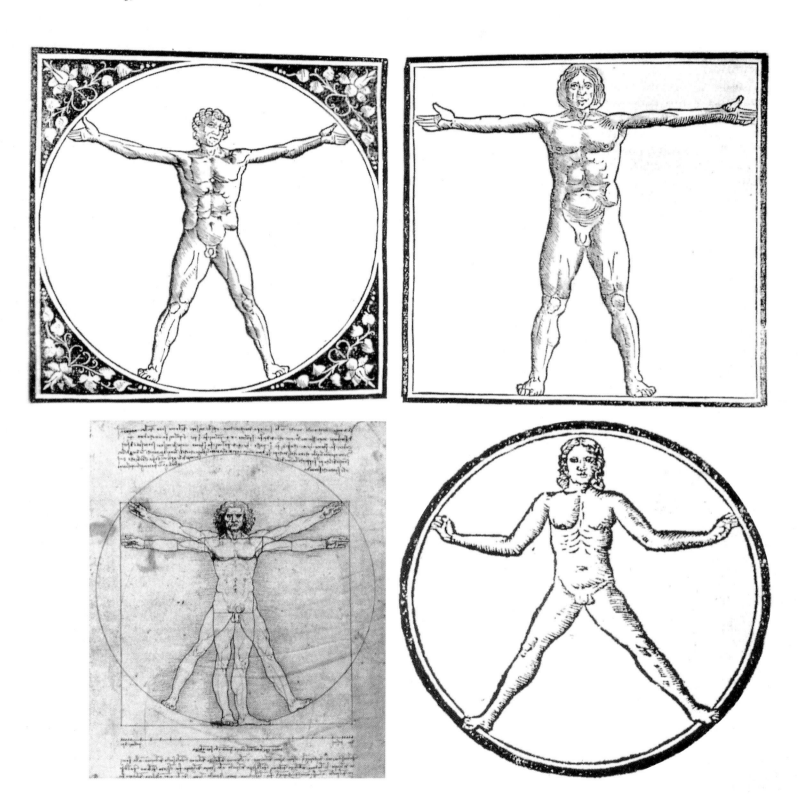

"Homo ad Circulum et Homo ad Quadratum".
Top left and right, Fra Giocondo, from his notes to the "Ten Books" by Vitruvius, 1511. Bottom left, Leonardo da Vinci, Accademia, Venice. Bottom right, Francesco di Giorgio Martini, Laurentian Library, Florence.

two-dimensional image, but takes place in a three-dimensional space. A person's route within the rooms of a building does not follow a single established axis, as happens in a painting, but can go in any direction. Viewpoint is dependent on the movement of the observer himself, and also on the movement of his head and eyes as he progresses through the building. Even in a space composed "in perspective," his perception of the sequence of vistas occurs naturally, that is to say, partially and subjectively. Nor is there any convention of a single vanishing point where all parallels meet; nor, even less, does the perception of spaces occur according to a rigid succession of perspective planes.

Francastel maintains that in a building the architect selects a certain number of planes, just as the artist does in a painting, arbitrarily choosing a few of the infinite possible visions of space. He selects perspective views and constructs the architecture according to these sequences. The perspective construction of every part of the building is linked to a single vanishing point, and the general design relationships of the surfaces are set with respect to this point. The hierarchy of volumes and the relationship among objects create a connected succession of spaces according to these emphasized axes. The three-dimensionality of the building is identified exclusively with these sequences of "planes of vision" that are linked by a system of rules for proportions and tied coherently to the selection of the vanishing points. Only along these principal alignments can there be "correct" and consistent perception by an observer of the perspective arrangement of the space, and the perception of the building is based on the comprehension of a system of harmonic relationships that can be identified only from those specific points.

Physical Multiplicity and Intellectual Unity

In physical reality, however, people do not necessarily go through the spaces of a building following one axis rather than another. The experience of a building is, in fact, the sum of a series of partial, three-dimensional images generated by the passage through a sequence of volumes orthogonally related to one another. This experience accumulates, in narrative fashion, in the mind of the individual observer; it is the task of the imagination to restore unity to the composition.

Modern individuals are fully accustomed to dynamically accumulating different views and – thanks to the evolution of the concept of space – they are also accustomed to sequencing "harmonic" images with other, "disharmonic" ones. It is possible to think that people of the Renaissance, in contrast, were bound by a much more partial vision, as it were, since the general composition of a building could maintain its coherence and correctness only from very few points; consequently, unity of perception of a building, hindered at the physical level by this drastic reduction in the significant points of the space, was achieved at the mental level.

Argan says that the eyes of Renaissance man perceive in the same way that his mind conceives. "The mind's eye" takes in the complex relationships of architecture, interprets its spatial mechanisms, perceives its sequences, appreciates its articulations, and comprehends its dimensional hierarchies. Although the Renaissance architect, for his part, does not ignore the fact that a building's space can be experienced along infinite paths, he bases his architectural composition on a selection of only a few of the many possible ways of perceiving. Upon this he organizes the building, completely divorcing physical from intellectual perception. In Santo Spirito, for example, the proportioning of the Latin-cross basilica scheme begins in the plan, taking the span of the nave as the intermediate modular unit. This procedure generates two series of elements, lower and upper, that make up a dimensional framework within which are fixed the positions of the columns, pilasters, and side chapels. In section, the span-module is equal to the measurement of the shaft of the column; it also gives rise to a sequence of dimensions that decrease in height from the center of the nave to the side chapels. Plan and section delineate a set of spatial sequences according to two principal perspective axes: the first is aligned with the nave and the second with the transept.

The unity of the building lies in the harmonic correspondence between the composition of the cubic volumes (the parallelepiped of the central nave, the square, sail-vaulted units of the aisles, the ogive-vaulted semi-cylinders of the side chapels) and the design of the architectural members (the columns of the central nave, the pilasters of the tribune, the semicolumns of the chapels). In Sanpaolesi's reconstruction of Brunelleschi's original project for the church, the four arms of the Latin cross – nave, presbytery, and transepts – are formed from an absolutely identical block, both in plan and in section. The two orthogonal axes on which the plan is developed have identical volumetric solutions at their extreme ends. The splitting of the principal axes of perspective alignment means that the space is experienced identically in both directions – the views are interchangeable. Seen from the tribune, the four arms are identical – except for the greater length of the nave. They can be joined in a single image, and they create an ideal centrality based on a formal coincidence of their parts rather than on their physical proximity. In the same way, the ambulatory surrounding the central space creates an ideal, constant sequence of equal cells repeated along a single axis, independently of their orientation.

Perspective space is therefore highly selective, and every building is characterized by a consistent relationship, with respect to a limited number of viewpoints, among its various architectonic elements. Organized within the spatial grid, these architectonic elements are governed by pure geometrical relationships. In this geometry of spaces, the empty space separating the architectonic elements is as important as their physical relationship to each other. Beyond the material reality of an object there is an intellective dimension thanks to which it is possible to establish relationships even between distant things. The architecture of a Renaissance building finds its true unity and real meaning in the mind of the architect or of the user, rather than in the mere physical appropriation of spaces. In this conception lies a potential detachment from physical reality which subsequently becomes inevitable and which will be reflected in two fundamental aspects.

The first is that in addition to the study made of the building in plan and with partial views of the interiors, the architect has an increasing need to verify the composition in its overall volumetric aspect, as an object, or like a sculpture. Leonardo studies composite or central-plan churches and makes bird's-eye-view drawings of them. The use of this impossible, unreachable viewpoint, high in the sky, illustrates the dichotomy between the physical and the intellective perception of architecture. The meaning of an architectonic space no longer lies in what can materially be seen, but in what the structure symbolically evokes. This is not a novelty in itself; the difference is that this intention is now extended to the entire organism, with a symbolism, as Tafuri puts it, "that invests the formal structures and the typologies." The architectural composition is undertaken with the objective of making all the parts of the building harmonize with the entire universe.

The second of these fundamental aspects is that in perspective space a contradiction is created between building – perfect, concluded "object" – and man, who becomes an accidental component, banished by the very perfection of that space for which he provides the module and the measure. In one of the oldest existing architectural designs, a barrel-vaulted space drawn by Pisanello, the space constructed according to the "rule of perspective" presents the typical squared grid outline marking in depth the succession of planes. A number of figures are present, but the context has clearly been defined a priori in its geometric perfection, and the human figure is treated as just another object within the space.

Granted these assumptions, the architectonic compositional research of the Renaissance can be understood as an attempt to reconcile the ambiguity between the intellective and physical dimensions of space. From this point of view, all of the research done into the central-plan system and polycentrism, and even the "license and heresy" of later experiences, can be interpreted as the attempt to eliminate any ambiguity of spatial

perception by means ranging from the radial identity of the parts, to the multiplication of centrality, to the complete re-examination of the very principles proper to the architectonic articulation of spaces.

The Construction of the Three Dimensions

Even though it is born of such a specific spatial model, the building cannot be understood simply as a system of geometrical relationships in which the construction of the architecture becomes a mechanical process. Nor is composition limited to a problem of three-dimensional assembly of parts according to given rules, since there exists for the architect another, much more important goal: to produce something that will be recognized as "beautiful."

Beauty is seen as an actual force through which – according to one neo-Platonic school – the individual can elevate himself. Alberti writes: "It is generally allowed, that the Pleasure and Delight which we feel at the view of any Building arise from nothing else but Beauty and Ornament . . . For who will deny that it is much more convenient to be lodged in a neat handsome structure than in a nasty ill-contrived Hole? Or can any building be made so strong by all the Contrivance of Art, as to be safe from Violence and Force? But Beauty will have such an Effect even upon an enraged Enemy, that it will disarm his anger, and prevent him from offering it any Injury: Insomuch that I will be bold to say, there can be no greater Security to any work against Violence and Injury, than Beauty and Dignity. Your whole Care, Diligence and Expense, therefore, should all tend to this, that whatever you build may be not only useful and convenient, but also handsomely adorned . . . I should define Beauty to be a Harmony of all Parts, in whatsoever Subject it appears, fitted together with such Proportion and Connection, that nothing could be added, diminished or altered, but for the worse".

From the theoretical point of view, beauty is understood as harmony between the various components that make up the work, and *eurythmia* and *symmetria*, as components of Vitruvius's *venustas*, find ample application insofar as the former governs the harmony and proportion between the elements, whereas the latter establishes perfect concord and attunement of the individual parts. From the practical point of view, on the basis of Alberti's principles, the harmonic balance of forms can be reached by two different types of action: arranging through proportion and arranging through discourse (*accomodando con proporzione* and *accomodando con discorso*).

"Arranging through proportion," i.e., the application of mathematical-geometrical methods of proportioning, leads to the development of studies on proportion that become an integral part of all treatises on architecture, beginning in 1485 with Alberti's *De Re Aedificatoria*, or are the subject of thorough study in more specialized works such as Luca Pacioli's *De Divina Proportione*. In these theoretical works, the achievement of harmony and beauty is linked to mathematical and proportional perfection, and the concept of proportion has a twofold meaning: a relationship between absolute numbers, and an anthropometric proportion.

"Arranging through discourse," i.e., the predisposition of a correct and coherent articulation of the composition, refines the methods of compositional research. And since the beauty of a structure depends on the way its different parts are placed together, the continuous, constant work of reflection (also referred to as *cogitatio*, by Vitruvius) is indispensable for the correct collocation (*dispositio*) of the architectonic components.

This punctilious activity of searching for the perfect balance of parts – "appropriate position, exact proportion, just disposition, and harmonious order"–is carried on with the aid of drawing instruments, not only in the elaboration of the plan, from the first drafts to the most detailed drawings, but also in the first sketches of the interiors and in the successive three-dimensional details of the building. The use of perspective transforms the three-dimensional study from a simple representational tool to an important means of verifying volumes, in order to examine the spatial implications of the plan. When studying the composition of a building, the Renaissance architect must, as Alberti puts it, always follow the ancient custom of "Builders who not only in Draughts and Paintings, but in real Models of Wood or other Substance, examin'd and weight'd over and over again, with the Advice of their best Experience, the whole work and the Admeasurements of all its Parts, before they put themselves to the Experience or Trouble." As a consequence, wooden models become an important tool for the verification of the building's volumetric complexity – for example, Santa Maria del Fiore, the cathedral of Pavia, Palazzo Strozzi, and St. Peter's.

Man the Measure

Since volumes and objects must be articulated with balance and concord among their parts in order to achieve beauty in perspective space, mathematical and proportional studies become essential. The problem that immediately arises, however, is finding a correct system of proportioning for use as a reference – a set of ratios capable of providing general indications for the relationships among different parts. And since there is no absolute reference in perspective space, where the laws of geometry govern the three dimensions, the only valid proportional system is the one that applies to man himself. Man, who is already ideally placed at the center of the universe, thus becomes the measure of things, both as a proportional principle and as a physical scale of dimensions.

The symbolic image of the human body had already been widely used, as can be seen in the figures in the twelfth-century *Liber Pontificalis* and in the thirteenth-century *Liber Divinorum Operum*. In the fourteenth and fifteenth centuries, however, man is no longer a cosmological reference – man as the representation of a macrocosm – but becomes a reference of an absolute order: man as the measure of all things. As Kruft observes, the "Vitruvian figure" of the man inscribed in a circle and a square is the most widespread reference. In this figure, the natural world of man and the artificial world of geometry find a point of contact. The square and the circle associated with the human figure are the two extremes between which – through the intermediate figures of pentagon, hexagon, octagon, etc. – the perfection of geometrical figures is developed. Man is in the circle and in the square, and Filarete can affirm absolutely in his treatise that "all figures whatsoever, circles and squares, and every other measurement, are derived from Man."

And with a promise that "I will show the building to be as a living man," Filarete produces figures in which man is taken as a harmonic reference, or as a mechanical and proportional reference. The whole human figure, architecture's measure-module, is used as a dimensional unit for the architectonic structure. The body becomes a symbol of unity, obtained through the concordance of different parts, all conformed to one use and one function within a larger harmonic and unitary model. The ratios between its parts – head-trunk, trunk-legs, temples-cheekbones-chin, ears-eyes-nose – serve as proportional references for the secondary parts of the building and for its details. Thus the human body is found inscribed in plans, as in the composite-plan outline by Francesco di Giorgio Martini, or utilized more simply as a reference for a proportional study of capitals, as in the sketches by Leonardo. The human figure becomes the scale of measurement for the geometrical space defined by the system of perspective vision. The infinitely extendible framework that represents it is proportioned on the basis of the metrics of the human body.

The Orthogonal Grid

In perspective space imagined as an infinite framework of orthogonal axes, therefore, there does not exist an absolute dimension scanning the intervals between the axes. As has been seen, within this grid the position of a point can be defined only with respect to another point or with respect to an object or a volume. If, however, the human body is taken as the measure of scale, this provides a dimensional reference within the space that can be used as a general proportional relationship. The grid of orthogonal axes can then be scanned on the basis of a common

dimensional scale and transformed into a network that orders the space. Absolute values of measurement, multiples of the basic module, can be identified within this network, as can relative measurements that express the relationships between volumes and parts with simple mathematical relationships. In the many drawings where it appears, the orthogonal grid has three main roles: spatial framework, regulating pattern, or modular grid. These functions often overlap, so that the grid may range from being a simple graphic support to being a fundamental element in the compositional development of the building's design.

As a spatial framework, the orthogonal grid is a system that controls and guides the three-dimensional organization of the plan by means of a minimum spatial module, relating the definition of the various internal spaces to their volumetric typology. In the portico of the Ospedale degli Innocenti, for example, the minimum spatial unit is the bay–square in plan and covered with a sail vault. The volumetric system is generated by the simple repetition of nine spatial units along an axis. Likewise, in the courtyard of the Medici-Riccardi palace – except for a shift at the level of the loggia – the spatial module of the portico is found in the succession of bays and in the depth of the entrance way; it also determines the size of the empty space of the courtyard. In more complex buildings, the spatial module can even become the organizational principle for the entire structure.

In the Old Sacristy, two independent volumes are aligned along a longitudinal axis of symmetry. The smaller space – the *scarsella* – is square in plan, covered with a small, hemispherical cupola, and its dimensions correspond to the minimum module of the space framework. The larger space, also square, is obtained by grouping nine modules together; it is covered by a rib-and-sails dome. In plan as well as in section, there is a proportional shift in the dimensions of height, width, and depth between the two volumetric units . In the Greek-cross plan of Santa Maria delle Carceri, in contrast, where four barrel vaults are connected to the square central space of the tribune, the minimum module of the vaults corresponds to one-half of the square of the tribune. The centrality of the scheme is the result of the mirrorlike equality of parts that derives from a coincidence of axes of alignment and axes of symmetry.

As a regulating pattern, the orthogonal grid has a direct influence on the plan of the building, from both formal and structural points of view. In the process of composition, particularly during the initial phase of study, the outline is a useful instrument for regulating the relationships, overall dimensions, proportions, and even the precise measurements of the various parts. Leonardo, like many other architects, uses it often in his sketches. It almost always appears in the plans, and occasionally also in the sections of his drawings, for central-plan and composite-plan churches. The various plan typologies are regulated by right angles and diagonals that establish their alignments and relate their dimensions to one another. Simple and complex forms can thus be linked, combined, or overlapped according to a common reference formula that regulates them and guarantees the overall proportions of the scheme. Apparently unrelated elements undergo the same process of positioning, and the building is organized according to a system of division of axes. The regulating pattern is not present as such in the completed building, but is rather an ideal network whose effects are felt in the reciprocal positions of the various elements that make up the space.

Finally, as a modular network, the orthogonal grid often has a twofold function. At times it involves a simple apportioning according to a measurement-module, serving as a compositional point of reference; at other times it serves a purely instrumental function, with the grid working simply as a squared-off system of reference lines, as an aid to transferring a drawing to a different scale. In the first case, it offers the possibility of setting the dimensions of the parts of a building by combining or subdividing one or more modules; in the second, its role is to facilitate the positioning of the elements. An example of this double function is provided by a pair of drawings – attributed to Raphael – for the Chigi chapel. The squaring differs in the two drawings: in one it is dense and small in scale; in the other it is wider. In the first case, the articulation of the architectural members, as well as the articulation of the walls, follows the squaring precisely. The use of a whole number of squares to define each element indicates that the squaring was probably a compositional module rather than a simple drawing tool. In the second case, however, the details of the plan are not drawn precisely on the grid. Here it seems more like the procedure used by painters when transferring a small sketch or study to the full-scale canvas. In this case, the grid serves to control the overall proportions and the correct placement of the various elements with respect to one another.

Harmonic Relationships

Tafuri writes: "As Man is the image of God, and the proportions of his body were conceived and fixed by the Divine Will, so must architectonic proportions include in themselves, and express, the cosmic order." In the same way, the Renaissance architect aspires to develop a system of harmonic relationships that will raise his building to a level of absolute beauty. However, he requires practical rules in order to accomplish this–easily applicable principles that allow him to control the complexity of the building. The objective is to reach a perfect scheme where perfection, like beauty, is understood to be an absolute value, attainable only when the various parts achieve an ideal, reciprocal equilibrium in the three dimensions.

This ideal led, as Wittkower notes, to the widespread use of a series of simple relationships, identified in antiquity by Pythagoras and mentioned by Plato, and recovered in their entirety thanks to the diffusion of neo-Platonic doctrines. The rules and relationships supplied by the Pythagorean system are all based on mathematical ratios of small whole numbers.

These relationships, originated as musical harmonies, could also be considered in spatial terms; this use altered their meaning and allowed their utilization in the design of buildings. There are three basic relationships: 1:2, 2:3, and 3:4 – octave, fifth and fourth – to which numerous other composite relationships can be added, based on combinations of the three basic ones. In addition to the simple proportions, there are two widely used relationships that involve irrational numbers: the square root of two indicates the relationship between the side of a square and its diagonal; the golden section is derived from the relationship of one side of a pentagon to a straight diagonal line that unites two nonconsecutive vertices.

The use of these relationships made it possible to relate measurements to one another, linking them through a fixed proportion. Starting with a dimension that functions as a basic module, by repetition it is possible to form numerical chains whose components increase in size according to a constant increase in quantities. Since the numbers expressed in the ratios can be transposed, the series obtained can be either multiples or fractions of the basic module, or the ratio can simply indicate a fixed relationship between two measurements. Take, for example, an imaginary square whose side has been chosen arbitrarily as a basic module. Applying the octave relationship of 1:2 means dividing the side, i.e., the module, into two equal parts, so that two proportional measures are now available – the whole side and the half side – making it possible to obtain both a minor and a major one. A 3:4 relationship would mean dividing the side into four parts, of which only three are utilized.

It is important for the Renaissance architect to set up a proportional system capable of both determining overall dimensions and defining architectonic details. The application of proportional relationships makes it possible to identify a series of progressive measures that do not limit the possibilities of composition, but provide – within precise proportional relationships – alternative dimensions that can be chosen according to taste or necessity.

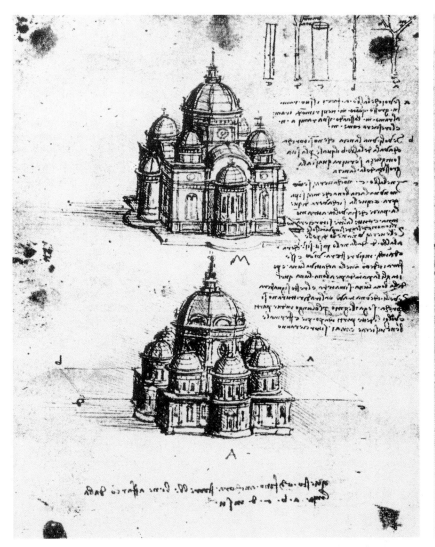

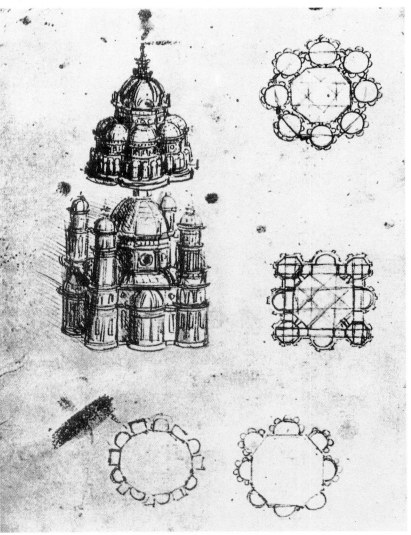

Starting with a dimension that functions as a basic module – the side of the square – it is possible to form numerical chains to dimension the different spaces of a building. The new dimensions will be in harmonical relationship with the original one. From top to bottom, 1; 1:4; 1:3; 1:√2; 1:2; 1:ø; 2:3; 3:4; 1:1.

Sebastiano Serlio, the rule of the architectonic Orders, IV Book, Venice 1537

Jacopo Barozzi da Vignola, the Tuscan Order, 1562

Andrea Palladio, the Ionic Order, 1570

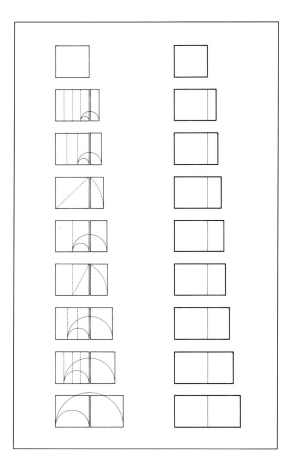

The Proportioning System

Proportions are a tool for controlling dimensions and harmony of parts. Their use is the consequence of a definite compositional choice. For example, the rectangular shape of a space may be the result of a freely made choice or dictated by already existing constraints. Once a rectangular form is chosen, the architect knows that if he uses a certain harmonic relationship, his setting the length of one side automatically determines the length of the side at right angles to it. He can thus vary the dimensions and with them the surface area of the space by utilizing different measurements with the same proportional relationship, but he can also radically modify the general relationship between the sides by employing a completely different set of proportions.

Proportional relationships allow the architect complete freedom in the design process and provide the assurance that all elements will satisfy the fundamental requirements of overall harmony. However, this does not exclude the possibility of an occasional departure from the norms. For aesthetic reasons, for example, different proportional systems may be used in conjunction with each other, or the same basic module may be used to generate the dimensions of limited sections of the space according to different harmonies. Some details may even abandon the general norm completely, being resolved without any proportional relationship to the other parts.

An interesting example of a chain of progressive dimensions is given by Palladio in his *Quattro Libri*, where he refers to the alternatives available in deciding the height of a space whose length and width are already established. Applying three different mathematical formulas to these two known numbers gives three different mean figures, of increasing size: an arithmetic mean, a geometric mean, and a harmonic mean. Each of these has a proportional relationship with the two initial dimensions. These three heights are possible solutions available to the architect for application to the space being designed. Whichever of the three is selected, the requirements of "cosmic" harmony will be satisfied. The method indicated by Palladio for civic buildings reveals, moreover, a marked attention to the dimensional harmony of architectonic spaces; it also underlines how the concordance of the parts is not only a parameter to be applied in the two dimensions of the plan (in order to verify the relationship between wall masses), but is also present, as a relation between volumes, in the three dimensions of the building itself.

This system of geometrical relationships is used, however, only when an approximate definition has already been given to the general plan of the building, since the choice of outline for the structure is made in the initial design phase according to the canonical prescriptions for the various building types.

After considering the questions of usage, function, and decorum, the architect chooses the most appropriate type for the building for the specific occasion. For the Palazzo, as Vasari mentions, the basic reference is the traditional courtyard scheme, enriched with porticos, loggias, and attics, if the function and location call for it. For churches – as Francesco di Giorgio Martini specifies in his treatise on civilian and military architecture – there are three basic types: circular, rectangular, and a composite type resulting from a combination of the other two. In this connection, Alberti is even more precise and reductive: he excludes the longitudinal plan, preferring the central-plan scheme. He indicates its possible polygonal forms and provides a number of typological schemes obtainable by the addition of chapels to the central, basic geometrical figure.

Surface Design

The beauty of a building lies not only in the harmony of its parts, but also in the use of the architectural orders and the dignity that they lend. Tradition, according to Alberti, tells us that "from an Imitation of Nature they invented three Manners of adorning a Building, and gave them Names drawn from their first Inventors. One was better contrived for Strength and Duration: This they called Doric ; another was more taper and beautiful, this they named Corinthian; another was a kind of Medium composed from the other two, and this they called Ionic. Thus much related to the whole Body in general. Then observing , that those three things which we have already mentioned, namely, the Number, Finishing and Collocation, were what chiefly conduced to make the whole beautiful, they found how they were to make use of this from a thorough Examination of the Works of Nature".

Thus, as Forssman points out, the Doric, Ionic, and Corinthian orders – together with the Tuscan and the Composite – are the basic grammar of architecture. They qualify the image of the building, and their correct use is a matter for architects to study and reflect upon.

Once this new expressive heritage has been acquired, the narrative style of decoration of the Gothic cathedrals disappears, because every detail is now subject to the general rule of the building. The standardization of the individual components of the architectural order precludes the individual, independent dressing of each stone, with resulting variations from piece to piece. The elements of the order are equal in every part of the building, and with the unification and standardization of decorative details, capitals, cornices, and fasciae are produced in series. The formal quality of the details decreases because it no longer has any value in itself.

The decorative significance of the orders becomes above all analogic rather than literal. The decorative system becomes interchangeable, and the positioning of a single piece is not unique, but is identical for corresponding points in the spatial framework. Benevolo notes that "the forms of the architectonic elements are not designed a posteriori, building by building, but are defined a priori in their proportions and in the greater part of their decorative details, that is, they are, as we would say today, standardized. The margin of variability which remains from one application to another is kept within precise limits, and must always leave the forms recognizable."

The Rhythm of the Orders

Not only do the orders raise the formal quality of a building; they also make the articulation of the spatial scheme perceptible through the rhythmic scansion of its walls. Thus the numerical series used for proportioning the plan find their harmonic counterpoint in the cadence of the orders. The orders represent a whole system of proportions and measurements, as can be seen in the treatises of Vitruvius, Alberti, and Francesco di Giorgio Martini, and in the comparative tables of Serlio and Vignola, where, together with the elements that make it up–base, shaft-capital, and entablature – a characteristic proportional relationship is shown for each order. The result is the identification of a canon that establishes a priori the formal and proportional characteristics of the architectural order. Once the architect enters into its use, he knows he can refer to a common practice that is fixed by proven measurements and relationships. The use of a given order – for example, the choice of Doric rather than Corinthian – is significant not only because it means the application of a certain formal repertory, or because it evokes certain symbolic associations, but also because it implies the use of a complete series of dimensional relationships characteristic of the style. Two different orders, for instance, will have–for the same column diameter–different height relationships and different spacing of the columns in plan.

The principal relationships between the various elements of the order are regulated by a series of grammatical and syntactical rules derived directly from the observation of ancient buildings. The architect simply gives indications that serve to set the general proportional relationships and to adjust the concordance of certain special solutions involving elements such as column and wall, pillar, pilaster and entablature, fascia and arch. These references from ancient architecture were known to all architects. For this reason the ancient buildings were surveyed and examined, and often their missing parts were replaced, in renderings, with completely fanciful elements. This attitude reveals a somewhat free

approach to ancient architecture and illustrates how the study of these monuments was an exercise for learning a new language: ancient archeological ruins that were barely comprehensible served as a pretext for verifying the knowledge regained and the ability to manipulate the classical language of architecture.

Certain classical models were selected and functioned as a repertoire of typical solutions. The Colosseum, for example, was the model par excellence for the vertical relationship between different registers. The superimposition of Doric, Ionic, Corinthian, and Composite is quoted in Palazzo Rucellai in Florence, the courtyard of the Accademia in Venice, and other buildings; even in the seventeenth century, Scamozzi could still affirm that "all five orders, placed one above the other in this way that we have arranged, create a most well-proportioned cadence."

As Summerson points out, theaters and basilicas offered a wide range of formal variations for the horizontal articulation of registers, both for the solution of problems related to the connections between the various elements and for the overall proportions of arch, architrave, and external frame. Triumphal arches, as well as certain halls of thermal complexes, provided models for the various positions that a pilaster could assume when it was detached from the wall and transformed into a column.

The Articulation of the Order

The rules of the orders do not, however, solve all problems of relationship between the components; on the contrary, they indicate only certain general principles, leaving a wide margin for free invention. The architect acts with the confidence that comes from knowing the rules and formulas of the ancients, but he also feels capable – as Scott points out – of making his own decisions and, if necessary, of breaking those rules. The rigid modular prescriptions of the canon were regularly ignored, and the harmonic cohesion of the different parts of a building was often the result of radical transgressions. There exist, in fact, numerous departures from the norm, innovations, and even "heresies," from building to building. The classical canon becomes, above all, a common source for norms and examples, and the importance of this set of rules and conventions was that, whether they were accepted or rejected, they represented a common point of reference. All architects had a command of the canon, and all were equally capable of appreciating any changes made in it. Thus they could be sure of the effect of even the slightest variations on traditional practice, such as an increase in the diameter of a column, or added emphasis given to a cornice. Indeed, at the end of a project – once the various problems had been resolved relative to specific points such as the facade, the corners, the tribune, and, to a lesser extent, the entablature and fascia, column and pulvin, column and arch – whether the architect had resolved these problems by quoting archeological examples or through his own taste and inventiveness, he always felt that he had created a new architectural order that could rival the ancient examples.

The fresco of the *Holy Trinity*, attributed to Masaccio, in the church of Santa Maria Novella in Florence, established the Renaissance prototype for the articulation of architectonic members based on models of archeological derivation. In this image, two pilasters support an entablature and frame an arch resting on two columns backed against the walls on either side. The architrave is tangent to a semicircular fascia that emphasizes the opening of the arch, itself flanked in the upper corners by two circular panels. The layout is of Roman derivation and can be read as a superimposition of two different planes. The first, outer plane is a frame with two verticals and one transverse element, i.e., the pilasters and the entablature. The second, inner plane consists of a solid wall containing an arched opening whose sides are articulated with an architectural order.

The organization of the outer plane, which runs the entire height of the register, has no structural implications. The entablature, ideally projecting out of the wall surface, does not support the weight of any upper level, but simply marks a specific height on the wall, defining a horizontal geometric plane. The inner plane, on the other hand, is treated as an uninterrupted wall where only a limited a number of elements are allowed – the decorative elements related to the series of openings, i.e., pilasters, semicolumns, capitals, curved fasciae and roundels. Only in later examples is this wall also marked by a continuous moulding that usually sets the height of the impost plane of the arched openings. However, this moulding is still emphasized as belonging to an inner plane because it is interrupted where it meets the primary elements belonging to the outer plane.

Perspective Alignment

The walls that provide the boundaries for the volumes of a building are always perceived two-dimensionally, as geometrical planes. Even a wall consisting of a series of columns is interpreted as a surface, insofar as it is considered "an open wall, pierced in several places." The column, and with it the articulation of the surface, remains a part of the wall, whether it detaches itself completely to become a free-standing element, or only partially, as in the case of semicolumns or pilasters.

Every space-plane of a building is defined by the lines of its perimeter. These may be "corners," i.e., physically perceptible boundaries between surfaces, or "registers," i.e., successions of points oriented in a particular direction. The corners are in evidence wherever two surfaces intersect, whereas the registers define sequences of points. The corners are continuous, whereas the registers, i.e., the *giaciture* (the attitude of elements defining a series of related physical elements) are not constrained by a continuity of physical elements: they proceed even over empty spaces, as the restatement of a certain level, a certain relationship, or a certain alignment. While the former have a material reality, the latter exist only in the imagination, when an observer recomposes in his mind the hidden correspondences of the spatial composition.

Together, planes and geometrical lines make it possible to read the three-dimensional space like a frame. The elements of these frames – the orders – are a part of the building system insofar as they mark the junction points of the space framework and are reciprocally linked by simple proportions. The rhythm of their sequence scans the characteristic points of the building's modular grid. The planes that define the architecture of a space are subdivided horizontally by superimposed registers that define the wall surfaces vertically.

Symmetry and alignment are the two principles that govern the decorative elements of the walls. Symmetry, in this case, can be understood as an equivalence of decorative elements on either side of a principal axis, so that walls with the same function have the same articulation, from the overall organization down to the details. Alignment, in the perspective sense, can be understood as the maintaining of a horizontal or vertical line with respect to which adjacent or distant architectural elements are organized. In the horizontal sense, it can be defined by the presence of common impost lines, or a succession of architectonic members belonging to the same register, identified in turn by continuous entablatures or, more simply, by bands marking the division between stories. In the vertical sense, in contrast, superimposition is the prevailing principle: the architectural order, whether column or pilaster, is interpreted as figure, with the intervening empty space perceived as ground.

The architectural orders give the eye a means of measuring a building's scale and appreciating the substantiality of its space. By relating himself to the column, as in the sketches by Francesco di Giorgio Martini, man finds in buildings the ideal projection of his dimension. The superimposition of registers allows him to measure the overall composition, the repetition of similar units.

Junctions and Intersections of Surfaces

The articulation of the wall planes consistently follows the hierarchy of the building's volumes. Thus an interwoven texture of wall surfaces is formed within the inner space of the structure. The various planes can be

perceived and measured by means of a single module and are part of a single system. The limits of the internal space are defined by a "cage" of lines, which is not intended to outline the actual supporting structure of the building but is only accidentally superimposed upon it. The dark-colored hard stone of the structural elements – limestone or sandstone – stands out against the background of the lighter colored, plastered walls, clearly showing the building's spatial skeleton. This linear outline envelops the internal space, emphasizing the connecting planes between the various spatial units. High entablatures mark off the horizontal registers and the impost lines of the roofing system. Continuous bands follow the main lines of the geometrical surfaces of vaults and domes, setting off the edges as well as the curved segments of the interior surface of the intrados. Smaller-scale cornices mark the junction points of the lesser volumes – chapels and niches– and the transition points from one unit to another create the organizational hierarchy of the interior volume.

In churches, the junction point between different volumetric systems becomes the fulcrum for the articulation of the structural, architectonic members. The articulation of the corners is the subject of particularly close study–especially the corners of the tribune, which is the connecting point for several volumetric units. Columns are used in association with pilasters to clarify the composition of the junction and the identity of the various volumes involved. The Old Sacristy provides an example of one solution: the simple juxtaposition, at the corner, of two pilasters on the two adjacent walls, serves to underline the independence of the four geometrical planes that form the interior space. At the other end of the spectrum are the much more complex solutions in which numerous elements are used together – pilasters on pilasters or pilasters with portions of columns – to create a more elaborate connection between the tribune and the subsidiary arms of the church.

The corner of the courtyard of a Renaissance palace provides another field for research into possible solutions for the relationship between two surfaces intersecting at right angles. The portico of the Ospedale degli Innocenti serves as a model for the surface treatment; the use of this scheme in the courtyard of the Medici-Riccardi palace marks the beginning of the first experiments. The use of a single column at the corner indicates that the relationship between the two arches meeting at ninety degrees to each other is conceived literally as the intersection between two surfaces. Later solutions, in contrast, tend to emphasize the independence and formal differentiation of the two walls. In the ducal palace of Urbino and in Palazzo Farnese in Rome, the origin of the open space of the courtyard is clearly seen as a consequence of placing together the four independent surfaces that surround it, and the negative space hollowed out at the corner junction sets off the mass of the architectural order of the pilaster or semicolumn.

The Composition of Architecture

Examination of drawings by Renaissance architects reveals a working method in which the various hypotheses for a building's conformation are investigated, evaluated, and selected by means of increasingly precise sketches. As the principal instrument of study, the plan is used as a two-dimensional tool for checking and verifying the composition. In the plan, the architectural elements are defined in length and width; they are fixed in position, determining form and size. The representation of the building on this purely ideal plane is an invaluable aid to the architect for regulating the proportional relationships of the parts that define the space of the building. The plan serves to fix the dimensions of the walls and is the most important drawing when it comes to the actual construction phase.

In drawings such as those by Giuliano da Sangallo for St. Peter's, or in study sketches such as those by Bramante and Peruzzi, the indications given for the organization of the building and for the articulation of the wall structures are almost always accompanied by geometric projections of the roofing systems that cover the spaces being designed; a conventional symbol – the geometric projection of the roofing system – which

refers to something that is not explicitly expressed in the drawing, is related to a tangible mark – the sectioned wall – which, conversely, has a physical significance. These references to the roof, which were not to be found in the ancient past (missing, for example, in the great marble plan of Rome, the *forma urbis*), appear for the first time in plans for Gothic churches. They also appear, as Erlande and Brandenburg show in their study, in the two sketches that Villard de Honnecourt made after a discussion with Pierre de Corbie about the ideal plan for the apse of a cathedral. In these thirteenth-century sketches, the delineation of the plan layout is not considered separately from the structural implications of the roofing system, and the positioning of the walls and pilasters is linked to the projection of the ribs of the vaults. These projections provide structural information about the thrusts of the vaults, as well as typological information about their form. However, the use of the pointed arch means that the length and width dimensions of the bay do not give any indication of the height of the arch or of its impost level. Thus the scale of the elevation cannot be inferred directly from the plan; and since harmonic proportioning is not applied homogeneously throughout the building, no useful indication is provided with regard to the volumes concerned.

In Renaissance architecture, where the round arch is used, the distance in plan between the two sides of an arch indicates unequivocally the height of the keystone above the impost plane. The height of a vault is determined in the same way, whether it is a barrel vault–which amounts to a repeated arch along a single axis – or a cross vault produced by the intersection at right angles of two barrel vaults, or a sail vault supported on four arches, the perfect prototype of the cellular unit of square-generated space. The plan is therefore able to provide, through the projections of the roofing structures, indications that are easily comprehensible not only from the structural and typological, but also from the formal and volumetric points of view. The two-dimensional representation of every space is linked through the plan to its spatial image, and, compared to the sketches of Villard, these projections make it possible to perceive, with a certain degree of completeness, the three-dimensional aspect of the spaces by determining the height of the keystones. However, it is not possible to imagine the height of the impost plane of the various roofing elements; this information is lacking. And although the relationships between the various elements that make up the space can be clearly understood, it is not an easy matter to perceive the overall scale of the building's volumes.

"Pyramidal" Organization

An analysis of Bramante's choir and tribune for the church of Santa Maria delle Grazie provides a very precise idea of the basic volumetric principle of the Renaissance church: a central parallelepiped-shaped volume – the tribune – located at the center and covered by a dome, with the secondary volumes of the wings or side chapels placed up against it.

The disposition of these units proceeds from the center outward, with units of decreasing height aligned on axes of radial symmetry with respect to the geometrical center of the tribune. This spatial organization is founded on certain considerations of a functional nature, with the most important spaces at the center and the secondary spaces and chapels on the perimeter; there are also considerations of a symbolic nature, with the elimination of the longitudinal sequence of traditional ritual and greater emphasis on the position of the congregation; finally, there are also important structural reasons for this type of plan.

The central space of the tribune is, in fact, formed of four major arches. The height of their keystones marks the impost level of the dome or, if there is one, the drum. The connection of the square or polygonal plan of the tribune to the circle of the dome is achieved by means of pendentives – triangular, spherical-sectioned elements that transmit the weight of the dome onto the arches below. However, the entire load of the dome cannot be transmitted vertically. There is, in fact, a large factor of lateral thrust, which must be absorbed by the wings and the chapels arranged

around the tribune; the outward forces generated by the dome are opposed by the masses of these volumes.

But even this system of thrust and counter-thrust would not be sufficient to absorb all of the stresses if there were not a continuous sequence of connections to transmit them downward and outward to the most external point at ground level, through the dome, the drum, the arch of the nave, the arches of the aisles, and the chapels. The loads are thus absorbed by a succession of blocks, and the thrust is transmitted in the points where the impost plane of one block of vaults coincides with the keystone of the next lower register. The volumes are arranged in decreasing order of size, from the highest point of the lantern to the lowest point at ground level, and the decreasing alignment of the volumes describes an ideal straight line – a diagonal running downwards and outwards. Thus there is a "pyramidal" volumetric organization, which distributes the loads in all directions.

Even more than a structural principle, this "pyramidal" system is a principle of spatial organization; it guarantees that the identity of the internal volume is expressed in the external mass. The walls are thickened sufficiently to bear the loads they are subjected to, without reaching dimensions that would make it difficult to comprehend the inner spaces from the outside. In order to respect the principle of correspondence between external wall masses and interior space, the architects often resorted to "artificial" subsidiary systems. The most common of these is the chain placed around the circumference of the dome and drum, within the thickness of the masonry structure; tension on the chain absorbs a considerable portion of the horizontal thrust component and avoids the need to make the supporting walls below excessively thick.

The Block System

In the three-dimensional organization of a church according to a "pyramidal" hierarchy, it is important to define the height above ground level of the impost plane of the four major arches of the tribune. This height determines not only the impost level of the dome system, but also the height of the secondary, lateral spaces connected to the tribune.

The height of the tribune arches is determined by the choice of the architectural order. Depending on the intended usage of the building and the consequent choice of Doric, Ionic, Corinthian, Tuscan or Composite order, the canon of proportions associated with the order dictates both the height of the register and the dimensions of the various architectural components – pedestal, base, shaft, capital, architrave, frieze, and cornice. Two measurements are unequivocally set, once the dimensions of the main space are fixed and the architectural order is decided: the height from which the dome system will rise and the height of the secondary spaces surrounding the tribune. In this scheme, the tribune thus functions as an ordering principle of the "pyramidal" system. It is the central nucleus that determines the proportions of the two volumetric elements that are connected to it: the drum-dome-lantern system and the wings with the side chapels.

This organization in blocks is clearly represented in a drawing by Baldassare Peruzzi. In the middle of a plan for St. Peter's there is a sketch of the interior, as shown in Lotz's study on central-plan churches. In this sketch, a single dimension defines the whole height of the section from ground level to the key of the dome. This measurement is the sum of two others: the height of the impost level of the hemispherical dome and the radius that defines the intrados of the dome itself, i.e., one-half of its span. The tribune block, corresponding to the first measurement – from ground level to the impost of the dome – is in turn the sum of two other parts: the first of these, higher than the other, is a register, made up of a superimposed order, that functions as a connecting fascia to the dome; the other, lower one is a minor register containing the system of arches that connect this space with the outer ambulatories and with the side chapels. Within this last register, a fascia marks the impost height of the arches, creating a further subdivision of the elevation.

A similar "mechanism" can be analyzed in the volumes of central-plan churches, such as Santa Maria della Consolazione in Todi. The plan of this building is set up on a square which is the base of the tribune. The plan of the church is completed by four wings – three semidodecagonal and one semicircular – at the sides of the square; there are no further spaces for side chapels. The tribune is covered by a dome on pendentives and the impost level of the dome and drum is situated above the height of the keystones of the tribune arches. A part of the load is borne by the tribune system, while another, significant part is balanced by the lateral counter-thrusts of the four semidomes of the arms. The impost level of the dome also coincides with the keystone of the arches of the wings, i.e., the arches of the tribune; this is the connection point between the two systems, through which stresses are transmitted from the central nucleus to the peripheral elements. The height of the keystones of the arches in the wings is the sum of two measurements: one is the radius of the intrados, and is, therefore, equal to one-half of the side of the tribune; the other measurement is provided by a giant Doric order whose height is approximately equivalent to the width of the tribune. This second measurement corresponds to the principal volumetric block and is, in turn, the sum of an upper register made up of a single order of pilasters and another, lower register. The total height of this lowest register is given by the sum of the impost level of the arches of the aediculae that open on every side, plus the height of the arches themselves.

The Central-Plan System

A "pyramidal" scheme of architectural composition centers the entire central-plan structure on the volume of the tribune, from which secondary spaces of decreasing surface area and height are generated. The development of the plan, therefore, must necessarily begin with the selection of a geometrical figure for the tribune space, which becomes the generator of the whole scheme. From this point, the composition may proceed according to a pre-established model – for example, the Greek cross or the round temple – or by the invention of a new typology. Wittkower notes that "by the addition of small geometrical units to the basic forms of the circle and the polygon, a great variety of composite configurations can be obtained, with a common characteristic: corresponding points on the circumference have exactly the same relationship to the focal point placed at the center."

Two basic models for central-plan churches are most widely adopted in practice. The first includes monocentric buildings, which, in the opinion of Lotz, are initially organized almost exclusively according to a centrality based on the square and are characterized by a limited number of alignment positions for the various volumes. Later, as the spaces surrounding the tribune grew in number, thanks to the adoption of polygonal and circular plans, the axes of symmetry multiplied until in some examples they became infinite in number. It is these schemes, where any possible ambiguity of the parts has been eliminated, that are considered to be perfect. They contain only one point – the center – from which the observer can perceive the unity and homogeneity of the space. And the radial identity of the parts cancels any possible confusion in the process of mental recomposition of the architectonic space.

The second basic model for a central-plan church augments the monocentric plan by the addition of a number of geometrical reference points, as Patetta remarks. Four or more auxiliary spaces are positioned diagonally with respect to the corners of the tribune. The layout of the church results from the superimposition of a principal centrality – based on two main, orthogonal axes – and a series of minor centers; a radial path around the periphery of the tribune unites the four secondary elements. Compared to the ideal organization of the "circular temple," the plan of the polycentric church can be seen as an attempt to resolve the ambiguity between the physical multiplicity and the intellective unity of perspective space: the multiplication of geometrical centers provides a greater number of places from which to recall the central integrity of the plan.

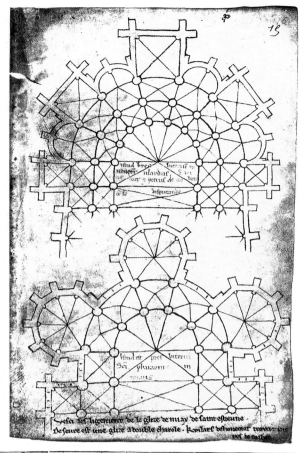

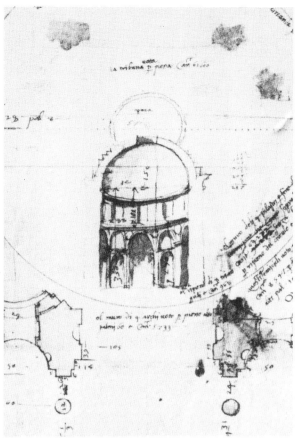

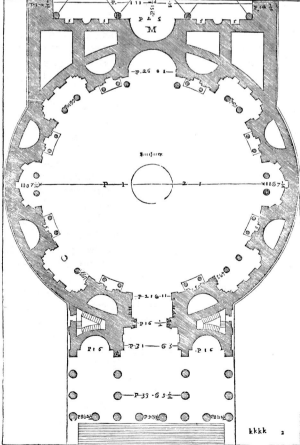

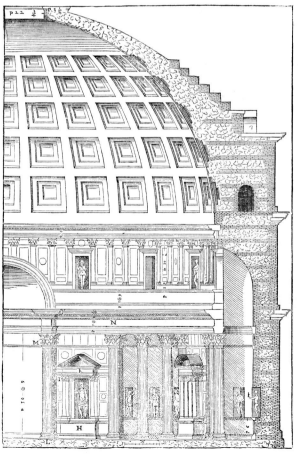

Villard de Honnecourt, plan of two sanctuaries of churches, XIII Century (ms. n. 19093), fol.15 v., Bibliothèque Nationale, Paris.

Baldassarre Peruzzi, project for the Basilica of St. Peter in Rome, ca. 1520

Andrea Palladio, plan and section of the Pantheon in Rome, 1570

Andrea Palladio, the Vesta temple in
Tivoli from his "Four Books on
Architecture", 1570

Andrea Palladio, the Vesta temple in
Rome from his "Four Books on
Architecture", 1570

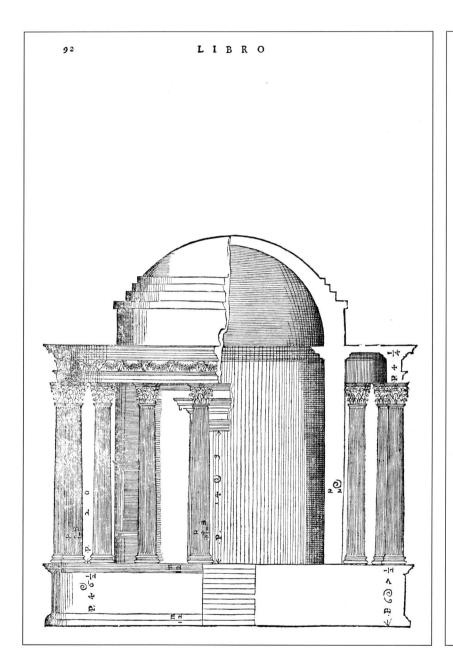

NELLA Prima, che è l'anteposta è disegnata la Pianta.

Nella Seconda l'Alzato cosi della parte di fuori come di quella di dentro.

Nella Terza sono i membri particolari.
 A, E' la Basa delle colonne.
 B, E' il Capitello.
 C, L'Architraue, il Fregio, & la Cornice.
 D, Gli ornamenti della porta.
 E, Gli ornamenti delle finestre.
 F, La Cornicietta di fuori intorno la cella, dalla quale cominciano i quadri.
 G, La Cornicietta di dentro sopra la quale è la soglia delle finestre.
 H, Il soffitto del portico.

*The geometrical construction of a
plan starting from the central square
of the tribune.*

*Analysis of Santa Maria della
Consolazione block system.*

The "pyramidal" organization.

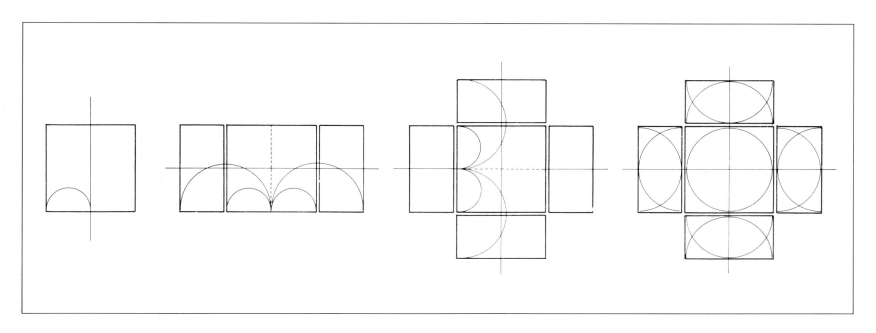

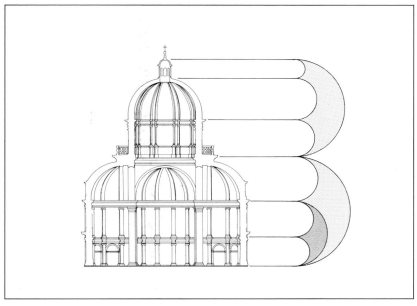

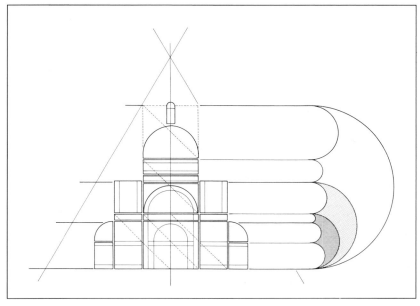

Articulation of the central system plan: from two volumes aligned on a single, common symmetry axis to a more complex polycentric system with various volumes radially articulated around a central tribune space.

The construction of the block system.

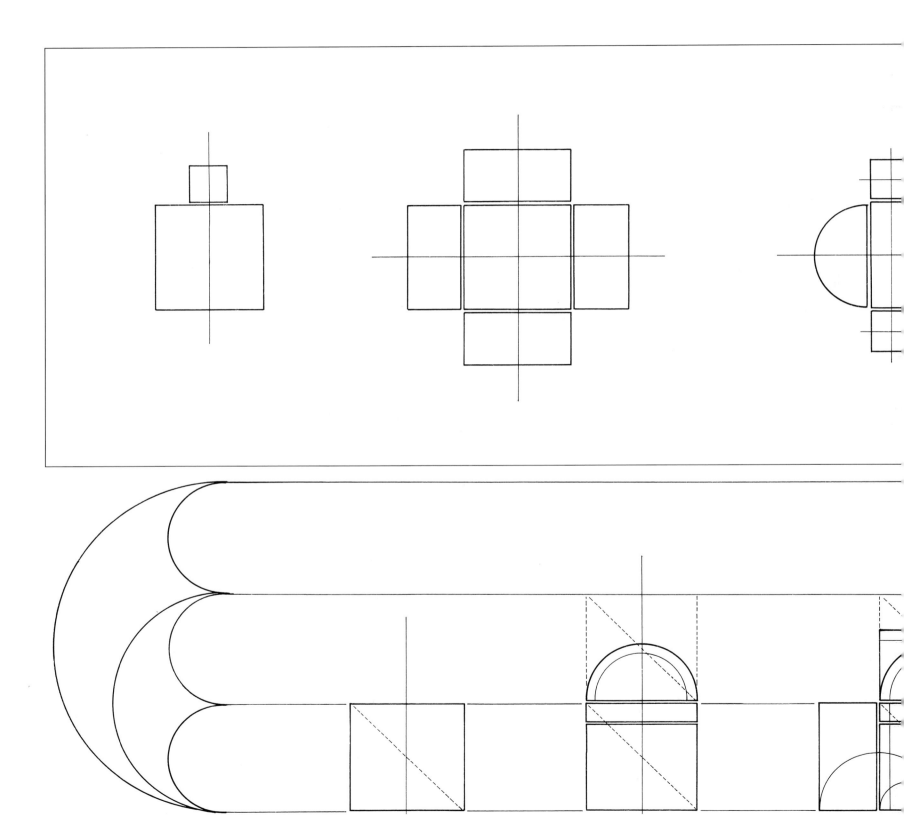

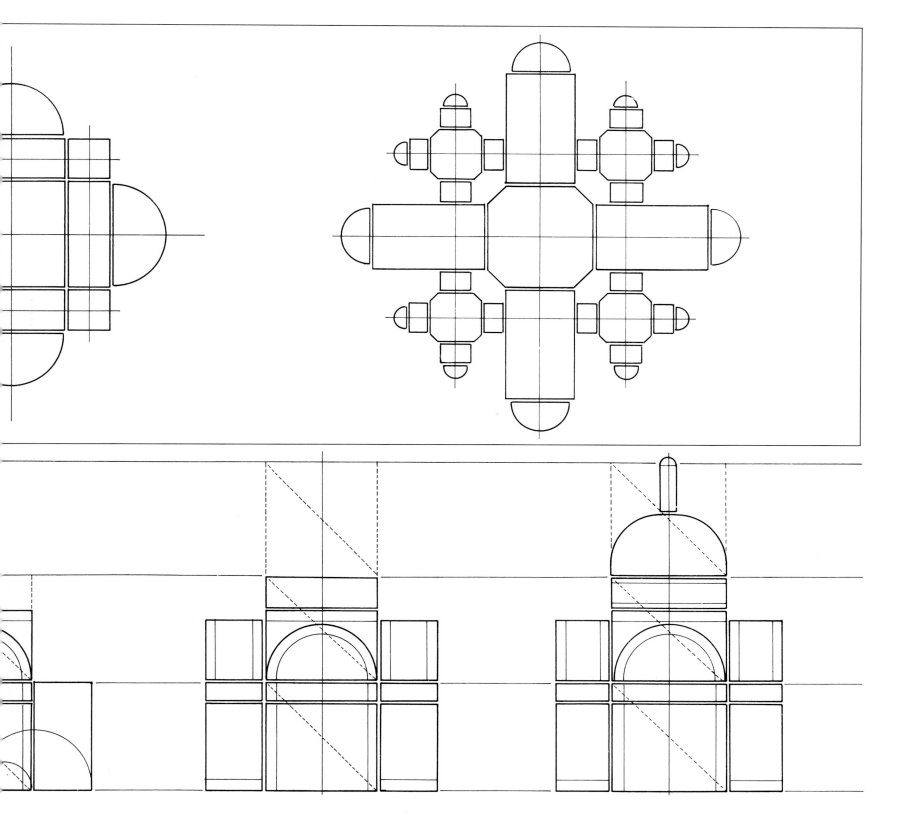

Harmonizing the predominant volume of the domed tribune with the volumes of the lateral spaces directly connected to it, or with the volumes of the side chapels, is a problem that arises in central-plan churches. The simplest solution involves an increase in the height of the tribune or a lower crowning line for the chapels arranged around the central space. The volumetric relationships are very simple and do not require intermediate transition elements. This is a typical solution for round Roman temples, one which continues to be seen in early Christian circular churches.

In his *Quattro Libri*, Palladio offers a reconstruction of the two temples of Vesta, in Rome and in Tivoli. The temples are shown with a circular colonnade, surmounted by an entablature; the full volume of the cella is higher and covered by a hemispherical dome. This is the volumetric model for such structures as the Tempietto of San Pietro in Montorio. However, as Lotz points out, the peripteral temple was not the universal reference for the central plan. This role was much more amply served by the Pantheon, which provided a volumetric model – for the interior only – as well as a symbolic model for the very concept of centrality. For central-plan systems that do not reflect the tradition of circular temples, a prototype for the pyramidal articulation of the external mass with respect to the internal volume can be found in the apse area of the Florentine cathedral of Santa Maria del Fiore. Three semi-octagonal wings project, along the main orthogonal axes, from the octagonal tribune. The four oblique sides of the central octagon are occupied by smaller connecting elements, also octagonal, whose primary function is to provide a link between the three wings as well as to the nave. In section, therefore, the entire apse was made up of three main volumes around the central tribune – the wings, covered with segmented semidomes – plus the four minor volumes of the connecting elements, which originally had flat roofs. Later, when the Tribune Morte were constructed on these roofs, these minor oblique connecting elements acquired the same volumetric relationship with the tribune as the three major wings. The completion of the dome, the lantern, and the Tribune Morte, generated a volumetric system that decreases, as it rises, by means of a progressive reduction of the external masses of the enclosed spaces that surround the central nucleus of the tribune.

Brunelleschi's insertion of the Tribune Morte bears witness to a deeply felt need to harmonize the external masses to reflect the organization of the interior spaces. The compositional principle of this three-dimensional model anticipates the "pyramidal" organization of the volumes of the central-plan churches; it can be compared with some of the later examples, among which are Santa Maria delle Grazie – the tribune and choir – Santa Maria delle Carceri, Santa Maria della Consolazione, and Sant' Eligio degli Orefici. In these examples, the relationship among the tribune, the dome, and the lateral elements reaches a state of equilibrium that identifies fully with the "pyramidal" outline. The way the various elements are linked together and the close correspondence between internal volumes and external mass make these buildings perfect spatial theorems.

In the church of San Biagio at Montepulciano, however, the addition of an apse area and two bell towers gives rise to a very unusual solution that partially anticipates the transformation of the pyramidal-system volumetric model. The interior of the church is arranged on a Greek-cross scheme; its integrity as a centrally organized space is not compromised by the presence of the apse, because the apse is not expressed internally as a part of the main space. On the exterior, a one-storey, apselike volume projects from the wing at the back of the church; this tends to unbalance the composition, but it is counteracted by the bell towers situated opposite, at the front. However, in this way the multiple axes of symmetry of the central-plan system are reduced to a single axis, and a preferred alignment is created which governs both the internal sequence of spaces – by identifying a main entrance – and the external succession of volumes. This alters the "pyramidal" arrangement. The search for correspondence between the articulation of interior and exterior comes to a first breaking point here, for the radial organizational system typical of the Greek-cross plan is replaced by an organization that prefers one single axis over the many possible ones. There is thus a mixture of two different organizational systems–one based on the concept of a rigorously centralized internal volume, the other, on an arrangement of the external mass along a longitudinal axis.

But the alteration of the equilibrium of the monocentric, central-plan system is linked especially to the transition toward polycentric schemes, that is, when new spaces for ambulatories, chapels, and minor tribunes begin to be annexed tangentially to the tribune. In Leonardo's study sketches, as Heydenreich remarks, it is possible to follow precisely the evolution of the problems and the factors that progressively led to a crisis in the relationship between mass and volume. His solutions for central-plan churches, including polycentric ones, systematically avoid the presence of an ambulatory. Polycentrism is achieved through a series of chapels connected only by small, secondary passages, while the principle connection is through the central space. The volumes of the side spaces can thus maintain their contiguity with the tribune, which – despite being absorbed in the mass of the elements surrounding it and no longer directly expressed on the exterior – retains its preeminent role as central pivot, thanks to the dome and drum that crown it. In the churches of Codex B, f. 17v. or in the plan of Ms. B, f. 25v, for example, four independent volumes are connected to the octagonal tribune, in a Greek-cross scheme. Four others are incorporated in a square and are characterized by the presence of smaller-scale domes. The volume of the tribune is expanded until it contains much of the building's mass, which nevertheless maintains its "pyramidal" arrangement thanks to this articulation. When, however, an ambulatory appears, as in Ms. B.N. 2037 f. 3v., only the reduced scale of the insertion, which does not alter the basic relationships of the volumetric scheme, permits the preservation of the building's overall integrity.

Alternatively, in churches like the Madonna di Campagna in Piacenza and Santa Maria della Steccata, and later examples such as Santa Maria Nuova and Santa Maria del Carignano, the tangential spaces – the secondary centers – begin to have a certain independence in both plan and section, and it is just this expansion and multiplication of centers that leads to a crisis for the "pyramidal" system. The volume of the tribune is considerably enlarged, since it must now include the ambulatory or the other spaces, and the length of its side no longer coincides with the width of the lateral wings. Direct correspondence also disappears from the volumetric point of view. The mass of the tribune plus ambulatory expands, becoming much larger than the surrounding volumes; the latter are consequently more distant from the corners of the building, which alters the scale of their mass with respect to the wall to which they are connected. The dome, in spite of its increased height, loses any sense of proximity to the lateral volumes, creating a horizontal break that inhibits any harmonic connection between the various volumetric groups.

A number of compositional expedients are used to remedy this situation. The impost level of the dome is raised on ever higher drums, in an attempt to relate the great horizontal dimension of the plan to a similar vertical measurement. Another solution is to increase the size and importance of the domes above the four corner spaces, so as to recall on the exterior – at least from the perspective point of view – the system of "pyramidal" organization, which in this case would nevertheless be completely independent with respect to the hierarchy of the internal space. Finally, bell towers may be situated at the four corners in order to establish, with the dome, a different organization of the external mass

through the creation of a great spatial prism that can substitute for the traditional arrangement of decreasing volumes.

These are the characteristics of the projects for St. Peter's and others that derive from them. But both the wooden model of Antonio da Sangallo's project and Duperac's engraving of Michelangelo's project demonstrate the ineffectiveness of these adjustments. They fail to establish a balance between the internal volumes and the disproportionate mass of the build-ing. Sangallo's bell towers and Michelangelo's secondary domes do not create a harmonic relationship between the various spatial components, so that the architects who, in the decades to come, would be charged with the completion of Michelangelo's scheme will have no choice but to base their work on an organization of the external mass that gives preference to the longitudinal succession of the internal volume according to the traditional sequence of principal facade, nave, tribune, and presbytery.

Bibliographic Note

This essay treats only limited and partial aspects of the far more complex, vast body of questions and events that represent Renaissance architecture as a whole. These comments derive directly from notes and sketches made during visits to the buildings and museums where most of the original drawings are located, as well as from a thorough study of the most important books published on Renaissance architecture.

First of all, I should mention of Rudolf Wittkower's *Architectural Principles in the Age of Humanism* and Erwin Panofsky's *Perspective as a 'Symbolic Form,'* Pierre Francastel's researches on figurative space and Wolfgang Lotz's studies on central-plan churches and Italian Renaissance architecture. As general reference books I have found valuable *The Architecture of the Renaissance* by Leonardo Benevolo, the always interesting and complex studies of Manfredo Tafuri and the very personal essays by Bruno Zevi. Geoffrey Scott's *Architecture of Humanism*, Peter Murray's *The Architecture of the Italian Renaissance*, John Summerson's *The Classical Language of Architecture*, and *Architecture in Italy 1400 to 1600* by Ludwig Heydenreich and Wolfgang Lotz have been very helpful. Among the many monographic studies available on buildings and architects, I have made extensive use of the work of Eugenio Battisti on Brunelleschi, Franco Borsi on Leon Battista Alberti, Arnaldo Bruschi on Bramante, C. L. Frommel, S. Ray, and M. Tafuri on Raphael.

I have also relied on Manfredo Tafuri's studies of Sansovino and Giulio Romano, Giulio Carlo Argan's text on Michelangelo and James Ackerman's work on Michelangelo and Palladio.

The above mentioned books are a very small part of a basic selection for an introductory bibliography on Renaissance architecture. They reflect only a very personal choice of books that have been important for my studies; thus, they are also a way of thanking the authors.

Reference Bibliography

Ackerman J., *L'architettura di Michelangelo*, London 1961

Ackerman J., *Palladio*, Harmondsworth 1966

Ackerman J., *Palladio e lo sviluppo della concezione della chiesa a Venezia*, in *Palladio e l'architettura sacra del Cinquecento in Italia*, in «Bollettino del Centro Internazionale di Studi di Architettura Andrea Palladio», XIX, 1977

Ackerman J., *La chiesa del Gesù alla luce dell'architettura religiosa contemporanea*, in Wittkower R./Jaffe I., *Architettura e arte dei Gesuiti*, Milan 1992

Adorni B., in *S. Maria della Steccata*, Parma 1982

Alberti L.B., *L'architettura*, translated by G. Orlandi, edited by P. Portoghesi, Milan 1989

Angelini L., *Le opere in Venezia di Mauro Codussi*, Milan 1945

Annoni A., *Considerazioni su Leonardo da Vinci Architetto*, in «Emporium», XLIX, 1919, 292

Argan G.C., *Michelangiolo Architetto*, in «Bollettino del Centro Internazionale di Studi di Architettura Andrea Palladio», IX, 1967

Argan G.C., *Classico Anticlassico Il Rinascimento da Brunelleschi a Bruegel*, Milan 1984

Argan G.C./Contardi B., *Michelangelo architetto*, Milan 1990

Arisi F./Arisi R., *Santa Maria di Campagna a Piacenza*, Piacenza 1984

Arnheim R., *Art and Visual Perception: a Psychology of the Creative Eye*, University of California 1954

Arslan E., *L'architettura milanese del primo Cinquecento*, in *Storia di Milano*, Milan 1957, vol. VIII

Arslan E., *Bramante in Lombardia*, in *Storia di Milano*, Milan 1957, vol. VIII

Barbieri F., *La Basilica Palladiana*, Vicenza 1968

Barbieri F., *Vicenza città di palazzi*, Milan 1987

Bargiacchi L., *Tempio e Opera della Madonna dell'Umiltà di Pistoia*, Pistoia 1890

Barocchi P., *Il Vasari Architetto*, in «Atti della Accademia Pontaniana», N.S., VI, 1956-57

Baroni C., *Santa Maria della Passione*, Milan 1938

Baroni C., *L'Architettura lombarda dal Bramante al Richini*, Milano 1941

Baroni C., *Bramante*, Bergamo 1944

Bartoli L., *La rete magica di Filippo Brunelleschi. Le seste, il braccio, la misura*, Florence 1977

Bartoli L., *La Basilica di San Lorenzo Nel tempo e nello spazio armonico*, in Baldini U./Nardini B. (ed.), *San Lorenzo La Basilica, le Sacrestie, le Cappelle, la Biblioteca*, Florence 1984

Bassi E., *Palazzi di Venezia Admiranda Urbis Venetae*, Venice 1976

Basso U., *Cronaca di Maser delle sue chiese e della villa palladiana dei Barbaro*, Montebelluna 1968

Battilotti D., *Le ville di Palladio*, Milan 1990

Battisti E., *Filippo Brunelleschi*, Milan 1976

Benedetti S., *Lo spazio architettonico in Bramante*, in *Bramante tra Umanesimo e Manierismo*, Rome 1960

Benedetti S., *S. Maria di Loreto*, Rome 1968

Benevolo L., *Introduzione all'architettura*, Bari 1960

Benevolo L., *Storia dell'architettura del Rinascimento*, Bari 1968

Benevolo L., *La cattura dell'infinito*, Bari 1991

Bettini S., *La fabbrica di San Pietro*, in Portoghesi P./Zevi B. (edited by) *Michelangiolo Architetto*, Turin 1964

Bondioli P., *Arte in Santa Maria di Piazza a Busto Arsizio*, Busto Arsizio 1930

Bonelli R., *La Piazza Capitolina*, in Portoghesi P./Zevi B. (edited by) *Michelangiolo Architetto*, Turin 1964

Borsi F., *Leon Battista Alberti L'opera completa*, Milan 1980

Borsi F., *Bramante ed il suo tempo*, Milan 1985

Borsi S., *Giuliano da Sangallo I disegni di architettura e dell'antico*, Rome 1985

Brandi C., *Il Tempio Malatestiano*, Turin 1956

Brandi C., *Il problema spaziale di Brunelleschi*, in *Filippo Brunelleschi La sua Opera il suo Tempo*, Florence 1980

Brandi C., *Disegno dell'architettura italiana*, Turin 1985

Brandi C., *Il tema spaziale del Peruzzi*, in Fagiolo M./Madonna M.L. (edited by), *Baldassarre Peruzzi pittura scena e architettura nel Cinquecento*, Rome 1987

Bruschi A., *Considerazioni sulla "Maniera matura" del Brunelleschi con un'appendice sulla Rotonda degli Angeli*, in «Palladio», n.s., XXII, 1972, I-IV

Bruschi A., *Bramante*, Bari 1973

Bruschi A., *Scritti rinascimentali di architettura*, Milan 1978

Bruschi A., *Bramante e l'immagine del "finto coro"*, in *La "prospettiva" bramantesca di Santa Maria presso San Satiro Storia, restauri e intervento conservativo*, Milan 1987

Bruschi A. (edited by), *Il tempio della Consolazione a Todi*, Cinisello Balsamo 1991

Bucci M./Bencini R., *Palazzi di Firenze Quartiere di Santa Croce*, Florence 1971

Bucci M./Bencini R., *Palazzi di Firenze Quartiere di Santa Maria Novella*, Florence 1973

Budinich C., *Il Palazzo Ducale di Urbino*, Trieste 1904

Burckhardt J., *L'Arte Italiana del Rinascimento*, Basel 1932

Burns H., *Progetti di Francesco di Giorgio per i conventi di San Bernardino e Santa Chiara di Urbino*, in *Studi Bramanteschi, atti del Congresso Internazionale*, Milan-Urbino-Rome 1970, Rome 1974

Burns H., *I progetti vicentini di Giulio Romano*, in *Giulio Romano*, Milan 1989

Burns H., *La facciata di palazzo Canossa a Verona, un'idea di Giulio Romano?*, in *Giulio Romano*, Milan 1989

Busignani A./Bencini R., *Le Chiese di Firenze Quartiere di Santo Spirito*, Florence 1974

Canova A., *Le Ville del Palladio*, Treviso 1985

Carpeggiani P./Tellini Perina C., *Sant'Andrea in Mantova Un tempio per la città del Principe*, Mantua 1987

Carpeggiani P./Tellini Perina C., *Giulio Romano a Mantova*, Mantua 1987

Carpiceci A.C., *L'architettura di Leonardo*, Florence 1978

Cataldi G./Formichi F., *Rilievi di Pienza*, Florence 1985

Cevese R., *L'opera del Palladio*, in *Mostra del Palladio Vicenza\Basilica Palladiana*, Milan 1973

Cevese R., *Invito a Palladio*, Milan 1980

Cevese R., *Asprezze e finezze nello scenografico Palazzo del Te*, in *Giulio Romano, Atti del Convegno Internazionale di Studi*, Mantua 1989

Chastel A., *Arte e Umanesimo a Firenze al tempo di Lorenzo il Magnifico*, Paris 1959

Chastel A., *La grande officina Arte Italiana 1460-1500*, Paris 1963

Chastel A., *I Centri del Rinascimento Arte Italiana 1460-1500*, Paris 1965

Chierici G., *Bramante*, Milan 1954

Chierici G., *Il Palazzo Italiano dal secolo XI al secolo XIX*, Milan 1964

Cipriani G., *Il Palazzo nella vita pubblica fiorentina*, in Cherubini G./Fanelli G. (edited by) *Il Palazzo Medici Riccardi di Firenze*, Florence 1990

Cozzi M., *Antonio da Sangallo il Vecchio Architettura del Cinquecento in Valdichiana*, Genoa 1992

Cresti C./Listri M., *Civiltà delle Ville Toscane*, Udine 1992

Curcio G./Manieri Elia M., *Storia e*

uso dei modelli architettonici, Bari 1982

De Angelis D'Ossat G., *Enunciati euclidei e «Divina Proportione» nell'Architettura del Primo Rinascimento*, in *Il Mondo Antico nel Rinascimento, Atti del V Convegno Internazionale di Studi sul Rinascimento*, Florence 1956, Florence 1958

De Angelis D'Ossat G., *Preludio romano del Bramante*, in «Palladio», n.s., XVI, 1966, I-IV

De Angelis D'Ossat G., *Origine e fortuna dei battisteri ambrosiani*, in «Arte Lombarda», XIV, 1969, 1

De Angelis D'Ossat G., *Brunelleschi ed il problema delle proporzioni*, in *Filippo Brunelleschi La sua Opera il suo Tempo*, Florence 1980

De Angelis D'Ossat G., *L'architettura della Biblioteca Laurenziana*, in Baldini U./Nardini B. (edited by) *Il complesso monumentale di San Lorenzo*, Florence 1984

De Angelis D'Ossat G./Pietrangeli C., *Il Campidoglio di Michelangelo*, Rome 1965

D.E.A.U. 1968 *Dizionario Enciclopedico di Architettura ed Urbanistica*, directed by P. Portoghesi, Rome 1968

De Fusco R., *L'Architettura del Cinquecento*, Turin 1981

De Fusco R./Scalvini M.L., *Segni e simboli del Tempietto di Bramante*, in «Op. cit.», XIX, 1970

Dewez G., *Villa Madama, modello del progetto ricostruito*, in Frommel C.L./Ray S./Tafuri M., *Raffaello Architetto*, Milan 1984

Dewez G., *Villa Madama Memoria sul progetto di Raffaello*, Rome 1990

Dionisi P.A., *Il Gesù di Roma*, Rome 1982

Elam C., *Palazzo Strozzi nel contesto urbano*, in *Palazzo Strozzi Metà Millennio 1489-1989, Atti del Convegno di Studi*, Florence, July 1989, Rome 1991

Fabriczy C. von, *Filippo Brunelleschi, sein Leben und seine Werke*, Stuttgart 1892

Fagnani F., *S. Maria di Canepanova*, Pavia 1961

Faldi I., *Il Palazzo Farnese di Caprarola*, Turin 1981

Fanelli G., *Firenze Architettura e Città*, Florence 1973

Fanelli G., *Brunelleschi*, Florence 1977

Fanelli G., *Firenze*, Bari 1980

Ferrara M./Quinterio F., *Michelozzo di Bartolomeo*, Florence 1984

Ferrario S., *Busto Arsizio*, Milano

1964, pp. 113 e sgg.

Finelli L., *L'Umanesimo giovane Bernardo Rossellino a Roma e a Pienza*, Rome 1984

Finelli L./Rossi S., *Pienza tra Ideologia e Realtà*, Bari 1979

Fiocco G., *Significato dell'opera di Michele Sanmicheli*, in *Michele Sanmicheli 1484-1559*, Verona 1960

Fiorio M.T. (edited by), *Le Chiese di Milano*, Milan 1985

Firpo L. (edited by), *Leonardo architetto e urbanista*, Turin 1962

Forssman E., *La concezione del palazzo palladiano*, in «Bollettino del Centro Internazionale di Studi Andrea Palladio», XIV, 1972

Forssman E., *Dorico, Ionico, Corinzio nell'architettura del Rinascimento*, Stockholm 1961

Forti A., *L'opera di Giorgio Vasari nella fabbrica degli Uffizi*, in «Bollettino degli Ingegneri», 11-12, 1971; 2-3, 1972

Francastel P., *Lo spazio figurativo dal Rinascimento al Cubismo*, Lyon 1951

Frommel C.L., *La villa Madama e la tipologia della villa romana nel Rinascimento*, in «Bollettino del Centro Internazionale di Studi Andrea Palladio», XI, 1970

Frommel C.L., *Palazzo Massimo alle Colonne*, in Fagiolo M./Madonna M.L. (edited by), *Baldassarre Peruzzi pittura scena e architettura nel Cinquecento*, Rome 1987

Frommel C.L., *Giulio Romano Architetto*, «Art Dossier», 40, November 1989

Frommel C.L./Ray S./Tafuri M., *Raffaello Architetto*, Milan 1984

Forster O., Bramante, in *Enciclopedia Universale dell'Arte*, Venice-Rome 1959

Gazzola P., *Opere di Alessio Tramello architetto piacentino*, Rome 1935

Gazzola P., *Michele Sanmicheli*, Venice 1960

Gemin M./Pedrocco F., *Ca' Vendramin Calergi*, Milan 1990

Gianani F., *Il Duomo di Pavia*, Pavia 1965

Giordano L., *Giovanni Battaggio e l'Incoronata*, in *Le stagioni de l'Incoronata*, Lodi 1988

Giovannoni G., *Antonio da Sangallo il Giovane*, Rome 1959

Giulio Romano, exhibition catalogue, Milan 1989

Giusti M.A., *Edilizia in Toscana dal XV al XVII secolo*, Florence 1990

Gombrich E.H., *Il palazzo del Te Riflessioni su mezzo secolo di fortuna critica 1932-1982 L'opera di

Giulio Romano*, in «Quaderni di Palazzo Te», 1, July-December 1984

Grossi M.C./Piccione E., *Il rilievo della Villa Farnesina Chigi*, Rome 1984

Heydenreich L., *Pius II als Bauherr von Pienza*, in «Zeitschrift fur Kunstgeschichte», I, 1937

Heydenreich L., *Leonardo Architetto*, Florence 1962

Heydenreich L., *Leonardo*, in *Enciclopedia Universale dell'Arte*, Venice-Rome 1967

Heydenreich L., *La villa: genesi e sviluppi fino a Palladio*, in «Bollettino del Centro Internazionale di Studi Andrea Palladio», XI 1970

Heydenreich L./Lotz W., *Architecture in Italy, 1400-1600*, Harmondsworth (Eng.)-Baltimore 1974

Heydenreich L./Passavant G., *I Geni del Rinascimento Arte Italiana 1500-1540*, Paris 1974

Huse N./Wolters W., *Venezia L'Arte del Rinascimento Architettura, scultura, pittura 1460-1590*, Venice 1989

Isermeyer C.A., *La concezione degli edifici sacri palladiani*, in «Bollettino del Centro Internazionale di Studi Andrea Palladio», XIV, 1972

Laschi G./Roselli P./Rossi P.A., *Indagini sulla cappella dei Pazzi*, in «Commentari», 1, 1962

Lavagnino E., *Il Palazzo della Cancelleria e la Chiesa di San Lorenzo in Damaso*, Rome 1924

Lewine M., *S.Andrea in via Flaminia e la chiesa a Maser*, in «Bollettino del Centro Internazionale di Studi Andrea Palladio», XV, 1973

Licht M. (edited by), *L'edificio a pianta centrale. Lo sviluppo del disegno architettonico nel Rinascimento*, exhibition catalogue, Uffizi, Florence 1984

Lieberman R., *L'Architettura del Rinascimento a Venezia 1450-1540*, Florence 1982

Lotz W., *La Rotonda: edificio civile con cupola*, in «Bollettino del Centro Internazionale di Studi Andrea Palladio», IV, 1962

Lotz W., *L'opera del Barozzi*, in *La vita e le opere di Jacopo Barozzi da Vignola 1507-1573* edited by W. Lotz, Bologna 1975

Lotz W., *Il Tempietto di Maser: note e riflessioni*, in «Bollettino del Centro Internazionale di Studi Andrea Palladio», XIX, 1977

Lotz W., *Studies in Italian

Renaissance Architecture*, Cambridge 1977

Luporini E., *Brunelleschi Forma e Ragione*, Milan 1964

Magagnato L., *L'interpretazione dell'architettura classica di Michele Sanmicheli*, in *Michele Sanmicheli 1484-1559*, Verona 1960

Magagnato L., *Palazzo Thiene Sede della Banca Popolare di Vicenza*, Vicenza 1966

Malaguzzi-Valeri F., *La corte di Lodovico il Moro*, vol. II, *Bramante e Leonardo*, Milan 1915

Maltese C., *Opere e soggiorni urbinati di Francesco di Giorgio*, in *Studi Artistici Urbinati*, Urbino, 1949

Maltese C., *Gusto e metodo scientifico nel pensiero di Leonardo*, Florence 1975

Maltese C., *Leonardo da Vinci Frammenti sull'Architettura*, in *Scritti Rinascimentali di Architettura*, Milan 1978

Manetti A., *Vita di Filippo Brunelleschi*, Milan 1976

Manieri Elia M., *Architettura e mentalità dal classico al neoclassico*, Bari 1989

Marchini G., *Il Cronaca*, in «Rivista d'Arte», XXIII, 1941, II series, XIII

Marchini G., *Giuliano da Sangallo*, Florence 1943

Marcianò A.F., *L'età di Biagio Rossetti Rinascimenti di casa d'Este*, Ferrara 1991

Mariani V., *Novità sul Battaggio*, in *Studi Bramanteschi, Atti del Convegno Internazionale*, Rome 1974

Mascagna S., *Caprarola ed il Palazzo Farnese Cinque secoli di storia*, Caprarola 1982

Matracchi P., *La chiesa di Santa Maria delle Garzie al Calcinaio*, Cortona 1991

McAndrew J., *L'Architettura veneziana del Primo Rinascimento*, Venice 1983

Meli F., *Matteo Carnelivari e l'architettura del '400 e '500 in Palermo*, Rome 1958

Miarelli Mariani G., *Il Tempio fiorentino degli Scolari; ipotesi e notizie sopra una irrealizzata immagine brunelleschiana*, in «Palladio», n.s., XXIII-XXV, 1974/76

Morisani O., *Michelozzo architetto*, Turin 1951

Morselli P./Corti G., *La chiesa di Santa Maria delle Carceri in Prato*, Florence 1982

Moscato A., *Il Palazzo Pazzi a Firenze*, Rome 1963

Murray P., *The Architecture of the

Italian Renaissance, London 1969
Murray P., *Architettura del Rinascimento*, Milan 1978
Nofrini U., *La chiesa della Consolazione a Todi*, in *Studi Bramanteschi, Atti del Convegno Internazionale*, Rome 1974
Norberg-Schulz C., *Architettura come storia di forme significative*, Milan 1979
Novasconi A., *L'Incoronata di Lodi*, Lodi 1974
Olivato L., *La concezione urbanistica dell'Alberti e il Sant'Andrea di Mantova*, in *Il Sant'Andrea di Mantova e Leon Battista Alberti, Atti del convegno di Studi nel quinto centenario della basilica di Sant'Andrea e della morte dell'Alberti*, Mantua 1974
Olivato L./Puppi L., *Mauro Codussi*, Milan 1977
Padovani G., *Biagio Rossetti*, Ferrara 1931
Pagliara P.N., *Palazzo Pandolfini*, in Frommel C.L./Ray S./Tafuri M., *Raffaello Architetto*, Milan 1984
Palladio A., *I Quattro Libri dell'Architettura*, 1570, Milan 1980, IV
Pampaloni G., *Palazzo Strozzi*, Rome 1982
Pane R., *Andrea Palladio*, Turin, 1961
Pane R., *Architettura ed Urbanistica del Rinascimento*, in *Storia di Napoli*, Naples 1974
Pane R., *Il Rinascimento nell'Italia Meridionale*, Milan 1975
Panofsky E., *La prospettiva come "forma simbolica"*, Warburg 1927
Parronchi A., *Il modello di Palazzo Strozzi*, in «Rinascimento», IX, 1969
Pasini P.G., *Cinquant'anni di studi sul Tempio Malatestiano*, in Ricci C., *Il Tempio Malatestiano*, Rimini 1974
Patetta L., *L'Architettura del Quattrocento a Milano*, Milan 1987
Patetta L., *Storia e Tipologia*, Milan 1989
Pedretti C., *Leonardo architetto*, Milan 1978
Polichetti M.L. (edited by), *Il Palazzo di Federico da Montefeltro*, Urbino 1985
Portaluppi P., *L'architettura del Rinascimento nell'ex Ducato di Milano. 1450-1500*, Milan 1914
Portoghesi P., *Il Tempio Malatestiano*, Florence 1965
Portoghesi P., *Roma del Rinascimento*, Milan 1971
Portoghesi P., *Architettura del Rinascimento a Roma*, Milan 1979
Preyer B., *L'architettura del Palazzo Mediceo*, in Cherubini G./Fanelli G. (edited by) *Il Palazzo Medici Riccardi di Firenze*, Florence 1990
Puppi L., *Andrea Palladio*, Milan 1973
Puppi L., *Michele Sanmicheli Architetto*, Rome 1986
Quintavalle A.G., *Parma, la Steccata*, in *Tesori dell'arte cristiana*, Bologna 1967
Quinterio F., *Madonna dell'Umiltà: evoluzione del linguaggio centrico ed influenze morfologiche*, in "Ventura Vitoni e il Rinascimento a Pistoia", exhibition catalogue, Pistoia 1977
Ragghianti C.L., *Tempio Malatestiano*, 2, in «Critica D'Arte», XII n. s., 1965, 74
C. L. Ragghianti , *Filippo Brunelleschi un Uomo un Universo*, Florence 1977
Ragghianti C.L., *Il modulo di Brunelleschi*, in Baldini U./Nardini B. (edited by), *San Lorenzo La Basilica, le Sacrestie, le Cappelle, la Biblioteca*, Florence 1984
Ray S., *Raffaello architetto*, Bari 1974
Ray S., *Lo specchio del cosmo Da Brunelleschi a Palladio: itinerario nell'architettura del Rinascimento*, Rome 1991
Rigon F., *Palladio*, Bologna 1980
Roselli P./Superchi O., *L'edificazione della Basilica di San Lorenzo*, Florence 1980
Rossi E., *Santuario di Santa Maria della Croce a Crema*, in «L'Architettura», 1965, 121
Rossi P.A., *Le cupole del Brunelleschi capire per conservare*, Bologna 1982
Rotondi P., *Il Palazzo Ducale di Urbino*, Urbino 1950
Ruschi P., *La Sacrestia Vecchia di San Lorenzo Storia ed Architettura* in *Brunelleschi e Donatello nella Sacrestia Vecchia di San Lorenzo*, Florence 1989
Salmi M., *Il Palazzo Ducale di Urbino e Francesco di Giorgio*, in *Studi Artistici Urbinati*, Urbino 1949
Salmi M., *Il Tempio Malatestiano*, in «Studi Romagnoli», II, 1951
Salmi M., Foreword to Pampaloni G., *Palazzo Strozzi*, Rome 1982
Sanpaolesi P., *La Sacristia Vecchia di San Lorenzo*, Pisa 1953
Sanpaolesi P., *Brunelleschi*, Milan 1962
Sanpaolesi P., *Precisazioni sul Palazzo Rucellai*, in «Palladio», N.S., XIII, 1963, I-IV
Schiavo A., *Il palazzo della Cancelleria*, Rome 1963
Scott G., *Architecture of Humanism*, London 1914
Scurati-Manzoni P., *Lo sviluppo degli edifici rinascimentali a pianta centrale in Lombardia*, in «Archivio storico lombardo» VII, 1968
Schwager K., *La chiesa del Gesù del Vignola*, in *Palladio e l'architettura sacra del Cinquecento in Italia*, in «Bollettino del Centro Internazionale di Studi di Architettura Andrea Palladio», XIX, 1977
Semenzato C., *La Rotonda di Andrea Palladio*, Vicenza 1968
Semenzato C., *Le chiese di Andrea Palladio*, in «Bollettino del Centro Internazionale di Studi di Architettura Andrea Palladio», XV, 1973
Simoncini G., *Architetti e architettura nella cultura del Rinascimento*, Bologna 1967
Simoncini G., *Città e società nel Rinascimento*, Turin 1974
Spagnesi G., *I continuatori della ricerca bramantesca*, in *Bramante tra Umanesimo e Manierismo*, Rome 1970
Spatrisano G., *Architettura del Cinquecento in Palermo*, Palermo 1961
Stegmann von C./Geymuller von H., *Die Architektur der Renaissance in Toscana*, 1-11, München 1885-1909, vol. VIII
Summerson J., *The Classical Language of Architecture*, London 1913
Tafuri M., *L'architettura del Manierismo nel Cinquecento europeo*, Rome 1966
Tafuri M., *J. Barozzi da Vignola e la crisi del Manierismo a Roma*, in «Bollettino del Centro Internazionale di Studi di Architettura Andrea Palladio», IX 1967
Tafuri M. , *L'architettura dell'Umanesimo*, Bari 19691
Tafuri M., *Jacopo Sansovino e l'architettura del '500 a Venezia*, Venice 19692.
Tafuri M., *Sansovino 'versus' Palladio*, in «Bollettino del Centro Internazionale di Studi Andrea Palladio, XIV, 1973
Tafuri M., *Venezia e il Rinascimento*, Turin 1985
Tafuri M., *Giulio Romano: linguaggio, mentalità, committenti*, in *Giulio Romano*, exhibition catalogue, Milan 1989
Tavernor R., *Reconstruction Drawings for San Sebastiano*, in *Leonis Baptiste Alberti*, in «A.D.» 21, 1980
Tea E., *I palazzi sanmicheliani*, in *Michele Sanmicheli 1484-1559*, Verona 1960
Thoenes C. in *Galeazzo Alessi e l'architettura del Cinquecento*, Genoa 1974
Tolnay, C. de, *Michelangelo*, Princeton 1947-60
Turri M., *La basilica di San Magno a Legnano*, Bergamo 1974
Valtieri S. (edited by), *Il Palazzo dal Rinascimento ad oggi*, Rome 1989
Vasari G., *Le vite de' più eccellenti pittori scultori et architettori*, Florence 1568
Vitruvio Pollione, *Dell'Architettura*, edited by G. Florian, Pisa 1978
Volpe G., *Francesco di Giorgio Architetture nel ducato di Urbino*, Milan 1991
Walcher Casotti M., *Il Vignola*, Trieste 1960
Wittkower R., *Architectural Principles in the Age of Humanism*, London 1962
Wittkower R., *Palladio and English Palladianism*, London 1974
Wittkower R., *Idea and Image, Studies in the Italian Renaissance*, Over Wallop 1978
Wittkower R./Wittkower M., *Born under Saturn*, London 1963
Zevi B., *Alberti*, in *Enciclopedia Universale dell'Arte*, Venice-Rome 1958
Zevi B., *Sanmicheli*, in *Enciclopedia Universale dell'Arte*, Venice-Rome 1964
Zevi B., *Saper vedere l'urbanistica Ferrara di Biagio Rossetti, la prima città moderna europea*, Turin 1971
Zevi B., *Architettura e Storiografia*, Turin 1974
Zevi B., *Brunelleschi anti-classico*, exhibition catalogue, Florence 1978
Zevi B., *Pretesti di critica architettonica*, Turin 1983

Index of Sites

Index of Architects

Typeset by Photocomp 2000, Naples
Photolitos SAMA, Naples
Printed by Incisivo, Salerno and
Centro dms, Naples
Bound by Legatoria S. Tonti,
Mugnano, Naples